Art & Visual Culture
1850–2010

This book is published by Tate Publishing in association with The Open University. The books in this *Art & Visual Culture* series are:

Art & Visual Culture 1100–1600: Medieval to Renaissance, edited by Kim W. Woods
 ISBN 978 1 84976 093 5 (paperback)
 ISBN 978 1 84976 108 6 (ebook)

Art & Visual Culture 1600–1850: Academy to Avant-Garde, edited by Emma Barker
 ISBN 978 1 84976 096 6 (paperback)
 ISBN 978 1 84976 109 3 (ebook)

Art & Visual Culture 1850–2010: Modernity to Globalisation, edited by Steve Edwards and Paul Wood
 ISBN 978 1 84976 097 3 (paperback)
 ISBN 978 1 84976 110 9 (ebook)

Art & Visual Culture: A Reader, edited by Angeliki Lymberopoulou, Pamela Bracewell-Homer and Joel Robinson
 ISBN 978 1 84976 048 5 (paperback)

Art & Visual Culture
1850–2010
MODERNITY TO GLOBALISATION

Edited by Steve Edwards and Paul Wood

Tate Publishing

in association with

The Open University

First published 2012 by order of the Tate Trustees
by Tate Publishing, a division of Tate Enterprises Ltd,
Millbank, London SW1P 4RG
www.tate.org.uk/publishing

in association with

The Open University
Walton Hall
Milton Keynes MK7 6AA
United Kingdom
www.open.ac.uk

Reprinted 2013
Copyright © 2012, The Open University

A catalogue record for this publication is available from the British Library

ISBN 978 1 84976 097 3 (paperback)
ISBN 978 1 84976 110 9 (ebook)

Distributed in the United States and Canada by ABRAMS, New York

Library of Congress Control Number applied for

Edited, designed and typeset by The Open University

Printed and bound in the United Kingdom by The Westdale Press, Cardiff

This publication forms part of the Open University module *Exploring art
and visual culture* (A226). Details of this and other Open University modules
can be obtained from the Student Registration and Enquiry Service, The
Open University, PO Box 197, Milton Keynes MK7 6BJ, United Kingdom
(tel. +44 (0)845 300 60 90, email general-enquiries@open.ac.uk).

1.2

Contents

Preface

This is the third of three books in the series *Art & Visual Culture*, which together form the main texts of an Open University Level 2 module, *Exploring art and visual culture*. Each book is also designed to be read independently by the general reader, to whom they offer an accessible introduction to some of the key issues raised by the study of art and visual culture across a broad historical period.

Central to each book is a concern with the ways in which the concept of art has developed over the course of time and how visual practices have both responded to and been shaped by these changing ideas. This final book in the series explores a period in which modern art diversified into a wide range of forms and media and spread from a few western centres to become a world-wide practice.

All of the books in the series include teaching elements. To encourage the reader to reflect on the material presented, each chapter contains short exercises in the form of questions printed in bold type. These are followed by discursive sections, the end of which is marked by ✑.

The three books in the series are:

Art & Visual Culture 1100–1600: Medieval to Renaissance, edited by Kim W. Woods

Art & Visual Culture 1600–1850: Academy to Avant-Garde, edited by Emma Barker

Art & Visual Culture 1850–2010: Modernity to Globalisation, edited by Steve Edwards and Paul Wood.

There is also a companion reader:

Art & Visual Culture: A Reader, edited by Angeliki Lymberopoulou, Pamela Bracewell-Homer and Joel Robinson.

Introduction: stories of modern art

Steve Edwards

This book addresses art and architecture across a broad period of two centuries, but it would be impossible to tackle the convoluted history of modern art in a volume of this size.[1] Instead, we have opted to present some snapshots of art made during this period. The eight topics discussed have been selected to highlight both what happened in art history and visual culture and to draw attention to some influential ways of thinking about modern art. The book is organised in two parts. Part 1 examines the period from the middle of the nineteenth century until the end of the 1930s. It considers French and English art of the nineteenth century, the rise of Cubism and abstract art and the modern movement in architecture and design. Part 2 looks at developments from the middle of the twentieth century up to the present day. It opens with a study of figurative painting and sculpture; then, focusing on two exhibitions, it considers influential trends associated with New York in the period after the Second World War; and the final two chapters cast a spotlight on globalisation and recent developments in art.

During the period covered by this book, art changed out of all recognition. At the beginning of our period, the various academies still held sway in Europe. Artists continued to learn their craft by drawing from plaster casts before progressing to the figure, and the trip to Rome remained a cultural rite of passage. It is true that the hierarchy of the genres was breaking down and the classical ideal was becoming less convincing. In 1859, the French poet Charles Baudelaire (1821–67) poured scorn on the new medium of photography. According to him, photographs that imitated paintings of ancient history were ludicrous:

> By bringing together a group of male and female clowns, got up like butchers and laundry-maids in a carnival, and by begging these *heroes* to be so kind as to hold their chance grimaces for the time necessary for the performance, the operator flattered himself that he was reproducing tragic or elegant scenes from ancient history.[2]

Baudelaire was suggesting that photographs that mirrored history painting – 'male and female clowns, got up like butchers and laundry-maids in a carnival' – were utterly unpersuasive, because tawdry details from everyday life undermined references to ancient

1

history. Many of his contemporaries went a step further, believing that paintings and sculptures of contemporary women posed as classical nymphs were equally preposterous. Increasingly, academic art failed to generate conviction, and ordinary landscapes and scenes from everyday life began to replace 'resurrected Romans'. Nevertheless, what counted as art in much of the nineteenth century remained pretty stable. Whether in sculpture, painting, drawing or printmaking, artworks represented recognisable subjects in a credible human-centred space. To be sure, subjects became less high-flown, compositional effects often deliberately jarring and surface handling more explicit. There were plenty of academicians and commentators who believed these changes amounted to the end of civilisation, but from today's perspective they seem like small shifts of emphasis.

In contrast, art in the first part of the twentieth century underwent a rapid gear change. Art historians agree that during this time artists began to radically revise picture making and sculpture. As you will see in chapters 1 and 3, painters flattened out pictorial space, broke with conventional viewpoints and discarded local colour.[3] Sculptors began to leave the surface of their works in a rough, seemingly unfinished state; they increasingly created partial figures and abandoned plinths or, alternatively, inflated the scale of their bases. Architects abandoned revivalist styles and rich ornamentation. To take one often cited example from painting, while the art of Paul Cézanne (1839–1906) is based on a recognisable motif, say a landscape, when looking at these paintings we get the distinct impression that the overall organisation of the colours and structural elements matters as much or more than the scene depicted. To retain fidelity to his sense impressions, Cézanne is compelled to find a new order and coherence internal to the canvas. Frequently this turns into incoherence as he tries to manage the tension between putting marks on a flat surface and his external observation of space.

As Paul Wood shows in chapter 3, in fifteen years some artists would take this problem – the recognition that making art involved attention to its own formal conditions that are not reducible to representing external things – through Cubism to a fully abstract art. Conventionally, this story is told as a heroic progression of 'movements' and 'styles', each giving way to the next in the sequence: Post-Impressionism, Fauvism, Cubism, Futurism, Dada, Constructivism, Surrealism Each changing of the guard is perceived

as an advance and almost a necessary next step on the road to some preset goal. This rapid turnover of small groups and personal idioms can seem bewildering and, in fact, this is a minimal version of this story. Whether they sought new expressive resources, novel ways of conveying experience or innovative techniques for representing the modern world, modern artists turned their backs on the tried and tested forms of mimetic resemblance. But what counted as art changed too. Bits of the everyday world began to be incorporated into artworks – as collage or montage in two-dimensional art forms; in construction and assemblage in three-dimensional ones. The inclusion of found materials played a fundamental role in modern art. The use of modern materials and technologies – steel, concrete, photography – did something similar. Some artists abandoned easel painting or sculpture to make direct interventions in the world through the production of usable things, whether chairs or illustrated news magazines. Not all artists elected to work with these new techniques and materials, and many carried on in the traditional ways or attempted to adapt them to new circumstances.

Autonomy and modernity

Broadly speaking, there are two different ways of thinking about modern art, or two different versions of the story. One way is to view art as something that can be practised (and thought of) as an activity radically separate from everyday life or worldly concerns. From this point of view, art is said to be 'autonomous' from society – that is, it is believed to be self-sustaining and self-referring. One particularly influential version of this story suggests that modern art should be viewed as a process by which features extraneous to a particular branch of art would be progressively eliminated, and painters or sculptors would come to concentrate on problems specific to their domain. This version of modern art and the theories associated with it will be examined in more detail in Part 1 of this book. Another way of thinking about modern art is to view it as responding to the modern world, and to see modern artists immersing themselves in the conflicts and challenges of society. That is to say, some modern artists sought ways of conveying the changing experiences generated in Europe by the twin processes of commercialisation (the commodification of everyday life) and urbanisation. From this point of view, modern art is a way of reflecting on the transformations that created what we call, in a sort of shorthand, 'modernity'.

While it has its roots in the nineteenth century, the approach to modern art as an autonomous practice is particularly associated with the ideas of the English critics Roger Fry (1866–1934) and Clive Bell (1881–1964), the critic Clement Greenberg (1909–94) and the New York Museum of Modern Art's director Alfred H. Barr (1902–81). For a period this view largely became the common sense of modern art.[4] This version of modernism is itself complex, and you will come up against it at various points in this book. The argument presumes that art is self-contained and artists are seen to grapple with technical problems of painting and sculpture, and the point of reference is to artworks that have gone before. This approach can be described as 'formalist' (paying exclusive attention to formal matters), or, perhaps more productively drawing on a term employed by the critic Meyer Schapiro (1904–96), as 'internalist' (a somewhat less pejorative way of saying the same thing).[5] According to Greenberg:

> Picasso, Braque, Mondrian, Miró, Kandinsky, Brancusi, even Klee, Matisse and Cézanne derive their chief inspiration from the medium they work in. The excitement of their art seems to lie most of all in its pure preoccupation with the invention and arrangement of spaces, surfaces, colours, etc., to the exclusion of whatever is not necessarily implicated in these factors.[6]

Rather than cloaking artifice, modern art, such as that made by Wassily Kandinsky (1866–1944) (see Plate 0.1), drew attention to the conventions, procedures and techniques supposedly 'inherent' in a given form of art. Modern art set about 'creating something valid solely on its own terms'.[7] For painting, this meant turning away from illusion and story-telling to concentrate on the features that were fundamental to the practice – producing aesthetic effects by placing marks on a flat, bounded surface. For sculpture, it entailed arranging or assembling forms in space. In a series of occasional pieces, Greenberg produced an account of the coming to consciousness of artists (or art) in which this fundamental recognition of the nature of painting was brought to fruition. For him modern art began with Edouard Manet (1832–83), who was the first to recognise or emphasise the contradiction between illusion and the flat support of the canvas. Cézanne pushed this recognition much further and his legacy was picked up by Henri Matisse (1869–1954) and the Cubists and further developed by Piet Mondrian (1872–1944) and the interwar abstract painters and some Surrealists (particularly Joan Miró, 1893–1983), culminating in the Abstract Expressionist generation

of American painters (see chapter 6), who were his contemporaries. Greenberg represented this trajectory as the modernist 'mainstream'.[8]

It important to understand that the account of autonomous art, however internalist it may seem, developed as a response to the social and political conditions of modern societies. In his 1939 essay 'Avant-garde and kitsch', Greenberg suggested that art was in danger from two linked challenges: the rise of the dictators (Stalin, Mussolini, Hitler and Franco) and the commercialised visual culture of modern times (the kitsch, or junk, of his title). Dictatorial regimes turned their backs on ambitious art and curried favour with the masses by promoting a bowdlerised or debased form of realism that was easy to comprehend. Seemingly distinct from art made by dictatorial fiat, the visual culture of liberal capitalism pursued instant, canned entertainment that would appeal to the broadest number of paying customers. This pre-packaged emotional distraction was geared to easy, unchallenging consumption. Kitsch traded on sentimentality, common-sense values and flashy surface effects. The two sides of this pincer attack ghettoised the values associated with art. Advanced art, in this argument, like all human values, faced an imminent danger. Greenberg argued that, in response to the impoverished culture of both modern capitalist democracy and dictatorship, artists withdrew to create novel and challenging artworks that maintained the possibility for critical experience and attention. He claimed that this was the only way that art could be kept alive in modern society. In this essay, Greenberg put forward a left-wing sociological account of the origins of modernist autonomy; others came to similar conclusions from positions of cultural despair or haughty disdain for the masses.

The period covered by this book has been tumultuous: it has been regularly punctuated by revolutions, wars and civil wars, and has witnessed the rise of nation states, the growth and spread of capitalism, imperialism and colonialism, and decolonisation. Sometimes artists tried to keep their distance from the historical whirlwind, at other moments they flung themselves into the eye of the storm. Even the most abstract developments and autonomous trends can be thought of as embedded in this historical process. Modern artists could be cast in opposition to repressive societies, or mass visual culture in the west, by focusing on themes of personal liberty and individual defiance. The New York School championed by Greenberg, which

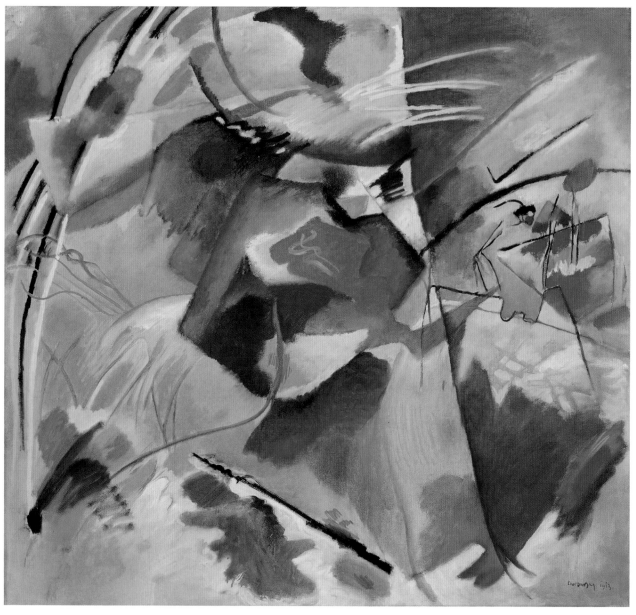

Plate 0.1 Wassily Kandinsky, *Painting with Green Center*, 1913, oil on canvas, 109 × 118 cm. Art Institute of Chicago, Arthur Jerome Eddy Memorial Collection, 1931.510. Photography: © The Art Institute of Chicago. © ADAGP, Paris and DACS, London 2012.

Michael Corris discusses in chapter 6, coincided with this political situation and with the high point of US mass cultural dominance – advertising, Hollywood cinema, popular music and the rest. In many ways, the work of this group of abstract painters presents the test case for assessing the claim that modern art offers a critical alternative to commercial visual culture. It could seem a plausible argument, but the increasing absorption of modern art into middle-class museum culture casts an increasing doubt over these claims. At the same time, as discussed in chapter 5, the figurative art that was supposed to have been left in the hands of the dictators continued to be made in a wide variety of forms. Brendan Prendeville, the author of this chapter,

argues that artists' encounters with the human body offered the same possibilities for a critical and engaging art in opposition to mainstream culture. If figurative art had been overlooked by critics during the high point of abstract art, it made a spectacular comeback with Pop Art.

Greenberg's story was particularly influential in the period from the mid-1940s to the mid-1960s. He produced a powerful synthetic account of developments or changes in art, but it was always a selective narrative. Even in the case of the paradigmatic example of Cubism (discussed in much more detail in chapter 3), it is possible to see other concerns. Whereas

the internal focus concentrated on the flattening of picture space through the use of small 'facet planes', art historians have recently paid a lot of attention to the way Pablo Picasso (1881–1973) and Georges Braque (1882–1963) engaged with the signs and materials of mass culture: their inclusion of newspaper cuttings, handbills, cinema tickets and the like. Cubism can be viewed as an experiment with the internal or formal concerns of art for a small audience of cognoscenti, and there is no denying that it is this, but embedded in this work is an engagement with the new forms of visual culture.

Let's take a step back to the middle of the nineteenth century and consider the emergence of modern art in Paris. The new art that developed with Gustave Courbet (1819–77), Manet and the Impressionists entailed a self-conscious break with the art of the past. These modern artists took seriously the representation of their own time. In place of allegorical figures in togas or scenes from the Bible, modern artists concerned themselves with the things around them. When asked to include angels in a painting for a church, Courbet is said to have replied 'I have never seen angels. Show me an angel and I will paint one.' But these artists were not just empirical recording devices. The formal or technical means employed in modern art are jarring and unsettling, and this has to be a fundamental part of the story. A tension between the means and the topics depicted, between surface and subject, is central to what this art was. Nevertheless, we miss something crucial if we do not attend to the artists' choices of subjects. Principally, these artists sought the signs of change and novelty – multiple details and scenarios that made up contemporary life. This meant they paid a great deal of attention to the new visual culture associated with commercialised leisure.

Greenberg contrasted the mainstream of modern art, concerned with autonomous aesthetic experience and formal innovation, with what he called 'dead ends' – directions in art that he felt led nowhere. Even when restricted to the European tradition, this marginalised much of the most significant art made in interwar Europe – Dada, Constructivism and Surrealism.[9] The groups of artists producing this art – usually referred to collectively as the 'avant-garde' or the 'historical avant-garde' – wanted to fuse art and life, and often based their practice on a socialist rejection of bourgeois culture.[10] From their position in western Europe, the Dadaists mounted an assault on the irrationalism and violence of militarism and the repressive character of capitalist culture; in collages, montages, assemblages

and performances, they created visual juxtapositions aimed at shocking the middle-class audience and intended to reveal connections hidden behind everyday appearances (see Plate 0.2). The material for this was drawn from mass-circulation magazines, newspapers and other printed ephemera. The Constructivists participated in the process of building a new society in the USSR, turning to the creation of utilitarian objects (or, at least, prototypes for them). The Surrealists combined ideas from psychoanalysis and Marxism in an attempt to unleash those forces repressed by mainstream society; the dream imagery is most familiar, but experiments with found objects and collage were also prominent. These avant-garde groups tried to produce more than refined aesthetic experiences for a restricted audience; they proffered their skills to help to change the world. In this work the cross-over to visual culture is evident; communication media and design played an important role. Avant-garde artists began to design book covers, posters, fabrics, clothing, interiors, monuments and other useful things. They also began to merge with journalism by producing photographs and undertaking layout work. In avant-garde circles, architects, photographers and artists mixed and exchanged ideas. For those committed to autonomy of art, this kind of activity constitutes a denial of the shaping conditions of art and betrayal of art for propaganda, but the avant-garde were attempting something else – they sought a new social role for art. One way to explore this debate is by switching from painting and sculpture to architecture and design, and Tim Benton follows this line of enquiry in chapter 4.

Marcel Duchamp (1887–1968), who is now seen as one of the most important artists of the twentieth century, occupies an important place in this alternative story. Duchamp started out as a Cubist, but broke with the idea of art as a matter of special visual experience and turned his attention to puns and perceptual or conceptual conundrums.[11] These activities brought him into the orbit of Dada in Paris and New York, but this was probably nothing more than a convenient alliance. Duchamp played games with words and investigated the associations of ordinary objects. He also messed around with gender conventions, inventing a female alter ego called Rrose Sélavy – a pun on 'Eros, c'est la vie' or 'Eros is life'. Critics and other artists have particularly focused on the strain of his work known as the 'readymades'. From 1914, Duchamp began singling out ordinary objects, such as a bottle rack, for his own attention and amusement and that of a few friends. Sometimes he altered these things in some small

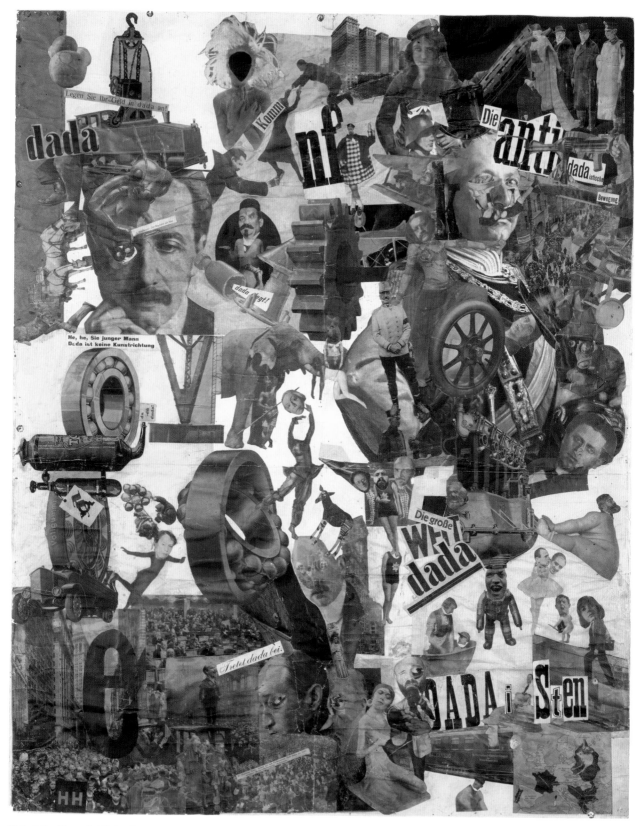

Plate 0.2 Hannah Höch, *Cut with the Kitchen Knife through the Last Epoch of the Weimar Beer-Belly Culture* (*Schnitt mit dem Küchenmesser durch die letzte Weimarer Bierbauchkulturepoche, Deutschlands*), 1919–20, photomontage and collage with watercolour, 114 × 90 cm. State Museums, Berlin, inv. NG57/61. Photo: © bpk/Nationalgalerie, SMB/Jörg P. Anders. © DACS 2012.

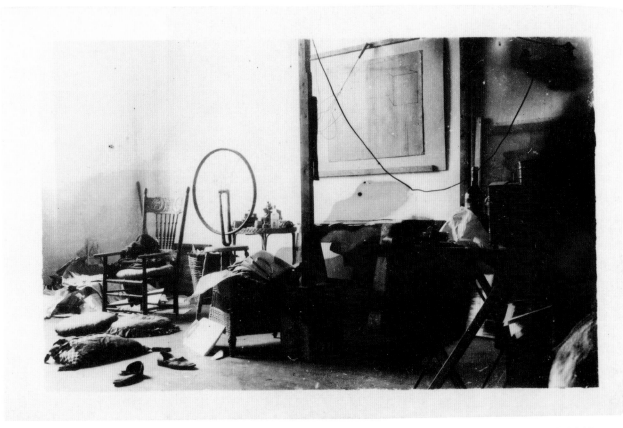

Plate 0.3 Henri-Pierre Roche, *Bicycle Wheel, 33 West 67th Street, New York*, 1917–18, gelatin silver print, 4 × 6 cm. Philadelphia Museum of Art; Gift of Jacqueline, Paul and Peter Matisse in memory of their mother Alexina Duchamp, 1998-4-61. Photo: © 2012 The Philadelphia Museum of Art/Art Resource/Scala, Florence. © Succession Marcel Duchamp/ADAGP, Paris and DACS, London 2012.

way, adding words and a title or joining them with something else in a way that shifted their meaning; with *Bicycle Wheel*, he attached an inverted bike wheel to a wooden stool – he seems to have been particularly interested in the shadow play this object created. We can see this odd object among the clutter of Duchamp's studio on West 67th Street in the photograph by Henri-Pierre Roche (Plate 0.3). He called these altered everyday things 'assisted readymades'.

Duchamp was interested in interrogating the mass-produced objects created by his society and the common-sense definitions and values that such things accrued. Mischievously, he probed the definitions and values of his culture for a small group of like-minded friends. It isn't at all clear that any of this was meant to be art; in fact, he explicitly posed the idea of making 'works' that could not be thought of as 'art'.[12] Nevertheless, artists in the late 1950s and the 1960s became fascinated with this legacy and began to think of art as something the artist selected or posited, rather than something he or she composed or made.

According to this idea, the artist could designate anything as art; what was important was the way that this decision allowed things to be perceived in a new light. This was to lead to a fundamentally different conception of art practice.

With the break-up of the hegemony of the New York School, artists began to look at those features of modern art that had been left out of the formalist story. During this period, Duchamp came to replace Picasso or Matisse as the touchstone for young artists, but he was just one tributary of what became a torrent. Perhaps most significantly, painting and anything we might straightforwardly recognise as sculpture began to take a back seat. As chapters 7 and 8 show, a host of experimental forms and new media came to prominence: performance art, video, works made directly in or out of the landscape, installations, photography and a host of other forms and practices. These works often engaged with the representation of modernity and the shifting pattern of world power relations we call 'globalisation'.

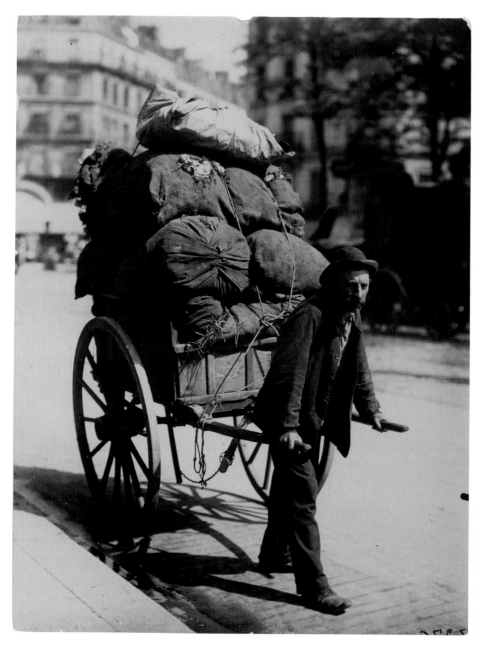

Plate 0.4 Eugène Atget, *Untitled (Ragpicker)*, *c*.1899–1900, gelatin silver print on paper, 22 × 17 cm. Museum of Modern Art, New York. Abbott-Levy Collection. Partial gift of Shirley C. Burden 1.1969.889. Photo: © 2012 The Museum of Modern Art/Scala, Florence.

National, international, cosmopolitan

Whether holding itself apart from the visual culture of modernity or immersed in it, modern art developed not in the world's most powerful economy (Britain), but in the places that were most marked by 'uneven and combined development': places where explosive tensions between traditional rural societies and the changes wrought by capitalism were most acute.[13] In these locations, people only recently out of the fields encountered the shocks and pleasures of grand-metropolitan cities. As the sociologist of modernity Georg Simmel (1858–1918) suggested: 'the city sets up

a deep contrast with small-town and rural life with reference to the social foundations of psychic life'. In contrast to the over-stimulation of the senses in the city, Simmel thought that in the rural situation 'the rhythm of life and sensory mental imagery flows more slowly, more habitually, and more evenly'.[14] This situation applies first of all to Paris.[15] In Paris, the grand boulevards and new palaces of commercial entertainment went hand in hand with the 'zone', a vast shanty town ringing the city that was occupied by workers and those who eked out a precarious

life. Whereas the Impressionists concentrated on the bourgeois city of bars, boulevards and boudoirs, the photographer Eugène Atget (1857–1927) represented the Paris that was disappearing – the medieval city with its winding alleys and old iron work – or those working-class quarters composed of cheap lodgings and traders recycling worn-out commodities (see Plate 0.4).[16] This clash of ways of life generated different ways of inhabiting and viewing the city with class and gender at their core. Access to the modern city and its representations was more readily available to middle-class men than to those with less social authority, whether they were working people, women or minority ethnic or religious groups.[17]

Before the Second World War, the alternative centres of modernism were also key sites of uneven and combined development: Berlin, Budapest, Milan, Moscow and Prague. In these places, large-scale industry was created by traditional elites in order to develop the production capacities required to compete militarily with Britain. Factory production was plopped down into largely agrarian societies, generating massive shocks to social equilibrium. In many ways, Moscow is the archetypal version of this pattern of acute contradictions. Before the 1917 Revolution, Moscow was the site of enormous and up-to-date factories, including the world's largest engineering plant, but was set in a sea of peasant backwardness. This is one reason that Vladimir Lenin described Russia as the weakest link in the international-capitalist chain.

This set of contradictions put a particular perception of time at the centre of modern art. As Wood demonstrates in chapter 1, opposition to the transformations of society that were underway could be articulated in one of two ways, and in an important sense both were fantasy projections: on the one hand, artists looked to societies that were seen as more 'primitive' as an antidote to the upheavals and shallow glamour of capitalism. On the other hand, they attempted a leap into the future. Both perspectives – Primitivism and Futurism – entailed a profound hostility to the world as it had actually developed, and both orientations were rooted in the conditions of an uneven and combined world system.

The vast urban centres – Paris, Berlin, Moscow – attracted artists, chancers, intellectuals, poets and revolutionaries. The interchange between people from different nations bred a form of cultural internationalism. In interwar Paris, artists from Spain, Russia, Mexico, Japan and a host of other places rubbed shoulders. Modernist artists attempted to transcend parochial and local conditions and create a formal 'language' valid beyond time and place, and 'the school of Paris' or the 'international modern movement' signified a commitment to a culture more capacious and vibrant than anything the word 'national' could contain. The critic Harold Rosenberg (1906–78) stated this theme explicitly. Rejecting the idea that 'national life' could be a source of inspiration, he suggested that the modernist culture of Paris, was a 'no-place' and a 'no-time' and only Nazi tanks returned the city to France by wiping out modernist internationalism.[18] Wood examines this theme in the introduction to chapter 1.

'No-place' then shifted continent. Perhaps for the only time in its history, after the Second World War modernism was positioned at the heart of world power – when a host of exiles from European fascism and war relocated in New York. American abstract art was centred on New York and a powerful series of institutions: the Museum of Modern Art, Peggy Guggenheim's gallery Art of This Century and a host of small independent galleries run by private dealers (including Betty Parsons, Samuel Koontz and Sidney Janis). In the main, these artists, such as Jackson Pollock (1912–56), Mark Rothko (1903–70), Arshile Gorky (1904–48), Robert Motherwell (1915–91) and Barnett Newman (1905–70), and associated critics (Greenberg and Rosenberg) were formed during the 1930s in the circles of the New York Left: they were modernist internationalists opposed to US parochialism in art and politics. After the war, they retained this commitment to an international modern art, while the politics drained away or was purged in the Cold War. The period of US hegemony in modern art coincided with the optimum interest in autonomous form and pure 'optical' experience. As you will see in chapter 6, this was the time when artists working in the modernist idiom were least interested in articulating epochal changes and most focused on art as an act of individual realisation and a singular encounter between the viewer and the artwork. At the same time, these artists continued to keep their distance from mainstream American values and mass culture. Some champions of autonomous art are inclined to think art came to a shuddering halt with the end of the New York School. Alternatively, we can see the Conceptual Art discussed by Michael Corris as initiating or reinvigorating a new phase of modern art that continues in the global art of today.

It should be apparent from this brief sketch that the predominant ways of thinking about modern art have focused on a handful of international centres and national schools – even when artists and critics

Plate 0.5 Baha Boukhari, *My Father's Palestinian Nationality*, 2007, medium variable, dimensions variable. 12th Istanbul Biennial, 2011. Photographed by Natalie Barki.

proclaim their allegiance to internationalism. The title of Irving Sandler's book *The Triumph of American Painting* is one telling symptom.[19] There is a story about geopolitics – about the relationship between the west and the rest – embedded in the history of modern art. These powerful forms of modernism cannot be swept aside, but increasingly critics and art historians are paying attention to other stories; to the artworks made in other places and in other ways, and which were sidelined in the dominant accounts of art's development. What we have tried to do in this book is to have our cake and eat it – to tell the mainstream story and simultaneously problematise it by raising some other possibilities. As you will see in the final two chapters of this book, a focus on art in a globalised art world leads to revising the national stories told about modernism. This history is currently being recast as a process of global interconnections rather than an exclusively western-centred chronicle, and commentators are becoming more attentive to encounters and interchanges between westerners and people from what has helpfully been called the 'majority world', in art as in other matters. In this book, we use this term – majority world – to characterise those

people and places located outside centres of western affluence and power; they constitute the vast majority of the world's inhabitants and this reminds us that western experience is a minority condition and not the norm.[20]

The standard perception of globalisation is that the entire world will gradually develop into the equivalent of New York or Strasbourg. Depending on your point of view, this is either utopia or hell. But irrespective of the value judgements, this idea of upward standardisation is a misconception. The reality is not that the majority world will be transformed into a high-tech consumer paradise. In fact, inequality is increasing across the world. What is referred to as globalisation is the most recent phase of uneven and combined development. The new clash of hypermodern and traditional forms of economic activity and social life are taking place side by side; megacities spring up alongside the 'planet of slums', and communication technologies play an important role in this clash of space and time (see Plate 0.5). Under these conditions, the making of modern art has entered a new and geographically extended phase. If an earlier phase of modernism is

identified with internationalism, it is increasingly apparent that this dream of a place that was nowhere (Paris, New York) was just that – a dream. Recent debates on globalisation and art involve a rejection of modernist internationalism; instead, artists and art historians are engaged with local conditions of artistic production and the way these mesh in an international system of global art making. Chapters 7 and 8 show that modern art is currently being remade and rethought as a series of much more varied responses to contemporaneity around the world. Artists now draw on particular local experiences, and also on forms of representation from popular traditions. You will see in chapter 1 that the engagement with Japanese popular prints played an important role in Impressionism, but in recent years this sort of cultural crossing has undergone an explosion.

Drawing local image cultures into the international spaces of modern art has once more shifted the character of art. The paradox is that the cultural means that are being employed – video art, installation, large colour photographs and so forth – seem genuinely international. Walk into many of the large exhibitions around the globe and you will see artworks referring to particular geopolitical conditions, but employing remarkably similar conventions and techniques. This cosmopolitanism risks underestimating the real forces shaping the world; connection and mobility for some international artists goes hand in hand with uprootedness and the destruction of habitat and ways of life for others. International travel and exhibition sit alongside increasing restrictions on migration and strong borders. Nevertheless, we are here dealing with art engaged with the most recent phase of modernity; this art brings other experiences and claims to the attention of a museum-going public. These are issues addressed in the final chapters of this book.

Notes

[1] One recent introductory book of about 900 pages (Foster et al., 2004) focused on just the second half this era.

[2] Baudelaire, 1981 [1859], p. 112.

[3] 'Local colour' is the term used for the colour things appear in the world. From the early twentieth century, painters began to experiment with non-local colour.

[4] O'Brian, 1986–95, 4 vols; Barr, 1974 [1936].

[5] Schapiro, 1978 [1937]. The opposition between 'internal' and 'external' approaches to art runs through much of Schapiro's subsequent writing.

[6] Greenberg, 1986 [1939], p. 9.

[7] Ibid., p. 8.

[8] For a succinct statement, see Greenberg, 1993 [1960].

[9] This perspective became particularly entrenched in 1961 with the publication of his book *Art and Culture: Critical Essays*. In this volume, he rewrote some earlier work, excluding reference to these 'dead ends' and consolidating what he viewed as the mainstream of modern art. See Greenberg, 1961.

[10] See, in particular, Bürger, 1984.

[11] Examples can be found in Duchamp, 1975.

[12] This account of Duchamp draws on Nesbit, 2000.

[13] The classic definition of uneven and combined development is to be found in Trotsky, 1962 [1928/1906].

[14] Simmel, 1997 [1903], p. 175.

[15] For Paris and modernity, see Clark, 1984; Harvey, 2003; Prendergast, 1992.

[16] Nesbit, 1992. See also Benjamin, 1983.

[17] Wolff, 1985, pp. 37–46; Pollock, 1988, pp. 50–90. Nesbit shows the argument must also be extended to class – see Nesbit, 1992.

[18] Rosenberg, 1970 [1940].

[19] Sandler, 1970.

[20] During the early 1990s, the Bangladeshi photographer Shahidul Alam began using the term 'majority world' as an alternative to the more common descriptions: 'third world', 'developing nations' or 'global south'. With the collapse of the Soviet Union and the Eastern Bloc there is no longer a 'second world', so reference to the 'third world' does not make sense; 'developing nations' presumes a pattern of economic growth with wealthy western nations as a norm on which all others are converging. This is unlikely. The 'global south', intended to convey the generalised conditions of poverty in distinction to the wealthy northern hemisphere countries, is the best of these descriptions, but the oxymoron is awkward.

Bibliography

Barr, A.H. (1974 [1936]) *Cubism and Abstract Art*, New York, Museum of Modern Art (exhibition catalogue).

Baudelaire, C. (1981 [1859]) 'On photography' in Newhall, B. (ed.) *Photography: Essays and Images*, New York, Secker & Warburg, pp. 112–13.

Benjamin, W. (1983) *Charles Baudelaire: A Lyric Poet in the Era of High Capitalism*, London, Verso.

Bürger, P. (1984) *Theory of the Avant-Garde*, Manchester, Manchester University Press.

Clark, T.J. (1984) *The Painting of Modern Life: Paris in the Art of Manet and his Followers*, London, Thames & Hudson.

Duchamp, M. (1975) *The Essential Writings of Marcel Duchamp* (ed. M. Sanouillet and E. Peterson), London, Thames & Hudson.

Foster, H., Krauss, R., Bois, Y.-A. and Buchloh, B.H.D. (2004) *Art since 1900: Modernism, Antimodernism, Postmodernism*, London, Thames & Hudson.

Greenberg, C. (1961) *Art and Culture: Critical Essays*, Boston, MA, Beacon Press.

Greenberg, C. (1986 [1939]) 'Avant-garde and kitsch' in O'Brian, J. (ed.) *Clement Greenberg: The Collected Essays and Criticism*, vol. 1: *Perceptions and Judgements, 1939–1944*, Chicago, IL, Chicago University Press, pp. 5–22.

Greenberg, C. (1993 [1960]) 'Modernist painting' in O'Brian, J. (ed.) *Clement Greenberg: The Collected Essays and Criticism*, vol. 4: *Modernism with a Vengeance, 1957–1969*, Chicago, IL, Chicago University Press, pp. 85–100.

Harvey, D. (2003) *Paris: Capital of Modernity*, London and New York, Routledge.

Nesbit, M. (1992) *Atget's Seven Albums*, New Haven, CT and London, Yale University Press.

Nesbit, M. (2000) *Their Common Sense*, London, Black Dog.

O'Brian, J. (ed.) (1986–95) *Clement Greenberg: The Collected Essays and Criticism*, 4 vols, Chicago, IL, Chicago University Press.

Pollock, G. (1988) *Vision and Difference: Femininity, Feminism and the Histories of Art*, London and New York, Routledge.

Prendergast, C. (1992) *Paris and the Nineteenth Century*, Oxford, Blackwell.

Rosenberg, H. (1970 [1940]) 'The fall of Paris' in *The Tradition of the New*, London, Paladin, pp. 185–94.

Sandler, I. (1970) *The Triumph of American Painting*, Westport, CT, Praeger.

Schapiro, M. (1978 [1937]) 'Nature of abstract art' in *Modern Art: 19th and 20th Centuries. Selected Papers*, New York, George Braziller, pp. 185–211.

Simmel, G. (1997 [1903]) 'The metropolis and mental life' in Frisby, D.P. and Featherstone, M. (eds) *Simmel on Culture: Selected Writings*, New York, Sage, pp. 174–85. Extract reprinted in Lymberopoulou, A., Bracewell-Homer, P. and Robinson, J. (eds) *Art and Visual Culture: A Reader*, London, Tate Publishing in association with The Open University, pp. 267–9 (Reader Text 5.18.3).

Trotsky, L. (1962 [1928/1906]) *The Permanent Revolution; Results and Prospects*, London, New Park.

Wolff, J. (1985) 'The invisible flaneuse: women and the literature of modernity', *Theory, Culture and Society*, vol. 2, no. 3, pp. 37–46.

Part 1

Art and modernity

Introduction

The first part of this book examines the subculture of modern art that developed in Paris during the 1850s and spread through a number of key western centres in the period up to the Second World War. The artists associated with modern art sometimes drew upon the new commercial visual culture of capitalism, but the images and objects they made were no longer addressed to the mainstream of society. Artists formed small circles of like-minded practitioners, often with a few associated and vocal champions who tended to be poets-cum-critics. This cultural faction set itself against the prevailing bourgeois cultural and moral values, if not always the political or economic ones. However, academic art did not suddenly wither and die, and the institutions that supported official art retained much of their power and authority into the twentieth century, but an alternative current developed in opposition to the tenets associated with the academic tradition. Changes in the structure of feeling that animated modern art had been evident at least since the generation associated with 'Romanticism', but these gathered pace from the 1850s. Artists who rejected academic values, or at least wanted to do something different, came to value those types of art that had previously seemed minor, such as landscape and genre pictures; spontaneous impressions replaced studied composition; handling became looser in painting and finish rougher in sculpture; and originality was attributed a higher importance than adherence to fixed rules. Architects explored the use of new materials and structural possibilities and rejected the obsession with historical-revivalist styles. Modern artists tried to face modern society, rather than looking back to classical Rome.

A breach with the past is seen by some as central to modern art or 'modernism', while others have argued for a continuity of values. Certainly, from the mid nineteenth century onwards, modern art underwent a series of rapid transformations. There was an intensification of formal experimentation and an urgent search for new ways of working. Right through this period, some artists continued to find ways of responding to modern life, both by introducing new formal equivalents for experience and by searching out novel subjects. Others attempted to remain aloof and develop a calmer space for art. This latter tendency is sometimes referred to as autonomous art. Abstract art is one clear example of this trend towards a focus on unique aesthetic experience that was unrelated to other kinds of knowledge or the wider visual culture. But this impulse had a wide appeal, beyond the circles of abstract artists.

It is important to understand that the art of this time does not follow a single track. Nevertheless, artists who were identified as modernist shared a belief that the old techniques and skills were increasingly inadequate, even redundant, in the face of new conditions, whether those concepts were thought to be social, spatial or aesthetic.

Even in the few western metropolitan cities where modern art developed, it was invisible to most people and the spread was definitely uneven. Modern art made little headway in Britain during this period, and whole swathes of the globe have remained immune to its influence for much longer, but in Paris, Berlin and Moscow small groups of artists and critics developed different ways for imagining and representing the forces that were transforming western European societies and which would eventually draw in most other parts of the world. As many artists and critics are discovering today, the alternative visions of modernity set out in the period covered by Part 1 of this book may have much to teach us about globalisation in our own time.

We are not going to survey this complex and involved history in this part of the book. Instead, we will fasten on four points, or moments, which we hope illuminate some of the larger contrasts and patterns. Part 1 opens with Paul Wood's chapter 'Avant-garde and modern world: some aspects of art in Paris and beyond c.1850–1914'. This chapter establishes many of the concepts that will appear throughout the book and it bears close attention. Wood considers the avant-garde art that developed in Paris, a city that was virtually synonymous with modern art in the period he covers. In the process, he looks at the influential account of this art offered later by the critic Clement Greenberg. Wood also provides some pointers to what we might mean by 'modernism' and how this important category might relate to 'modernity'. He also shows that, while Paris was the key site for modern art, it was always connected to the visual culture of other societies. Principally, he reflects on the response to Japanese prints by Impressionist artists; the technical radicalism they saw in these images fired their imagination and provided important resources for rethinking pictures. The final section of this chapter considers the decline of a concern with contemporary society as artists turned to visions of the future or fantasy conceptions of 'primitive' life.

The second chapter, 'Victorian Britain: from images of modernity to the modernity of images', takes Britain as a counter-example to the Parisian avant-garde. In this chapter, Steve Edwards suggests that there is no

automatic link between modernity and modern art. Britain, the most powerful industrial and commercial economy, produced no equivalent to the Parisian avant-garde. Looking at three different responses to modernity in Britain, Edwards suggests that we need to distinguish between images of modern life and the role images played in shaping modern experience. Here, visual culture occupies a prominent position in the argument. He concludes by suggesting that the most powerful response to modernity in the British Isles was developed by William Morris in an idiom that at first sight has little to do with the concerns that underpinned the Parisian artists' fascination with the appearance of contemporary urban life.

In chapter 3, '*Cubism and Abstract Art* revisited', Paul Wood picks up the story of modern art and considers some of the central developments and transformations that took place in the first half of the twentieth century. The art of this period – from Paul Cézanne and Henri Matisse to Pablo Picasso and Piet Mondrian and then Vladimir Tatlin and Władysław Strzemiński – includes some of the most challenging work of the century. In many ways, this was a pivotal moment: the point at which artists turned their backs on resemblance to the external world (mimesis). For many, this is difficult to comprehend. Wood offers a clear account of the concerns that informed these choices and shows that, despite the overt hostility towards established forms of depiction, Cubism and abstract art were very much wrapped up with the tumultuous events of European history.

Part 1 concludes with Tim Benton's chapter 4, 'Modernism in architecture and design: function and aesthetic'. Developed around a study of buildings by Le Corbusier (Charles-Edouard Jeanneret, 1887–1965), Benton looks at what 'modernism' means in architecture and design. He introduces key concepts and reflects on the concerns of architects with new forms and materials, and at their commitment to a pared down, anti-ornamental building style. Benton considers the way modernist architecture and design took inspiration from industry and reflects on how the latest materials, such as glass, concrete and tubular steel, allowed new developments in building and furniture. He looks at different trends within the modern movement, principally contrasting the 'functionalists', who rejected aesthetics and suggested buildings should be constructed in a way that foregrounds their structural principles and their use or purpose, with the 'formalists', who felt that the new building forms should convey a unique experience through the composition of volumes, planes and the use of light.

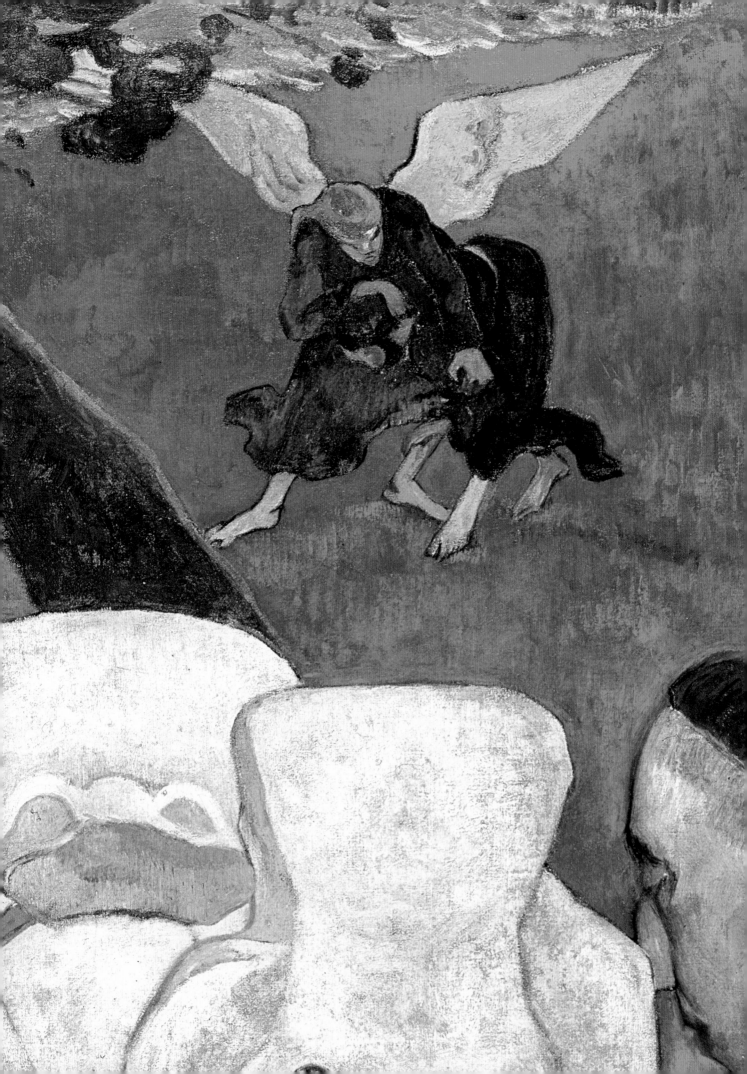

Chapter 1

Avant-garde and modern world: some aspects of art in Paris and beyond *c.*1850–1914

Paul Wood

Introduction

The trajectory of 'modern art' has been remarkable. From a ridiculed subculture in one city in the middle of the nineteenth century, it had become by the middle of the twentieth the official art of the western world. In the early twenty-first century, major museums of art dot the globe, no longer just in Europe and 'the west', and the exhibitions that are guaranteed to bring in the crowds are those of the late nineteenth-century pioneers of the 'modern movement'. People in enormous numbers want to experience the art of Edouard Manet, Claude Monet (1840–1926), Paul Gauguin (1848–1903), Vincent van Gogh (1853–90), Paul Cézanne and others, as well as their immediate successors in the early twentieth century, such as Pablo Picasso and Henri Matisse, all of whom worked in the city of Paris.

Not that they all lived in Paris all of the time. Picasso was Spanish, van Gogh Dutch. Monet came from Le Havre, Cézanne from the Mediterranean south. Gauguin produced his most lasting art on the other side of the world, in Polynesia. But none of it could have existed without Paris, without the network of dealers and galleries that grew up there, without the periodical literature, and without something more difficult to pin down: the evolving social relations, the ferment of ideas, the distinctive politics and culture that was Paris. In the 1930s, the exiled German philosopher-critic Walter Benjamin (1892–1940), who was among the first to open up a complex and nuanced understanding of that place and time, dubbed Paris 'the capital of the nineteenth century'. The phrase has almost become a cliché now, but that does not mean it is not, in

Plate 1.1 (Facing page) Paul Gauguin, *The Vision after the Sermon (Jacob Wrestling with the Angel)* (detail from Plate 1.22).

important respects, true. At the end of the nineteenth century, Joseph Conrad (1857–1924) called London 'the biggest, and the greatest, town on earth'.[1] But for Paris it seems to have been a matter less of quantity than of quality, as if the city precipitated the essence of the modern consciousness. Only a few years after Benjamin's pioneering attempt to think through the origins of modernity, the American critic and poet Harold Rosenberg wrote a kind of obituary for Paris after it had fallen to the Nazis in June 1940. For him, Paris was not in France; it was an enchanted island, floating above the world – an international non-place, or supra-place, which more than any other had produced the modern mind. And modern art.

The story of modern art fills libraries. It has been told time and again. The present chapter can introduce only some of its outstanding features, features which seem interesting now. That is itself an important point. For no telling of the story now can remain innocent of the ways it has already been told. Even though this is only an introduction, the reader has to hold in place two distinctive registers: the history and the historiography. By which I mean something like 'the facts' on the one hand, and on the other the way those historical facts have been represented, framed and arranged, according to the priorities and interests of the time when the tale was being told. Most people who possess some sense of the narrative of modern art would probably say the story has been told in two broad ways, with one type of account replacing the other some time in the 1970s and 1980s. The former was called then, and is frequently still called, 'modernist'. Its successor was a product of the 'new art history' which emerged at that time, and set the terms of reference for what followed, up to the present day. This picture is, of course, simplified, but it offers a way of gaining traction on some key terms without which it is hard to tell the story at all.

1 Modernism

In the discussion that follows, I want to remain as close to actual examples of art as I can, while yet paying due attention to the ideas that animated them.

Exercise

Look at Manet's *Olympia* (Plate 1.2).

Try to write down what you, as a contemporary viewer, or reader (of a book like this), see.

Discussion

The first thing I see is the image of a young woman, naked, on a bed, staring out of the picture. At me. She is naked apart from a necklace, a pair of earrings, a gold bracelet, and one slipper. Her skin is very pale. She has a pink-ish ribbon, or perhaps it is a flower, in her hair. The bed on which she reclines is quite sumptuous. She is lying on an embroidered shawl and is half propped up on an enormous pillow. The white of the bed combines with Olympia's pale skin to form an extensive light-coloured area all along the bottom half of the picture, reaching higher up on the left-hand side. All of this is pretty much instantaneous. Then I notice a black maid, standing behind the bed, and proffering a large bouquet. She too is dressed in a pale robe, which forms another light-coloured area, rising up to the same height as the naked girl, on the right side of the picture. She is looking at Olympia, just as Olympia is looking at me. Then I realise there is another pair of eyes staring at me. The deep yellow eyes of a small black cat, its back arched, near the lower right-hand edge of the frame. If I carry on looking, I pick up out of the darkness which surrounds the very light areas I have described, a green velvet curtain at the upper left, a patterned screen behind Olympia's head and torso, its vertical edge catching the light right down the middle of the picture, and a dark space in which the maid stands. It is hard to tell how deep this is, and equally hard to tell if the pale rectangle at the top is a window. Or maybe it is some distant wallpaper in a room beyond, just visible between two dark curtains through which the maid has emerged.

What I have just described is my response to a coloured illustration in a book, a few inches square, with the characteristic sheen of such things, which in conjunction with the relatively small size can make it difficult to pick out details. If I were standing in front of the real thing, I would see differently. The surface would be relatively matt. If I moved closer I might be able to see the detail of the brushstrokes out of which the image is made. And depending on where the painting was hung on the wall, I would be more powerfully aware of those eyes of Olympia, looking out at me, level with my own.

Now read what the American modernist art critic Clement Greenberg had to say about Manet's art in the canonical essay 'Modernist painting' that he wrote in 1960, and then revised in 1965, a hundred years after *Olympia* was exhibited at the Salon in Paris:

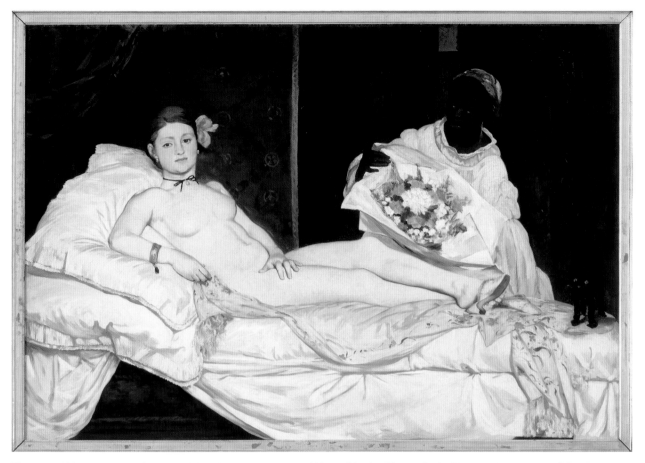

Plate 1.2 Edouard Manet, *Olympia*, 1863, oil on canvas, 130 × 190 cm. Musée d'Orsay, Paris. Photographed by Jean-Gilles Berizzi. Photo: © RMN (Musée d'Orsay)/Jean-Gilles Berizzi.

Manet's paintings became the first Modernist ones by virtue of the frankness with which they declared the surfaces on which they were painted.

In the next two sentences, Greenberg went on:

The Impressionists, in Manet's wake, abjured underpainting and glazing, to leave the eye under no doubt as to the fact that the colours used were made of real paint that came from pots or tubes. Cézanne sacrificed verisimilitude, or correctness, in order to fit drawing and design more explicitly to the rectangular shape of the canvas.

Then he proceeded to draw the general lesson from these observations about particular artists and their work:

It was the stressing, however, of the ineluctable flatness of the support that remained the most fundamental in the processes by which pictorial art criticised and defined itself under Modernism. Flatness alone was unique and exclusive to that art.[2]

The difference is remarkable. My first inclination, looking at the illustration of *Olympia*, was to pick out the depicted subject matter of the painting – naked girl, black maid, flowers, cat, bed – and only secondarily to notice the masses of light and dark and the relatively indistinct space in which those pictorial illusions are constructed. Although he is talking about Manet's painting in general, and not *Olympia* in particular, Greenberg's priorities are the opposite. The things that matter for him are the flat surface on which the picture is painted, the actual paint it is painted with, and the rectangle of the framed canvas, the 'support'.

Clearly, we have to ask ourselves what is happening here. Our main subject is the nineteenth-century French avant-garde, but, as I have already said, the significance of that subject is inseparable from the ways it has already been represented. Greenberg's view of Manet's importance is a powerfully stated example of what has come to be known as modernism. It would take us too far from our nineteenth-century subject to engage with that concept fully, for modernism is a discourse, a set of ideas and practices, that reached its

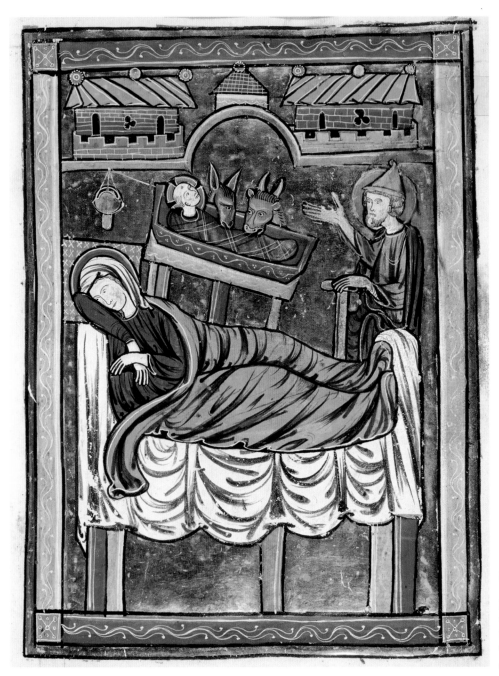

Plate 1.3 French School, *The Nativity*, from Psautier à l'Usage de Paris, thirteenth century, vellum. Bibliothèque Municipale, Rouen. Photo: Giraudon/The Bridgeman Art Library.

fullest fruition in the mid twentieth century. However, certain of its key principles remain relevant, both to the study of modern art in general and to the French avant-garde of the nineteenth century. I will mention only two here, but both have had profound ramifications for our relationship with art in the west throughout the modern period. These are 'formalism' and the 'autonomy' of art.

Greenberg's apparent disregard for Manet's depicted subject matter is a product of his concentration on the *formal* properties of the work of art. All pictorial art can be considered in terms of subject matter on the one hand and form on the other, where these two terms mean

something like what is depicted, and *how* it is depicted. Thus a Nativity scene may be depicted by a medieval artist or a Renaissance artist (see Plates 1.3 and 1.4). The subject matter is the same, but the formal properties of the works are very different. In one the shapes are relatively flat, features such as the folds in clothing are quite stylised, and the space in which the figures are situated is only suggested and not even coherent across the picture. Whereas the other demonstrates an almost magical degree of illusionism in the treatment of the figures and a fiction of coherent spatial depth. These kinds of things, the lines, colours and shapes that artists use to depict their chosen subject, and the

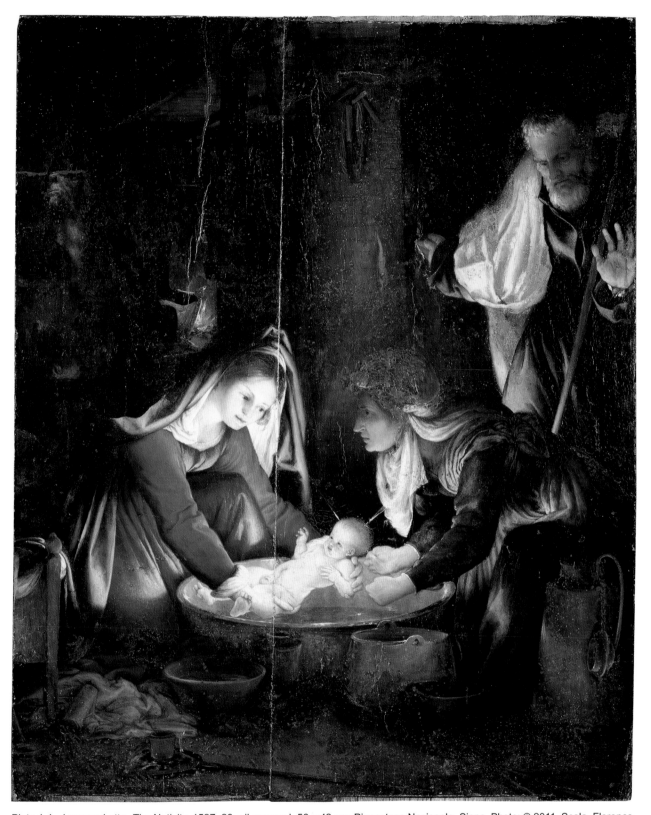

Plate 1.4 Lorenzo Lotto, *The Nativity*, 1527–28, oil on wood, 56 × 42 cm. Pinacoteca Nazionale, Siena. Photo: © 2011, Scala, Florence. Reproduced with the permission of the Ministero per i Beni e le Attività Culturali.

kind of illusionistic space those subjects are placed in, together constitute the formal aspect of the work of art. Until the twentieth century, all works of art in the western tradition had that dual aspect. With the advent of abstract art, of course, depicted subject matter seems to diminish in significance, or even to disappear entirely. This is not to say that meaning disappears from abstract art, as we shall see in subsequent chapters,

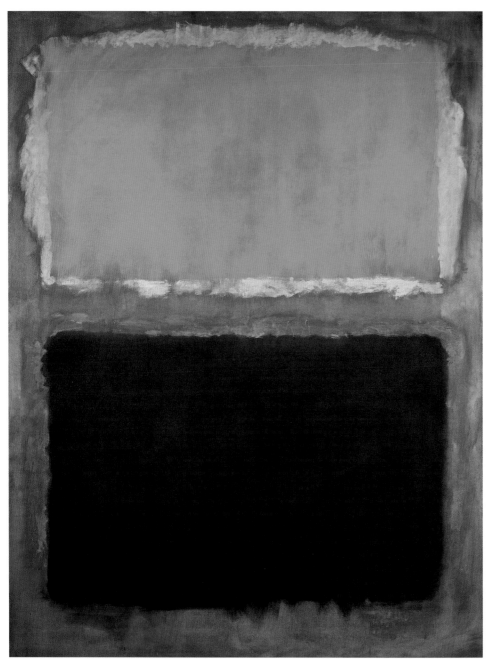

Plate 1.5 Mark Rothko, *Black and Dark Red on Red*, 1958, oil on canvas, 233 × 176 cm. Private collection. Photo: © Christie's Images/The Bridgeman Art Library. © 1998 Kate Rothko Prizel & Christopher Rothko ARS, NY and DACS, London.

but twentieth-century abstraction did tilt the balance between depicted subjects and the formal features of art to an unprecedented degree.

That is the point. Greenberg is writing as a defender of the modern tradition, where that tradition is seen as culminating in a fully abstract art. A painting by Mark Rothko (1903–70) would be a good example (see Plate 1.5). So what Greenberg is constructing is an example of 'historicism', retrospectively locating Manet's art at the head of an evolution that, by the time he was writing, had come to occupy the centre-stage of the western tradition. That was the modernist tradition

exemplified by 'modern masters' such as Matisse and Rothko, the key to which for Greenberg and similar modernist critics was its 'autonomy'.

'Autonomy' is one of those terms that has been the focus of so much debate, of such drastically conflicted views, that it is futile to search for a neutral definition of what it 'really' means. For present purposes, all I want to say is this: from the Renaissance onwards, the academically accepted sense of art's purpose was contained in the doctrine *ut pictura poesis*, which approximately means 'as is poetry, so is painting'. This idea, also known as the theory of the 'sister arts',

held that the fundamental task of visual art was to tell stories, as a parallel to, or a reinforcement of, literature. Most of the stories it told were the narratives of classical antiquity and the Christian Bible, with a view to the edification of the spectator. Eventually, hitherto lowly genres such as still life and landscape, and also portraiture, began to establish some independence from this weighty expectation, and to some degree even began to address modern-day subjects. But the higher genres for long remained hidebound by the combination of classicism and Christianity. Indeed, the developing crisis of the academic system in the nineteenth century largely amounts to a combination of two forces: on the one hand, the challenge to Antique ideals posed by modernisation; on the other, art's gradual exploration of a measure of independence – the organisation of its own surfaces and spaces to produce its own effects. During the early nineteenth century, this challenge to tradition coalesced into two distinct viewpoints. One, that it was the business of art to assist the progress of humanity in the here and now – that is to say, a broadly utilitarian perspective that art should join with natural and social science and progressive politics to help move society forwards by treating modern subjects. The other, that art had no such obligation and needed to look for no justification outside itself; that, at its best, art rehearsed the highest spiritual values, and its principal job was to articulate and reinforce those values in its own terms.

Although the full picture is much more deeply nuanced than this sketch can communicate, there is a sense in which the formalist modernism articulated by Greenberg is a twentieth-century descendant of the second position. This is the view that art can express emotions without a coherent narrative support; that a painting, for example, can communicate powerful feelings more like a piece of music than a story. The aesthetic power of a painting, it is claimed, does not depend on literary narrative; visual art can be independent of literature. It can be, indeed if it is to perform to the maximum purity and intensity, it *has* to be, 'autonomous'. Far from being the servant of traditional morality or modern politics, the claim is that art has to be self-running, self-regulating, consecrated first and foremost to aesthetic value.

Perhaps it is now possible to see how Greenberg's at first glance puzzling focus on the technical radicalism of Manet's painting both stems from a central tradition in the practice and the theory of art in the modern period, and accords Manet a generative place in that tradition. From a modernist point of view, by emphasising the

formal aspects of the work of art as an independent entity, and the purely aesthetic effects that formal configuration could produce, Manet can be seen as opening up a road of formal innovation that leads through Cézanne to Picasso, Matisse and Mondrian, and thence to Jackson Pollock (1912–56) and Rothko; that is, the so-called modernist 'mainstream' as it existed at the time Greenberg himself was writing.

One only has to state the position in that condensed fashion for problems to present themselves. Modernism in Greenberg's sense was never an uncontested tradition, and many would say it has now been entirely eclipsed. In important respects, such modernism is indeed historical. The fact remains, though, that however much the legacy of modernism is challenged, it would be very difficult to gain purchase on the western tradition in the century or so between the 1860s and the 1960s, without some understanding of it.

2 Modernity

This brief discussion of modernism brings us back to Manet. For when the modernist tradition did run into crisis in the 1960s, new interpretations of the art of the French avant-garde began to emerge that formed the basis for a 'new art history' that continues to be developed today. Far from emphasising the autonomy of art, this art history sought to resituate the art of Manet and his followers in the social milieu whence it emerged. If the modernist critics, curators and historians positioned themselves, so to speak, in front of the picture and considered the aesthetic value produced by its visual *effects* – the emotional effects the spectator got from focusing exclusively on the formal configuration of the work – then the new historians started to look behind the picture, to investigate its *causes*. The quest became a matter of trying to understand what social forces had caused these things to be the way they were – to answer the question: what were the social roots of modern art?[3] As time went on, as that search for understanding broadened and deepened, the sense of the 'social' itself mutated – from the social in the sense of a sociology, involving relatively objective historical factors including the state of French politics and the contending forces at work within French society, most notably the relations between the classes, to questions of the relations between men and women in French society, to the situation of France in the world. The province of art history came to include the spectrum of forces exerting influence on cultural representations: ranging from the

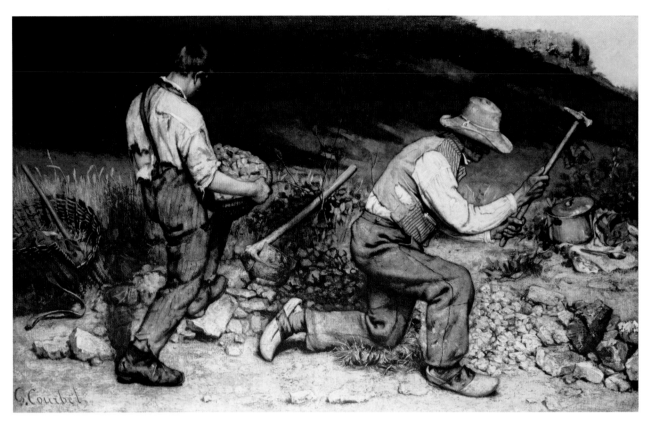

Plate 1.6 Gustave Courbet, *The Stonebreakers*, 1849, oil on canvas, 159 × 259 cm. Galerie Neue Meister, Dresden (destroyed 1945). Photo: © Staatliche Kunstsammlungen, Dresden/The Bridgeman Art Library.

social to the psychic, from class to gender, to sexuality, to ethnicity. All these factors, which from a more traditional point of view would have been regarded as falling outside the remit of art history, have become the warp and weft of our historical understanding of the art and culture of modernity.

An apprehension that the modern condition demanded new forms of representation had begun to emerge earlier in the nineteenth century with Romanticism. In his review of the Salon of 1824, the novelist Stendhal (1783–1842) inveighed against huge academic pictures, full of nude figures copied from classical bas-reliefs, arguing that 'the Romantic, in all the arts, is the man who represents people as they are today, and not as they were in those heroic times so distant from us, and which probably never existed'.[4] On the contrary, for Stendhal 'the time has come for good painters to try and be modern'.[5] It is one thing, however, to recognise a need, quite another to be able to fulfil it. In a sense, literature seemed better able to do so than the visual arts, in the novels of Stendhal himself, Honoré de Balzac (1799–1850) and, in England, Charles Dickens (1812–70). The most resonant theoretical attempt to articulate just what it was that made people 'as they are today' different from their forebears, and thus to define

the modern condition, did not appear until Baudelaire's review of the Salon of 1846. Addressing himself explicitly to the new bourgeoisie, as the majority force in French society, he proceeded to delineate the 'heroism of modern life'. For Baudelaire in 1846, all beauty contained 'an element of the eternal and an element of the transitory'; it was this latter that characterised the modern condition, that was overlooked in the continuing adherence to academic classicism, and that artists should recognise. He is explicit that the 'heroism' of contemporary life is not to be found in 'public and official subjects', the kind of thing government commissions were dished out for. Rather, it was to be found in 'private subjects', in the 'pageant of fashionable life and the thousands of floating existences' to be found in the modern city: all the way from the margins of 'criminals and kept women' to the sartorial detail of bourgeois life itself, 'the dress-coat and the frock-coat', 'a black coat, a white cravat', 'slight nuances in design in cut', 'creases'. Put together, these kinds of things added up to a new form of life, and it was up to painting to fix this unrecognised modern beauty. For 'the life of our city is rich in poetic and marvellous subjects. We are enveloped and steeped as though in an atmosphere of the marvellous; but we do not notice it.'[6]

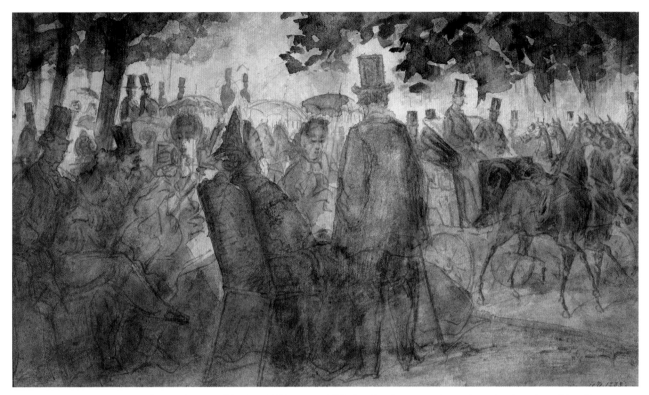

Plate 1.7 Constantin Guys, *On the Champs-Elysées*, 1850, pen and ink drawing, brown wash, sepia and watercolour, 24 × 42 cm. Musée du Petit Palais, Paris. Photo: © akg-images/Maurice Babey.

No visual artist responded to this call in the 1840s, the final years of the July monarchy in France, which was largely a period of eclecticism in the arts. The revolutions of 1848 did, however, foster the emergence of Realism, most notably in the art of Gustave Courbet. Realism was an art resolutely of its time, and certainly represented an affront to conservative academic values. As the social historian T.J. Clark resoundingly demonstrated, works like *The Stonebreakers* (Plate 1.6) and the *Burial at Ornans*, with their controversial representations of class division in rural France, were an affront to academic decorum. Rough and aggressive in their manner, violating the hierarchy of genres through their scale, they scared the status quo in a way in which it is hard for us to conceive anyone being frightened by a painting.[7] But, with few exceptions, Courbet's Realism was not an art of urban modernity.

Even by the late 1850s, when Baudelaire composed his fullest account of the urban situation which the 'painter of modern life' should aspire to represent, no artist had yet appeared who seemed able to do that.[8] Baudelaire's essay was, in fact, centred on the popular illustrator Constantin Guys (1802–92) (see Plate 1.7). As you will see in chapter 2, such illustrators also played a prominent role in the negotiation of modernity in England. But the relatively stable condition of

capitalism in England meant that the field of artistic representation remained mostly within the orbit of the Academy. The painstaking literary naturalism of the Pre-Raphaelite Brotherhood marked the limit of English artistic radicalism. But the more volatile situation in France created the conditions for the emergence of a genuinely dissident subculture in the arts. Revolution and *coup d'état* in 1848 and 1851, and the subsequent proclamation of an empire which had nothing like the industrial base of the British empire to sustain it, invested Parisian high culture with an edginess that London lacked, for all its working masses and its trade. London did, of course, experience social stress and conflict, and produced its own distinctive culture of modernity which is discussed in the next chapter. But conflict remained contained and negotiated. Not so in Paris, which politically and culturally displayed unparalleled volatility, making the new conditions sharply visible to intellectuals and artists. It was the emergence there in the 1860s of an artistic avant-garde deeply opposed to the conventions of the Academy that created the possibility both of something more lasting than illustration, and something more vivid, more modern in itself, than the artistically conventional images of modern life that were appearing in England (such as that depicted in Plate 2.7 in chapter 2).

It was the art of Manet and his followers, the Impressionists, that definitively established the connection between modern subjects and modern techniques. But it remains an open question quite why Paris became the fountainhead of the modern movement. Sociological explanations in terms of modernity are powerful, but modernity was appearing in other European cities too, not least London. It seems to be the combination of modernity with certain kinds of radical responses to it that produced early modernism in Paris. But it would take a further step to say why that modernism proved so attractive, both to a certain kind of new consumer of the values held to be embodied in art and to a new generation of imaginative young producers – artists themselves. And also, of course, to say why that response, which was after all originally a minority response, did eventually not only survive but, by the mid twentieth century, come to hold sway as a kind of official culture comparable to that which the Academy itself had once represented, albeit trading in values more suited to volatile modernity than to stable tradition.

One of the main things that made Paris new in the Second Empire was its physical modernisation under the programme of the mayor Baron Georges Eugène Haussmann (1809–91). Nothing could have been further from Haussmann's mind than the creation of a new art. His modernisation of the city was a response to contemporary capitalist crisis, in David Harvey's words, 'to absorb the surpluses of capital and labour power' that were blocking productivity.[9] Nonetheless, the new boulevards, with their attendant buildings, from the Stock Exchange to the Opera, from railway stations to department stores and covered arcades, really precipitated that modern life that Baudelaire had first glimpsed the decade before in a city that was then still largely medieval. It was this constellation of features, especially the new forms of commodified leisure in music halls, cafes and bars, that stimulated the new art. Traversed by all kinds of fissures of class and gender, freedom and power, these were the places and the experiences that both demanded and received a Baudelairean modern art. Fashion, the crowd, the dandy, the prostitute, carriages, cosmetics, and, of course, cafes and shops, were the visible features of the new life: the extraordinary cocktail of modernity that was Haussmann's Paris. The sexual, the social, the power relations of the modern world were being worked out there, and the undoubted strangeness of art like Manet's was the result of the effort to represent that equally strange new condition, and, importantly, to represent what made it tick, not just to illustrate what it looked like.

3 Manet and 'Japonisme'

'Modernity' as a subject in art-historical literature has mostly been discussed in terms of temporality. The principal meaning of 'modern', after all, is 'not old'. The notion of a modern art, of a modern condition, is primarily defined against a sense of the past. Academic art is one aspect of this 'pastness', with its roots in an amalgam of memory and fiction of an even deeper past, the past of classical antiquity, mediated through the Italian Renaissance. This temporal vector is the fundamental measure of something's being considered modern. But the European modernity that began to emerge in the late eighteenth century, and was established at least in the leading metropolitan centres by the middle of the nineteenth century, also had a significant spatial dimension. Modernity was measured not just against a European past but also against a non-European present. To the nineteenth-century mind, European progress was measured against the supposed stasis of the Islamic world, Asia and Africa. Modernity was spatial as well as temporal.

This can amplify our understanding of the nineteenth-century French avant-garde. Since the late eighteenth century, non-western subjects had increasingly been assimilated into the academic repertoire within the sub-genre of 'Orientalism'. Edward Said (1935–2003) was the first of many to show how Europeans constructed an imaginary 'Orient' as a way both of fantasising about what European culture lacked and ultimately contributing to the control of the non-European Other (see Plates 1.8 and 1.9).[10] In terms of the visual arts, the key thing is that such subjects, however challenging they may have been in terms of their violence or their sexuality, were subsumed within the technical conventions of representation. Needless to say, there was a spectrum of responses. An academic artist like Jean-Léon Gérôme (1824–1904) did employ a stable framework to depict exotic subjects, whereas a Romantic like Eugène Delacroix (1798–1863) stretched his technique, employing looser brushwork and heightened colour (and was therefore of more interest to the new avant-garde). But, at bottom, illusionism – or mimesis – the technical keystone of the European academic canon, held. European representational decorum continued to frame its depicted subjects, however exotic.

With the advent of the avant-garde, that changed substantially. It has become a commonplace to say that the Impressionists were 'influenced by Japanese prints'. But what does this mean? It was actually modernist art history that established this connection.

Plate 1.8 Eugène Delacroix, *The Death of Sardanapalus*, 1827, oil on canvas, 392 × 496 cm. Musée du Louvre, Paris. Photo: © RMN/ Hervé Lewandowski.

Plate 1.9 Jean-Leon Gérôme, *The Snake Charmer*, 1870, oil on canvas, 84 × 122 cm. Sterling & Francine Clark Art Institute, Williamstown, USA. Photo: © The Bridgeman Art Library.

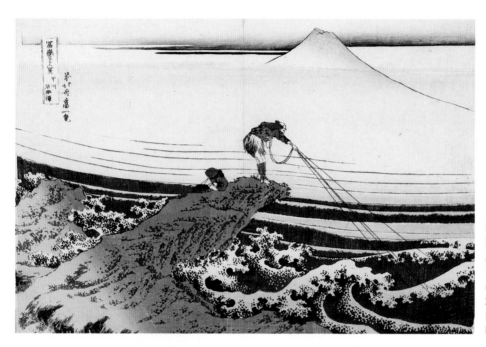

Plate 1.10 Katsushika Hokusai, *Kajikazawa in Kai Province*, from the series *Thirty-Six Views of Mount Fuji*, *c.*1830, colour woodblock print, 26 × 38 cm. Private collection. Photo: © Christie's Images/The Bridgeman Art Library.

Plate 1.11 Utagawa Hiroshige, *Asakusa Kinryuzan Temple*, *c.*1856, woodblock print, trimmed, 34 × 22 cm. Frederick W. Gookin Collection, 1939.1438. Art Institute of Chicago. Photography © The Art Institute of Chicago.

Plate 1.12 Unknown artist, *The Fight of the Parisian People in February 1848*, 1848, Epinal (coloured engraving). Musée de la Ville de Paris, Musée Carnavalet, Paris. Photo: © Archives Charmet/The Bridgeman Art Library.

Modernist explanations of modern art, as we have seen, emphasised formal and technical matters. The Japanese woodblock prints which appeared in Paris around 1860 were radically unlike European art. Most obviously, they lacked half tones that modulated shading from light to dark and which formed the technical basis of illusionistic representation (see Plate 1.10). In a word, they seemed flatter, especially employing large, unmodulated areas of colour. Other features of the Japanese prints, such as the way figures were cropped by the framing edge, as well as visually startling juxtapositions of foreground and background, rapidly made an impression on the nascent avant-garde (see Plate 1.11).

As we have seen in the case of Baudelaire, it is one thing to sense the need for a new pictorial language, quite another to deliver it. It is important to see that it was specifically the dominant academic tradition, with its often elevated subject matter and its strict standards of 'finish', that seemed unable to meet the representational challenge of modernity. Accordingly, Manet and others were trying to look beyond the core Franco-Italianate academic tradition for hints as to how to deal technically with the representation of modernity. Of particular

interest to them were Spanish and Dutch art, with their freer application of paint and an interest in daily life (artists such as Diego Velázquez, 1599–1660, Francisco de Goya, 1746–1828, Rembrandt, 1606–69, and Frans Hals, 1581/85–1666). Lying even further off-limits from the moribund academic canon were visual manifestations of popular culture, such as the cheap coloured prints from Epinal (which came to be known as 'Epinals' – see Plate 1.12). It was into this mix of new representational possibilities that the Japanese prints fell.

There is no doubt about this. It has long been known and the evidence from the time, both in the form of written testimony and the pictures themselves, is unequivocal. None other than Baudelaire wrote to his friend Arsène Houssaye in 1861 that:

> I have had a packet of *japonneries* in my possession for a long time now. I share them with my friends, and I have kept three of them for you. They are not bad at all (the Japanese equivalents of Epinal prints, two sous apiece in Edo). On rag paper and in bamboo or Chinese red lacquer frames, they are highly effective.[11]

Plate 1.13 Edouard Manet, *The Cats' Rendezvous*, 1868, lithograph, 43 × 33 cm (image), proof for poster. Museum of Fine Arts Boston. Gift of W.G. Russell Allen, 32.472. Photo: © 2012 Museum of Fine Arts, Boston.

Later, in 1878, Théodore Duret (1838–1927) wrote that:

> It took the arrival of the Japanese prints among us for someone to dare to sit down on the bank of a river, to juxtapose on one canvas a boldly red roof, a high white wall, a green poplar, a yellow road and some blue water. Before the example of the Japanese, it was impossible.[12]

For Duret, it was the sight of Japanese prints that made avant-garde painters finally understand 'that there were new methods for reproducing certain effects of nature which till then were considered impossible to render'.[13] Clear evidence of the technical interest in Japanese composition can be seen in Manet's prints, for example his oft-reproduced etching of cats (Plate 1.13). Certainly Manet's large, complex portrait of his defender Emile Zola (1840–1902) attests to an interest in Japonisme in the avant-garde milieu (Plate 1.14). Alongside a print of his own *Olympia* can be seen a Japanese print of a famous wrestler; and behind Zola is a painted screen which belonged to Manet himself. Degas's use of Japanese-derived techniques is even clearer than that of Manet (see Plate 1.15), and he had an extensive collection of prints. Van Gogh similarly collected Japanese prints, copied them, and incorporated the lessons in his own compositions. Mary Cassatt (1844–1926) adapted Japanese composition in her innovative images of female

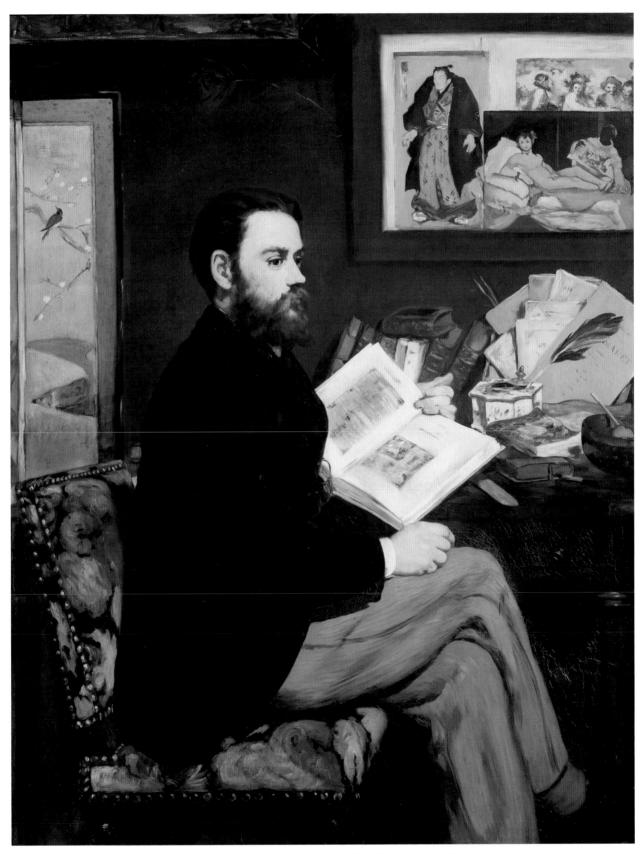

Plate 1.14 Edouard Manet, *Portrait of Emile Zola*, 1867, oil on canvas, 146 × 114 cm. Musée d'Orsay, Paris. Photo: akg-images/ Erich Lessing.

Plate 1.15 Edgar Degas, *Mary Cassatt in the Louvre, The Paintings Gallery*, 1879–80, etching, 31 × 13 cm. Sterling & Francine Clark Art Institute, Williamstown. Acquired in honour of Stephen Paine, Institute Trustee. Photo: © The Bridgeman Art Library.

However, in the struggle to broaden art history from a restricted 'modernist' interest in the technical concerns of an autonomously conceived art, and to relate it instead to a wider social condition of modernity, some of the implications of this Japanese 'influence' have become occluded. Certainly the art of the avant-garde was successfully repositioned in relation to contemporary nineteenth-century modernity rather than subsequent twentieth-century modernism. But the implications of Japonisme tended to be lost in the identification of modernity exclusively with Paris – the effects of Haussmannisation, the commodification, the alienation and the spectacle of modernity. 'Modernity' came to mean 'Paris'. But 'Paris' means more than just 'Haussmannisation', or, later, the Eiffel Tower. Or rather, Haussmannisation and the Eiffel Tower both signified that Paris was a world city. The Universal Exhibitions brought the world into Paris just as they did into London. For good or ill, European modernity was world-facing. *Around the World in 80 Days* is, after all, a nineteenth-century text, conceived while Jules Verne (1828–1905) read a newspaper in a Paris cafe. More than that, the French construction and engineering industry of the Second Empire did not just build the boulevards. In 1869, it completed the Suez Canal. The French empire may have been second to the British, but it was equally global. Even after the disastrous Franco-Prussian war of 1870 and the trauma of the Paris Commune the year after, French capitalism survived and the empire too; and with it, needless to say, modernity.

There is no doubt that much French avant-garde art seeks to represent new forms of life in the modern metropolis. But sometimes the 'worldedness' of that modernity leaks through. The Japanese print phenomenon is the most important aspect of this. But its implications are more than just technical. In a recent study of the impact of Japonisme on French literature, Jan Walsh Hokenson has drawn attention to earlier attempts to assess the true cultural-historical significance of Japanese prints for the visual arts. Thus, the German historian Klaus Berger argued that the encounter marked a 'Copernican' moment in art.[14] As long ago as the 1970s, the literary historian Gabriel Josipovici had assessed the deep impact of such a different mode of representation as being the way it enabled European artists to realise that single-point perspective was not a 'natural' way of representing the world, but the product of convention. 'This is not simply a widening of the cultural horizons; it is the discovery of the relativity of artistic norms.' Such representational conventions were, moreover, rooted in wider 'metaphysical assumptions' of European Renaissance civilisation, including those of a stable,

domesticity (see Plate 1.16). Examples could easily be multiplied. The technical impact of Japanese prints, and the more widespread fascination with Japanese culture, both within the avant-garde and beyond it in the world of interior decoration and fashion, is not in doubt.

Plate 1.16 Mary Cassatt, *La Toilette*, *c.*1891, drypoint and aquatint on paper, 38 × 26 cm. Brooklyn Museum of Art, New York. Photo: © Brooklyn Museum of Art Collection Fund/The Bridgeman Art Library.

unified viewing subject, a clear distinction of that subject from the object of his gaze, and the very possibility of the rational ordering of space.[15]

It is as if it was only the force of the struggle to represent modernity, which had bred avant-garde scepticism about academic convention, that made the different representational mode of the Japanese prints visible as art. Before Japan had been 'opened' to western eyes and to western markets by forcible American intervention in 1854, after two centuries of seclusion, a few examples of Japanese art and culture had made their way to the

west. A museum of such work had existed in Holland since 1828, along with scholarly studies. But the point is that this had no impact in artistic terms. Indeed, after the 'opening', the first exhibition of Japanese culture had taken place in London. But it had little effect on art in England, its main impact being in the fields of interior design and craftwork. It took the avant-garde aspiration to a counter-academic representation of modernity to create that connection; to be able to see the Japanese print as a demonstration of the 'relativity of artistic norms'. As the brothers Edmond and Jules de

Plate 1.17 Edouard Manet, *The Battle of the Kearsarge and the Alabama*, 1864, oil on canvas, 134 × 127 cm. Philadelphia Museum of Art, John G. Johnson Collection, inv. No.1027. Photo: © akg-images.

Goncourt noted in their *Journal* of January 1862, 'Art is not one, or rather there is no single art. Japanese art is as great as Greek art.'[16]

There are indications that in terms of subject matter as well as formal devices, nineteenth-century proto-globalisation is not entirely absent from avant-garde art. Manet seems to have been aware of the implications more than most. In a series of works in the late 1860s,

in the final years of the Second Empire, and then again towards the end of his life, he made several paintings which seem to indicate an awareness of the spatial aspect of modernity. The first and last of these were two curious 'seascapes' painted in 1864 and 1880. Both incorporate 'Japanese' formal elements: the high horizon, the sea as a relatively flat wall of water seen as if from an elevated viewpoint, the displacement of elements to the edges of the picture. Both are a long way

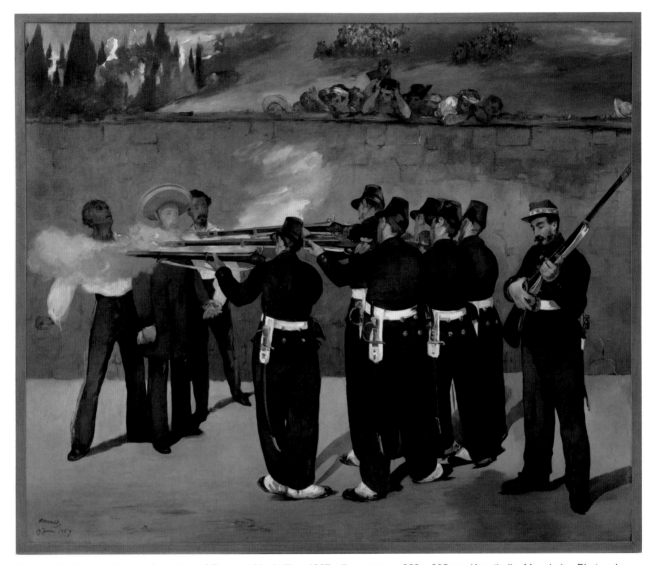

Plate 1.18 Edouard Manet, *Execution of Emperor Maximilian*, 1867, oil on canvas, 252 × 305 cm. Kunsthalle, Mannheim. Photo: akg-images/Erich Lessing.

from a conventional history painting in the academic tradition. Yet that is precisely the ground on which they aspire to stand. The 1880 picture, *The Escape of Rochefort,* represented the escape of an exiled Communard from the French penal colony on New Caledonia in the south Pacific. The 1864 picture, *The Battle of the Kearsarge and the Alabama* (Plate 1.17), represents an engagement from the contemporary American Civil War, in which a smaller Confederate vessel was engaged and sunk by a Union corvette off the coast of Cherbourg, after having initially sought refuge in the French port. Spectators watched from the shore. It would have been relatively easy to make a melodrama out of this. But eschewing conventional heroics and sentimentalism alike, Manet used unequivocally modern means to offer a curiously distanced representation of a foreign war suddenly getting close to home.

The same 'distant' quality is evident in his next attempt at history painting. In 1867 he embarked on what was probably his single most ambitious project: the *Execution of Emperor Maximilian* (Plate 1.18). Only historians know about Maximilian now, but in 1867 the circumstances surrounding his death bespoke scandal. The scion of Austrian Habsburgs, installed on the Mexican throne, depended on French military support. The withdrawal of that support, under American pressure, revealed the limits of real French power, despite imperial rhetoric. Maximilian's execution by Mexican nationalist forces, added to newspaper reports of his personal bravery, made the case a flashpoint for Republican opposition to the Second Empire. To this end Manet generated no less than three large-scale oil paintings and a related print in his attempt to arrive at a truthful representation of the consequences of imperial

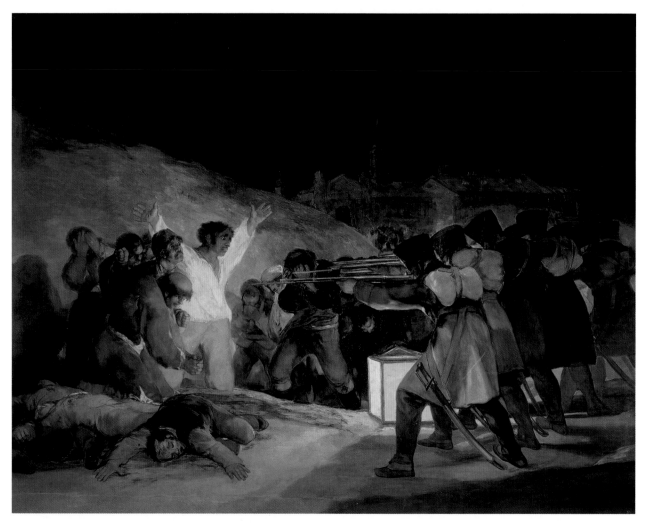

Plate 1.19 Francisco de Goya, *Executions of 3rd May 1808*, 1814, oil on canvas, 266 × 345 cm. Museo del Prado, Madrid. Photo: © akg-images/Rabatti–Domingie.

hypocrisy. This he achieved through a combination of assiduous research in the contemporary periodical press, and a studied reworking of *Executions of 3rd May 1808* by Goya (Plate 1.19). Commonly acknowledged as a universal condemnation of man's inhumanity to man, Goya's image also happened to relate to an earlier episode of French imperialism gone wrong – the first Napoleon's Peninsular war in Spain. Manet did not waste all that effort on something that didn't matter. The execution of Maximilian was a subject that, though it happened thousands of miles from Paris, got to the heart of at least one aspect of Second Empire modernity.

Another aspect of that modernity caught Manet's attention, also in 1867. *View of the Universal Exposition of 1867* is one of the strangest works of his entire career (Plate 1.20). Nothing seems to fit together. The figures are out of scale, the middle ground is missing, the showground itself looks like a cardboard castle. Even the position from which it was painted was artificial,

the shape of the natural hill having been modified – by Haussmann – in order to provide a more pleasing vantage point. The hollowness of official spectacle has seldom been more convincingly demonstrated, by the apparently simple (but, of course, actually complex) expedient of, as it were, allowing the joins to show.

This was the second 'universal exhibition' to be held in Paris following the first, in 1855, which in turn had set out to emulate the 'Great Exhibition' held in London in 1851. In all of these, the rest of the world, parcelled and packaged and re-presented for consumption, was brought before the inhabitants of the imperial metropolis. As it happened, the star attraction of the one that Manet painted in 1867 was the Japanese pavilion. After the success of a display of Japanese art in London in 1862, the Japanese government threw its weight behind the Paris display, intending to open a window to the west and stimulate mutually profitable trading relations. It is a small point, though

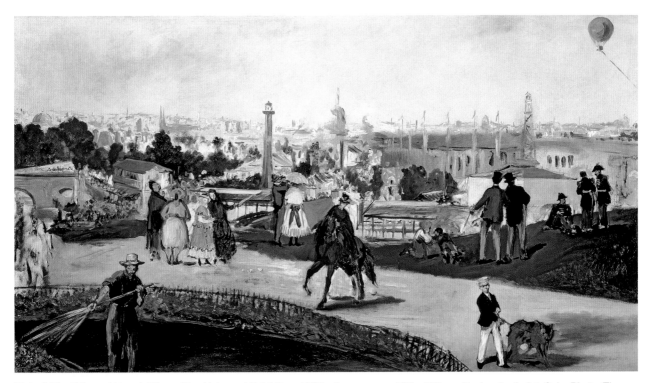

Plate 1.20 Edouard Manet, *View of the Universal Exhibition*, 1867, oil on canvas, 107 × 197 cm. Nasjonalgalleriet, Oslo. Photo: The Bridgeman Art Library.

an interesting one, that the display of woodblock prints added at the last minute came from the collection of the French avant-gardist Philippe Burty (1830–90). In Japan itself, such things were not valued at all, being regarded as modern and debased, not fit to represent the ancient heritage of Japanese culture. In an interesting echo of the avant-garde, the principal subject of the Japanese printmakers was itself a kind of modernity. The *ukiyo-e*, that is, the 'fleeting' or 'floating world' they depicted, was eminently comparable to that which the Parisian avant-garde were striving to represent. Theatres, the street, night life, including places of sexual encounter as well as music and dancing, all these constituted what became known as the 'floating world' in Edo. The artists of the 'green houses' of Yoshiwara, the nocturnal district of Edo, shared more than a little with those of Pigalle and the boulevards of Paris, both in terms of the techniques they employed and the subjects they used those techniques to represent.

Manet was many things. To modernists he was the point of departure. To radical art historians he was the quintessential artist of modernity, of urban modernity as exemplified in the salons, the night life and the boulevards of Paris. He most certainly was that, but his Paris was worlded. The city itself and its bourgeoisie were made out of imperialism as well as capitalism, and Manet knew it.

4 Gauguin and primitivism

In the next part of this chapter I want to look at some later episodes in the work of the nineteenth-century avant-garde, continuing the theme of the linked spatial and temporal aspects of modernity. The painting of modern life, otherwise often referred to by the style label 'Impressionism', is widely regarded as having entered a crisis in the 1880s. Indeed, the final Impressionist group exhibition took place in 1886. There was more at stake than just individuals going their own ways, a deeper shift in the concerns of the avant-garde. Baudelaire had written about the 'heroism' of modern life, and across the spectrum of early avant-garde activity there is a palpable sense of the modern condition being explored, tested and inhabited with a kind of relish. But by the mid-1880s, there does not seem to be much heroism in Georges Seurat's (1859–91) tableau of middle-class relaxation, nor relish either (see Plate 1.21). Life appears to have drained away from the cast of cut-outs, isolated in their own thoughts, isolated precisely, it seems, in their sociality. If ever there was a first depiction of the lonely crowd, this is it. Even some of Seurat's contemporaries accused him of turning Parisian society into an Egyptian frieze.

As we have seen, the project of representing modern life was rooted in a strong sense of temporality, of

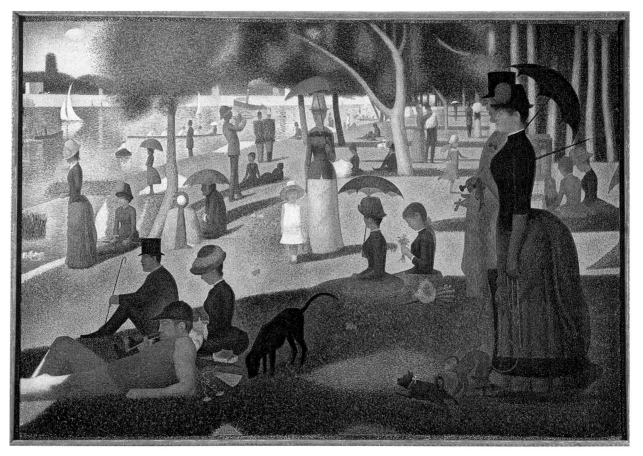

Plate 1.21 Georges Seurat, *Sunday Afternoon on the Island of the Grande Jatte*, 1884–86, oil on canvas, 208 × 308 cm. Art Institute of Chicago, Inv. No.1926.224. Photo: © The Bridgeman Art Library.

the present making its demand, and a failure to heed that demand consigning one to irrelevance. Yet, from the late 1880s, for many in the avant-garde present-day reality seems to have become an imaginative constraint rather than a means of liberation from a dead past. To some, at least, of a younger generation of the avant-garde, by definition displaced from the core cultural values of the middle class (if not always from its social and political values), contemporary life in the bourgeois Third Republic represented closure, hypocrisy and falsehood, rather than a modern truth. For them, it had ceased to be the material out of which a critical art could be made. Impressionism was an amalgam of, on the one hand, naturalism, an objective, quasi-scientific commitment to scrupulous looking, and, on the other, a commitment to the integrity of the painting as an entity whose own internal relations were no less important than the relations between the representation and its motif. Keeping those two aspects in balance seems to lie at the heart of the Impressionist enterprise. However, with the decline of naturalism, considered as an attempt to fix the look of the present, the constraints on what a painting could be made of were significantly loosened.

Gauguin painted *The Vision after the Sermon (Jacob Wrestling with the Angel)* in the autumn of 1888 (Plate 1.22). Whatever else it is, it is not a work of painterly naturalism; and though it is evidently a *modern* painting – it would have been completely incomprehensible outside the avant-garde – it is not a painting of modern life.

Exercise

Repeat the exercise you did at the beginning with Manet's *Olympia*. Try to write down what you see when you look at Gauguin's painting.

Discussion

The first thing I see is a large red area. I am not at first sure what it is. A receding plane of ground would normally take my eye into the depth of the picture. But the visual property of red is to pull it right up to the front. Almost simultaneously, large contrasting areas of black and white at the bottom of the picture resolve into a group of women in Breton costume. I think it is important to make this point,

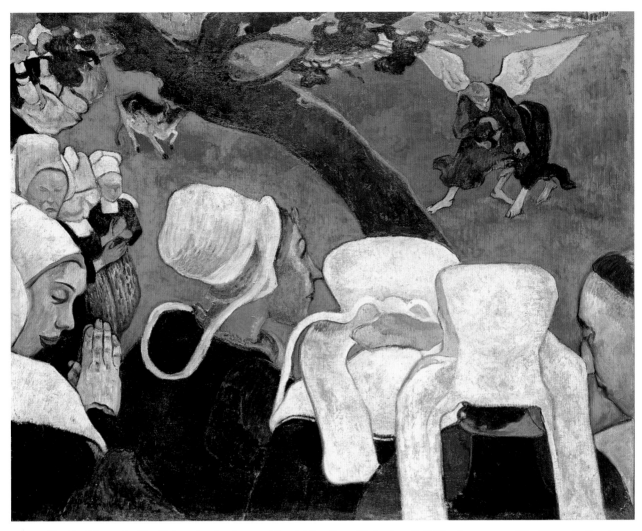

Plate 1.22 Paul Gauguin, *The Vision after the Sermon (Jacob Wrestling with the Angel)*, 1888, oil on canvas, 72 × 91 cm. National Gallery of Scotland, Edinburgh. Photo: © The Bridgeman Art Library.

even though it can hardly be classed as a stable visual perception. With *Olympia*, even though it is in no sense a traditional illusionistic picture, indeed was a deliberate frustration of the expectations associated with such a picture, nonetheless I saw the naked girl first and only secondarily noted the disposition of lights and darks out of which she, her attendant and her room were made. Now the two perceptions seem to be much closer together, maybe even reversed. I see the colours and shapes, lights and darks at the same time as – or even a moment before – the figuration fixes. Or does it indeed 'fix' at all? What is going on? And where is it going on? The 'what' is easy, to an extent. A group of women, whom the viewer seems to be standing behind, or even *with*, are praying. Most of them seem to have their eyes shut, as does a tonsured man at the far right. Only the central figure has her eyes open, and is looking into the pictorial space. But as to 'where' she is looking, the picture

remains enigmatic. Two men, one with golden wings, are grappling. But there is no naturalistic sense of 'where'. They might be on a meadow outside the church where the sermon has been preached. But, if so, why is it red? The tree, or rather, the diagonal brown band, may give a clue. Is it separating off the physical world of the Breton women from some spiritual realm which is not *in* their world at all. Are even the ones with closed eyes seeing the vision? The imaginary depicted space of the picture is thrown out of joint by the colour, and all the colours are much flatter, much less modelled in terms of gradations from light to dark than normally brings about an illusion of spatial recession. Both the how and the what of the picture, its representational means and its depicted subject, are unusual, even mysterious, not clearly resolvable. This is not accidental.

Some of what is going on here found expression in an article published soon afterwards, in 1891, titled 'Symbolism in painting: Paul Gauguin'.[17] The author, Albert Aurier (1865–92), contended that 'the objects in the painting have no meaning at all as objects, but are only signs ...'. By this, he most likely intends to claim that the meaning of a painting is not to be identified with the things it depicts in the 'real world' outside the painting. Instead, the 'objects' in a painting have their life in relation to the other features of the work; that is, they relate to each other rather like words in a poem, or notes in a piece of music. For Aurier, the goal of painting 'can never be the direct representation of objects. Its aim is to express Ideas, by translating them into a special language.' The result would be an art that eschewed the 'banality of the photograph', and was instead 'simple, spontaneous and primordial'. Aurier is here sounding a note that would continue to echo through the avant-garde for many decades: that artistic authenticity is not to be found in appearances, not in the surface phenomena of a civilisation that had become decadent, but should instead be sought in experiences that were 'simple' and 'primordial'. The most advanced art, for him 'the true and absolute art', was in fact 'fundamentally identical with primitive art'.

Manet was a dandy, a flâneur. He wore a top hat, gloves and patent-leather shoes. He, like Degas, was haute-bourgeois. Both were modern Parisians. Yet Gauguin – a sometime stockbroker – is now to be found extolling his wooden clogs and striving to get in touch with the superstitions of Breton peasants. Sceptical historians have made much of the rhetorical nature of Gauguin's primitivism, pointing out that there was a flourishing colony of artists in Brittany who were not far from being part of an early tourist trade, and who certainly got there by train; pointing out also what a canny operator Gauguin was, who never lost sight of a need to figure in the marketplace. Be that as it may, primitivism struck roots in the avant-garde, even to the point of displacing the painting of modern life. And Gauguin himself, out of whatever mixture of accident, courage and opportunism, ended up canonised as an avant-garde hero by living his dream to the bitter end on the other side of the world. Brittany proved insufficient. For two years from 1891 to 1893, and then again for the eight years from 1895 to his death in 1903, he lived and worked first in Tahiti and finally in the Marquesas Islands, about as far from 'civilisation' as it was possible to get. For Gauguin, once he had given up the stock exchange and committed himself to art, his only station in life, precarious as it was, was the Parisian avant-garde. Nonetheless, European modernity, and European art, had well and truly lost any heroism they might once have had. On the eve of his departure for Tahiti, he wrote: 'Terrible times are in store for the next generation: gold will be king!! Everything is rotten, men and the arts alike.'[18]

Back in Paris in the mid-1890s, between his two sojourns in the Pacific, Gauguin wrote a fictionalised, self-mythologising account of his life there, under the title *Noa Noa*.[19] The phrase means 'perfume', or 'scent', and is associated in Gauguin's mind with both the sensuality and the freedom he thought he had found in the people of Polynesia, and so singularly lacking in the 'rottenness' he had left behind. In *Noa Noa*, Gauguin recounts a parable. He tells the story of going off into the forest with a young Tahitian to collect wood for a sculpture. Gauguin's writing is a mix of plain and portentous, and it is not always easy to tell exactly what he means; mystery and suggestion tend to win out over clarity. But in the story Gauguin the middle-aged white man seems to be sexually tempted by the sight of his androgynous companion. Overcoming this temptation (something he conspicuously failed to achieve with the young women of the islands), Gauguin experiences a rebirth:

> Yes, wholly destroyed, finished, dead, is from now on the old civilization within me. I was reborn; or rather another man, purer and stronger, came to life within me.
>
> This cruel assault was the supreme farewell to civilization, to evil ... Avidly I inhaled the splendid purity of the light. I was, indeed, a new man; from now on I was a true savage, a real Maori.[20]

Yet for all the value accorded to simple things, Gauguin's primitivism was never less than complex. We have seen how Manet made his modern art out of a mixture of Spanish and Dutch old masters and Japanese prints, how a new language to express modernity was improvised, or constructed, out of a range of cast-offs, exotica and the everyday. Gauguin did something not too dissimilar with his primitivism, almost sticking it together from a repertoire of motifs ranging from Christian symbolism, to pagan Tahitian myths, to old master art, to modern photographs of ancient temples and tombs. In both cases, however great their differences, what glued the pieces together were contemporary ideas: partly naturalistic and positivist, in Manet's case, indubitably idealist and primitivist in Gauguin's. Equally, in both cases, what they did made sense in one place and one place only: the evolving sub-culture of the avant-garde in Paris.

Plate 1.23 Paul Gauguin, *Ta Matete* (*We Shall Not Go to Market Today*), 1892, oil on canvas, 73 × 92 cm. Kunstmuseum, Basel. Gift of Dr. H.C. Robert von Hirsch. Photo: © The Bridgeman Art Library.

Most of Gauguin's Tahitian works represent an imaginary arcadia in which any trace of contemporary modernity is excluded. These are more or less compelling depending on your point of view: falsifications of colonial reality, or meditations on matters transcending the merely historical. Very occasionally, however, 'modern life' did make an appearance, albeit a highly oblique and mediated one. *Ta Matete* (Plate 1.23), painted in 1892, shows a group of Tahitian women sitting on a bench, with what looks like a municipal flower bed in front, and behind them a glimpse of the sea through some trees. Mostly Gauguin excluded signifiers of modernity from his painting, concentrating instead on Tahitian myth, as in *Hina Tefatou* (*The Moon and the Earth*) (Plate 1.24), from his first stay in 1893, or on metaphysical doubts, as in *Where do we come from? Who are we? Where are we going?* (Plate 1.25), one of his late works dating from 1897. At first, however, before moving into rural areas, Gauguin had been struck by

the gap between the myth he had created for himself and the reality of Papete, the French colonial capital of Tahiti. In June 1891, he had written to his wife that 'the Tahitian soil is becoming completely French and little by little the old order will disappear. Our missionaries had already introduced a good deal of protestant hypocrisy and wiped out some of the poetry, not to mention the pox which has attacked the whole race.'[21] It is this which forms at least part of the content of *Ta Matete*.

I have already mentioned the flower bed; the bench is also unmistakably European, with its little green painted iron legs. The women are not wearing Tahitian clothes, but neither do they seem to be wearing the shapeless coverings that Christian missionaries had got the native women to wear. On the contrary, they are wearing elegant, fashionable dresses. Disposed along the bench, parallel to the picture plane, they look like figures on a frieze. And so they are. A clue is given by

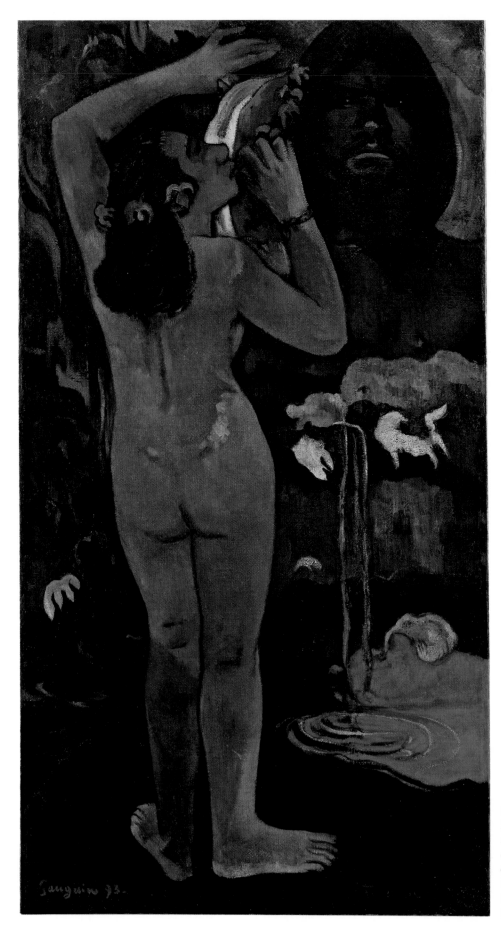

Plate 1.24 Paul Gauguin, *Hina Tefatou* (*The Moon and the Earth*), 1893, oil on canvas, 114 × 62 cm. Museum of Modern Art, New York, Lillie P. Bliss Collection, 50.1934. Photo: © 2011 The Museum of Modern Art/Scala, Florence.

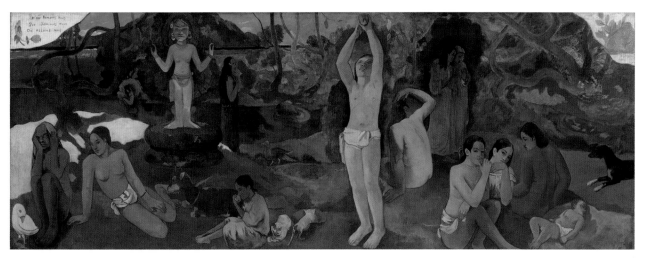

Plate 1.25 Paul Gauguin, *Where do we come from? Who are we? Where are we going?,* 1897, oil on canvas, 139 × 375 cm. Museum of Fine Arts, Boston, Tomkins Collection – Arthur Gordon Tomkins Fund, 36.270. Photo: © 2012 Museum of Fine Arts, Boston.

Plate 1.26 Fragment of Nebamun tomb painting of female guests at a banquet, *c.*1350 BCE, natural ochres on plaster, 76 × 126 cm. British Museum, London, EA 37986. Photo: © The Trustees of the British Museum.

the hand gesture of the woman at the far left. Gauguin had taken with him a large array of source material in the form of prints, drawings and photographs. Among these were photographs of Ancient Egyptian wall paintings from the tomb of Nebamun, Grain-accountant in the temple at Karnak, which Gauguin had seen in the British Museum. Some of these fragments showed a banquet attended by well-dressed men and women (see Plate 1.26). Exceptionally for Ancient Egypt, these paintings displayed a vivacity, even a kind of Impressionist spontaneity, which must have caught Gauguin's eye. His fashionably dressed Tahitians are disposed after the manner of Nebamun's guests. The clue to what they are doing there is given partly by the

title, and partly by a detail which is absolutely key, but easy to overlook. The title has been translated as *We Shall Not Go to Market Today*, and refers to the market square in Papete which, as Belinda Thompson puts it, was 'the nearest Tahitian equivalent to the night-life district of Pigalle'.[22] Tahitian sexuality, and its radical disjunction from European custom, had been the fuel that fired the myth of a paradise on the other side of the world since the first encounters of European sailors with the islanders in the late eighteenth century. These women, however, were Europeanised prostitutes, waiting for the sailors. Their ship is what can be seen out to sea in the gap between the bushes. It has even been suggested that the rectangular cards two of the women are holding are official certificates declaring their freedom from venereal disease. This conjunction of the new decorative art of Symbolism, marked by flat planes of increasingly non-naturalistic colour, with an ancient source and a modern subject represents an unstable complexity rare in Gauguin. Normally, the past wins out over the present, myth over history.

5 Marinetti and Futurism

Primitivism has proved one of the more dubious legacies of late nineteenth- and early twentieth-century avant-gardism. The combination of political and psychic views about women and non-western people that in the twenty-first century would count as both sexist and racist, with an artistic practice that progressively broke the centuries-old grip of the Academy and hence laid the basis for a modern way of seeing, is not easy to untangle. The heart of the problem is that it brings out how contentious is our own modernity, what its price has been: we come face to face with the cost of 'making it new'. But primitivism is only half the story. The imaginative retreat from the present, the cleaving to a mythology of the past, acquired an unlikely doppelganger by the first decade of the twentieth century. In February 1909, the Parisian daily paper *Le Figaro* published the announcement of a new movement by the Italian poet Filippo Tommaso Marinetti (1876–1944). This was the 'Manifesto of Futurism'. It opened with yet another parable, which forms a remarkable pairing with Gauguin's. Marinetti and his friends are gathered in a flat, engaged all night long in fevered discussion about poetry and art. The ambience is Symbolist: light is provided by mosque lamps, covered by brass domes with star-shaped holes; the poets, arguing and writing, are pacing backwards and forwards on rich oriental rugs. Suddenly they are shaken out of their dreams by the rumble of the first

tram. Marinetti drags them out of the Orientalist fog, down to the street, where they pile into motor cars and roar off into the dawn. A mad race ensues, Marinetti crashes his car and ends up in the muddy water of a factory drainage ditch. Far from discomfited, he emerges triumphant. This is his baptism. He emerges as a new man, a Futurist. In Gauguin's mythology of the primitive, he is reborn as a Maori warrior. In Marinetti's vision, the man of the future draws his strength from machines. The Futurist Manifesto contains the key avant-gardist slogan that a motor car is more beautiful than the Antique *Nike* of Samothrace, the winged female personification of Victory on display in the Louvre. It also contains not only the clarion call to 'destroy the museums, libraries, academies of every kind', but also the assertion that war is 'the world's only hygiene'. Five years away from August 1914, and with the clouds already gathering, this is an edge of avant-gardism even less congenial than sacrifices to the heart of darkness. Both in Marinetti's rhetoric and in much of the visual art it inspired, Futurism emphasised the disruptive, revolutionary forces gathering below the surface of modernity: 'We will sing of great crowds excited by work, by pleasure, and by riot; we will sing of the multicoloured, polyphonic tides of revolution in the modern capitals'[23] (see Plate 1.27).

Futurism has an uncertain status in the history of avant-garde art. In some ways it is more important as an idea than as an actual art practice. Certainly in modernist histories, which focused on the tradition of painting, Futurism was downplayed as a provincial variant of the French avant-garde. But looking back with the hindsight of a century, it can now be seen as an important precursor of the much more diverse activities that marked both the revolutionary avant-gardes of the 1910s and 1920s, including Dada, Surrealism and Constructivism, and also the multifarious 'post-modernist' arts of installation and performance that came to prominence in the later decades of the century. Futurism's emblematic 'going down to the street' had endless resonance for artists who during the twentieth century perennially sought to leave what they regarded as the ivory tower of the aesthetic in pursuit of an ideal that would affect politics and daily life beyond the conventional reach of art. At the time of its emergence, it had an impact across the continent as a complex cultural phenomenon affecting not merely painting but poetry, music and more. By the first decade of the twentieth century, the avant-garde was beginning to take root beyond Paris, and Futurism soon found adherents from London to Moscow (see Plate 1.28).

Plate 1.27 Luigi Russolo, *La Rivolta* (*The Revolt*), 1911, oil on canvas, 151 × 231 cm. Collection of the Gemeentemuseum Den Haag. Photo: © The Bridgeman Art Library. © The Estate of Luigi Russolo.

In the journalistic and popular imagination the term became a synonym for the modern movement as a whole. Any art that was unfamiliar, 'distorted' or 'abstract' was liable to be dubbed 'Futurist'. In the present compass, we cannot follow the detail of Futurism's development, nor its complex relationship with the newly emergent movement of Cubism in Paris (which is discussed in chapter 3). But what we can do is note something about the idea itself.

As we have seen, modern art emerged in the mid nineteenth century out of a temporal register, a fixation on the present, in the overlapping ideologies of Realism, naturalism and the painting of modern life. In the later nineteenth century, as the 'present' coagulated into the routines and repressions of 'bourgeois society', and in the process lost its heroism, the avant-garde created a myth of the past to compensate. The myth of a primitive authenticity allowed artists to gain critical leverage on modernity, turning the values of imperialism inside out, presenting metropolitan civilisation with an image of what it had supposedly lost. But although urban civilisation

might have lost its soul, it more than made up for that by its own increasing power and dominance; and that power was embodied above all in the machine. Futurism grasps that fact and holds up a very different kind of mirror to modernity. Yet the critical image reflected back by Futurism is no more content with the actuality of modern capitalism than was that of primitivism. Only now the image is reversed. Rather than confronting modernity with an image of its archetypal past, Futurism confronts it with an image of what lies ahead. The forest is replaced by the factory. But this is not just the factory as it actually existed, producing commodities for the middle class to buy and sell. It is, rather, a sort of magic factory, producing a revolutionised modernity, symbolised by things like racing cars and aeroplanes, as well as new people to live such a life (see Plate 1.29). The primitive totem is matched by the machine-man. It is surely noteworthy that in the decade before the greatest cataclysm European civilisation had then experienced, cutting-edge art, the antennae of the civilisation so to speak, had withdrawn from the centre-ground of its actual constitution into two equal and opposite idealisations

Plate 1.28 Lyubov' Popova, *Travelling Woman*, 1915, oil on canvas, 159 × 123 cm. State Museum of Contemporary Art – Costakis Collection, Thessaloniki.

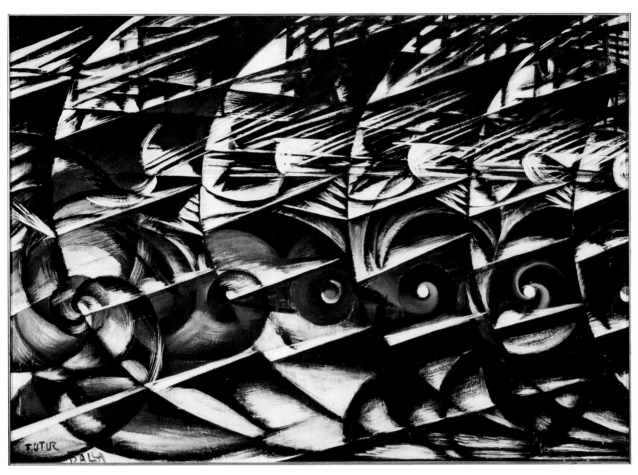

Plate 1.29 Giacomo Balla, *Abstract Speed* (*The Car Has Passed*), 1913, oil on canvas. Private collection. Photo: DEA/M.E. Smith/ akg-images/De Agostini Picture Library. © DACS 2012.

of the past and the future. Indeed, past and future were almost the same thing in the avant-garde imagination, united by what they were *not*. What Primitivists and Futurists were not, it goes almost without saying, were happy, rounded, fulfilled and productive members of society. Because modern society had, in effect, become imaginatively uninhabitable; in the words of the German sociologist Max Weber (1864–1920), it was 'an iron cage'.[24]

Two Futurist images serve to underline the point. I say images, but in fact these were objects. Neither is by a French artist, but both are inconceivable without the avant-garde in Paris. The first is by the Italian Futurist Umberto Boccioni (1882–1916); the second by the Anglo-American Jacob Epstein (1880–1959), who was associated with Vorticism, the English avant-garde group much influenced by Marinetti's vision.

The Boccioni represents a striding male figure (Plate 1.30). One assumes he has to be striding along a city street. It is not an image of a peasant trudging along the furrow. Urban though it must be, however,

neither is it an image of the flâneur. This is no stroller. Nonetheless, there is a distant echo of Baudelaire. For him, modernity had been characterised by a sense of the fugitive, or fleeting, nature of things. By the early twentieth century, this sense of the impermanence characteristic of modernity had been galvanised into the notion of 'simultaneity': that the perceiving subject, travelling through the world, was being simultaneously assaulted by a welter of sensations. The French painter Fernand Léger (1881–1955) wrote: 'When one crosses a landscape by automobile or express train, it becomes fragmented ... The view through the door of the railroad car or the automobile windshield, in combination with the speed, has altered the habitual look of things.'[25] Avant-garde artists were not philosophers, and neither were they scientists. However, a sense of prodigious new scientific theories, including non-Euclidean geometry and Einstein's theory of relativity, allied with the ideas of philosopher Henri Bergson (1859–1941) about the subjectivity of time, of living in a stream of consciousness, were contributing to undermine traditional ideas of stable

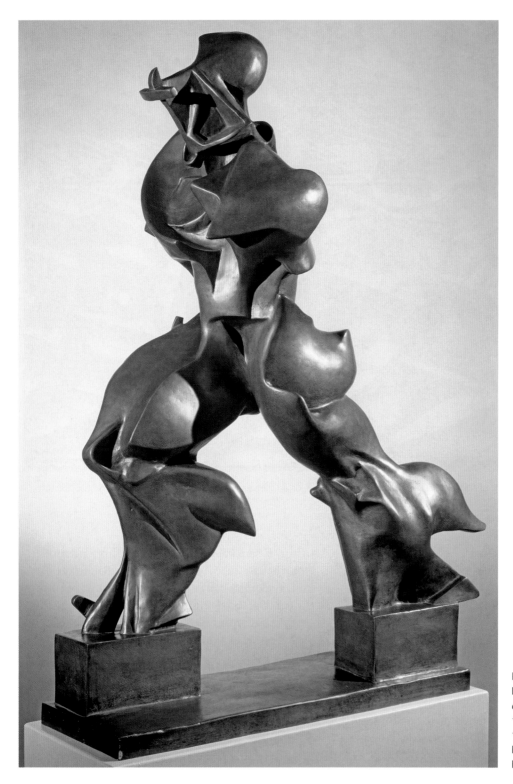

Plate 1.30 Umberto Boccioni, *Unique Forms of Continuity in Space*, 1913 (cast 1972), bronze, 118 × 88 × 37 cm. Tate, London. Photo: © Tate, London 2012.

matter and of a clear-cut distinction between things and their surroundings. Cubist and Futurist painters, such as Léger and Giacomo Balla (1871–1958), used fragmentation, faceting and 'lines of force' to capture such ideas. Boccioni likewise tried to represent the interpenetration of the perceiver and the world he or she was perceiving. His sculpture, titled *Unique Forms of Continuity in Space* represents another attempt

to capture the dynamism now felt to characterise not just external phenomena, but the very heart of existence itself.

Epstein's extraordinary sculpture *The Rock Drill* (see Plate 1.31 for a reconstruction), made in 1913 and destroyed by its maker not long after the outbreak of the First World War, arguably goes even further than

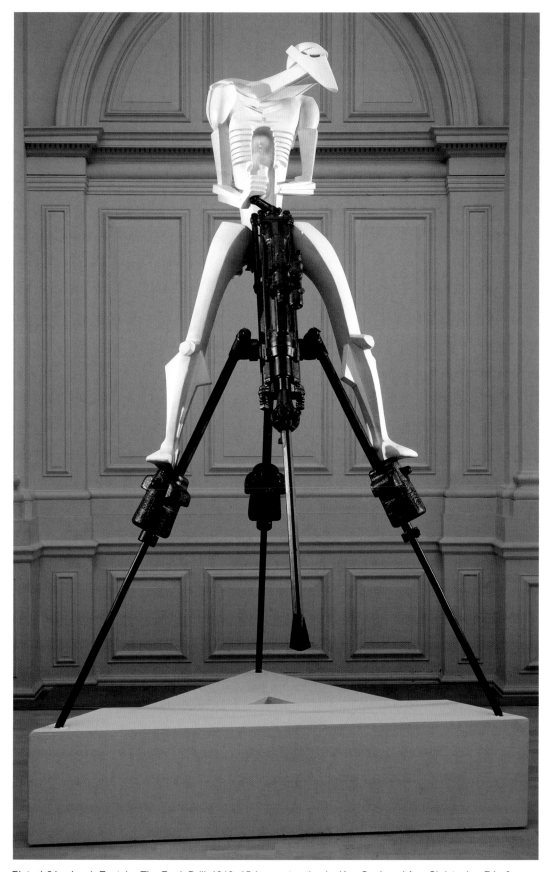

Plate 1.31 Jacob Epstein, *The Rock Drill*, 1913–15 (reconstruction by Ken Cook and Ann Christopher RA after the dismantled original, 1973–74), polyester resin, metal and wood, 205 × 142 cm. Birmingham Museums and Art Gallery, 1982 P42. Photo: © Birmingham Museums and Art Gallery. © The estate of Sir Jacob Epstein.

Boccioni in its transcendence of any conventional humanism. If the Boccioni represents a weird hybrid of a medieval knight in armour and a moving machine, ploughing through the air like a ship through water, then Epstein's machine-man seems to have entirely fused with technology, to be dependent on it for his existence. The plaster figure is in symbiosis with the real pneumatic drill. However suggestive the figure's head might be of a certain melancholy, it is hard to see the overall effect as anything other than aggressive, even threatening. The unmistakeably phallic drill sees to that. It is as if the human is run by the machine, not the other way round.

Conclusion

So much now for the heroism of modern life. In the years since Baudelaire had formulated his idea of modernity, the modern condition bore down on art in a variety of ways. Initially something which conferred on art a vitality it had lost under the sway of the Academy, contemporary modernity subsequently became something to escape from, and imaginative vitality now came to depend on visions of the past and the future. The equal and opposite figures of the idol and the machine served to provide the avant-garde artist with an oblique purchase on a modernity which otherwise seemed to have become unrepresentable. The combination of increasingly globalised productive forces with increasingly intensified self-consciousness certainly escaped conventional 'picturing'. As European civilisation stood on the brink in 1914, it must have seemed that only an art in exile from the present, an art of extremes, could match the extremes of modernity itself.

Notes

[1] Conrad, 1989 [1902], p. 27.

[2] Greenberg, 2003 [1960/65], p. 775; see also Greenberg, 1993 [1960].

[3] The work of the new generation of the 1970s had its roots in earlier social histories of art by figures including Arnold Hauser (1892–1978), Francis Klingender (1907–55), Max Raphael (1889–1952) and, perhaps above all, Meyer Schapiro.

[4] Stendhal, 1998 [1824], p. 37 (22 December 1824).

[5] Ibid., p. 31 (31 August 1824).

[6] Baudelaire, 1998 [1846], pp. 303, 304.

[7] Clark, 1973.

[8] Baudelaire, 1998 [1859/63], pp. 493–506.

[9] Harvey, 2003, p. 118 (see also p. 94 for a fuller discussion).

[10] Said, 1978. Said's focus was on literature. The application of his thesis to the visual arts began with Linda Nochlin's 'The imaginary Orient', 1991 [1982/83].

[11] Charles Baudelaire, letter to Arsène Houssaye, cited in Berger, 1992 [1980], p. 16.

[12] Théodore Duret, cited in Hokensen, 2004, p. 42, trans. p. 424 note 8.

[13] Théodore Duret, cited in Smith, 1995, p. 31.

[14] Berger, 1992 [1980], p. 1

[15] Gabriel Josipovici, *The World and the Book*, cited in Hokenson, 2004, p. 18.

[16] de Goncourt and de Goncourt, 1998 [1857–64], p. 417.

[17] Aurier, 1998 [1891] (the following quotations are taken from pp. 1027–8).

[18] Gauguin, 2004 [1890], p. 86 (letter to J.F. Willumsen, summer 1890).

[19] Gauguin, 1994 [1893/1919].

[20] Ibid., p. 48.

[21] Gauguin, 2004 [1891], p. 111 (letter to Mette Gauguin, late June 1891).

[22] Thomson, 1987, p. 152.

[23] Marinetti, 1998 [1909], p. 148.

[24] Weber, 2003 [1904–05], pp. 136–7.

[25] Léger, 2003 [1914], p. 160.

Bibliography

Allan, S. and Morton, M. (eds.) (2010) *Reconsidering Gérôme*, Los Angeles, CA, J. Paul Getty Museum.

Aurier, G.-A. (1998 [1891]) 'From "Symbolism in painting: Paul Gauguin"' in Harrison, Wood and Gaiger (1998), VIC10, pp. 1025–9.

Baudelaire, C. (1998 [1846]) '"To the bourgeoisie" and "On the heroism of modern life" [from the *Salon of 1846*]' in Harrison, Wood and Gaiger (1998), IID13, pp. 300–4.

Baudelaire, C. (1998 [1859/63]) 'From "The painter of modern life"' in Harrison, Wood and Gaiger (1998), IIID8, pp. 493–506.

Berger, K. (1992 [1980]) *Japonisme in Western Painting from Whistler to Matisse*, Cambridge, Cambridge University Press.

Clark, T.J. (1973) *Image of the People*, London, Thames & Hudson.

Clark, T.J. (1985) *The Painting of Modern Life: Paris in the Art of Manet and his Followers*, London, Thames & Hudson.

Conrad, J. (1989 [1902]) *Heart of Darkness*, London, Penguin.

Cork, R. (2009) *Wild Thing: Epstein, Gaudier-Brzeska, Gill*, London, Royal Academy of Arts (exhibition catalogue).

de Goncourt, E. and de Goncourt, J. (1998 [1857–64]) 'From *Journal*' in Harrison, Wood and Gaiger (1998), IIIB16, pp. 415–17.

Futurism (2009) London, Tate Publishing (exhibition catalogue).

Gauguin, P. (1994 [1893/1919]) *Noa Noa* (trans. O.F. Theis, 1919), San Francisco, CA, Chronicle Books.

Gauguin, P. (2004 [1890]) 'Letter to J.F. Willumsen, summer 1890' in Thomson (2004 [1993]), p. 86.

Gauguin, P. (2004 [1891]) 'Letter to Mette Gauguin, late June 1891' in Thomson (2004 [1993]), p. 111.

Gauguin's Paradise Remembered. The Noa Noa Prints (2010) Princeton University Art Museum, New Haven, CT, Yale University Press (exhibition catalogue).

Greenberg, C. (1993 [1960]) 'Modernist painting' in O'Brian, J. (ed.) *Collected Essays and Criticism,* vol. 4: *Modernism with a Vengeance, 1957–1969*, Chicago, IL, Chicago University Press

Greenberg, C. (2003 [1960/65]) 'Modernist painting' in Harrison and Wood (2003), VIB5, pp. 773–9.

Harrison, C. and Wood, P. (eds) (2003) *Art in Theory 1900–2000: An Anthology of Changing Ideas*, Oxford, Blackwell.

Harrison, C., Wood, P. and Gaiger, J. (eds) (1998) *Art in Theory 1815–1900: An Anthology of Changing Ideas*, Oxford, Blackwell.

Harvey, D. (2003) *Paris, Capital of Modernity*, London and New York, Routledge.

Hokensen, J.W. (2004) *Japan, France, and East–West Aesthetics: French Literature 1867–2000*, Madison, WI, Fairleigh Dickinson University Press.

Lambourne, L. (2005) *Japonisme: Cultural Crossings between Japan and the West*, Phaidon, London.

Léger, F. (2003 [1914]) 'Contemporary achievements in painting' in Harrison and Wood (2003), IIA11, pp. 159–62.

Manet: The Man Who Invented Modernity (2011) Paris, Gallimard/Musée d'Orsay (exhibition catalogue).

Marinetti, F.T. (1998 [1909]) *Mafarka the Futurist: An African Novel*, London, Middlesex University Press.

Marinetti, F.T. (2003 [1909]) 'The foundation and manifesto of Futurism' in Harrison and Wood (2003), IIA6, pp. 146–9.

Nochlin, L. (1991 [1982/83]) 'The imaginary Orient' in *The Politics of Vision: Essays on Nineteenth Century Art and Society*, London, Thames & Hudson, pp. 33–59.

Prendergast, C. (1992) *Paris and the Nineteenth Century*, Oxford, Blackwell.

Said, E. (1978) *Orientalism*, London, Routledge & Kegan Paul.

Smith, P. (1995) *Impressionism: Beneath the Surface*, London, Everyman Art Library.

Stendhal (1998 [1824]) 'From "Salon of 1824"' in Harrison, Wood and Gaiger (1998), IA4, pp. 30–7.

The Spectacular Art of Jean-Léon Gérôme (2010) Paris, Skira (exhibition catalogue).

Thomson, B. (1987) *Gauguin*, London, Thames & Hudson.

Thomson, B. (ed.) (2004 [1993]) *Gauguin by Himself*, London, Time Warner.

Thomson, B. (ed.) (2010) *Gauguin: The Maker of Myth*, London, Tate Publishing (exhibition catalogue).

Weber, M. (2003 [1904–05]) 'Asceticism and the spirit of capitalism' in Harrison and Wood (2003), IIA2, pp. 136–7.

Weisberg, G. (ed.) (1975) *Japonisme: Japanese Influence on French Art 1854–1910*, Cleveland, OH, Cleveland Museum of Art (exhibition catalogue).

Wichmann, S. (2007 [1981]) *Japonisme: The Japanese Influence on Western Art since 1858*, London, Thames & Hudson.

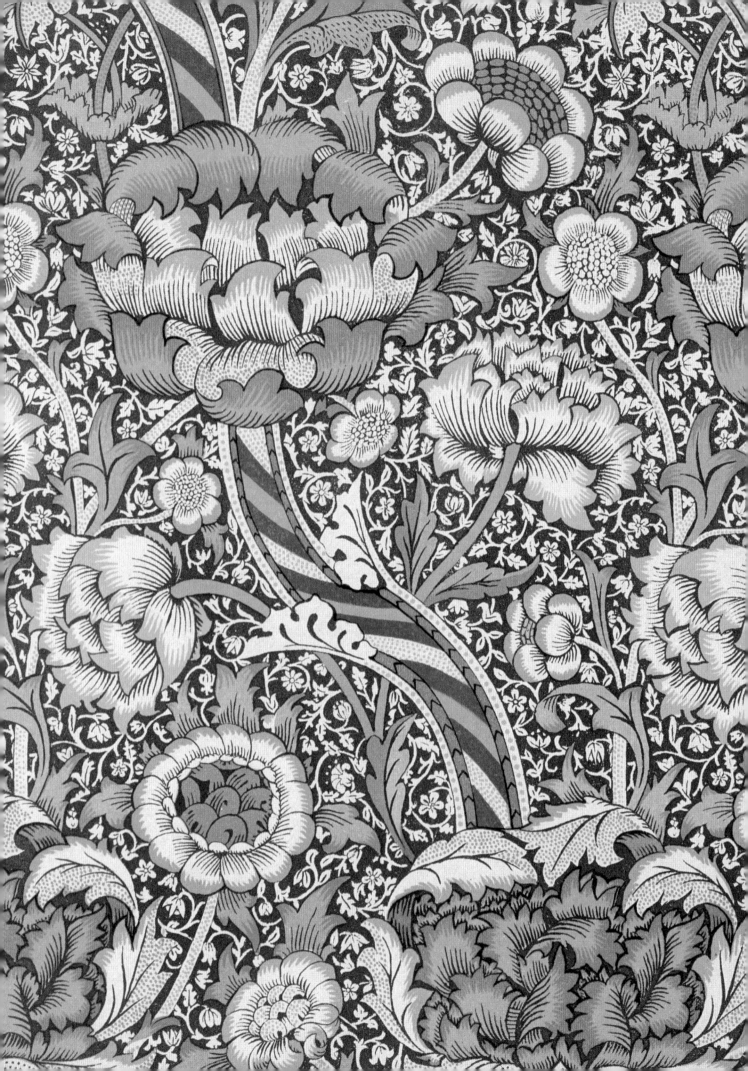

Chapter 2

Victorian Britain: from images of modernity to the modernity of images

Steve Edwards

Introduction

We saw in the preceding chapter the ways that French painters – principally Manet and the Impressionists – pictured new forms of commercialised leisure. The avant-garde artists in Paris combined attention to novel subjects associated with bourgeois life with innovations in the handling of the paint surface in order to create complex representations of modern experience. Whereas 'modernity' is the term often used to characterise the forms of experience generated by the capitalist transformation of social life, 'modernism' is seen as the mode in which these new experiences were given artistic form. In the main, art historians have taken the Parisian avant-garde as its norm and tended to judge other forms of art as mere artistic failure of nerve, but it was the modernist art of Paris that was the anomaly. In order to develop this argument further it may help to think about modernity and its representations in a different setting, so this chapter focuses on three distinct approaches to modernity

in the visual culture of Britain in the nineteenth century. The first section explores the distinction between modernity and modernism by comparing a canonical avant-garde painting with a lesser-known English genre scene. The second section leaves painting aside in order to examine the mass-image culture that took hold in a rapidly developing capitalist nation; rather than consider depictions of modernity here we will look at the role of images in shaping modern experience. The final section focuses on medieval revivalism in the period as an alternative to industrialisation and commercial culture: neo-Gothic architecture, the criticism of John Ruskin (1819–1900), the Pre-Raphaelite Brotherhood and William Morris (1834–96). In this final section, we will see that there is no necessary correlation between modernity and the modernism of the French avant-garde; the decorative idiom that Morris developed suggests an alternative way of considering modernity.

Plate 2.1 (Facing page) 'Wandle', printed fabric, manufactured by William Morris and Co. and Aymer Vallance (detail from Plate 2.30).

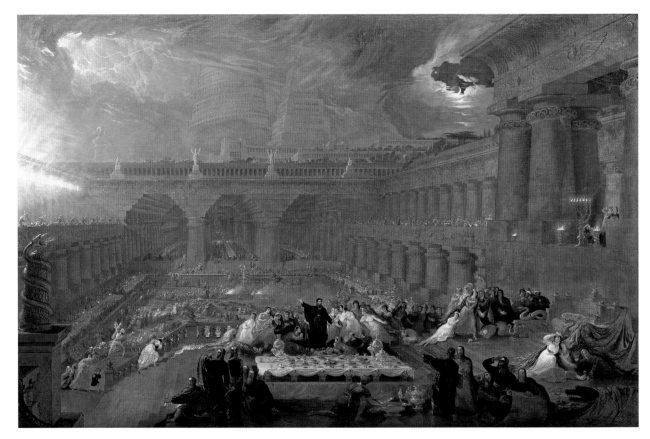

Plate 2.2 John Martin, *Belshazzar's Feast*, 1820, oil on canvas, 160 × 249 cm. Private collection. Photo: © Christie's Images/The Bridgeman Art Library.

1 The painting of modern life

During the course of the nineteenth century, market pressures reshaped the world of British art. The Royal Academy came under attack from middle-class critics as a locus of aristocratic values – it was deemed exclusive and private – and artists began to establish independent and explicitly commercial exhibitions outside its hegemony. As early as the 1820s, John Martin (1789–1854) displayed his sublime and cataclysmic paintings in pay-to-view exhibitions. He sold *Belshazzar's Feast* (Plate 2.2) for £1,000, but just as importantly 5,000 people paid to see it.[1] Artworks like this were sold as commodities and generated entrance fees from shilling visitors, and they also provided the basis for engraved reproductions aimed at the lower middle class and even skilled artisans. The development of commercial prints from artworks was well advanced at this point, but the trend accelerated. This commercial strategy proved particularly lucrative for selected artists and for print dealers such as Ernest Gambart (1814–1902), who is said to have paid the huge sum of 5,500 guineas for *The Finding of the Saviour in the Temple* by William Holman Hunt (1827–1910).[2] This proved a sound investment: he took £40,000 from spectators who paid to see the picture, £5,000 from

sales of engravings and a further £1,500 when he sold the painting. The point is not just that these commercial ventures created new outlets for art, but that they also changed its form. For instance, pictures might be selected 'not for their merits but as vehicles for the exhibition' of the engraver's skill.[3] Subjects became more popular and compositions more eye catching; increased scale and minute detail went hand in hand. Artists became occupied with making an immediate splash.

The almost total absence of state patronage in Britain meant that artists had to rely for sales on middle-class collectors. This patronage expanded the market and increased the wealth and status of many painters, but it also transformed the prevailing academic protocols and hierarchies:[4] first, pictures tended to be designed for the domestic environment of their patrons and thus were smaller; second, subjects became more topical and, we might say, more 'bourgeois'.[5] James Northcote (1746–1831) observed that artists did not wish to be 'led down the garden path' of esteemed but expensive and unsaleable history painting.[6] Similarly, William Powell Frith (1819–1909) told a parliamentary committee in

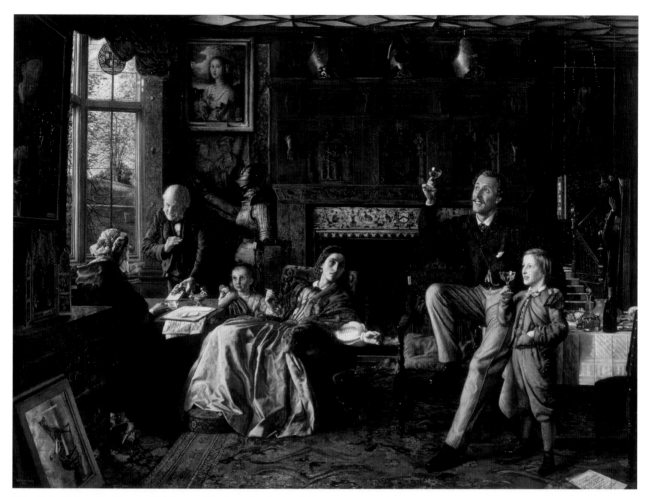

Plate 2.3 Robert Braithwaite Martineau, *The Last Day in the Old Home*, 1862, oil on canvas, 107 × 115 cm. Tate, London, N01500. © Tate, London, 2012.

1860 that the market for art in England was dominated by landscape and genre scenes.[7] In fact, it is arguable whether academic history painting ever had much of a foothold in Britain; even Joshua Reynolds (1723–92) – the chief advocate of the academic view – produced classicising portraits, rather than grand history paintings. Northcote and Frith simply blurted out the reality, rather than sticking to the official line.

Paintings of middle-class leisure in Britain range from the celebration of simple pleasures and comic incidents to moralising pictures designed to inculcate appropriate modes of bourgeois decorum. In the main, these are narrative pictures that avoid the surface effects and formal experiments of the French avant-garde. Look at *The Last Day in the Old Home* by Robert Braithwaite Martineau (1826–69), which presents one such Hogarthian image (Plate 2.3). You should be able to find enough visual clues to indicate that the aristocrat to the right has frittered away the family fortune on alcohol and horses. While he introduces his son to the pleasures of the glass, a solicitor is going over deeds to

the family estate with the boy's distraught mother and grandmother. The wife, who is the moral hinge of the composition, bridging the two areas, beckons to the boy, calling him to follow the path of virtue and duty. Pictures like these seem to demand a narrative decipherment, identifying figures and suggesting a clear moral 'story'.

One early and provocative account of the distinction between British genre painting and French avant-garde art of the period was penned by the British formalist critic Clive Bell in his book *Art*. Bell suggested that he had spent many a 'weary forty minutes' in front of William Powell Frith's *The Railway Station* (1862) (Plate 2.4) 'disentangling its fascinating incidents and forging for each an imaginary past and an improbable future'.[8] However, Bell went on to claim that *The Railway Station* is 'not a work of art; it is an interesting and amusing document'.[9] Such paintings were 'superfluous', he thought, 'wasting the hours of able men' – they would be superseded by the '*Daily Mirror* photographers in collaboration with a *Daily Mail*

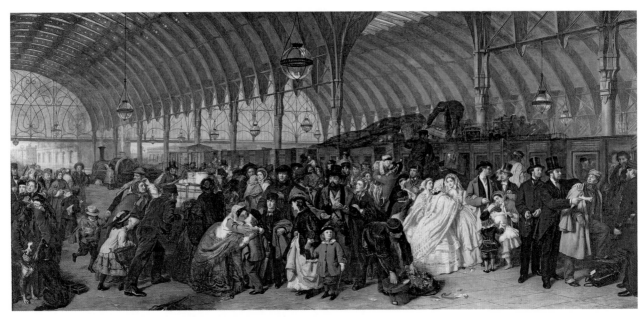

Plate 2.4 William Powell Frith, *The Railway Station (Paddington Station),* 1862, oil on canvas, 117 × 256 cm. Royal Holloway College, University of London, Egham. Photo: © The Bridgeman Art Library.

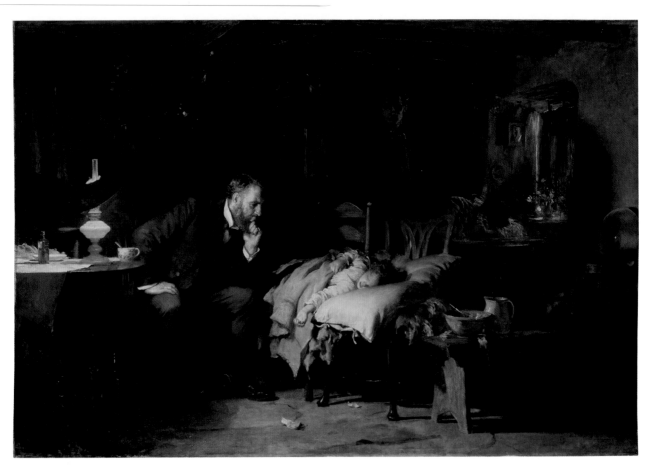

Plate 2.5 Sir Luke Fildes, *The Doctor,* 1891, oil on canvas, 166 × 242 cm. Tate, London, N01522. © Tate, London, 2012.

reporter'.[10] The one thing going for *The Railway Station* was that it was not as abject as Sir Luke Fildes's *The Doctor* (1891) (Plate 2.5) – one of the founding pictures of the Tate's collection – a picture in which, he claimed:

> Form is not used as an object of emotion, but as a means of suggesting emotions. This alone suffices to make it nugatory; it is worse than nugatory because the emotion it suggests is false. What it suggests is not pity and admiration but a sense of complacency in our own pitifulness and generosity. It is sentimental ... Not being a work of art, 'The Doctor' has none of the immense ethical value possessed by all objects that provoke aesthetic ecstasy; and the state of mind to which it is a means, as illustration, appears to me undesirable.[11]

Bell championed 'post-Impressionist' art (the work of Cezanne, Gauguin and others) in the British context. You will have noticed that he distinguishes between works that suggest (debased) emotions and those that 'provoke' real emotional responses; the former turn on the way the subject is arranged, the latter on 'significant form' (his term for the formal characteristics, which, regardless of subject, give rise to an aesthetic response in appropriately sensitive viewers). For Bell, genuine artworks provoked self-sufficient aesthetic feeling; in contrast, he thought descriptive pictures provoked traduced emotions, in ways that were manipulative or 'false'. It is worth pausing to consider that, whatever you make of Bell's claim, he introduces an influential distinction between what he considers to be an art of pure aesthetic emotion and academic, literary or narrative painting focused on a determined tugging at the heart-strings. For him, descriptive genre pictures such as these simply were not art.

Two paintings: modernity and modernism

We are going to further probe the distinction between English genre scenes and the painting of modern life developed by the avant-garde by contrasting two contemporaneous images: Edouard Manet's painting *A Bar at the Folies-Bergère* (1881–82) (Plate 2.6) and *The Public Bar* (1883) by John Henry Henshall (1856–1928) (Plate 2.7). An opposition like this is always a bit like shooting fish in a barrel, but it is designed to clarify the way art historians have thought about the relation of modernity and modernism.

Exercise

Make a list of the similarities and differences between the two paintings, taking note of subject matter, composition and the encounters between the figures. (You might also like to consider which picture painting Bell would have preferred and why.)

Discussion

Both paintings tackle similar subjects: Manet depicts the interior of a fashionable Parisian night spot; Henshall presents us with an English pub scene. Both place the bar at the centre of their image, bisecting the space into foreground and a middle or distant area; each picture depicts bar workers and a crowd of customers separated by this division. In each painting the trappings and details of modern life are visible: Henshall focuses on plain jugs and tankards rather than on gleaming bottles, flowers and fruit, but you might notice that the logo for Bass beer appears in both (on some of Manet's bottles and as a wall sign to the left in Henshall's picture). In both paintings there is an encounter between a barmaid and a man in a top hat: this occurs in a strangely dislocated form in Manet's painting at the right side; it is displaced to the left edge in Henshall's work.

You will have observed important differences between these paintings: Manet's picture focuses on an encounter between two figures, but this is only one incident among many in Henshall's painting. *A Bar at the Folies-Bergère* seems to depict an altogether flashier establishment, with expensive commodities and fashionably-attired figures; in contrast *The Public Bar* depicts a shabbier joint, with the view of the pawnbroker's shop through the window. Interestingly, Henshall reveals the working accoutrements of the bar. Manet's paint handling is a virtuoso display, his colours more high key and whole areas of the canvas are loosely defined, even indeterminate; Henshall, in contrast, delineates and defines his figures and spaces. We could continue to pile up details of similarity and difference, but the key point remains to be articulated. Manet employs modernist formal means to unsettle the viewer's understanding, whereas Henshall's picture uses much more traditional techniques and offers a more secure position for spectators.

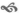

Plate 2.6 Edouard Manet, *A Bar at the Folies-Bergère*, 1881–82, oil on canvas, 96 × 130 cm. The Samuel Courtauld Trust, The Courtauld Gallery, London.

Manet's *A Bar at the Folies-Bergère* has long perplexed its viewers. It is a painting in which brilliance of handling is matched by formal incongruities and spatial oddities, which can make it appear incoherent. It becomes easier to comprehend if you understand the space behind the barmaid as Manet's rendering of a large mirror (note the gilt frame running along the bottom). What we see behind the woman are probably events taking place on our imaginary side of the bar; however, while this explains some anomalies, things still do not align. In 1966, Anne Coffin Hanson wrote:

> The barmaid's reflection does not seem to me to be where it should be, the reflected images of bottles on the marble bar do not match their more tangible models. Historians have attacked the problem like sleuths, expecting to find some key to a logical and naturalistic explanation. There is none.[12]

Art historians have repeatedly returned to this pictorial conundrum (symptomatically, one publication is entitled *12 Views of Manet's Bar*[13]). T.J. Clark advanced one of the most influential recent accounts in his book *The Painting of Modern Life*.[14] Clark places the inconsistencies and incongruities at the heart of his description. What most readers take from this account of the picture is his description of the barmaid's blank, emotionless expression and her encounter with the male figure. If the woman's back to the right is the barmaid's reflection – and Clark thinks we cannot ultimately be certain – the displacement from its naturalistic location makes it possible to introduce the image of the man on our side of the bar. The effect is to align the beholder with the depicted man; putting viewers, whether male or female, imaginatively in his shoes. As it is known that the barmaids in this establishment at this time sold sex as well as other commodities, it is not a comfortable feeling to be placed in the position of a man who may be propositioning the woman. Her blank response only compounds this sense of unease. But for Clark this is only part of what makes this picture modern. He focuses on the flat surfaces, such as the bottle labels and white floating orbs, that seem to detach themselves from

Plate 2.7 John Henry Henshall, *The Public Bar*, 1883, oil on canvas, 62 × 111 cm. Private collection. Photo: © Christopher Wood Gallery/The Bridgeman Art Library.

substance; he tries to stick with the gaps, oddities and spatial dislocations that fail to add up or convince. In his description these awkward passages in Manet's art provide parallels for modern experience. This is a complex argument, but the key point to grasp is that paintings such as Manet's *Bar* work with ambivalence and uncertainty as equivalents for modern life. In this painting, there seems to be no position of moral certainty – no stable position from which to grasp the events depicted. Manet, Clark argues, found a formal way of conveying something important about the new age of capitalism, beyond merely representing its fashions and glittering surfaces.

With this in mind, you may be able to see that Henshall's *The Public Bar* is a painting that evades this kind of anxiety. There are two points to note here. First, the space behind the bar seems impossibly deep, so that the viewer is allocated a detached perspective from which to survey the scene without personal entanglement. Second, Henshall's picture is crammed with dramatic incidents that have a clear moral value: the frieze-like array of figures makes for ease of comprehension. Let's start from the right with the drinking figures. (You might like to try to work out for yourself the roles or stories attached to these individuals and groups.) On the extreme edge there is a figure with a damaged eye draining his tankard. Next, somewhat further back, a man in a top hat seems to be watching him; behind him are two working men in conversation. (Hats play

an important role in this picture, positioning figures socially.) Next comes an old (and probably Jewish) musician in conversation with the barkeeper. The two women form one point of focus; the younger of the two is feeding her baby gin as a pacifier – clearly not an ideal vision of motherhood. It is possible that you have overlooked the small child with the bottle whose head peeps over the bar, located between the old musician and these women. I suspect the woman with the baby and the musician occupy pride of place to heighten the moment when beholders register the presence of the child, who is at the centre of the painting, both compositionally and morally. You begin like this Next appears another little parable in which a respectable young man (probably a clerk) attempts to rescue his 'old dad', who seems the worse for wear. The decorative glass screen marks off a distinct zone of seduction – a young gad about, with hat at a jaunty angle, engages the barmaid who is fiddling with her earring. Her nervous attitude seems a mile away from the blankness of Manet's barmaid. The younger male bar worker to the right observes this encounter and we can envisage a novelistic plotline in which he 'saves' her from her 'fall'. At the far left are a man and woman in intimate conversation over drinks. For middle-class viewers the presence of a young woman in this type of establishment would almost certainly point to 'vice'. It all adds up to a familiar Victorian temperance theme, which suggests that the demon drink leads to ruin.

Clarity and the grey area

Whereas Manet gives us dislocation, incoherence and uncertainty, Henshall's painting is all too legible. Both artists *depict* modern life, but the differences are symptomatic of the distance between avant-garde art and most English genre scenes; between modernism in art and an art that depicts modernity with traditional means and forms. The disparity might be clarified by looking at the distinction introduced by the literary critic Franco Moretti between bourgeois European literature and the English novel.[15] For Moretti, high European literature of the nineteenth century (his example is the Norwegian playwright Henrik Ibsen) was characterised by the moral ambiguity inherent in the chicanery of the new world of business and finance. He suggests that business ethics generated a 'grey area whose nature is never completely clear'. Bourgeois social relations may have been perfectly legal, but for Moretti they gave rise to an ambivalent world of 'reticence, disloyalty, slander, negligence, half truths'.[16] (There are clear echoes of this in the banking collapse of 2007–09.) In contrast, 'even the masterpiece of bourgeois Britain' – George Eliot's novel *Middlemarch* –

> cannot accept the idea of a world of *perfectly lawful injustice*. The contradiction is unbearable: lawfulness must become just, or injustice criminal: one way or the other, form and substance must be aligned, making capital ethically comprehensible. That's what Victorianism *is*: social relations cannot always be morally good – but they must be morally *legible*. No ambiguity.[17]

(Today, most mainstream movies and TV dramas conform to this simplified idea of a perfect fit between law and justice.) Moretti's point allows us to modify Bell's distinction between an avant-garde art of 'aesthetic rapture' and English (non-)art of sentimental and anecdotal detail. The formal incoherence of Manet's *Bar* can be set against the moral legibility of Henshall's *The Public Bar*, or many other English genre paintings. This is not to say that some English artists didn't experiment with novel effects and produce genuinely strange and compelling pictures. Nevertheless, something about English society prevented them from finding a way to make ambivalence and incoherence suggestive of modern experience; from making a moral dilemma from uncertainty. Modernity is depicted in the British art of the period, but modernist form doesn't really break the surface. In France, the on-going clash between traditional ways of life and the rapid transformations of Paris and other urban centres made these changes

available for representation; for instance, the clash between rural and urban values remained a live issue. However, in Britain the process of capitalist development was much more advanced and widespread.[18] This side of the Channel, the decisive confrontations occurred significantly earlier and capitalist culture had long been familiar. Of course, Britain was not conflict free and massive changes were still underway; the point is that capitalist modernity had been around for a long time and had come to seem natural; this made it more difficult to depict modern society as bewildering or awkward, simultaneously exhilarating and horrifying. If this is indeed so, it suggests that representing modernity may require an alternative perspective in time or space from which to perceive modern life; we will return to this point in the final section of this chapter.

2 A mass-image culture

Arguably the greatest transformation in the visual experience of modernity came from the redevelopment of the city itself. Britain was becoming a predominantly urban society. The huge numbers of people living cheek-by-jowl in the great cities that made Britain the 'workshop of the world' were subject to a battery of novel visual experiences. These included: immersion in the life of the crowd; the impact of new technologies of vision; the display of goods imported from around the empire or resulting from new manufactures; the fleeting views from the omnibus or train; the culture of glass – the huge plate windows that both invited the gaze and blocked the hand; the aesthetics of flickering shadows cast by gas lighting. All this and a thousand similar sensory jolts constituted the new culture of modern life, which reordered the senses and, according to the social thinker Georg Simmel, created a new subjectivity – the blasé type who responded to the nervous over-stimulation of big city life with an attitude of reserve, indifference and anonymous detachment from others.[19] Another way of saying this is that it was a culture of private experience in which most middle-class people learned to 'turn a blind eye'. In this section we shift our emphasis from paintings of modern life to the mass visual culture that played an important role in shaping experience in Britain. In doing so, we move from the images traditionally studied by art historians to the part played by the sheer volume and rapid turnover of pictures in the formation of modern sensibility, to which Simmel called attention. This reshaping of the image world was underway in France too, but the dynamic commercial market in Britain hugely intensified the process.

The shows of London

In one of the most powerful images of the Industrial Revolution, Philippe-Jacques de Loutherbourg (1740–1812) painted *Coalbrookdale by Night* in 1801 (Plate 2.8), which depicted the Bedlam iron foundries in what is now Shropshire. De Loutherbourg employs his aptitude for light effects to represent a cataclysm in the English landscape; a deep, dark scar cuts through the foreground. The intensity of effect is produced by the contrast of the inky sky and the rose-coloured efflorescence; at the centre of the flames the painter has daubed pure white pigment, which appears as an alternative source of light to the moon. *Coalbrookdale by Night* is a painting in the sublime mode. Since the eighteenth century, the sublime had been understood as an aesthetic category for forms of experience in which immensity or uncontrollable natural forces menaced the human beholder. Sublimity was one way of depicting the transformed English landscape as something awesome and overpowering; in this way, de Loutherbourg's painting suggests that Pandemonium, the capital of Hell, has been set down in the English Midlands. The sublime was originally concerned with the experience of actual nature rather than landscape and, arguably, painted versions are a way of taming the experience, allowing an aesthetic frisson from a secure distance. However, my main reason for introducing this picture is to provide a bridge to a different account of English modernity.[20] De Loutherbourg had been a painter of theatrical scenery and in 1781 he opened a commercial spectacle called the Eidophusikon (see Plate 2.9). On a stage 6 feet (1.8 m) wide by 8 feet (2.5 m) deep he exhibited paintings lit by powerful lamps for an audience of up to 130. Coloured glass was placed in front of the lights to provide mood effects; clouds depicted on strips of linen moved across the scene. At the premier performance de Loutherbourg showed *Aurora: or the Effects of Dawn, with a View of London from Greenwich Park*, which represented a prospect across the city to the port of London. When the curtain rose:

> A faint light appeared along the horizon; the scene assumed a vapourish tint of grey; presently a gleam of saffron, changing to the pure varieties that tinge the fleecy clouds that pass away in morning mist; the picture brightened by degrees; the sun appeared, gilding the tops of the trees and the projections of the lofty buildings, and burnishing the vanes on the cupolas; when the whole scene burst upon the eyes in the gorgeous splendour of a beauteous day. [21]

Plate 2.8 Philippe-Jacques de Loutherbourg, *Coalbrookdale by Night*, 1801, oil on canvas, 68 × 107 cm. Science Museum, London, Inv. 1952-0452. Photo: © Science Museum Pictorial/Science and Society Picture Library.

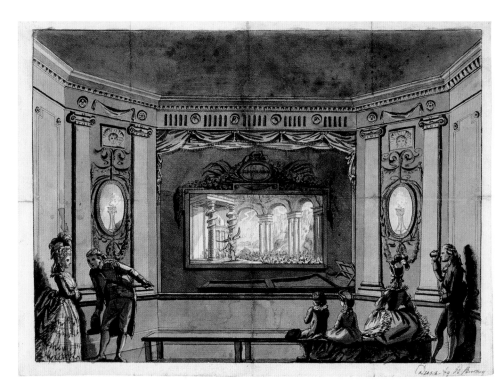

Plate 2.9 Edward Francis Burney, *The Eidophusikon, showing Satan arraying his troops on the Banks of a Fiery Lake with the Raising of Pandemonium from Milton*, 1782, watercolour. British Museum, London, 1963-7-16-1. Photo: © The Trustees of the British Museum.

The performance continued with musical interludes and further Mediterranean views of *Noon*, *Sunset* and *Moonlight* and ended with *The Conclusive Scene, a Storm at sea, and Shipwreck*. The finale again depicted Pandemonium, from John Milton's *Paradise Lost*.[22]

It should be apparent that de Loutherbourg's work on the Eidophusikon and *Coalbrookdale by Night* employ related effects. Art historians have dealt with paintings like this by applying the label Romanticism, but it might be more appropriate to consider instead the impact of capitalism on the organisation of senses; that is to say, the way commercial visual culture played a part in transforming attention. There are several distinctive factors to this image culture of immersive sensation; brilliant light effects and the exotic displays of far-away places or large set-piece events for the stay-at-home are clearly part of this. Novelty was also an important factor, as new effects drew paying crowds; last year's attraction wouldn't do for the fashionable bourgeois-about-town. The new breed of artist-showmen like de Loutherbourg were driven constantly to renovate their displays in order to attract an audience. Each new show had to be more scintillating and more dazzling; these commercial enterprises were constantly changing hands and undergoing face-lifts. This dynamic of novelty and turnover produced an endless search for innovation, which had several knock-on effects. One was the trend to giganticism: the displays got bigger and the shows were driven to

go one step further, to create ever more spectacular and attention-grabbing events. The shows elicited bodily responses, through the combination of visual and sound effects combined with duration.[23] There was also an increasing symbiosis with the press that entailed new levels (or depths) of 'puffing', in which the showmen induced journalists to write notices for new attractions; in turn the press obtained novelties and grandiloquent claims with which to pepper their publications. These shows were sites of sociability for the middle class in the making. This process could and did go hand in hand with a culture of distraction, where attention was both actively sought and constantly dissipated through redirection onto the next attraction.

There were lots of these shows and they came in all shapes and sizes; some were more up-market, some were really seedy, but among the most significant spectacles in the first half of the nineteenth century were the panoramas (from the Greek for all-embracing-view). These were detailed painted depictions of vast tracts of space that engulfed the viewer; typically the scenes were depicted from a commanding viewpoint.[24] There were enormous panorama paintings on display at Leicester Square, the Strand and the Colosseum (now demolished) on the edge of Regent's Park.[25] A list of panoramas on show at Leicester Square reveals a combination of pictures drawn from classical antiquity, battle scenes, sublime views and topographic paintings. There was also a vogue for moving panoramas (huge

Plate 2.10 English School (nineteenth century), *The Colosseum, the panorama of London seen from a painter's platform*, published 1829, colour lithograph. Guildhall Library, City of London. Photo: © The Bridgeman Art Library.

painted scrolls that moved past a fixed viewing point).[26] Showmen competed to exhibit the grandest painted behemoth.

The panorama *London by Day*, by Thomas Hornor (1785–1844), displayed at the Colosseum, depicted the city from the top of St Paul's Cathedral (see Plate 2.10). At 134 feet (41 m) in diameter and covering around 46,000 square feet (4355 m^2) it was perhaps forty times larger than the Leicester Square panorama.[27] In such things size definitely matters. The Colosseum panorama had its origins in the sketches of the city that Hornor made from the top of St Paul's in 1821. *London by Day* was encountered from circular viewing galleries way above the ground. The painting provided a view, uninterrupted by cloud or smog, of London and its environs for twenty miles in all directions.[28]

The illusion was rendered in immense detail and it is said that Hornor visited every street to check the correctness of his sketches (though this seems the kind of myth typically associated with such ventures). It no longer exists, but you can see from the illustration that the illusion gave the viewer an imaginary position gazing over the city from the top of St Paul's. It is worth considering the symbolic significance of this view with the established church at its centre. This was a perspective from the imperial centre of London, with the official state religion at its heart, looking out over the fashionable shopping and residential areas towards the suburbs and manufacturing areas, and the fields and forests beyond. It offers a perspective in which we move from the established church to commerce, then industry and finally landscape or agriculture.

Exercise

Compare the following two descriptions of viewing panoramas at the Colosseum, both by American visitors, and consider the viewing experience they describe.

(a) In 1834, the naval officer C.S. Stewart described *London by Day*:

> The winding river, with its craft and numerous bridges; the undulating sea of brick and mortar, sweeping widely on every hand; the long vistas here and there, marking the grand avenues – by Fleet street and the Strand, Oxford street, and the new road – through the city; the unnumbered public edifices; the parks, the palaces, the gardens, and the distant, but lovely regions encircling the whole, for twenty miles in every direction, all are presented to the view, as distinctly and minutely, as faithfully to themselves and to their colouring in the finest shades of the purest atmosphere, as if seen under the best possible advantages, from the giddy height itself.[29]

He noted that the viewer was 'obliged almost to reason with' himself that this was a 'work of art' and not nature.

(b) William Wells Brown, an African American visiting London on an abolitionist tour, described his experience of *Paris by Night*:

> There, all brilliant with gas-lights, and favored by the shining moon, Paris lay spread far out beneath us, though the canvas on which the scene was painted was but half a dozen feet from where we gazed in wonder. The moon herself seemed actually in the heavens. Nay, bets were laid that she had risen since we entered. Nothing can surpass the uniformity of appearance which every spire, and house, and wood, and river – yea, which every shop-window, ornamented, presented. All seemed natural, from the twinkling of the stars above us, to the monkey of the organ-man in the market-place below.[30]

Discussion

Stewart refers to 'giddy height', 'long vistas' and his obligation to convince himself that he was seeing a picture, while Wells Brown's invokes 'the uniformity of experience' and Paris 'spread far out beneath us'. Both writers refer to vast sweeps of space, illumination and unhindered vision. Their accounts embed detail within an untrammelled perspective or point of view. The panorama seems to offer a stable point of view, which results in a visual command of all surveyed.

If this kind of immensity and the overview was one type of visual experience propagated by capitalist modernity, it was accompanied by a drift towards particularity and dispersal of attention in mass images, to which we now turn.

Print capitalism

In 1842, the photographer Antoine Claudet (1797–1867) hauled his apparatus 124 feet (38 m) up to the top of the Duke of York's column (situated near where

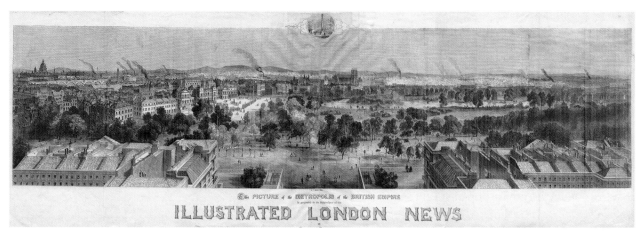

Plate 2.11 London in 1842: 'picture of the metropolis of the British empire', 1843, engraving, from a drawing by C.F. Sargent based on a series of Daguerreotypes by Antoine Claudet, 83 × 118 cm. Supplement to the *Illustrated London News*, 7 January 1843. Photo: © Illustrated London News Ltd/Mary Evans.

Regent Street meets The Mall) and made a series of Daguerreotypes of London from this vantage point.[31] The photographs no longer exist; in any case, these plates were just a starting point for an engraved panorama published as 'London in 1842' in the *Illustrated London News*.[32] The following year it was reissued as a separate sheet measuring 83 × 118 cm (see Plate 2.11). Claudet's panorama was one of the first of the printed panoramas that developed in the 1840s and provided competition for the painted monsters, bringing together key facets of print capitalism as it was transfigured during the nineteenth century: photography and the illustrated press. The term 'print capitalism' was coined by Benedict Anderson to account for the way printed books changed modern experience, particularly national consciousness. Anderson suggests that print fuelled 'capitalism's restless search for markets'[33], but this process went through a new phase in the first half of the nineteenth century with the mass production of images in two key forms. In this section we will consider the contribution images made to what Simmel saw as the overload of the senses in the metropolis.

Photography

Photography revolutionised image making. In the middle of the nineteenth century there were plenty of uses for this new technology: there were images that brought home far-away places (particularly the empire); there were also fantastic opportunities for new niche markets (pornography is an obvious example), but here we focus on the revolution in portraiture. Portraiture was fundamentally transformed in the middle of the nineteenth century. In 1841, the coal merchant Richard Beard (1801–85) purchased the rights to the Daguerreotype in Britain (Plate 2.12). Beard set up three studios and licensed others, and one contemporary estimated that this brought him £25,000 in two years.[34] Daguerreotypes massively cut the cost of portrait production and drove miniature painters out of business, but they were inherently limited as single and fragile images modelled on miniature paintings. A series of technical developments during the 1850s made paper-based photographic portraiture viable, particularly in the carte de visite format – a small paper photograph mounted on card.[35] During the period of 'Cartomania' in Britain in the early 1860s, hundreds of photographic studios supplied the middle class with their carte portraits and pictures of celebrities (see Plates 2.13 and 2.14).[36] Tens of millions were sold during the 1860s.[37] This indicates the scale of the transformation of image production in modernity.

Plate 2.12 Richard Beard, *George Francis Robert Harris, 3rd Baron Harris*, 1840s, ninth plate Daguerreotype, 9 × 4 cm. National Portrait Gallery, London, NPG P117. Photo: © National Portrait Gallery, London.

The acceleration in the rate of production of these commodity images transformed the way that portraits were experienced. Portraits ceased to be grand statements of symbolic power depicting the wealthy and very powerful and instead took their place in what the critic Walter Benjamin described as 'the universe for the private citizen'.[38] For the first time, ordinary middle-class people could preserve their likenesses. Alongside these bourgeois portraits there was a booming trade in photographs of celebrities. A photographer who could obtain the portrait of some renowned figure could make big profits. The writer Andrew Winter suggested that the wholesale houses ordered 10,000 prints of popular celebrities, sometimes paying £400. In one passage he provided a fascinating commentary on these images. He suggested:

> The commercial value of the human face was never tested to such an extent as it is at the present moment in these handy photographs. No man, or woman either, knows but that some accident may elevate them to the position of hero of the hour, and send up the value of their countenance to such a degree they never dreamed of.[39]

Plate 2.14 Camille Silvy, Unknown woman, 1860s, albumen print (carte de visite), 9 × 6 cm. Scottish National Portrait Gallery, Accession No. PGP R 892. Reproduced larger than actual size.

Fame is an old phenomenon, but celebrity was generated by print capitalism. The cult of celebrity began in the eighteenth century, but it was taken to another level by the middle of the nineteenth. Celebrity requires a mass press, an elaborate transport network and postage system and, not least, a mass-image technology to promote the figure of the day.

Some commentators were particularly disturbed by the patterns of proximity set up in the display in windows of photographers, or print sellers. As a writer in the *Daily Telegraph* put it:

> in almost every shop window devoted to the sale of photographic prints there are exhibited, side by side with the portraits of bishops, barristers, duchesses, Ritualistic clergymen, forgers, favourite comedians, and the personages in the Tichborne drama, a swarm of cartes-de-visite of tenth-rate actresses and fifth-rate ballet girls in an extreme state of *deshabille*.[40]

Photography standardised portraiture and extended it to the middle class; it elevated some to the instant visibility of celebrity and at the same time displayed less regard for propriety. The lineaments of the twentieth-century mass media with which we are all too familiar are already apparent in this trend of mass produced and prying reverence.

The illustrated press

We have already noted the importance of prints made from paintings. During the nineteenth century, copies of artworks began to appear in the British art publications *The Art Journal*, *The Magazine of Art* and, later, *The Studio*. These magazines increased the circulation of reproductions making their contribution, in the words of the influential design reformer Henry Cole, to the 'moral good of the poor'.[41] Even more significantly, print capitalism resulted in a huge increase in the number of illustrated papers and magazines. In a range of publications – the *Penny Magazine*, *The Graphic*, the *Pictorial Times*, the *Illustrated London News*, the *Illuminated Magazine* and so on – reports of events increasingly appeared alongside pictures (Plate 2.15). *Punch* and others in the same mode carried masses of satirical cartoons, and all manner of magazines were aimed at specialist readers, ranging from religious publications, through gardening journals to women's magazines. Image production underwent a massive transformation at this point. It has been estimated that by 1861 there were nearly 500 magazines and reviews circulating in England and Wales and more than 1,000 newspapers.[42] The last remnants of the stamp duty on newspapers and periodicals were finally lifted in 1855; the end of this backdoor censorship, combined with steam-driven letterpress, an increase in the number of wood engravers, cheap postage and cheap wood-pulp paper enabled mass journalism to take off in England.[43] The condition for all this was the growth of an urban middle-class readership.

One rival publisher complained that the *Illustrated London News*'s standard fare focused on novelty:

> Court and fashion; Civic Processions and Banquets; Political and Religious Demonstrations in crowded halls; Theatrical Novelties; Musical Meetings; Races; Reviews; Ship Launches – every scene, in short, where a crowd of great people can be got together, but never, if possible, any exhibition of vulgar poverty.[44]

According to print historians, other magazines, such as *The Graphic*, *Punch* (certainly in its radical early years) and the *Penny Magazine*, were much more prepared to include images of inequality and urban conditions (Plate 2.16).[45] However, it is probably more important to understand that the impact of print capitalism resides with form rather than content. We have all become so used to illustrated papers and magazines that it can be difficult to grasp the novel forms of attention involved, which echoes Simmel's description of modernity. It is worth stepping back and thinking about these developments in visual culture.

In its first issue, the *Illustrated London News* claimed: 'The public will have henceforth under their glance, and within their grasp, the very form and presence of events as they transpire, in all their substantial reality, and with evidence visible as well as circumstantial.'[46] In the same vein, two months later it announced that drawings were 'able to illustrate events uncontaminated by party spirit – in a word, with truth, and without bias'[47] (see Plate 2.17). The claim that illustrations constituted direct evidence – to present 'an accurate and most faithful sketch' – was central to the new graphic journalism. In 1851, *The Economist*, in an article titled 'Speaking to the eye', suggested that artists spoke a 'universal language' and were able to 'illustrate passing events truly and graphically'.[48] This claim to 'objectivity', to be devoid of sectional interest, was central to the ideology of the professional middle class; the very term 'middle' was significant in this argument, suggesting a role independent of either the aristocracy or working class.

The illustrated press incorporated a range of picture formats and we need to consider scale and placement: for instance, some large and special images were meant to be cut out and kept.[49] However, these were exceptions and the regular pictures that appeared in these journals signalled a different kind of attention; they were ephemeral, intended to be skimmed over or flicked through as the reader turned the pages. Interest might alight on something particular, pausing for a moment, before moving to the next article or alighting on the next picture. Within a short time these publications would be consigned to the rubbish or used for cheap packing. Novelty was at the heart of the culture of the printed image, which was constantly seeking to grab the eye, to find a new attraction, something unusual or depicted for the first time – huge engineering works, a fire, state funerals, figures of the stage or from sport, imperial heroics and so on. The connection between the new sights and news was intimate and integral. Whereas eye-witness accounts had been common since the eighteenth century, graphic journalism provided a different sense of immediacy or instantaneity and a sense of being present at the events depicted for their viewers.

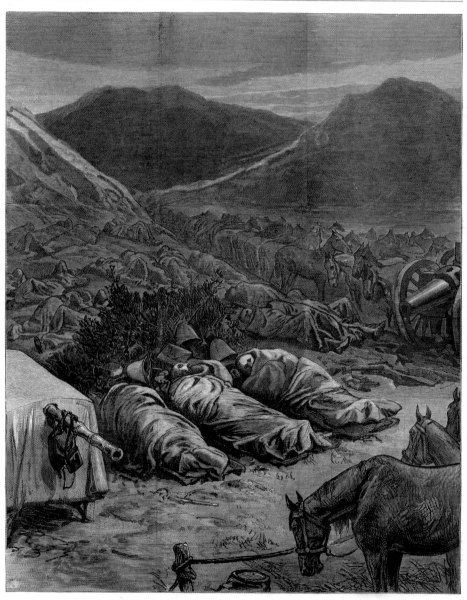

THE AFGHAN WAR: SPECIAL CORRESPONDENTS SLEEPING ON THE BATTLE-FIELD, NIGHT BEFORE THE ATTACK ON FORT ALI MUSJID.
FROM A SKETCH BY MR. WILLIAM SIMPSON, OUR SPECIAL ARTIST.

Plate 2.15 'The Afghan War', 4 January 1879, engraving, cover of *Illustrated London News*. Photo: © Illustrated London News Ltd/Mary Evans. Special correspondents, including Archibald Forbes of the *Daily News*, Phil Robinson of the *Daily Telegraph* and William Simpson, Special Artist of the *Illustrated London News*, find a sheltered spot to sleep on the battlefield on the night before the successful attack on Fort Ali Musjid.

A DAY AT A COTTON-FACTORY.

[Power-looms.—Cotton Manufacture.]

IF we take the town of Manchester as a centre, and draw around it a circle of ten miles radius, we shall find within that circle the seat of the most extraordinary manufacture which the world has yet witnessed : settling at Bolton, within the district which we have marked out, established the processes of spinning and weaving there. Again, when the revocation of the Edict of Nantes drove many weavers from France, in

Plate 2.16 'A day at a cotton-factory', June 1843, engraving, 11 × 14 cm. *Penny Magazine* of the Society for the Diffusion of Useful Knowledge, vol. 12, Supplement. Photo: © Malcolm Daisley.

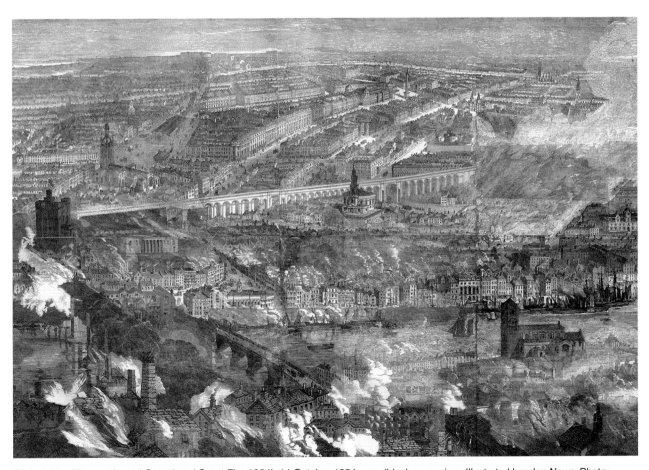

Plate 2.17 'Newcastle and Gateshead Great Fire 1854', 14 October 1854, woodblock engraving, *Illustrated London News*. Photo: © Illustrated London News Ltd/Mary Evans. A view over Newcastle (on the far side of the River Tyne) and Gateshead (in the foreground) during the great fire which killed 50 people.

The visual spectacles and print capitalism, whether photography or illustrations, vastly increased the volume of images produced; like the panoramas, printed images and photographs proved attention grabbing, but these mass images contributed to the making of a dissipated and distracted kind of attention, rather than an overview. For a long time mainstream art history tended to ignore this sort of visual culture and concentrated on 'masterpieces', but if some avant-garde painters depicted modernity we should be aware that some new types of representation were central to that modernity, disseminating visual material through the culture and reordering perception.

3 The medieval revival and the critics of modernity

The International Exhibition of 1851, often called the Great Exhibition, is regarded by many historians as the very incarnation of the Victorian world view. With its glass and iron architecture, exhibits of working machines and displays of commodities drawn from across the globe, this exhibition encapsulated the idea of progress and stability through industry and work; it presented an ideal of peace and plenty centred on the liberal values of free trade and imperial expansion.[50] At the same time, the exhibition measured the economies of other nations against British industry and found them wanting. Some colonies were represented solely by raw materials, suggesting, according to the scheme of the exhibition, that they remained in an undeveloped state and lacked the values associated with industriousness and commerce. It was a vast and triumphant incarnation of British middle-class values.

There were, though, two sections of the exhibition that did not fit this pattern – the Indian displays and the Medieval Court designed by the architect Augustus Welby Pugin (1812–52) (Plates 2.18 and 2.19). The display of Indian handicrafts focused on beautiful artisan-produced objects. As Lara Kriegel has noted, the Indian weaver seated under a tree appeared as an exemplary figure.[51] However, whereas the idea of the colonial subject without history was a familiar enough conception in the imperial vision, the Indian displays proved much more troubling, because these elaborately worked artefacts meant that India could not easily be dismissed as uncivilised. While some observers claimed that the Indian artefacts testified to the barbaric despotism of rulers who could lavish enormous resources on objects of pomp, others saw a high level of skill and inventiveness that they believed

testified to an advanced culture. Pugin was the main architect behind the nineteenth-century Gothic revival; the Medieval Court incarnated his vision of a harmoniously integrated society based on handicraft production. Neither the display of Indian handicrafts nor Pugin's medieval revivalism seemed to conform to the narrative of industrial progress and modernity; both represented alternatives to the exhibition and its audience by counterposing lavish hand production to machinofacture. The art historian Tim Barringer has coined the term 'Colonial Gothic' for this linked challenge to the common sense of modernising liberals.[52] Both the Indian and the medieval displays suggested that capitalist development was not the only path society could take.

In the previous chapter, Paul Wood examined the encounter between Parisian avant-garde artists and other cultures seen as 'primitive' or 'exotic'. He suggested that geographic dislocation from the metropolis provided a place from which to review modernity, and the Indian displays at the Great Exhibition provide another example for his argument, though in this instance they complicate the story about the 'primitivism' of other societies. But if spatial distance offered one perspective from which to view the capitalist metropolis, distant time could equally offer an alternative point of view on the present. In the final section of this chapter we will explore the medieval revival in mid-Victorian Britain as a critical engagement with industrial and commercial civilisation. This interest in the Middle Ages is manifested in Sir Walter Scott's historical novel *Ivanhoe*, the Gothic revival in architecture, the art criticism of John Ruskin, the paintings of the Pre-Raphaelite Brotherhood, the recovery of the Arthurian legends and the version of them in *Idylls of the King* by the poet laureate Alfred Lord Tennyson (1809–92), the photographs of Julia Margaret Cameron (1815–79), and the Oxford Movement in religion, which sought to return to the high spiritualism and ritual associated with the Catholic Church.[53] This structure of feeling received a particularly vigorous form in the work of William Morris and the Arts and Crafts movement. As we will see, many of those involved in the medieval revival actively rejected modernity, but Morris was able to give form to his attitude to modern society in decorative pattern.

No doubt there is something incongruous about dreaming of the fourteenth century and the simple life in a context of factory whistles and steam trains. Two examples will serve to make the point: Wightwick

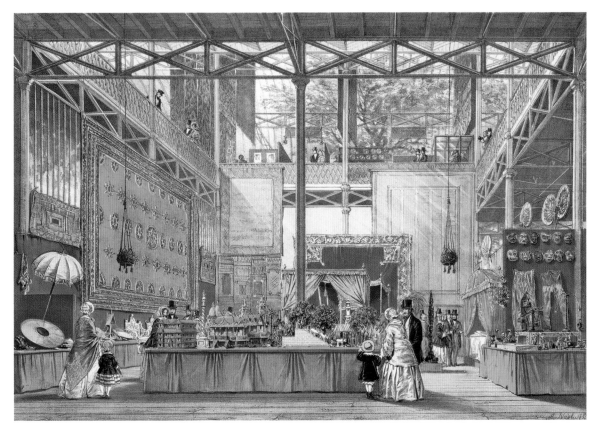

Plate 2.18 *View of the India Section of the Great Exhibition of 1851*, hand-coloured lithograph, 46 × 64 cm, Plate 6 from *Dickinson's Comprehensive Pictures of the Great Exhibition of 1851*, London, Dickinson Brothers, 1852–54. Private collection. Photo: © The Stapleton Collection/The Bridgeman Art Library.

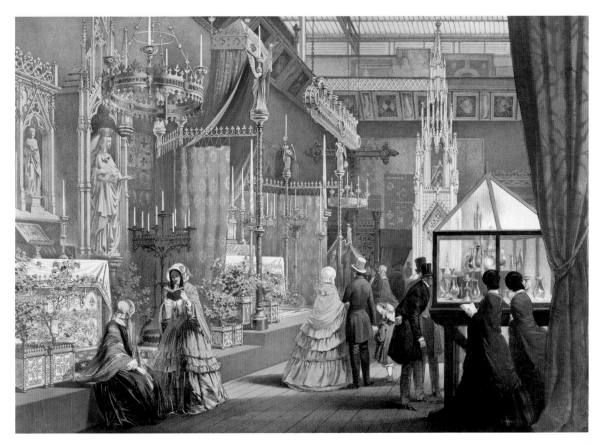

Plate 2.19 *The Medieval Court*, hand-coloured lithograph, 35 × 42 cm, Plate 40 from *Dickinson's Comprehensive Pictures of the Great Exhibition of 1851*, London, Dickinson Brothers, 1852–54. Yale Center for British Art, Paul Mellon Collection. Photo: © The Bridgeman Art Library.

Plate 2.20 The Great Parlour seen from the Hall, Wightwick Manor, Wolverhampton. Photo: © National Trust Photographic Library/ Andreas von Einsiedel/The Bridgeman Art Library.

Manor, outside Wolverhampton, and the painting *Ophelia* (1851–52) by John Everett Millais (1829–96). Built for the industrial paint manufacturer Theodor Mander between 1887 and 1893 in Tudor Timber vernacular, Wightwick was decorated using objects and materials from prominent arts and crafts designers: wallpapers, furniture and other items came from William Morris & Co., light fittings were made by W.A.S. Benson, ceramics and tiles were produced by William de Morgan, and stained glass was supplied by Charles Kempe (see Plate 2.20). At the same time, the house was one of the first in the country to have central heating and gas lighting. Later, Pre-Raphaelite artworks were added. Millais's painting, which is one of the most popular works in the collection of Tate Britain, depicts the character Ophelia from Shakespeare's *Hamlet* (Plate 2.21). Driven mad when her lover murdered her father, Ophelia wandered gathering flowers in her ravings before drowning. Millais depicts the scene, paying attention to the detail of the river bank and its flora, and many of the

flowers are attributed symbolic value (nettles for pain, poppy for sleep and death, and so on), but to achieve the effect he posed his model in a bathtub, heated from below. There is something bizarrely contradictory about painstaking observation of nature and a young woman catching a chill in a cold bath, or a fortune made from industrial paints combined with handmade décor; mod cons alongside the taste for all things medieval. In all its forms, the medieval revival combines this sense of then and now, old and new.

The medieval revival has often been dismissed as a weird taste for 'ye olde worlde' and damsels in wafting frocks, but it is worth asking whether it might be seen as a reaction to industrial capitalism and the social conditions it generated in the large cities. It was certainly part of an English reaction against continental influences, and the Gothic 'style' was regularly described as an appropriate English style because of its historical resonances. However, the critic Raymond Williams has suggested that the Pre-

Plate 2.21 John Everett Millais, *Ophelia*, 1851–52, oil on canvas, 76 × 112 cm. Tate, London, N01506. © Tate, London, 2012.

Raphaelite Brotherhood was a dissident 'faction' of the commercial bourgeoisie in which 'an attachment to a certain romantic and decorative kind of beauty' became 'a critique of the ugliness of nineteenth-century commercial and industrial civilization'.[54] In fact, this argument can be extended to wider sections of what Williams calls the 'culture and society' tradition and which we might alternatively call 'romantic anti-capitalism'; the medieval revival takes its place in this field of moral debates.[55] We can get a sense of this reaction to modernity by looking at the architecture of Pugin and the art-criticism-cum-social thought of Ruskin. The medieval revival had been gathering pace for some time (*Ivanhoe* was published in 1819), but we can take the work of Pugin as setting the tone for this structure of feeling. Pugin, who was a convert to Roman Catholicism, found spiritual decline in all aspects of post-Reformation society. When the Palace of Westminster burnt down in 1833, it was decided that the new building should be constructed in a 'national' English mode rather than the Neo-classical style. Pugin made a huge contribution to the new Houses of Parliament (1836–68) officially attributed to Charles Barry (1795–1860). He worked on all aspects of the

building from the external architecture to the internal fittings (see Plate 2.22), but his involvement remained in the background because it was thought unseemly for so prominent a Catholic to be involved in building the nation's parliament. Against the prevailing taste for classicism, Pugin carried his vision into reviving Gothic architecture with a series of cathedrals, parish churches and other buildings. According to him, good architecture did not come from Neo-classical elegance, but from respect for materials and craftsmanship. The best architecture was Gothic or, as he was inclined to call it, 'Pointed or Christian Architecture'.[56] In 1836, Pugin published *Contrasts* (revised in 1841), in which he linked the moral character of a society to its architecture (Plate 2.23). With *Contrasts*, Pugin found a form for articulating his moral purview, by juxtaposing contemporary scenes with idealised views of the fourteenth century; modern urban squalor was set against visions of social and environmental harmony. In one plate the Christian church spires of 1440 have been replaced by factory chimneys and the common land in the foreground has been built over with a prison. The point seems to be that the communal and spiritual values of the Middle Ages have been replaced by social and religious strife.

Plate 2.22 The Sovereign's Throne in the House of Lords, Westminster, built *c.*1844. Photographed by John Bethell. Photo: © Palace of Westminster/John Bethell/The Bridgeman Art Library.

The critic John Ruskin (Plate 2.24) advanced related arguments, but unlike Pugin he did not believe that Gothic architecture could simply be revived in a modern setting. Ruskin was the outstanding art critic of the mid-Victorian period who advocated the close study of nature as a fundamentally moral practice.[57] Ruskin was a Tory whose fierce criticism of Victorian industrial civilisation was to influence thinkers such as Mohandas K. Gandhi (1869–1948), William Morris, Leo Tolstoy (1828–1910) and founders of the Labour Party. The study of architecture led Ruskin to believe that

something had gone awry with western culture. He felt that medieval Gothic architecture followed nature and did glory to God, but the emergence of classicism in the Renaissance saw the rise of a conventional attitude to nature in architecture and a revival of pagan sensuality.

These views come through forcefully in the chapter 'The nature of the Gothic' published in the second volume of the *Stones of Venice*, which was to become one of the most influential texts of the nineteenth century.[58] In this work, Ruskin turned his back on

Plate 2.24 John Everett Millais, *Portrait of John Ruskin*, 1854, oil on canvas, 79 × 68 cm. Private collection. Photo: © National Portrait Gallery, London.

Palladian architecture and celebrated the medieval builders (see Plate 2.25). He was particularly concerned with architectural decoration as the vehicle for craftsmanship and right emotion; for him, the hand and passions of the heart were joined. Whereas Gothic ornamentation gave full rein to the craftsman's imaginative powers and spiritual development, Ruskin believed modern society demeaned the worker and debased the products of labour. From this argument we can begin to see emerging key themes of romantic anti-capitalism, which did not simply appropriate the medieval as a style, but as a source of values and ideals about life and society. First, Ruskin, like Pugin and others in this tradition, did not view artworks and buildings as isolated creations, but held them to be expressions of the moral climate of a particular culture; 'the art of any country is the exponent of its social and political virtues'.[59] Ruskin regarded cultures as wholes or totalities in which art and buildings reflected the prevailing ethical culture. Second, he came to see great art as the product of a healthy and just society and bad art as springing from a morally corrupted world.

According to Ruskin:

> the Gothic architecture of Venice had arisen out of, and indicated in all its features, a state of pure national faith, and of domestic virtue; and that its Renaissance architecture had arisen out of, and in all its features indicated, a state of concealed national infidelity, and of domestic corruption.[60]

It should be clear that Ruskin thought the Renaissance represented a falling off from the culture of the Middle Ages. From his perspective, Britain only claimed fidelity to Christian creed, but it worshipped Mammon; the modern factory system alienated, demoralised and immiserised the working population; and the modern city was both ugly and unsanitary – a blight on nature. A great nation, he said, in a passage with many contemporary echoes, does not:

> send its poor little boys to jail for stealing six walnuts; and allow its bankrupts to steal their hundreds of thousands with a bow, and its

Plate 2.25 John Ruskin, *Part of St Mark's, Venice, sketch after rain*, 1846, graphite, watercolour and bodycolour on grey paper, 42 × 29 cm. Ashmolean Museum, University of Oxford, Accession No. WA.RA.ED.209.

bankers, rich with poor men's savings, to close their doors 'under circumstances over which they have no control', with a 'by your leave'; and large landed estates to be bought by men who have made their money going armed with steamers up and down the China Seas, selling opium at the cannon's mouth, and altering, for the benefit of the foreign nation, the common highwayman's demand of 'your money or your life,' into that of 'your money *and* your life'.[61]

Industrial civilisation, he proclaimed in the same essay, had no use for art, books, compassion, nature, morals or science. It was a culture of 'Blanched Sun, – blighted grass, – blinded man'.[62] In contrast, he famously argued 'There is no Wealth but Life.'[63] Ruskin and Pugin kept their distance from the modernity of their own time by drawing their inspiration – artistic and social – from a vision of the fourteenth century. Rather than engage with the ambivalence or contradictions of modern life, they preferred to withdraw.

The Pre-Raphaelite Brotherhood and William Morris

The Pre-Raphaelite Brotherhood (PRB) was formed in London in 1848 – the year of the European revolutions – and played a prominent role in this medievalising criticism of Victorian culture (see Plate 2.26). Founded by seven young men of whom William Holman Hunt, John Everett Millais and Dante Gabriel Rossetti (1828–82) formed the core, the group despised the teachings of the Royal Academy and shared a passion for poetry and Christian scripture as well as a sense of empathy with the poor.[64] In a letter to *The Times*, Ruskin suggested that the Pre-Raphaelites would 'lay in our England the foundations of a school of art nobler than the world has seen for 300 years '.[65] Like Pugin and

Plate 2.26 Dante Gabriel Rossetti, *Ecce Ancilla Domini! (The Annunciation)*, 1849–50, oil on canvas, 72 × 42 cm. Tate, London, N01210. © Tate, London, 2012.

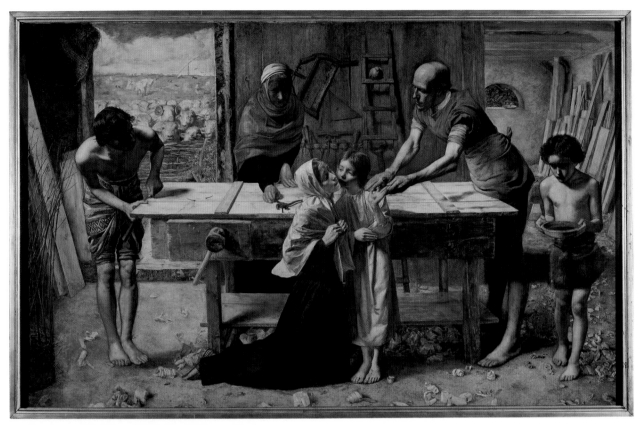

Plate 2.27 John Everett Millais, *Christ in the Carpenter's Shop* (*Christ in the House of His Parents*), 1849–50, oil on canvas, 86 × 140 cm. Tate, London, N03584. © Tate, London, 2012.

Ruskin, these artists saw the tradition stemming from the Renaissance as representing a period of artistic and moral decline; they rejected the academic canon and looked for inspiration to the 'Early Christian' art of the fourteenth century, prior to the work of Raphael (1483–1520). Pre-Raphaelite art was based on intense colours, relatively flat surfaces and ostensibly unidealised forms, though to our eyes these works may seem more like the epitome of Victorian taste than fourteenth-century Italian pictures. Subjects were drawn from Christian narrative, and un- or anti-classical authors. Settings, objects, furniture and clothes were carefully researched with regard to historical accuracy. Under the impact of Ruskin's ideas, the members of the PRB paid increasing attention to study from nature, instigating a contradiction between historicist revivalism and naturalism. The tension was observed at the time: for instance, Ruskin himself praised the close observation in these works, while keeping his distance from the historicising and potentially Catholic dimension of PRB medievalism. Charles Dickens described *Christ in the Carpenter's Shop* (1850) as 'mean, odious, hideous and revolting': the Christ figure was a 'hideous, wry-necked, blubbering red-headed boy in a bed gown' and Mary was 'so horrible in her ugliness, that she would

stand out ... in the vilest cabaret in France, or the lowest gin-shop in England' (see Plate 2.27).[66] In both these comments, we again witness a tension between history and the present.

The group's anti-establishment ideology was infused from the beginning with a cult of the romantic genius and is an important milestone in the development of the idea of art as an activity spiritually superior to, and apart from, everyday life. Like other romantic anti-capitalists, the artists of the PRB were drawn to medievalism as a point of contrast to the modern world. This was a historical point of identification which allowed them to distance themselves from the prevailing values in art and 'the cash nexus'. This is an attitude to modernity that differs from that of both modernist painters such as Manet and painters of modern life such as Henshall (see Plates 2.6 and 2.7). The PRB looked backwards to imagine an alternative future. An idealised image of female beauty plays a fundamental role in this purview. This cloying cult of womanhood drew on the medieval tradition of Courtly Love, particularly as expressed in the poetry of the troubadours. In PRB paintings, fetishistic images of women stand for an unattainable aesthetic

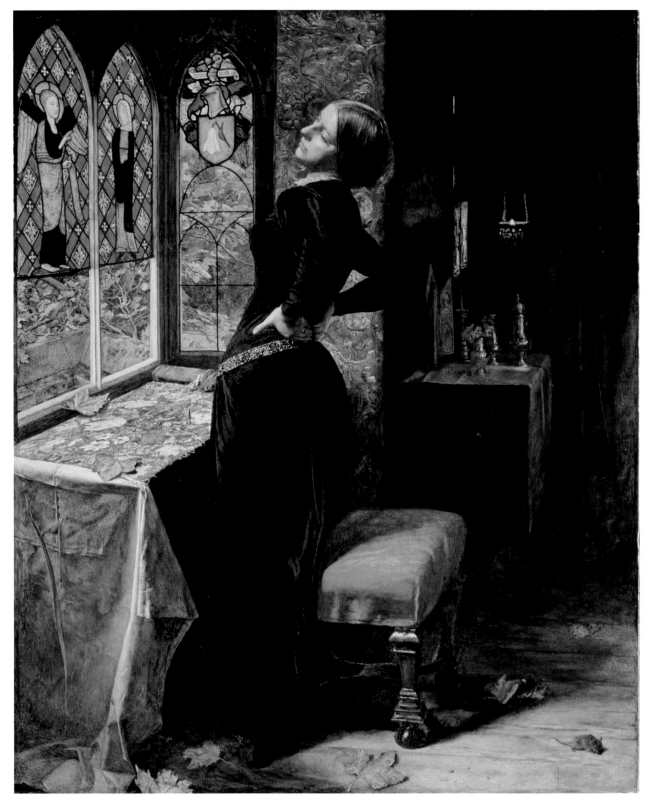

Plate 2.28 John Everett Millais, *Mariana*, 1851, oil on panel, 60 × 50 cm. Tate, London, T07553. © Tate, London, 2012.

of pure beauty; enchantment or obsessive passion is counterposed to everyday life. Millais's *Mariana* (1851) can be taken as an example (Plate 2.28). Drawn from Tennyson's poem of the same name, Mariana has risen from the embroidery on the table to stretch her back. Embroidery was one of the standard accomplishments of femininity that encapsulated the home-bound values of decorum through patient, decorative work.

Here Mariana is depicted leaving off this task to gaze on the stained-glass panels depicting the annunciation of the Virgin (the shrine in the corner may also involve Marian devotion). The falling leaves and the dormouse suggest an autumn scene. With reference to Mary, the autumnal setting and the positioning of Mariana's hips and bottom, Millais suggests she is akin to a ripe fruit. Two leaves have dropped onto her needlework and Millais revels in his ability to convincingly distinguish between a painted leaf and a painted embroidered leaf. Yet the fallen leaves also tug through the confined space, connecting her to the world outside; they emphasise how bounded is Mariana's life. Everything about this picture proclaims a sense of (sexual) frustration and an intense desire for fulfilment or release. In the works of the PRB, medievalism, nature and 'woman' all appear as antitheses to the world of commerce and instigate a sense of longing or yearning for another kind of life, one that would be more beautiful and less constrained by the culture of modernity. Despite the masculine vision, this yearning might well be thought of as a sub-genre of the utopian impulse.

Today, William Morris is often seen as the creator of chintz patterns beloved by a certain section of the middle class, but he was a key figure in the continuation and transformation of romantic medievalism (see Plate 2.29). Morris began as a follower of Ruskin and the PRB (particularly Rossetti), but he took the themes associated with their work somewhere else when, in 1883, he became active in Marxist politics. In the essay 'The lesser arts' (1877), Morris argued that the arts, and the decorative arts in particular, were 'sick' as a consequence of the split between intellectual and mechanical work that occurred during the Renaissance. There was a time, he argued, when all handicraftsmen had been artists producing beautiful and useful artefacts, but the division of labour had made architecture, painting and sculpture arts 'of the intellect' and concomitantly the handicraft worker had been reduced to a mere labourer. Both high art and decorative art was scarred by this process, but the so-called lesser arts particularly suffered and were now 'trivial, mechanical, unintelligent, incapable of resisting the changes pressed upon them by fashion or dishonesty ... nothing but dull adjuncts to unmeaning pomp, or ingenious toys for a few rich and idle men'.[67] Morris spoke of art as 'fruit' growing from the conditions of society. He felt that the unhealthy art of his time needed clearing: 'a burning up of the gathered weeds, so that the field may bear more abundantly'.[68] It should be clear how close this line of argument is to Ruskin, but while Morris retained many of the values articulated by earlier proponents

of medieval revivalism, increasingly he attributed the process of cultural decay to the rise of capitalism and posited socialism as an alternative, rather than the dreamy idea of turning back the clock.[69] It is significant that Morris's medieval ideal, which he elaborated in the utopian novel *News from Nowhere*, unfolds from the social upheavals of his own time.[70]

The first thing to note about Morris's designs is the sheer power of the works he produced (see Plate 2.30). Apart from the best paintings of the French avant-garde, there is little in Europe in the latter part of the nineteenth-century to match these works for aesthetic energy. The emphasis on organic growth and change makes for a good way to represent dynamic patterns of social transformation. In an important recent reinterpretation of these works, the art historian Caroline Arscott argued that, for Morris, pattern suggests an analogy for a 'properly functioning human community', where the elements of geometry and naturalism 'correspond to the practical political aims of equality and variety'.[71] Arscott was not interested in what Morris depicted, rather she concentrated on his dynamic patterning – his process of ordering and organising his material and the way this captured a vital and changing image of the world. In a famous biography, E.P. Thompson suggested that Morris's design work represented a retreat from serious political engagement.[72] In direct contrast, Arscott suggested that a careful look at these designs shows that they are not the safe and comforting patterns that some take them to be. Morris's designs are wild and dynamic; they imagine an overcoming of social contradictions in an allegory performed 'through the twists and turns of plants'.[73] In this way his aesthetic stands as a powerful equivalent for the recovered wholeness of men and women, of their relations to their fellows and to nature. Morris directly connected pattern and a conception of society: 'No stem should be so far from its parent stock as to look weak or wavering. Mutual support and unceasing progress distinguish real and natural order from its mockery, pedantic tyranny.'[74] In contrast to what he saw as the sick society of his day, Morris's designs entail a healthy, pulsating and vibrant ecosystem in which plant and animal forms suggest natural harmony, development and social solidarity. In Arscott's account, Morris might not depict the scenes and sites of modern life, but he successfully conveys a critical experience of that world centred on pleasure in labour. This is not modernism, or not what we usually mean by that practice in art, but an alternative way of putting modern life into artworks.

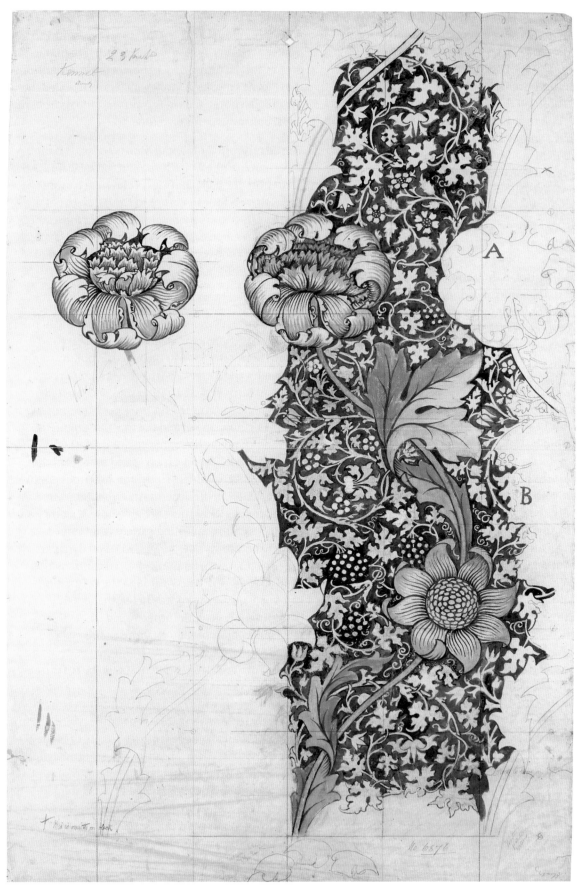

Plate 2.29 William Morris, Working drawing for 'Kennet', 1883, pencil drawing, watercolour and body colour, 101 × 67 cm. Birmingham Art Gallery, Accession No. 1941P404. Photo: © Birmingham Museums and Art Gallery.

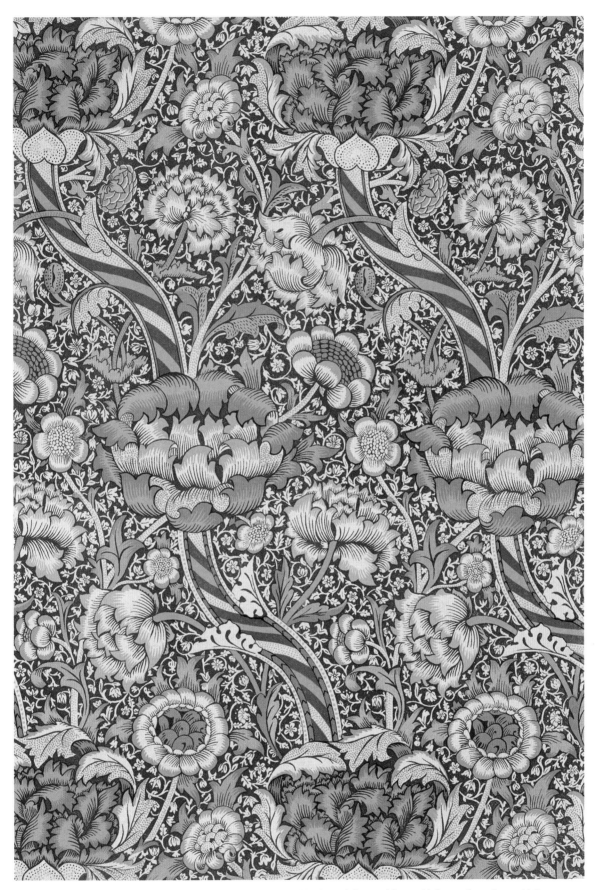

Plate 2.30 'Wandle', printed fabric, manufactured by William Morris and Co. and Aymer Vallance, from Aymer Vallance, *The Art of William Morris*, London, Calmann & King, 1897. Photo: © The Bridgeman Art Library.

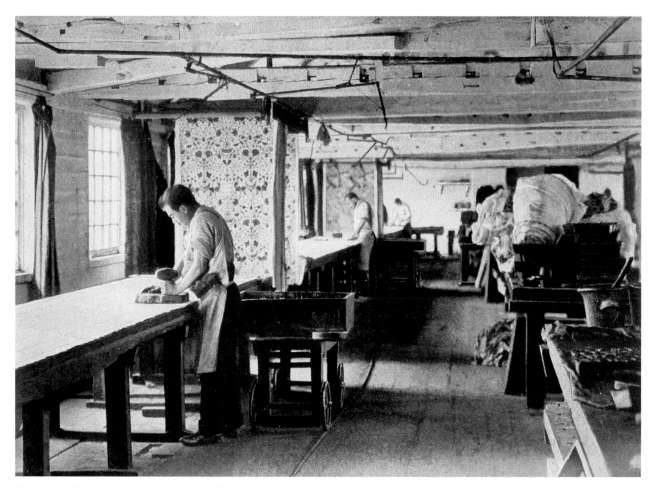

Plate 2.31 Chintz printing by hand at the William Morris works, Merton Abbey, London, photograph. Private collection. Photo: © The Stapleton Collection/The Bridgeman Art Library.

Morris sought to revive craft traditions, and his own experiments ranged from textile weaving to hand-block printing of wallpaper and wood-engraving of fine books. He taught many of these crafts and gave demonstrations. He also set up the Merton works and trained skilled workmen to produce items of artistic craftsmanship (see Plate 2.31), and he established the 'firm' to distribute and sell them. In each instance, he was thwarted by the cost of decorative work. Hand production simply couldn't compete against mass production, and the items he made proved too costly for all but the middle class. This paradox – what he called 'ministering to the swinish luxury of the rich' – only increased his social radicalism. As one wag put it, Morris 'would disturb the foundation of our Society in order that a higher artistic value may be given to our carpets'.[75] But this made sense to Morris because he perceived an intimate connection between these things: carpets that were worthy of living with could only be produced by a truly human society and, in turn, ugly carpets were a palpable sign for the absence of a habitable world.

The arts and crafts ethos that stemmed from Ruskin and Morris was to have a sustained impact on modes of living in Britain and beyond. In contrast to the 'shoddy' goods turned out by capitalist industry, the arts and crafts designers produced well-made furniture, favouring solid materials, simplicity and traditional forms of construction.[76] The aesthetic they elaborated was to dominate the decorative arts journals and the schools of art for twenty years and reached into the middle-class home (see Plate 2.32). Paradoxically, this medieval revival fed directly into modernist architecture and design, encouraging the rejection of Victorian eclecticism in favour of 'truth to materials' and 'honest construction'. This is a story that will be picked up by Tim Benton in chapter 4 of this book.

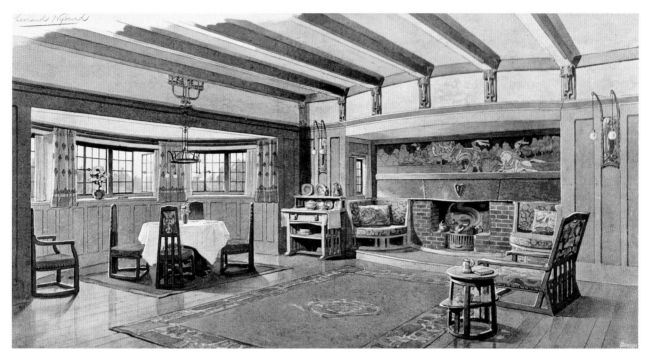

Plate 2.32 Leonard Wyburd, *Arts and Crafts Drawing Room*, *c.*1900, colour lithograph. Private collection. Photo: © The Stapleton Collection/The Bridgeman Art Library.

Conclusion

This chapter has looked at modernity and images from three perspectives. First, by contrasting Parisian modernism with English genre painting we have seen that depictions of modernity need to be carefully distinguished from modernist paintings. Second, we have considered the role of images in the development of modernity as a force for reshaping attention and restructuring perception in the sense observed by Simmel. Finally, we have examined an interpretation of the medieval revival as a displaced critique of the culture of nineteenth-century modernity. For Morris, this involved developing a series of formal equivalences for modern experience without having to illustrate contemporary life. The medieval revival was one strand that fed into modernism, but it should be clear that the mass-image culture is still weaving its spells as a part of our own modernity.

Notes

[1] Dart, 2008, p. 153; Altick, 1978, p. 414.

[2] Maas, 1975.

[3] Ivins, 1969, p. 69.

[4] Macleod, 1996; Gillett, 1990; Seed and Wolff, 1990.

[5] 'Bourgeois' was originally a French term for town dwellers, but it has increasingly come to refer to industrialists, merchants, financiers and their political and intellectual allies who replaced the aristocracy as the ruling class in capitalist society. As a class the bourgeoisie are defined by their ownership and control of the means of production. 'Bourgeois' is often used as a synonym for 'middle class'.

[6] Gillett, 1990, p. 4.

[7] Ibid.

[8] Bell, 1987 [1914], p. 17.

[9] Ibid., p. 18.

[10] Ibid.

[11] Ibid., pp. 19–20.

[12] Hanson, 1966, p. 185.

[13] Collins, 1996.

[14] Clark, 1985.

[15] Moretti, 2010. See also Moretti, 1998.

[16] Moretti, 2010, p. 119.

[17] Ibid., p. 124.

[18] Lefebvre, 1995.

[19] Simmel, 1997.

[20] For de Loutherbourg, see Baugh, 2007; Daniels, 1993, pp. 68–73; Klingender, 1945.

[21] W.H. Pyne, 1823, cited in Klingender, 1945, pp. 78–9.

[22] He had previously built a Demon Temple setting for the Gothic novelist William Beckford, who described de Loutherbourg's lighting as 'necromantic'. Baugh, 2007, p. 258.

[23] Brewer, 2007, p. 233.

[24] Comment, 1999; McCalman, 2005; Brewer, 2007.

[25] The architect was Decimus Burton, who designed several buildings in the area as well as Kew's Palm House.

[26] Altick, 1978, pp. 198–210.

[27] Ibid., p. 142.

[28] Ibid., p. 149.

[29] C.S. Stewart, *Sketches of Society in Great Britain and Ireland,* 1834, vol. 1, pp. 145–6, cited in Altick, 1978, p. 149.

[30] William Wells Brown, *Sketches of Places and People Abroad,* 1855, p. 131, cited in Altick, 1978, p. 157. Altick notes that the distance of 6 feet was probably an error.

[31] Daguerreotypes were a type of early photograph on glass developed in France.

[32] 'London in 1842', 1842.

[33] Anderson, 1983, p. 41.

[34] A Practical Chemist and Photographist [Jabez Hogg], [1845], p. ix.

[35] The carte was patented in Paris by André-Adolphe Disdéri in 1854. For Disdéri, see McCauley, 1995; Rouillé, 1987.

[36] Plunkett, 2003.

[37] One historian suggests that as many as one hundred and five million were sold in 1862 alone., but this is probably an exaggeration. See Darrah, 1981, p. 4.

[38] Benjamin, 1983, pp. 166–7. This account of the carte photograph draws on Edwards, 2006.

[39] Winter, 1862, p. 135; see also Winter, 1870.

[40] *Daily Telegraph*, cited in 'More indecent photographs', 1873, p. 655.

[41] Henry Cole, cited in Fox, 1988, p. 8.

[42] Wolff and Fox, 1973, note 1, p. 575.

[43] Fox, 1988, pp. 39, 51; Koss, 1981; Woolford, 1982, pp. 110–42.

[44] Charles Knight of the *Penny Magazine*, cited in Wolff and Fox, 1973, pp. 561–2.

[45] See Wolff and Fox, 1973; Fox, 1988.

[46] *Illustrated London News*, 14 May 1842, cited in Fox, 1988, p. 12.

[47] *Illustrated London News*, 9 July 1842, cited in Wolff and Fox, 1973, p. 566.

[48] *The Economist*, 'Speaking to the eye', 1851, cited in Wolff and Fox, 1973, p. 566.

[49] For the phenomenology of the print media, see Gretton, 2000, 2005.

[50] See Auerbach, 1999.

[51] Kreigel, 2008, pp. 115–16; see also Kreigel, 2001.

[52] Barringer, 2005.

[53] For an overview of Victorian medievalism, see Alexander, 2007.

[54] Williams, 1986, p. 78.

[55] Williams, 1958. Michael Löwy offers a succinct definition: 'The essential characteristic of Romantic anti-capitalism is *a thorough critique on modern industrial (bourgeois) civilization ... in the name of certain pre-capitalist social and cultural values*', Löwy, 1987, p. 904.

[56] Pugin, 1841a.

[57] See Ruskin, 1903–12, *Modern Painters*.

[58] Ruskin, 1903–12, 'The Nature of the Gothic'.

[59] John Ruskin, Inaugural Slade Lecture, 1870, cited in Hewison et al., 2000, p. 18.

[60] Ruskin, 1903–12, 'Traffic', p. 433.

[61] Ruskin, 1903–12, 'Of kings' treasuries', p. 82.

[62] Ruskin, 1903–12, *The Storm-Cloud of the Nineteenth Century*, p. 40.

[63] Ruskin, 1903–12, *Unto this Last*, p. 105.

[64] The PRB was always a relatively disparate group and became only more so with time. By the 1860s the key figures had gone their separate ways: Rossetti withdrew from exhibiting after critical reviews and focused on confections of female beauty in medieval settings; Hunt pursued an intensely religious vision, often employing authentic settings; and Millais turned out pictures of modern bourgeois life, eventually becoming President of the Royal Academy. For a modern overview of the PRB, see Barringer, 1998.

[65] Ruskin, 1851, p. 8.

[66] Charles Dickens, cited in Eisenman, 2007, p. 247.

[67] Morris, 1984 [1878], p. 32.

[68] Ibid., p. 39.

[69] Morris, 1984 [1885].

[70] Morris, 1968 [1891].

[71] Arscott, 2008, p. 168.

[72] Thompson, 1976.

[73] Arscott, 2008, p. 43.

[74] William Morris, 'Making the best of it', 1880, cited in Arscott, 2008, p. 50.

[75] *Echo*, 1 October 1884, cited in Thompson, 1976, p. 310.

[76] For the Arts and Crafts Movement, see Naylor, 1971; Carruthers and Greensted, 1994.

Bibliography

Alexander, M. (2007) *Medievalism: The Middle Ages in Modern Britain*, New Haven, CT and London, Yale University Press.

Altick, R.D. (1978) *The Shows of London*, Princeton, NJ, Princeton University Press.

Anderson, B. (1983) *Imagined Communities: Reflections on the Origins and Spread of Nationalism*, London, Verso.

Arscott, C. (2008) *William Morris and Edward Burne-Jones: Interlacings*, New Haven, CT and London, Yale University Press.

Auerbach, J. (1999) *The Great Exhibition of 1851: A Nation on Display*, New Haven, CT and London, Yale University Press.

Barringer, T. (1998) *Reading the Pre-Raphaelites*, New Haven, CT and London, Yale University Press.

Barringer, T. (2005) *Men at Work: Art in Victorian Britain*, New Haven, CT and London, Yale University Press.

Baugh, C. (2007) 'Philippe de Loutherbourg: technology-driven entertainment and spectacle in the late eighteenth century', *Huntington Library Quarterly*, vol. 70, no. 2, pp. 251–68.

Bell, C. (1987 [1914]) *Art*, Oxford, Oxford University Press.

Benjamin, W. (1983) 'Paris – capital of the nineteenth century' in *Charles Baudelaire: A Lyric Poet in the Era of High Capitalism*, London, Verso, pp. 166–7.

Brewer, J. (2007) 'Sensibility and the urban panorama', *Huntington Library Quarterly*, vol. 70, no. 2, pp. 229–49.

Carruthers, A. and Greensted, M. (1994) *Good Citizen's Furniture: The Arts and Crafts Collection at Cheltenham*, Cheltenham, Cheltenham Art Gallery and Museum (exhibition catalogue).

Clark, T.J. (1985) *The Painting of Modern Life: Paris in the Art of Manet and his Followers*, London, Thames & Hudson.

Collins, B.R. (ed.) (1996) *12 Views of Manet's Bar*, Princeton, NJ, Princeton University Press.

Comment, B. (1999) *The Panorama*, London, Reaktion.

Cook, E.T. and Wedderburn, A. (eds) (1903–12) *Works of John Ruskin*, 39 vols, London, George Allen.

Daniels, S. (1993) *Fields of Vision: Landscape Imagery and National Identity*, Oxford, Polity Press.

Darrah, W.C. (1981) *Cartes de Visite in Nineteenth Century Photography*, W.C. Darrah.

Dart, G. (2008) 'On great and little things: Cockney art in the 1820s', *Romanticism*, vol. 14, no. 2, pp. 149–67.

Dickinson's Comprehensive Pictures of the Great Exhibition of 1851 (1854), London, Dickinson Brothers.

Edwards, S. (2006) *The Making of English Photography: Allegories*, University Park, PA, Pennsylvania State University Press.

Eisenman, S.F. (2007) 'The rhetoric of realism: Courbet and the origins of the avant-garde', *Nineteenth-Century Art: A Critical History*, 3rd edn, London, Thames & Hudson, pp. 242–63.

Fox, C. (1988) *Graphic Journalism in England During the 1830s and 1840s*, New York and London, Garland.

Gillett, P. (1990) *The Victorian Painter's World*, Gloucester, Alan Sutton.

Gretton, T. (2000) 'Difference and competition: the imitation and reproduction of fine art in a nineteenth-century illustrated weekly news magazine', *Oxford Art Journal*, vol. 23, no. 2, pp. 143–62.

Gretton, T. (2005) 'Signs for labour-value in printed picture after the photomechanical revolution: mainstream changes and extreme cases around 1900', *Oxford Art Journal*, vol. 28, no. 3, pp. 371–90.

Hanson, A.C. (1966) *Edouard Manet, 1832–1883*, Philadelphia, PA, Philadelphia Museum of Art (exhibition catalogue).

Hewison, R., Warrell, I. and Wildman, S. (2000) *Ruskin, Turner and the Pre-Raphaelites*, London, Tate Publishing (exhibition catalogue).

Ivins, W.M. (1969) *Prints and Visual Communication*, Cambridge, MA, MIT Press.

Klingender, F.D. (1945) *Art and the Industrial Revolution*, London, Noel Carrington.

Koss, S. (1981) *The Rise and Fall of the Political Press in Britain: The Nineteenth Century*, Chapel Hill, NC, University of North Carolina Press.

Kriegel, L. (2001) 'Narrating the subcontinent in 1851: India at the Crystal Palace' in Purbrick, L. (ed.) *The Great Exhibition of 1851: New Interdisciplinary Essays*, Manchester, Manchester University Press, pp. 144–78.

Kriegel, L. (2008) *Grand Designs: Labor, Empire, and the Museum in Victorian Culture*, Durham, NC, Duke University Press.

Lefebvre, H. (1995) *Introduction to Modernity*, London, Verso.

'London in 1842' (1842) *Illustrated London News*, 16 May.

Löwy, M. (1987) 'The Romantic and the Marxist critique of civilization', *Theory and Society*, vol. 16, no. 6, pp. 891–904.

Maas, J. (1975) *Gambart, Prince of the Victorian Art World*, London, Barrie and Jenkins.

Macleod, D.S. (1996) *Art and the Victorian Middle Class: Money and the Making of Cultural Identity*, Cambridge, Cambridge University Press.

McCalman, I. (2005) 'Magic, spectacle and the art of de Loutherbourg's Eidophusikon' in Bermingham, A. (ed.) *Sensation and Sensibility: Viewing Gainsborough's Cottage Door*, New Haven, CT and London, Yale University Press, 181–97.

McCauley, E.A. (1995) *A.A.E. Disdèri and the Carte de Visite Portrait Photograph*, New Haven, CT and London, Yale University Press.

'More indecent photographs' (1873) *Photographic News*, 21 November, p. 655.

Moretti, F. (1998) *Atlas of the European Novel 1800 to 1900*, London, Verso.

Moretti, F. (2010) 'The grey area: Ibsen and the spirit of capitalism', *New Left Review*, Series 2, no. 61, Jan/Feb, pp. 116–31.

Morris, W. (1968 [1891]) *News from Nowhere* in Morton, A.L. (ed.) *Three Works by William Morris*, London, Lawrence & Wishart, pp. 181–401.

Morris, W. (1984 [1878]) 'The lesser arts' in Morton (1984), pp. 31–54.

Morris, W. (1984 [1885]) 'Useful work versus useless toil' in Morton (1984), pp. 86–108.

Morton, A.L. (ed.) (1984) *The Political Writings of William Morris*, London, Lawrence & Wishart.

Naylor, G. (1971) *The Arts & Crafts Movement*, London, Studio Vista.

Plunkett, J. (2003) 'Celebrity and community: the uncanny poetics of the *carte-de-visite*', *Journal of Victorian Culture*, vol. 8, no. 1, pp. 55–79.

A Practical Chemist and Photographist [Jabez Hogg], [1845] *Photography Made Easy. A Practical Manual of Photography, Containing Full and Plain Directions for the Economical Product of a Really Good Daguerreotype Portrait & Every Other Variety of Pictures According to the Latest Improvements. Also on the Injustice and Validity of the Patent Considered with Suggestions for Rendering it a Dead Letter*, London, E. Mackenzie.

Pugin, A.W.N (1841) *Contrasts: or a Parallel between the Noble Edifices of the Middle Ages, and Corresponding Buildings of the present day; shewing the present Decay of Taste*, 2nd edn, London, Charles Dolman.

Pugin, A.W. (1841a) *The True Principles of Pointed or Christian Architecture*, London, John Weale.

Rouillé, A. (1987) 'The rise of photography (1851–70)' in Lemagny, J.-C. and Rouillé, A. (eds) *A History of Photography: Social and Cultural Perspectives*, Cambridge, Cambridge University Press, pp. 29–51.

Ruskin, J. (1851) 'The Pre-Raphaelite painters: to the editor of *The Times*', *The Times*, 30 May, p. 8.

Ruskin, J. (1903–12) *Modern Painters* in Cook and Wedderburn (1903–12), vols 3–7.

Ruskin, J. (1903–12) 'Of kings' treasuries', *Sesame and Lilies* in Cook and Wedderburn (1903–12), vol. 18.

Ruskin, J. (1903–12) 'The nature of the Gothic', *Stones of Venice* in Cook and Wedderburn (1903–12), vol. 10.

Ruskin, J. (1903–12) *The Storm-Cloud of the Nineteenth Century* in Cook and Wedderburn (1903–12), vol. 34.

Ruskin, J. (1903–12) 'Traffic', *The Crown of Wild Olive* in Cook and Wedderburn (1903–12), vol. 18.

Ruskin, J. (1903–12) *Unto this Last* in Cook and Wedderburn (1903–12), vol. 17.

Seed, J. and Wolff, J. (eds) (1990) *The Culture of Capital: Art, Power and the Nineteenth Century Middle Class*, Manchester, Manchester University Press.

Simmel, G. (1997) 'Metropolis and mental life' in Frisby, D. and Featherstone, M. (eds) *Simmel on Culture*, London, Sage, pp. 174–85. Extract reprinted in Lymberopoulou, A., Bracewell-Homer, P. and Robinson, J. (eds) *Art and Visual Culture: A Reader*, London, Tate Publishing in association with The Open University, pp. 267–9 (Reader Text 5.18.3).

Thompson, E.P. (1976) *William Morris: Romantic to Revolutionary*, New York, Pantheon.

Vallance, A. (1897) *The Art of William Morris*, London, Calmann & King.

Williams, R. (1958) *Culture and Society 1780–1950*, Harmondsworth, Penguin.

Williams, R. (1986) *Culture*, London, Fontana.

Winter, A. (1862) 'Cartes de visite', *Once a Week*, 25 January.

Winter, A. (1870) *Curiosities of Toil* (reproduced as 'Portraiture as commerce'), *Photographic News*, 12 August, pp. 382–3.

Wolff, M. and Fox, C. (1973) 'Pictures from the magazines' in Dyos, H.J. and Wolff, M. (eds) *The Victorian City: Images and Reality*, vol. 2, London and Boston, Routledge & Kegan Paul, pp. 559–82.

Woolford, J. (1982) 'Periodicals and the practice of literary criticism' in Shattock, J. and Wolff, M. (eds) *The Victorian Periodical Press: Samplings and Soundings*, Leicester, Leicester University Press, pp. 110–42.

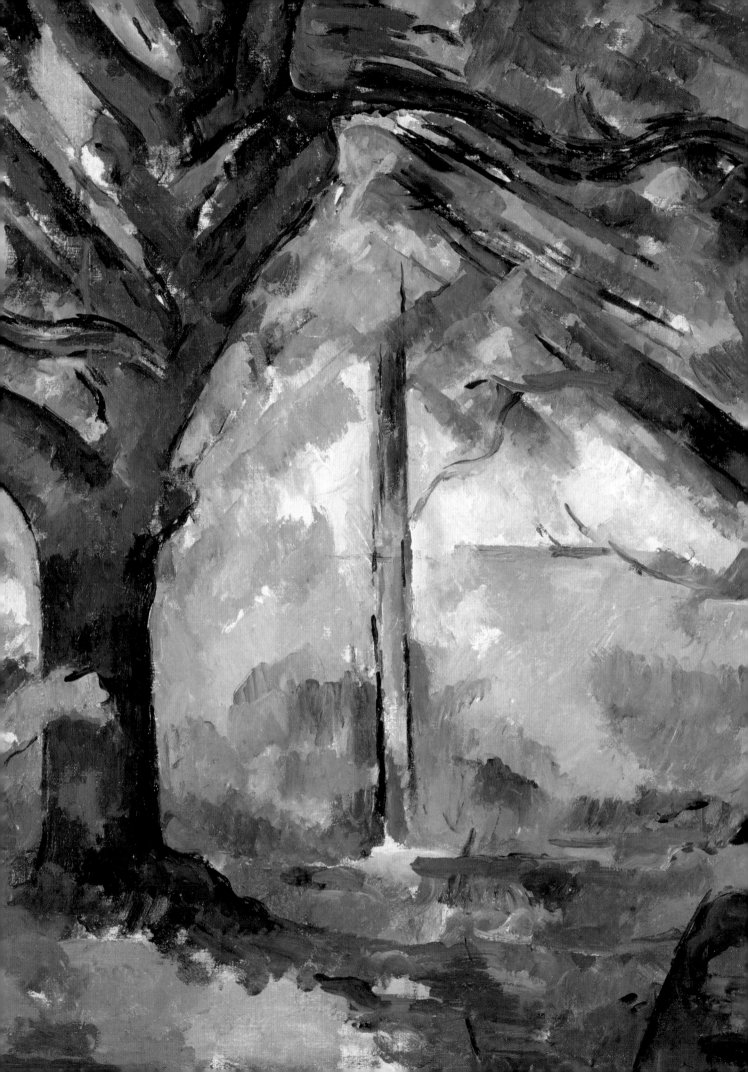

Chapter 3

Cubism and Abstract Art revisited

Paul Wood

Introduction

Cubism, which emerged just over a hundred years ago around 1910, was not the first of the succession of 'movements' that characterised the European avant-garde in the early twentieth century. It does, however, have some claim to be the most important, at least until the advent of Surrealism about fifteen years later, in greatly changed circumstances after the watershed of the First World War. Unlike Surrealism, Cubism was never popular. To a lay audience it was difficult, if not impossible, to understand (see, for example, Georges Braque's *Clarinet and Bottle of Rum on a Mantelpiece* – Plate 3.2). Yet Cubism had an impact that would be hard to overestimate. It transformed the practice of art, seeming finally to enable a generative and diverse abstract art in both two and three dimensions, which had been an aspiration of the avant-garde since the late nineteenth century (see, for example, Plate 3.3 – *Spatial Composition #4*, by Katarzyna Kobro, 1898–1951). Thus, from the acorn of Cubism grew the many-branched tree of modernist art. From Pablo Picasso's technical breakthrough to an autonomous art based on tireless formal innovation, there descended the school of modernist abstraction that by the late 1950s not only dominated the whole international field of art but had come to symbolise the freedom of the western world.

Or at least that is one version of the story. We may as well call it the 'modernist' version. It emerged in the mid-1930s at a point when large parts of Europe were already under the sway of dictatorial regimes that proscribed avant-garde art. The Second World War that was shortly to follow would have as one of its effects the transplantation of the centre of modern art from Europe to the USA, and it was in America in the 1930s that a particular account of the modern movement was already being institutionalised. The Museum of Modern Art had been founded in New York as early as 1929 on the basis of money provided by a raft of wealthy patrons. The exhibitions of its first director, Alfred H. Barr, along with their accompanying catalogues, began to map the European 'modern movement' of the early part of the century. In *Cubism and Abstract Art*, the catalogue for his 1936 exhibition of the same name, Barr's central claim was that, by 'a common and

Plate 3.1 (Facing page) Paul Cézanne, *Big Trees* (detail from Plate 3.4).

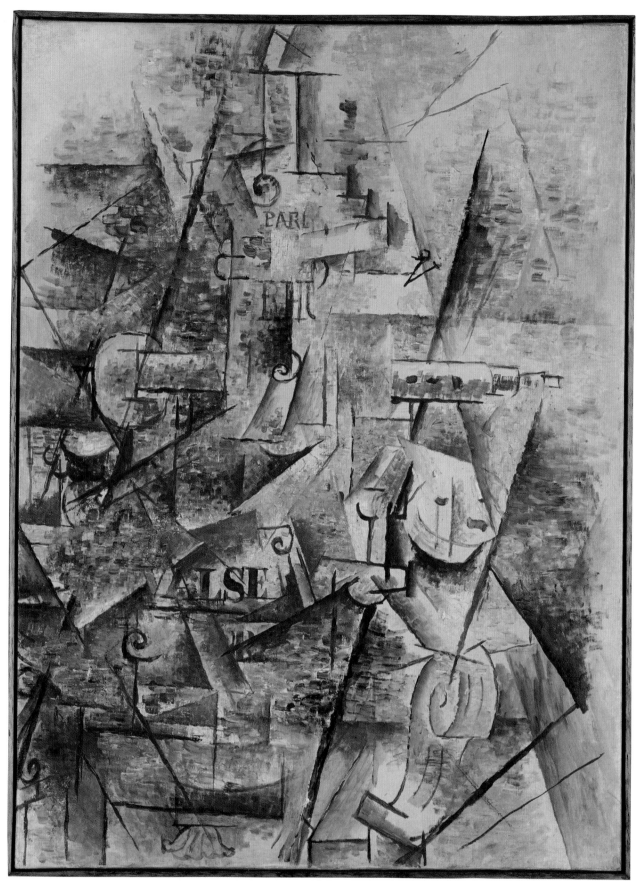

Plate 3.2 Georges Braque, *Clarinet and Bottle of Rum on a Mantelpiece*, 1911, oil on canvas, 81 × 60 cm. Tate, London, T02318.
Photo: © Tate, London, 2012. © ADAGP, Paris and DACS, London 2012.

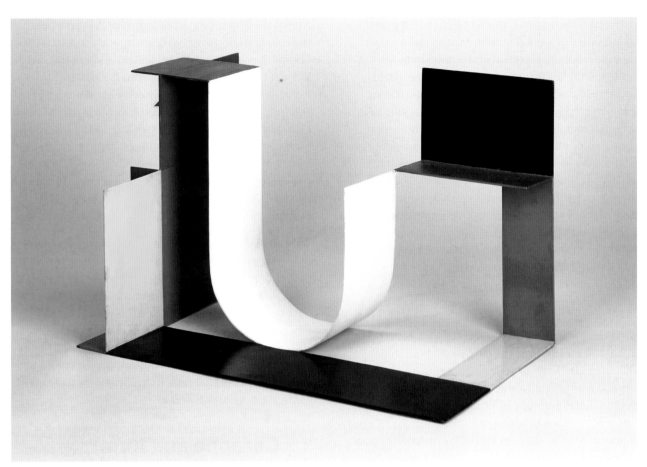

Plate 3.3 Katarzyna Kobro, *Spatial Composition #4*, 1929, painted steel 40 × 64 × 40 cm. Muzeum Sztuki, Łódź. Photo: Muzeum Sztuki/ Piotr Tomczyk.

powerful impulse', the most adventurous artists had abandoned depiction of the physical world and also the traditional 'connotations' of such subject matter as reflected in a range of 'documentary, political, sexual, religious' themes.[1] These various themes were now seen as 'adulterating' a formally grounded aesthetic core of art, and the driver of the modern movement was defined as a logic of 'purification', an ever-tightening focus on that core to the exclusion of all else. But Barr was far from oblivious to politics, having travelled through both the Soviet Union and Nazi Germany, and he went so far as to dedicate his exhibition to 'those painters of squares and circles (and the architects influenced by them) who have suffered at the hands of philistines with political power'.[2] The section of his catalogue essay which concluded with that statement included a brief survey of the modern movement's entanglements with Italian Fascism, Soviet Communism and German Nazism.

It is important to understand that Barr's position here is itself a political one: a type of liberalism. And later on, during the Cold War, modernist abstract art was very much allied with liberal politics. But the explicit force of Barr's argument in the context of the 1930s was always to separate modern art from politics, especially to lose its troubling revolutionary or anarchist image, to treat the avant-garde as a province of innocent experimentation, more a victim of politics than a political creature itself. There is, of course, much to support this view. In the 1930s, politics was turning into a murderous trap, and, despite decades of revisionist art history since then, an art history which has re-politicised the avant-garde, two things remain true. The first is that, in the 1930s, abstract art did only survive and prosper in capitalist democracies that more or less left art alone; and the second is that in the peace that followed the Second World War, many modernist painters and critics did repeatedly assert the independence of art from politics. It was not until the 1960s that a new wave of avant-garde artists and intellectuals began to recover the political dimension of the early twentieth-century modern movement that had by then been lost under decades of totalitarianism, war and Cold War.

In the later twentieth century (often referred to as a 'postmodernist' period in the arts), the claim arose that the modernist account of the development of twentieth-century art had been 'cubocentric'. It was argued that other forms of early avant-gardism involving all kinds of mixed media installations and activities, ranging from utopian quasi-architectural constructions to performances involving music and poetry as well as visual art, had all been as generative as Cubism, if not more so.[3] Yet Cubism itself had also involved more than painting. Figures as central to the development of Cubist painting as Picasso and Braque had early on developed *papier-collé*, in which papers, including newspapers, were attached to drawings. This quickly led to cardboard reliefs which left the two-dimensional plane of painting, and, in Picasso's case, to fully three-dimensional 'constructions': an entirely new genre in the history of art which arguably opened up the space for all subsequent mixed-media work. Neither did it stop there. Before the First World War, Sonia Delaunay (1885–1979) designed clothing inspired by her and her husband Robert's version of Cubism, and, at the Salon d'Automne of 1912, a group of artists were involved in a project to design the interiors for a Cubist house. In a sense, the response to the question of how influential Cubism was became 'Which Cubism?'

To give an adequate answer to that question, care is required. It is important to resist a stereotyping of alternatives. It is not a simple choice between the Cubism that led to a 'purified' practice of 'autonomous' abstract painting on the one hand, and the Cubism that reached beyond all that to an altogether more open-ended and heterogeneous engagement with modernity on the other. The key to the issue lies in the concept of 'autonomy' itself. Time and again, early twentieth-century artists assert the independence of their practice. The point is that, for many of them, especially in the period between the end of the First World War and the onset of renewed political crisis in the early 1930s after the Crash of 1929, their hard-won independent art represented not so much a retreat from the world as a lever for changing it. This is the key area of debate about Cubism's significance, and also about the significance of the practices of abstraction which it enabled. Through that abstract art, Cubism affected design and architecture, and thus, paradoxically for such a difficult and apparently rarefied art form, it had repercussions for the very appearance of the world. In the hands of artists more radical even than its inventors, for a brief period in the early Soviet Union of the 1920s, under the name Constructivism, a Cubist-derived abstraction seemed to speak the language of revolution itself and

to bear the hope of a world transformed. Even where those dreams of change were less apocalyptic, in western Europe, it was difficult to be modern and not to have assimilated Cubism. The programme of designing a new world, embodied in the Bauhaus in Germany and the De Stijl movement in Holland, in the architecture of L'Esprit Nouveau in France associated with Le Corbusier,[4] as well as the more obviously 'autonomous' painting of figures such as Piet Mondrian, Ben Nicholson (1894–1982) in England, and the Abstraction-Création group in Paris, would all have been unthinkable without the prior example of Cubism.

To get a sense of both Cubism and the abstract art to which it gave rise, we need to take a step back. We need to look at the historical context of its emergence and subsequent development. Recent social historians of art have complicated and deepened this picture far beyond that provided by modernism. This chapter will draw on their histories to provide an introduction to Cubism in Paris before the First World War, and then move on to explore further developments in the European avant-garde in the inter-war period.

1 Cézanne and form

In the beginning, there was Cézanne. That is the classic modernist starting point. The English critic Clive Bell dubbed him 'the Christopher Columbus of a new continent of form'.[5] 'Form' is the key word here. For, cornerstone of modern art that it was, the Cubism of Picasso and Braque did not picture modernity. Neither, of course, had Cézanne.

Exercise

Look at the painting *Big Trees* by Cézanne (Plate 3.4). Say what you think are its most characteristic features as well as what distinguishes it from previous landscape paintings.

Discussion

Most people will think of the subject first. Here the principal subject appears to be two large trees, with the trunk of a third further away in the distance. There may be a sketchily delineated path leading from the foreground, between the two big trees towards the one further away. That is sufficient to establish that the painting is in the traditional genre of the 'landscape'. Yet one can quickly see that Cézanne's painting departs significantly from many of the features associated with that genre. It is not an

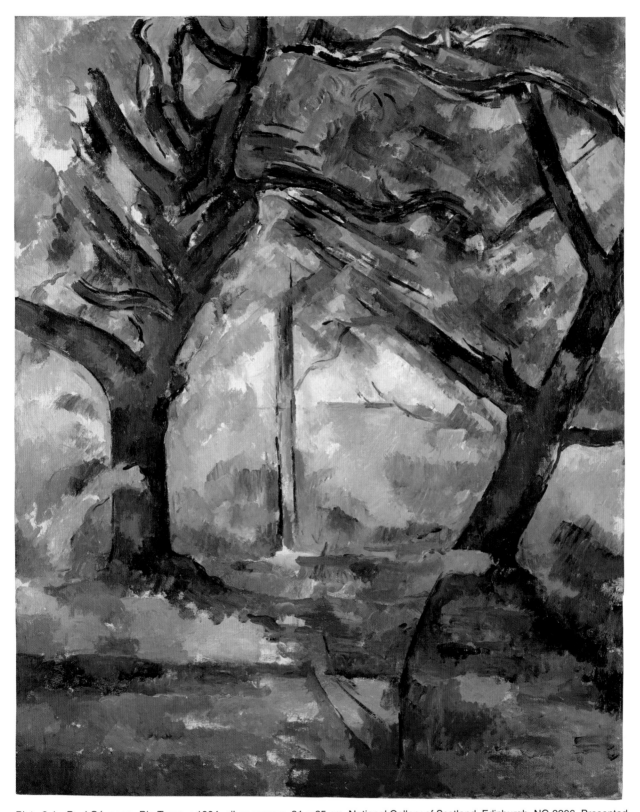

Plate 3.4 Paul Cézanne, *Big Trees*, *c*.1904, oil on canvas, 81 × 65 cm. National Gallery of Scotland, Edinburgh, NG 2206. Presented by Mrs Anne F. Kessler 1958; received after her death 1983. Photo: National Gallery of Scotland.

overtly classicised or idyllic landscape in the way of earlier painters such as Nicolas Poussin (1594–1665) or Claude Lorrain (*c*.1604/05–82). It is not a scene of cultivation and the fruits of labour as one might find in a Dutch landscape. Neither is it a study of atmospheric effects such as are also often found

in Dutch pictures, or in the work of John Constable (1776–1837), or in later Impressionist art. In fact, it appears to be neither idealised nor naturalistic in any conventional sense.

So is the painting's distinctiveness something to do with the way the landscape subject is treated? The answer is surely 'Yes'. The trunks and branches of the two foregrounded trees have an effect almost like scaffolding. The distant tree is not described at all, it functions solely as a vertical form that closes off the spatial recession. As well as the verticals and diagonals of the trees, there are also several horizontals. These, coupled with that strong central vertical, make the picture space very 'front-on'; in technical terms, the scene is parallel to the picture plane. Even the diagonals of the branches do not serve to indicate spatial recession, as diagonals often do in a painting. Rather, they almost seem to sit on the surface. In fact, judging by where the bases of their trunks are situated, it looks at first as though the tree to the right is further forward than the one to the left. But when you look just at the top half of the picture, at the branches, it is as though they intersect. Cézanne seems to have collapsed the space. As for the colour, this appears to have been laid on very regularly, especially in the bottom half of the picture. If you look carefully, you may be able to tell that the brushstrokes are all of much the same size. They are far more visible than traditional academic 'finish' would have required, but they are also more deliberate, more regular, than 'spontaneous' Impressionist dabs and touches. The overall effect is to enhance a sense of regularity and structure.

So the painting is in a conventional genre, but its treatment is far from conventional. So much so that it is scarcely a 'picture' of the 'Big Trees' at all. Its effect has something to do with the cathedral-like emotional experience of being in nature, dwarfed by giant trees, with light slanting down through the branches, but it is also very much a pictorial construction in its own right, much more independent of the depicted subject than would normally be the case. Cézanne has clearly sought to bring a structure and a harmony to the whole composition, even to the point of sacrificing verisimilitude to the demands of the formal framework that locks the whole thing together.

This is an example of what Cézanne called a 'harmony parallel to nature'.[6] He was not striving to offer a

'reflection' or an 'imitation' of nature, but what he regarded as an 'equivalent' to it. That is to say, he aimed to produce a pictorial configuration that could, in its own right, have an effect on the spectator paralleling the effect that he – Cézanne – had experienced in nature itself, not a pallid second-hand approximation to it. In Cézanne's art, the work is not entirely separable from its subject in nature, but it is also relatively independent of it, a visual (and hence also an emotional) configuration in its own right. This independence had much to do with its originality, much to do with what made it 'modern', rather than a clichéd repetition of representational convention.[7]

The railway stations and cafes of Paris did not provide the subject matter for Cézanne's avowedly modern art, as they had for the previous generation of Impressionists. As discussed in chapter 1, the generation that modernist historians called the 'Post-Impressionists', which included van Gogh and Gauguin as well as Cézanne, had largely ceased to focus on the visible phenomena of the modern city and had been variously influenced by Symbolist ideas. Leaving aside the mysticism and religiosity, and also the *literariness* that marked much Symbolist art, the kernel of its significance for the turn-of-the-century avant-garde lay in the conviction that it was no longer the business of art to provide information about the world. Painting should offer a challenging, indeed liberating, emotional experience prompted not by second-hand data about appearances but by the way it marshalled its own unique elements: colours, shapes, lines combining to produce forms in the illusionistic space beyond the picture plane. For this, the important model was music. Music was already an 'abstract' art form, working not through narrative description or depiction, but through what appeared to be the directly expressive effects of certain sounds in combination with each other. Although at that point no artist had produced what a twentieth-century viewer would describe as a fully 'abstract' work, nonetheless the meaning of a work of art had been significantly separated from resemblance to things, and correspondingly greater emphasis had come to be put on the effects of pictorial elements themselves.

This insight is encapsulated in the slogan-like assertion by Maurice Denis (1870–1943), one of Cézanne's most ardent young supporters in the Symbolist milieu of the 1890s, that 'a picture – before being a war-horse, a nude woman, or telling some other story – is essentially a flat surface covered with colours arranged in a particular pattern'.[8]

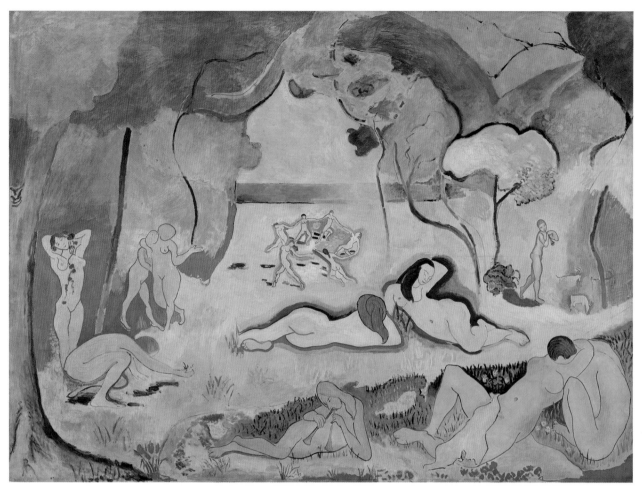

Plate 3.5 Henri Matisse, *Le Bonheur de vivre*, 1905–06, oil on canvas, 177 × 241 cm. The Barnes Foundation, Merion, BF719. Photo: © 2011 The Barnes Foundation. © Succession H. Matisse/DACS, London 2012.

2 Decoration, expression and primitivism

Obviously, the work of Cézanne was not the only thing going on in the French avant-garde. Nor did the avant-garde itself exist in isolation from the wider forces at work on French culture in what subsequently came to be known as the *avant-guerre*, the period before the First World War. Within the avant-garde itself, the dominating influence in the early years of the twentieth century was still the twin legacy of Impressionism and Symbolism. The key figure was Henri Matisse. In works such as *Le Bonheur de vivre*, Matisse elaborated a decorative art of vividly heightened colour (Plate 3.5). 'Decoration' was an ambiguous quality in art. Considered as 'mere' decoration, it functioned as fine art's mundane, commodified counterpoint, the sphere of fashion and interior decor, curtains, wallpaper and the like. However, once verisimilitude had been abandoned, decoration's conceptual role now shifted to a place within the

new idea of art. It became the quality that replaced illusionistic fidelity as the key to the painting. The goal of the modern artist became less the achievement of a correspondence between the shapes in the painting and some object exterior to the painting, than the coherence – the 'decorative' coherence, the 'harmony' – of the colours and forms within the picture.

What rescued such 'decoration' from triviality was the idea of 'expression'. In 1908, Matisse wrote that 'What I am after, above all, is expression.'[9] But he immediately made it clear that, by this, he did not mean the accurate depiction of a human facial expression from which emotions could be read off by the spectator. Rather, as he put it, 'the entire arrangement of my picture is expressive'. That is to say, the intensified colours, the non-naturalistic forms themselves, now carried the

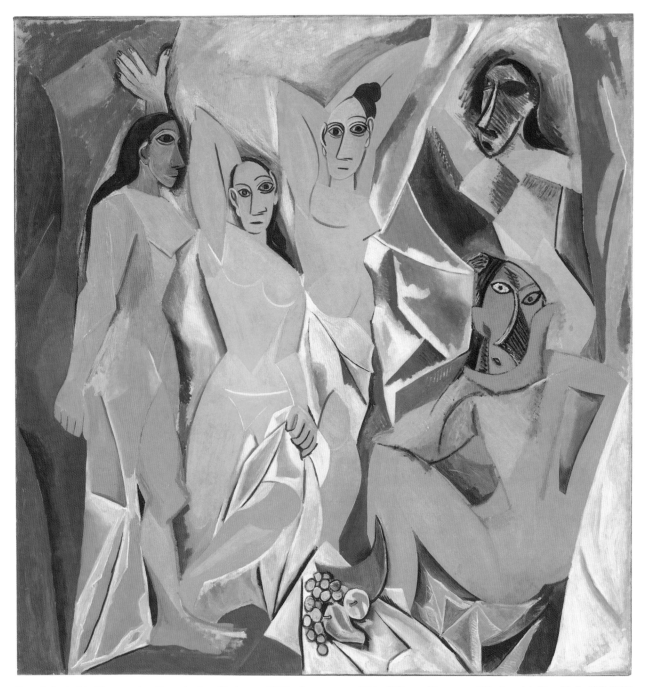

Plate 3.6 Pablo Picasso, *Les Demoiselles d'Avignon*, 1907, oil on canvas, 244 × 238 cm. Museum of Modern Art, New York, 333.1939. Acquired through the Lillie P. Bliss Bequest. Photo: © 2011 The Museum of Modern Art/Scala, Florence. © Succession Picasso/DACS, London 2012.

burden of the picture's expressive meaning. This is one of the main reasons behind the paradoxical importance of 'primitivism' for the avant-garde of this period. Just when avant-garde artists were beginning to perceive the European, capitalist modernity around them as intolerably oppressive and inauthentic, the appearance of artefacts from the Pacific and from Africa suddenly seemed to offer a reservoir of 'expressive' forms that

artists could translate into their work and be assured of emotional impact.

In the late twentieth century, post-colonialist and postmodernist critics demolished both primitivism and expression-theory; indeed, even by the end of the First World War, the implicit subjectivism of Expressionism had caused it to be widely rejected. But in the pre-war period, 'primitive' carvings seemed, precisely through

Plate 3.7 Georges Braque, *Houses at L'Estaque*, 1908, oil on canvas, 73 × 60 cm. Hermann and Margrit Rupf Foundation, Kunstmuseum Bern, Inv. Nr. Ge 006. Photo: Kunstmuseum Bern. © ADAGP, Paris and DACS, London.

their lack of verisimilitude, to hold out to artists committed to the idea of expressive form a wellspring of profound feeling. By aspiring to plumb depths of feeling that lay beneath the shared visible world of things and of people going about their day-to-day business, artists were trying to reconnect with something that those preoccupied with modernity seemed to have lost. The most extreme point of this expressive primitivism was reached in Picasso's *Les Demoiselles d'Avignon* of 1907 (Plate 3.6).

Largely because of the power of American modernist art history and museum practice in the mid twentieth century, *Les Demoiselles d'Avignon* is often elected as 'the first Cubist painting'. This is due in approximately

equal measure to its manifest technical radicalism, the way the figures are distorted and the illusionistic space disrupted, and to the fact that it was acquired by the Museum of Modern Art in 1939, whereupon it became the lynchpin of their modern collection. It is, however, now more usually regarded as preceding Cubism proper, being a product of Picasso's own iconoclastic authorial personality, the pervasive notion of 'expression', and the ideology of primitivism. Closer in character to what did indeed become 'Cubism' were a series of landscapes painted by Braque in late 1908 and exhibited at Kahnweiler's gallery in Paris in November of that year (see, for example, Plate 3.7).

3 Tradition, modernity and the two Cubisms

Cézanne's death in October 1906 had been followed by a memorial exhibition at the Salon d'Automne in 1907. This had a considerable impact on younger artists who were trying to go beyond the mixture of Impressionist 'touch' and Expressionist primitivism that were the *lingua franca* of early twentieth-century radical art. Two ostensibly opposed forces continued to bear down on the avant-garde. On the one hand, there was modernity itself. An emerging consumer society, saturated by mass media and advertising, as well as the typical political conflicts of such a world, could not be denied. Yet, on the other hand, casting its own long shadow, was the pervasive classicism of French culture. Discourses of nationalism and tradition, of what was and was not truly French, swirled through avant-garde debate every bit as forcefully as commodification and fashion.[10]

Cézanne himself had spoken of a wish to re-do Impressionism in the manner of the paintings in museums, a tacit statement of a quest for something more substantial. There is a strong sense that post-Symbolist ideas about art advancing towards greater independence or autonomy also arc back to tradition. The very dependence of Impressionism on nature, or rather on the 'sensation' of it, pulled against autonomy. Cézanne, who had done more than anyone to elaborate the possibility of a work of art as an equivalent reality of its own alongside nature, nonetheless almost always painted from nature. Cézanne himself maintained a highly charged balance between accurate perception and harmonious conception. But to the generation coming after, the balance seems to have tipped towards the latter. Before Impressionism, almost all art had been made in the studio. Now the demand to be modern found itself in a renewed alliance with certain aspects of tradition, with classically derived notions of order and structure, as the Impressionist tendency to amorphousness came to seem compromised. While some avant-garde artists kept up the pressure to address modern subjects, others suspended engagement with modern subject matter and instead focused the originality of their art on the technical means of representation, on the 'how' rather than the 'what'.

In retrospect, the work of Picasso and Braque dominates our sense of Cubism. However, social historians of art have recently uncovered the extent to which there were two 'Cubisms' operative in the years before the First World War. Picasso and Braque formed the nucleus of one milieu working in the north of Paris, in Montmartre, involving the poets Guillaume Apollinaire (1880–1918) and Max Jacob (1876–1944) and others, and crucially linked to the private gallery of the dealer Daniel-Henry Kahnweiler (1884–1979). But another, larger group, active in Montparnasse in the south of the city, represented the public face of Cubism. This was because, unlike Picasso and Braque, who had exclusive contracts with Kahnweiler, the artists of this second group exhibited in the two 'salons' which functioned as the principal public forums for contemporary art: the Salon des Indépendants held every year in the spring, and, at the opposite end of the season, the Salon d'Automne. It was among artists in this group that the competing claims of classicism and modernity were most evident.

The public debut of what has become known as 'salon' Cubism came at the Indépendants of 1911. The work which received most attention was a large picture, almost two metres high, by Henri Le Fauconnier (1881–1946) titled *Abundance* and representing an allegorical nude figure in a landscape in a loosely Cézannist style (Plate 3.8). To us now, this looks like a relatively conventional, even a somewhat clumsy effort, with its ostensibly modern technique grafted onto a traditional subject. Yet at the time it was received as evidence of a challenging new direction. The monumental nude mother with her child strides through a French landscape of agricultural fecundity, anchored by a chateau in the distance. Yet at the other end of the spectrum, Robert Delaunay (1885–1941), arguably with greater success, also used faceted planes to suggest the dynamism of urban modernity in works such as *Eiffel Tower* of 1911 (Plate 3.9).

Nonetheless, the real technical innovations on which this public debut of Cubism rested had been made earlier in Braque's response to the Cézanne memorial exhibition. Because of its subsequent impact on modernism, it is to so-called 'gallery' Cubism that we will now turn. The work of Braque and Picasso continued obliquely to address questions of classicism and modernity; indeed, in Picasso's case, contemporaneity loomed especially large in his collages of 1911–12, discussed below. But in the work of both these artists it was their revolutionising of the technical means of their art that mattered most. In his Cézanne-derived landscapes of late 1908, Braque took this

Plate 3.8 Henri Le Fauconnier, *Abundance*, 1910–11, oil on canvas, 191 × 123 cm. Collection of the Gemeentemuseum Den Haag.

technical radicalism further than anyone else yet had (see Plate 3.7). Historians have now charted a sequence of moves in which Picasso and Braque continually responded to each other's technical innovations over the next three years. Initially, Picasso's proto-Cubism, like Braque's following on from the example of late Cézanne, was based in landscape (see Plate 3.10). But, by 1910, Cubism in their hands was becoming an indoor art as subjects became more and more 'neutralised' – vehicles for formal experimentation, restricted to still life or at most to the single human figure. Although, having said that, it is immediately

Plate 3.9 Robert Delaunay, *Eiffel Tower*, 1911, oil on canvas, 195 × 129 cm. Oeffentliche Kunstsammlung Basel, Kunstmuseum. Photo: © 2011 White Images/Scala, Florence. © L & M Services B.V. The Hague 20110601.

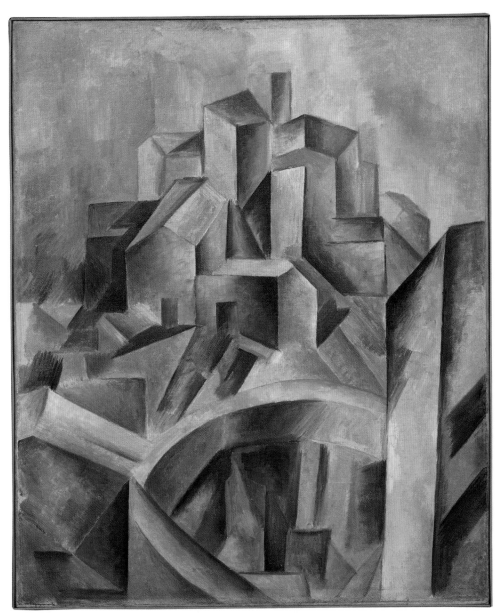

Plate 3.10 Pablo Picasso, *Reservoir at Horta de Ebro*, 1909, oil on canvas, 60 × 50 cm. Museum of Modern Art, New York. Fractional gift to the museum from a private collector, Acc. N.: 81.1991. Photo: © 2011 The Museum of Modern Art/Scala, Florence. © Succession Picasso/ DACS, London 2012.

necessary to reaffirm that the subject never disappears and that those kinds of subject that do continue to be represented are characteristic of the type of life the artists were then living. The restriction to the studio, the cafe and such places for the sources of their still life and portrait subjects bespeaks a deliberate plainness, the affirmation of a subcultural attitude that sought to play by its own rules and manifestly not to ingratiate itself with the echelons of 'high culture'.

4 Analytical Cubism

The work of Braque and Picasso through 1909 and 1910 seems to involve a process of analysing their various figures – still-life elements such as bottles and musical instruments or actual human figures – into increasingly geometrical facets, hence the term which is often used to describe this phase is 'analytical Cubism' (see Plate 3.11). This faceting into angled planes is carried over from the figures to their (back)grounds so that the difference between them is less pronounced than it would be in a conventional picture, but still allows them, on the whole, to be distinguished – just. The overall effect is one of a greater unity. But as 1910 went on into 1911, it is as if the facet planes took on a life of their own and the effect was to completely break asunder the still relatively integral bodies, to open them up and spread them across the entire picture surface. This scrambled the conventional distinction of figure and ground, thereby making the whole painting flatter and still more unified.

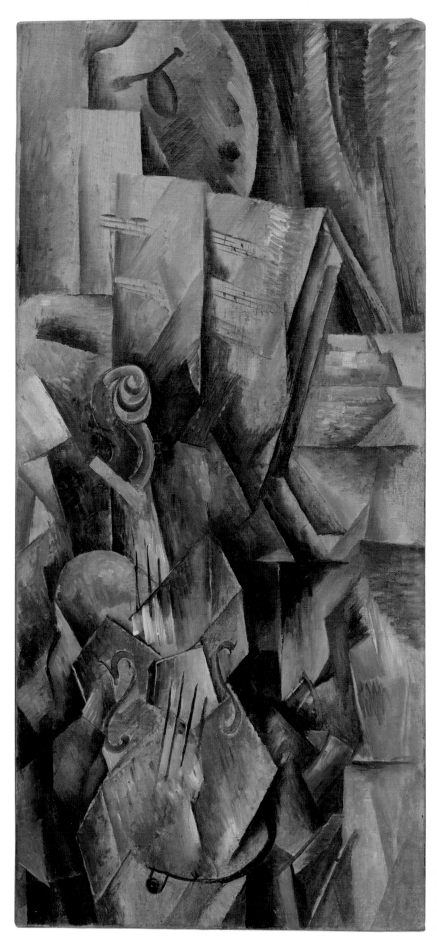

Plate 3.11 Georges Braque, *Violin and Palette*, 1909, oil on canvas, 92 × 43 cm. Solomon R. Guggenheim Museum, New York, 54.1412. Photo: Solomon R. Guggenheim Museum, New York. © ADAGP, Paris and DACS, London 2012.

Exercise

Look at Braque's *Clarinet and a Bottle of Rum on a Mantelpiece* (Plate 3.2). In the light of the foregoing, try to 'read' this Cubist painting. Look carefully at details, but also try to note some general points.

Discussion

Unlike the Cézanne you studied earlier in this chapter (Plate 3.4), here it is hard to distinguish a subject. There is no coherent illusion of space in the picture – for example, no conventional foreground, middle ground or distance. Another general feature is that the colours are very muted, light and dark greys with greenish and brownish-yellow tinges. Also, the brushstrokes covering most of the surface are regular, smallish horizontal blocks, repeated and varied over and over again, in a more deliberate way than in the Cézanne landscape. Yet when you look carefully, what at first seems to be an arbitrary jumble does resolve to a certain extent; it loses some of its arbitrariness and even appears to be composed. For example, both the top corners are lighter and have less going on in them than the bottom ones. This is consonant with pictorial convention whereby the 'weight' tends to be at the bottom. Another traditional compositional device is a large triangle, truncated just before the top edge and running down towards the bottom corners.

The title might help you to go further. In a conventional still life depicting a musical instrument and a bottle, the objects will be shown on a horizontal surface. You might expect the tallest element to be at the top, and so it is: the stylised neck and shoulder of a bottle is visible at the apex of the triangle. Easier to see is the clarinet, positioned horizontally across the centre, sound bell to the left, finger holes to the right; in fact, along this right-hand portion there is some relatively conventional 'shading' along the bottom of the tube, giving a brief illusion of three-dimensionality. Also relatively conventionally 'iconic' (that is, 'picture-like'), albeit in a somewhat cartoonish fashion, is a scroll-like form at bottom right. This is probably the decorative plaster scroll supporting the horizontal mantelpiece. Another cartoonish, relatively iconic element can be seen at the bottom edge, just to left of centre. This might be a fluted decoration on the fireplace below the mantelshelf.

Also recognisable, though not 'icons', are three sets of lettering 'PAR' at centre top, part of 'RHU' below it, and lower down to the left 'VALSE'. Given the title, and its position, 'RHU' is probably part of the word 'RHUM', and hence the label on the bottle. Again given the title, and the recognisable instrument, the word 'VALSE' ('waltz') may be the title on a piece of sheet music, also tucked on the mantelpiece. In short, then, with a little concentration and some imaginative deduction, we have been able roughly to place some of the elements into an approximation of a pictorial composition.

The obvious next question is: Why is it all made so difficult? We may well have had some degree of success in recovering a depicted subject, but the main thing is surely that the picture seems to be trying to stop you doing that. That seems to be the point. When we talk about Picasso and Braque 'exploding pictorial conventions', they seem to be doing just that: showing up pictorial conventions as conventional. They are preventing, or interrupting, conventional looking, and therefore blocking conventional responses. At the same time, they seem to be taking all the components out of which illusions are usually made, colours, brushstrokes, edges, shading, etc., and separating them from their conventional illusionistic function.

For example, there is a spiral shape which crops up several times throughout the painting. When it appears at bottom right, it functions relatively conventionally; we read it as the side of the decorative plaster scroll, receding in the picture space. That is to say, it has a relatively conventional iconic function. Moving to the left, just under the 'V' of 'VALSE', there is another spiral. It is just possible, given its positioning, that this represents a bass clef on the sheet music. Then, in the centre of the painting, below 'RHU', there is another spiral. Given the shape below it, this may signify the edge of a rolled-up piece of paper, possibly again part of the sheet music or other odds and ends on the mantelpiece. The shape then occurs again higher up, above 'PAR'. Here it has no discernible iconic function at all. This is an example of Braque playing a kind of serious game, pulling apart the normally seamless or invisible relationship between the technical aspects of a visual representation and the thing it is a representation of.

Finally, and again this bears on the register of cartooning and wit that seems to flit across the work, there is the spindly 'V' shape above the clarinet and to the right of 'RHU'. Closer inspection reveals that this is probably not a 'V' shape flat on the canvas like the 'V' in 'VALSE'. It is a cartoon-like drawing of a nail hammered into the wall at 45 degrees, casting a shadow on the surface of the wall. It thus becomes the key to the whole picture. It is a token of the visual convention of depicting objects in space – shadows and all – that constitutes the representational tradition that the rest of the picture is taking apart. To add another layer, the stylised nail is itself a quotation of an earlier work of 1909 by Braque himself (also containing sheet music and an instrument) where the nail had been used to hang up a palette (Plate 3.11). That is to say, it looks as though, in the painting, Braque is taking a relatively typical neutral subject in an established genre of fine art, and using a series of devices to reveal the process of visual representation as a series of conventions, rather than being 'natural'. This was in opposition to the European illusionistic tradition, whose principal tactic had been to persuade spectators to suspend belief in the illusion and to take it as 'real'. It begins to seem, then, that this kind of early Cubism represents a profoundly reflexive meditation on the business of representation itself. In doing this, it confers on the practice of art a critical role, most notably with respect to the inheritance of the European tradition.

5 Synthetic Cubism and politics

Yet that suggestion should prompt further reflection. For we must not lose sight of the fact that these are paintings – works of art. They are not scientific demonstrations. Picasso and Braque carried on making and developing Cubism. Just as Cézanne was striving for an artistic equivalent to a response he felt in nature, so one must assume that Braque, in this instance, is striving to produce a resolved aesthetic totality, some kind of harmonious whole even out of the dismembered bits and pieces that artists usually used to achieve their effects. It raises the game of representation, so to speak, to another level: a level still dedicated to producing an aesthetic resolution, but one which self-consciously reveals the means of its doing so.[11]

By 1910–11, the analytical Cubism of both Picasso and Braque was very close to being 'abstract' (see, for example, Plate 3.12). It is always difficult and sometimes more or less impossible to recover figuration from these paintings. Yet it is important to acknowledge that, despite the sense that an 'abstract' art was something that had been on the avant-garde agenda for twenty years or more, neither of them took that route. Quite the reverse. Both artists began to incorporate non-art elements drawn from surrounding reality into their work (see Plate 3.13). This phase is often dubbed 'synthetic Cubism'. The additional features that were introduced were varied. For example: techniques for producing an illusion of wood grain that Braque had encountered in his apprenticeship as a house decorator were employed; sand was mixed with the paint to produce a roughly textured surface; coloured tissue paper was pasted to drawings; pieces of newspaper were added; eventually, physical objects were imported into the work of art.

All this seems to have functioned to make the layers of representational device ever more sophisticated and self-conscious. As Rosalind Krauss has shown, for example, Picasso took the convention whereby one pictorial element being smaller than another one signified its greater distance within pictorial space.[12] Now, by representing two 'f-holes' of different sizes, he suggests a violin angled in pictorial space, in the absence of both the object and the coherent space presupposed by such a convention (Plate 3.14). The depth signifier floats free of the object whose position in space it would conventionally have indicated. The result seems to be a repertoire of illusionistic devices, unpicked and recycled, underlining time and again the conventionality of meaning, the arbitrariness of the visual sign just as much as the verbal. Yet ironically, of course, the unpicking itself is not at all arbitrary; in fact, the work of art, the collage, is being consciously and cleverly recomposed by a sort of artist-trickster. All of which prompts the question of what it is that the dismantled repertoire of previous art is being made over into. Pure form? A self-conscious critique of representational convention? Or something more?

Much has been made of this last possibility in relation to Picasso's use of cut-out pieces of newspaper in the autumn of 1912. In the modernist critical tradition, these were regarded as formal devices to establish a visually interesting, animated grey plane; which is indeed how Braque seems to have used them. Not until much later did anyone trouble to read Picasso's papers. When Patricia Leighten did, it was incontrovertibly clear that he had been choosing the stories deliberately.[13] There is now a considerable literature demonstrating how Picasso used newspaper reports on the 1912 Balkan wars (lost to history now, but at the time among the tremors which signalled

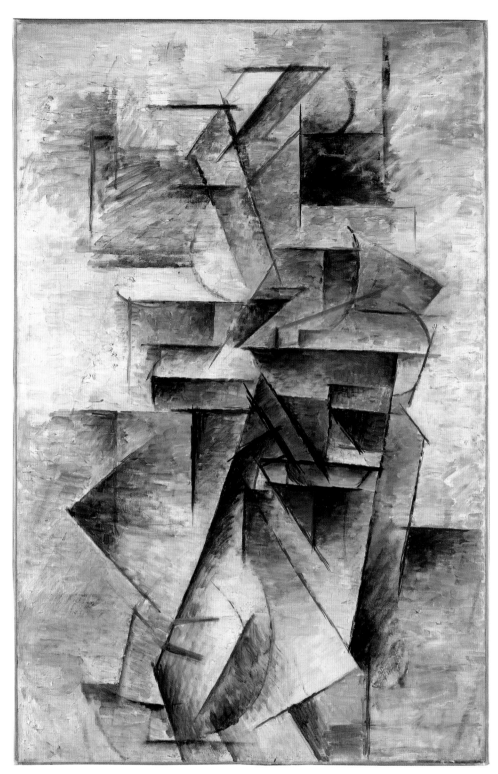

Plate 3.12 Pablo Picasso, *Woman with a Mandolin*, 1910, oil on canvas, 92 × 59 cm. Museum Ludwig, Cologne, ML 01268. Photo: © Rheinisches Bildarchiv Köln, rba_c010772. © Succession Picasso/DACS, London 2012.

the approaching earthquake of the First World War) to signify allegiance to anti-war campaigns and opposition to nationalist rhetoric (Plate 3.15). As Leighten has shown, the collage *Glass and Bottle of Suze* contrasts newspaper reports of a socialist anti-war demonstration in Paris with reports from the battlefront, which are reproduced upside down to signify negativity and rejection. To anyone versed in the ways of reading a Cubist composition, a collage such as *Glass and Bottle of Suze* can be imaginatively reconfigured as representing a cheap cafe interior with an oval zinc-topped table with a central leg on which there stands a bottle of aperitif, a glass and a newspaper.

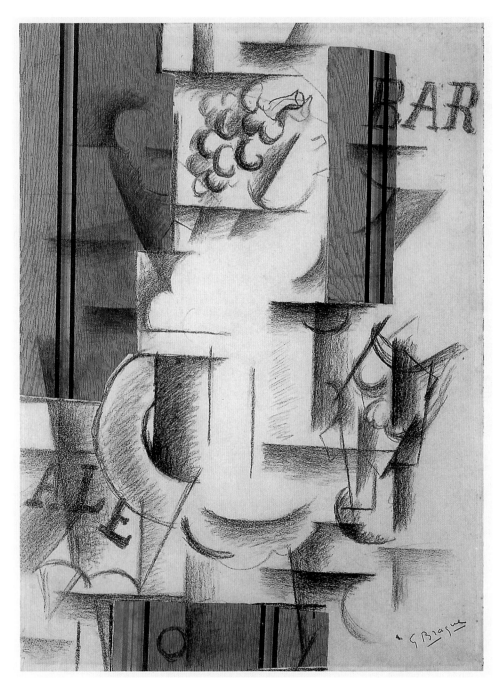

Plate 3.13 Georges Braque, *Fruit Dish and Glass*, 1912, charcoal and pasted papers, 62 × 45 cm. Private collection. Photo: © ADAGP, Paris and DACS, London 2012.

What this all 'means' is an issue of some complexity. During the period of *c*.1909–11, the Cubism of Picasso and Braque effectively demolished the coherent fiction of pictorial space that had been the central support of European art since the fifteenth century. As the eminent modernist critic Clement Greenberg put it: 'By the end of 1911, both masters had pretty well turned traditional illusionist paintings inside out.'[14] During 1911–12, they introduced fragments of the 'real' world into Cubism: postcards, advertisements, bits of quotidian 'stuff' drawn from a life of studios and cafes, and, in Picasso's case, newspapers with overt political content. The long-term context for this was the development of the 'avant-garde' during the nineteenth century. The nineteenth century had witnessed the beginning and development of a long challenge to academic practice across the whole gamut of its commitments: from its ideological complicity with bourgeois values and taste to the technical features with which it conveyed those values. The development of a largely independent avant-garde subculture laid the ground for an art that by the end of the first decade of the twentieth century was not merely hard to understand from within the central value system of the culture, but was an explicit and intentional critique of the presumptions of 'normal' representations of the world.

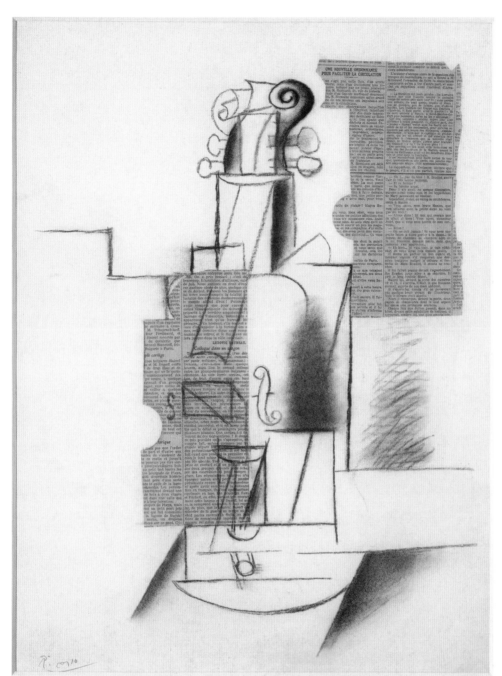

Plate 3.14 Pablo Picasso, *Violin*, 1912, pasted papers and charcoal on paper, 62 × 47 cm. Musée National d'Art Moderne, Paris, AM2914D. Photo: © Collection Centre Pompidou, Dist. RMN/Rights reserved. © Succession Picasso/DACS, London 2012.

This is an epochal shift, and its ramifications go beyond art. For one thing, the traditional idea of an 'avant-garde', which emerged in the socialist milieu of the 1820s, had involved a sense of common purpose between radical art and radical politics, liberating art and society alike from the dead hand of the past.[15] The increasing technical radicalism of the nineteenth-century avant-garde had altered this balance. Although many Impressionists and Post-Impressionists continued to be politically radical, others were either politically neutral or even conservative. Technical radicalism, aesthetic radicalism, a radicalism of taste, call it what you will, did not necessarily march in step with

commitment to democracy or secularism, let alone socialism or anarchism. In some it did, and Picasso is probably one. He had emerged from an anarchist milieu in Barcelona, and David Cottington re-tells the story of how, in the pre-war Cubist heyday, Picasso and Braque would love to don workers' blue overalls and go to collect their pay packets from the boss – *le patron* – Kahnweiler. But it would be sentimental to overstate this. Cottington is surely right to point out that no one in the workers' movement would have had the faintest idea of how to read a Cubist collage, and, for their part, the Cubist movement was socially quite distinct from the milieu of the left, trade unionists and

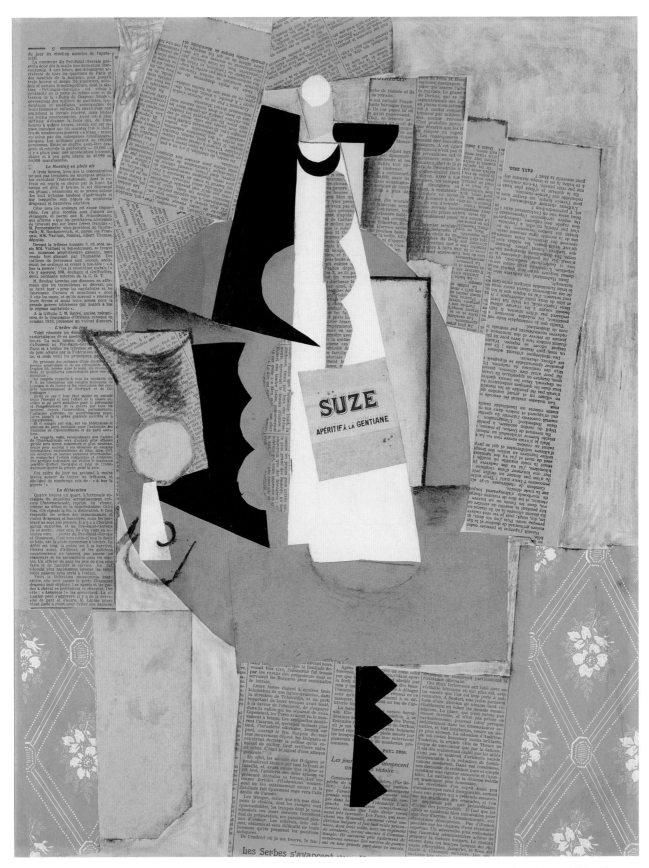

Plate 3.15 Pablo Picasso, *Glass and Bottle of Suze*, 1912, pasted papers, gouache and charcoal on paper, 65 × 50 cm. Mildred Lane Kemper Art Museum, Washington University in St. Louis. University purchase, Kende Sale Fund, 1946. Inv. WU 3773. © Succession Picasso/DACS, London 2012.

anarcho-syndicalists.[16] Picasso is first and foremost an avant-gardist. The collage is an autonomous work of art. But, and this is the important point, that does not mean that the collage lacks meaning. Rather, it is making its meanings on its own terms. Picasso did sympathise with the left's opposition to the war, and it seems incontrovertible that he embedded these views in his Cubist collages of late 1912. This does not, however, mean that Cubist collage was an art form with popular resonance, either in social fact or in Picasso's intention. The radical message is encoded into the collage, but the collage could signify only in the much more restricted milieu of the avant-garde; indeed, only to an avant-garde within the avant-garde. There is a considerable element of play involved in such collages, albeit serious play. Picasso is wittily cocking a snook at the bourgeoisie from the point of view of, and on the basis of, an established avant-garde subculture. That is not the same position as, say, the organisation of an anti-war demonstration, however much sympathy a member of the former may have for the latter.

Part of the complexity of Cubism is that, with the benefit of hindsight, it can be seen to mark a key point in the historical relationship of artistic and political radicalism. After that point, political challenges to bourgeois society usually required of art a more transparent vehicle for their message than Cubism could provide, given the sheer density of its reflections on the medium. The upshot was that, from the orthodox communist left (not to mention the fascist right), Cubism was condemned as an elitist symptom of bourgeois decadence. Seeing things from the other side, many post-Cubist 'abstract' artists, as we have seen from Barr's account, came to regard the political dimension as a threat to their aesthetic freedom. The ultimate risk for this position was that such a politically neutered abstraction did indeed decline into a form of modern decoration, for either the sophisticated bourgeois domestic interior or, later, the corporate foyer. Yet, despite that fate, which arguably came to pass for much of the modernist abstraction produced after the Second World War, the situation of abstract art in the inter-war period remained open and complex. Especially in the earlier part of that period, before the Wall Street Crash, before Stalin and Hitler, a tensioned space continued to exist wherein the post-Cubist avant-garde could continue to see 'abstract' art not merely as the object of aesthetic enjoyment by a cultivated middle class, but as key to a wider social transformation.

6 War and revolution

By 1914, the avant-garde had become a semi-independent subculture distinct, on the one hand, from the organised practice of socialist or anarchist politics, and, on the other, from the official culture of mainstream bourgeois society. It was a contradictory position: simultaneously critical of bourgeois values and sustained by bourgeois money. Avant-gardists, as the name implies, were never fully paid up representatives of the status quo. But whether their politics consisted of allegiance to the workers, or to a more idealistically conceived 'people' or 'nation', or indeed to a professed neutrality, avant-garde art itself remained largely incomprehensible to anyone outside its orbit. No socialist demonstrating against the Balkan wars would have been able to decode Picasso's collage. It needed more than radical artists wanting it to be so for avant-garde art to have any resonance in the world at large.

This is easy to say of art, a century later; it almost summons a condescending smile to the effect 'How could it be otherwise?' But it is a key imaginative requirement when reflecting on the radical art of a century ago not to assume that our own values were those of the participants. Regarding the complex interactions of art and culture, politics and society in history, it is only to state the obvious to say that 'more than' avant-garde wishful thinking was required for their art to gain a wider purchase. But, extraordinarily, that 'more than' did in fact happen. First in 1914, when the most advanced civilisation in human history began to tear itself apart, and then with renewed impact in 1917, when the Russian Revolution shook what remained of the old order to its roots and seemed to hold out the prospect of a new world born from the wreckage of the old. The meaning of Cubism and its abstract avant-garde successors is very much bound up with all of these: first the climate of the *avant-guerre*, then the cataclysmic effects of war and revolution. Our present task is not to rehearse a stereotypical stand-off between formalist, modernist accounts of abstraction, celebrating aesthetic innovation, and contextualist histories prone to exaggerate the extent of artists' social commitment, all played out in terms of 'autonomy' versus 'engagement'. For many abstract artists in the inter-war years, autonomy *was* the form of engagement.

Plate 3.16 Constantin Brancusi, *Newborn [1]*, 1915, white marble, 15 × 21 × 15 cm. Philadelphia Museum of Art: the Louise and Walter Arensberg Collection, 1950. Acc. 1950-134-10. © ADAGP, Paris and DACS, London 2012.

7 Exploring abstraction

Even if Picasso and Braque did not go down the path of abstraction that Cubism opened up, others did. An abstract art, released from what had come to be regarded as the burden of naturalism, or indeed of mimesis of any kind, had been an object of desire for many avant-gardists for the past twenty years. For Alfred Barr, indeed, it was 'the logical and inevitable conclusion to which European art was moving'.[17] By about 1930, in Barr's view, abstraction had evolved into two distinct but complementary traditions: on the one hand, 'geometrical abstract art' derived from Cubism; on the other, 'non-geometrical' abstraction consisting of organic or biomorphic shapes and exemplified by artists including Constantin Brancusi (1876–1957) (see Plate 3.16). But, as we have seen, Anglo-American modernist theory, as it developed from the 1930s

onwards, tended to 'clean up' abstract art, seeing it as 'purified' of political and religious baggage, an art of harmony and balance that you could appreciate in fine white rooms purged of all distraction, with any lingering concern that the museum was built on the profits of the Rockefellers or the Goodyears being ruled offside *a priori*.

Yet at the time of its emergence, that was far from the case. Almost without exception, the pioneering European abstract artists were partisans of one sort or another. Even the transcendentalist Wassily Kandinsky (1866–1944), whose abstract art owed nothing to Cubism and much to Fauvism and expression-theory, saw his art as a harbinger of apocalypse (see Plate 3.17). Moreover, he was onto something. Apocalypse duly

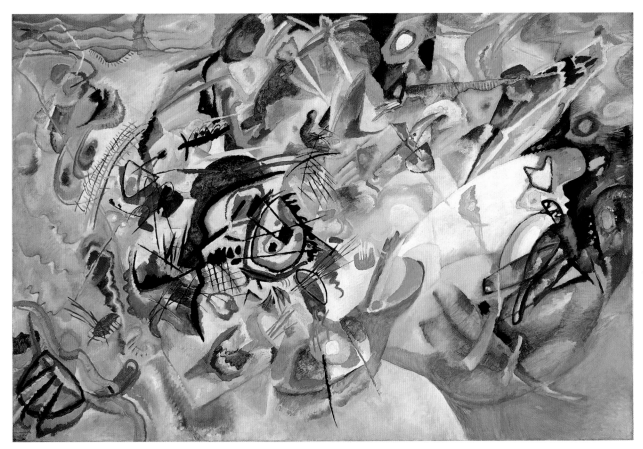

Plate 3.17 Wassily Kandinsky, *Composition VII*, 1913, oil on canvas, 200 × 300 cm. State Tretyakov Gallery, Moscow. Photo: © State Tretyakov Gallery/The Bridgeman Art Library. © ADAGP, Paris and DACS, London 2012.

came, albeit not in the form he expected. Europe's Judgement Day came not to the blast of golden trumpets but the rattle of machine guns. However, Kandinsky's post-Symbolist abstraction, like that of the Czech František Kupka (1871–1957), was idiosyncratic and subjective, technically as well as intellectually. These abstractions were, at bottom, peculiar to the foibles of their authors. What Cubism provided, by contrast, was something more akin to a usable language, at least in the sense of a usable set of conventions: a loose quasi-grammatical system that could accommodate a wide range of different ideological emphases and combinations, ranging from utopian idealism to would-be scientific materialism. The point being that both were addressed to change, to transformation, be it spiritual or social.

Early examples could be found at both ends of the continent. Before the First World War broke out in August 1914, the Dutchman Piet Mondrian, working in Paris, as well as several members of the newly emergent Russian avant-garde, some of whom had also visited Paris and seen what Picasso and Braque were doing

first hand, had pioneered technically quite similar forms of abstraction, alike predicated on Cubism. Initially, all pushed forward the process of abstracting from some motif, in a broadly post-Cézannist/Cubist fashion, gradually 'purifying' the resulting works of extraneous references. Mondrian's various series of sand dunes, building façades and trees are exemplary (see, for example, Plate 3.18). Following the model of analytical Cubism, colour is toned down, lines and planes are simplified to echo the rectangular frame, the overall effect is more unified. In Russia, Kasimir Malevich (1878–1935) drew on a different aspect of Cubism, collage, to produce complex collisions of words, iconographic images and flat planes of colour (see Plate 3.19). Shortly, it seems, he began to perceive the possibility of making compositions just from the coloured planes, floating in pictorial space.

Mondrian's and Malevich's work of that time represents variant responses to Cubism, admixed with elements of their own. In Mondrian's case, these involved 'Theosophical' quasi-religious ideas that were widespread in the avant-garde (shared by Kandinsky,

Plate 3.18 Piet Mondrian, *Flowering Apple Tree*, 1912, oil on canvas, 78 × 106 cm. Collection of the Gemeentemuseum Den Haag. © 2012 Mondrian/Holtzman Trust c/o HCR International, Washington, DC, USA.

among others) and a kind of mystical mathematics. Malevich drew on the technical lessons of Cubist collage and mixed them with a welter of scientific, mystical and 'futurist' ideas from the Russian literary avant-garde about disrupting conventional meaning. Fuelled by this cocktail of complicated subcultural references, Mondrian and Malevich, in ignorance of each other's work, both crossed a Rubicon of abstraction during the war years. By this point, the pan-European avant-garde had been sundered by the war. This is a factor not to be underestimated. Mondrian was out of Paris for five years; the Russians were cut off from contact with the western avant-garde from 1914 until 1922. Once it had become apparent, after several years of painstaking 'analysis' and refinement, that an art almost completely abstracted from a motif could be viable without falling into 'mere

decoration' (as Kandinsky had also feared), both took the unprecedented step of starting to build up an abstract work from a basic compositional element. This was the rectangle, or square form, with its roots in the Cubist facet plane. In hindsight, the change can seem small, but in fact it represents a conceptual leap: from purifying a motif down and down until arriving at a sort of basic element, to assembling a completely abstract work from already completely abstract elements. Mondrian did this in a series of exploratory 'compositions' (Plate 3.20). Malevich arrived at something like a 'big bang' moment with his *Black Square* of 1915 (Plate 3.21); he rapidly went on to produce a series of what he dubbed 'Suprematist' compositions, extending and elaborating his new visual 'language'.

Plate 3.19 Kasimir Malevich, *Lady at a Poster Column*, 1914, oil and collage on canvas, 71 × 64 cm. Stedelijk Museum, Amsterdam. Photo: © Collection Stedelijk Museum.

Plate 3.20 Piet Mondrian, *Composition with Colour Planes 3*, 1917, oil on canvas, 48 × 61 cm. Collection of the Gemeentemuseum Den Haag. © 2012 Mondrian/ Holtzman Trust c/o HCR International, Washington, DC, USA.

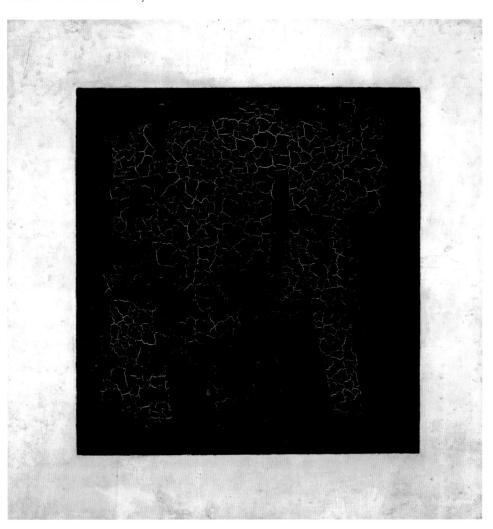

Plate 3.21 Kasimir Malevich, *Black Square*, 1915, oil on canvas, 80 × 80 cm. State Tretyakov Gallery, Moscow. Photo: State Tretyakov Gallery, Moscow.

8 The readymade

However, before proceeding to look in more detail at some examples of abstract art in the inter-war period, one other spin-off from Cubism has to be mentioned, since it later came to assume enormous importance in the history of twentieth-century art. This is the 'readymade' strategy of Marcel Duchamp. Like Mondrian and Malevich, Duchamp had undergone a sort of apprenticeship in Cubism in the years of the *avant-guerre*. The lesson he drew, however, had little to do with either the production of an abstract art or the production of abstract designs intended to influence the look of the world. Rather than experiencing Cubism as an aesthetic liberation, Duchamp had run into the *realpolitik* of the Parisian art world. As a junior member of the 'salon' Cubist group, of which both his two brothers were also members, Duchamp fell foul of the group's attempts at self-policing. Keen to cement their status as the latest French avant-garde, the committee in charge of the Cubist representation at the 1912 Salon des Indépendants forced Duchamp to withdraw his painting *Nude Descending a Staircase* for what they

perceived to be a mix of provocative frivolity in the title, and implicitly giving too much credence to the Italian Futurists' obsession with movement. The result was that instead of conforming, Duchamp soon abandoned painting altogether.

Once the experimental Cubist avant-garde (or, at least, that fraction of it known to Duchamp) had revealed itself in another light, as yet another sect vying for its place in the sun, patrolling its borders as avidly as any academy, the intelligent Duchamp moved the goalposts. Through a series of witty interventions, he undermined the unspoken rules separating art from design and popular culture, and raised questions going to the heart of abstraction, autonomy and indeed art itself. The contemporary interest in movement, form and 'dynamism' was met, in 1913, by Duchamp placing the front forks and wheel of a bicycle upside down on a stool in his studio (see Introduction, Plate 0.3). This 'readymade sculpture' really did move. It may well have been a joke, but some of the questions it raised

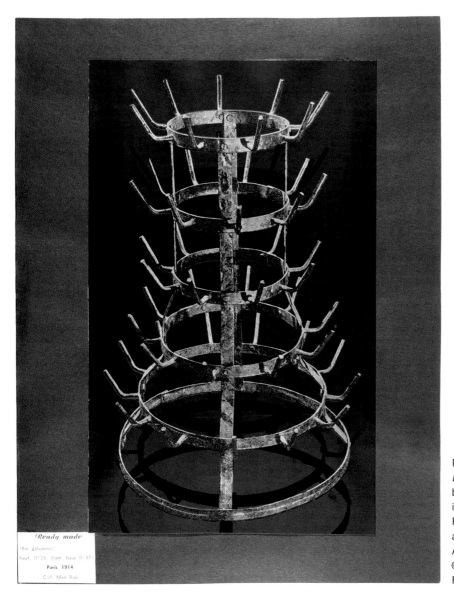

Ready made

Fer galvanisé;
haut. 0"59, diam. base 0"37.
Paris 1914
Coll. Man Ray

Plate 3.22 Marcel Duchamp,
Bottlerack, black and white photograph
by Man Ray of 1936 version, as used
in Duchamp's *Box-in-a-Valise* (1941).
Philadelphia Museum of Art: The Louise
and Walter Arensberg Collection, 1950.
Acc.1950-134-934 (Box-in-a-Valise).
© Succession Marcel Duchamp/ADAGP,
Paris and DACS, London 2012.

were challenging for an 'abstract' art, questions that were further sharpened by his next step. Shortly after the outbreak of war, in which he had no intention of becoming involved, Duchamp left Europe for New York. Before he went, he had taken the 'readymade' idea a stage further by buying a bottle drying-rack, and again placing it in his studio, this time as an 'unassisted readymade' (Plate 3.22). Again, the questions proliferated. Was it a work of art? It was, after all, 'abstract' – *sort of*. It was also formally complex and quite interesting to look at – *sort of*. Furthermore, it was in an artist's studio; no question about that. So was it art?

These questions, which initially seem to have amounted to little more than private musings and lightly handled irony about the pieties and solecisms of the new art, attracted more attention in New York. Duchamp had already made a splash there with the very painting rejected from the 1912 Salon des Indépendants, the

Nude Descending a Staircase. Now he achieved a *succès de scandale* when he manipulated the rules of an avant-garde exhibition to display another 'readymade', this time a porcelain urinal, as a sculpture titled *Fountain*, and signed in a quasi-expressionstic daub by the fictitious 'R. Mutt' (Plate 3.23). Duchamp chose his examples well. The bottlerack looked *a bit* like a putative Cubist sculpture. The urinal looked *a bit* like a smooth abstract sculpture by Brancusi. Its organic/biomorphic curves might have been chosen as a deliberate counterpoint to the bottlerack's spiky geometry. Needless to say, the committee in charge of hanging the exhibition once again took fright and censored it. Duchamp, as ever one step ahead, had an article placed in a short-lived avant-garde magazine, *The Blind Man*, under the mock-legalistic title of 'The Richard Mutt case'. Having disposed of the claim that the urinal was somehow immoral, he proceeded to float an idea with far-reaching implications:

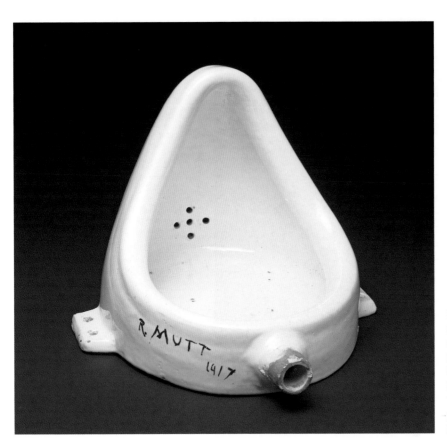

Plate 3.23 Marcel Duchamp, *Fountain* (replica of 1917 original), 1950, porcelain urinal, 31 × 38 × 46 cm. Philadelphia Museum of Art. Gift (by exchange) of Mrs Herbert Cameron Morris, 1998. Photo: © Philadelphia Museum of Art/ The Bridgeman Art Library. © Succession Marcel Duchamp/ADAGP, Paris and DACS, London 2012.

Whether Mr. Mutt with his own hands made the fountain or not has no importance. He CHOSE it. He took an ordinary article of life, placed it so that its useful significance disappeared under the new title and point of view – created a new thought for that object.[18]

Initially, the deeper implication of Duchamp's gesture lay dormant. It was effectively submerged in the greater wave of 'Dadaist' anti-art provocations stimulated by the catastrophic progress of the war, which was busily wrecking all pretensions to European culture and civilisation. Only decades later, when abstract modernism ran into a different kind of crisis, did Duchamp's serious jokes rise from the depths. What is a work of art? What is *the* work of art? What is an artistic author? These and other questions resonated mightily in the 1960s. No avant-gardist from the early twentieth century had a greater effect on the art of the late twentieth century.[19] By the time of Duchamp's death in 1968, the artist Jasper Johns (b. 1930) could write in his obituary that: 'He has changed the condition of being here.'[20]

However, after the end of the First World War and the wave of revolutions that succeeded it, much of Europe lay in ruins, materially as well as culturally. In that situation, the individualistic-subjective bias of 'Expressionism' which had preceded the war, and the

anarchic provocations of Dada that had emerged as a response to it, both lost traction. The overwhelming desire among artists was to try to rebuild something from the ruins. These developments, it goes almost without saying, were complex and varied, depending both on the objective situation in which artists found themselves as well as on their own differently inflected commitments. But even a glimpse should be enough to show the distance avant-garde art had travelled since an idea of 'abstraction' first began to be mooted in French Symbolist circles in the late 1880s. In the immediately post-Revolutionary period in the nascent Soviet Union, art as such became something the erstwhile avant-garde wanted to get away from as an undesirable vestige of bourgeois life which had no place in socialism. In western Europe after the end of the war, comparable ideas, albeit not so extreme as to do away with 'art' altogether, also began to inform a new 'constructive' role for the avant-garde.

9 Mondrian and De Stijl

Exercise

Look at *Composition with Red, Blue and Yellow* (Plate 3.24), painted by Mondrian in 1930. Write a description of what you can see.

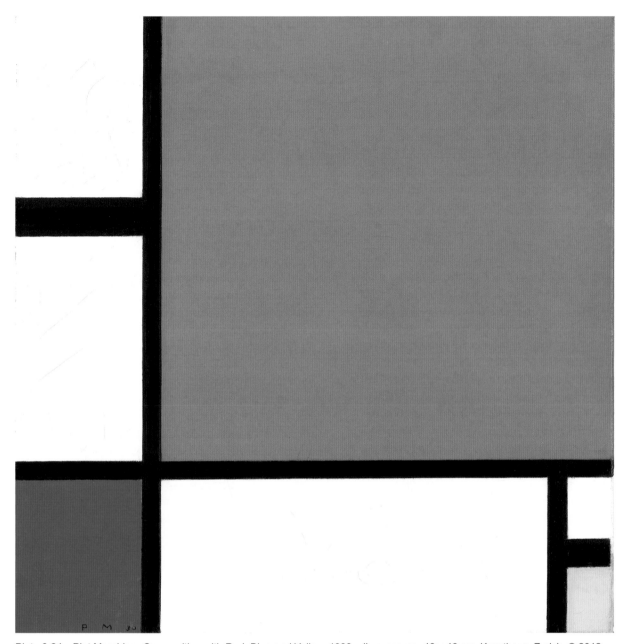

Plate 3.24 Piet Mondrian, *Composition with Red, Blue and Yellow*, 1930, oil on canvas, 46 × 46 cm. Kunsthaus, Zurich. © 2012 Mondrian/Holtzman Trust c/o HCR International, Washington, DC, USA.

Discussion

The illustration I am looking at is dominated by a large red square. The painting as a whole seems to be balanced: it too is square. But this balance is not achieved by symmetry. The large red square is offset to the top right. The effect of balance seems to be achieved by the blue rectangle at bottom left, and the smaller yellow rectangle at bottom right. Both of these are taller than they are wide, but the blue one is perhaps six times larger than the yellow one, though both are many times smaller than the large red square. If they do indeed perform a work of balancing, they must do it partly by virtue of the way their colours and sizes interact with the large

red square above, and partly by relative position – not just laterally, but in the pictorial space of the painting – because the tendency of red is to come forward visually, of blue to recede. And what of the white rectangles? How do you read these? As white planes parallel to the red, blue and yellow planes, but differently placed in the pictorial space? Or as just that: space? The black bars which separate the colours are also more varied than first glance might suggest. The upper one of the two horizontals at the left is thicker. So too is the short stubby bar at bottom right. Insofar as the painting is balanced, the balance is produced by all these different elements

in combination, something after the fashion in which a range of different notes on a piano or a guitar, when carefully chosen, will harmonise to form a chord.

That seems to be about as far as one can go with the illustration. But what this does is to bring out the limitations of looking at illustrations of 'abstract' art. For perhaps *the* key point about 'abstract' art is that it is not itself an illustration of anything. Paradoxically, it is a 'concrete' or 'plastic' configuration of shapes and colours. So when you are looking at an illustration, you are not looking at the work itself. Mondrian did not use masking tape or graph paper to produce such paintings. Presumably he used a ruler or straight edge to steady his hand, but he worked empirically, changing the shapes of rectangles and the width of bars until he intuitively arrived at the balance he sought. In answer to a question about what he wanted to express in his work, he replied: 'Nothing other than what every artist seeks: to express harmony through the equivalence of relationships of lines, colours and planes', but, he added, 'in the clearest and strongest way'.[21] One can see why Barr spoke of 'distilling' and 'purifying'. But, for all that, a Mondrian painting is a surprisingly artisanal thing, made by hand and visibly so. Obviously a painting of this type by Mondrian does not involve the agitated brushstrokes of a painting in the expressionist tradition by an artist like van Gogh. But this is quite deliberate. Mondrian is trying to get away from what he sees as the negative elements of exaggerated individualism, in search of something more universal.

This raises the question of the relation between the internally resolved painting, the autonomous work of art, and the wider avant-garde project. For Barr and other modernists, the destiny of the autonomous artwork is to be 'enjoyed' or 'appreciated' aesthetically by an adequately sensitive spectator in an otherwise neutral space, preferably designed for the purpose. Yet for the majority of the inter-war avant-garde, the achievement of an 'autonomous' art was not, or at least was not wholly, defined by a notion of contemplative spectatorship in controlled conditions. It also functioned as a kind of lever, a way of gaining purchase on a wider world of norms, conventions and assumptions. It seems that, both in the form of an autonomous work of art and as a version of the same idea, applied to furniture, to an interior space, to entire buildings even, abstraction could aspire to reform life. Contemplating a resolved aesthetic totality, and

using autonomous form as a lever to change the world, ultimately travel in very different directions. But it is hard to come to an understanding of the motivations of avant-garde artists in that period, including 'abstract' artists, without some imaginative grasp of the avant-garde as a critical, potentially transformative social project.

The art historian Yve-Alain Bois has written of Mondrian's painting as a 'model'. In this sense the internal harmony of the painting can be regarded as prefiguring some future utopian state of harmony in society.[22] But, more practically, Mondrian's work was also part of a wider project to 'construct a new world': 'De Stijl' (see Plate 3.25). Founded at the end of the war, this Dutch-based group sought to implement such ideas in a wide-ranging programme of architecture and design, also involving links during the 1920s with the Bauhaus in Weimar Germany and similar groups in Russia. The De Stijl Manifesto, composed by Theo van Doesburg in 1918, puts the argument clearly. First, 'The old is connected with the individual. The new is connected with the universal. The struggle of the individual against the universal is revealing itself in the world war as well as in the art of the present day.' Second, 'Traditions, dogmas, and the domination of the individual are opposed to this realisation.' Therefore 'the founders of the new plastic art' seek the 'reformation of art and culture' by getting rid of all vestiges of outmoded tradition and bourgeois individualism. Furthermore they 'sympathise with all who work to establish international unity in life, art, culture, either intellectually or materially'.[23]

The paradoxical nature of these aspirations is both clear and wilful. Much hinges on the point where idealism meets materialism, where utopian dreams encounter practical proposals. In his *Principles of Neo-Plastic Art*, published in 1919, van Doesburg clearly evokes a conception of the autonomous work of art: 'The work of art becomes an independent, artistically alive (plastic) organism in which everything counterbalances everything else.'[24] In a series of 'Declarations' in 1921 and 1922, the goal for such art is clearly stated: 'Art, just like science and technology, is a method for organising life generally'; and again: 'We demand that art stop being a dream and direct itself instead to the reality of the world … Art is a universal and real expression of creative energy which organises the progress of humanity.'[25] But, at the same time, all three of the socialist Internationals – that is, including the contemporary communist one in the new Soviet Union – are condemned as 'ludicrous', 'external' and consisting 'only of words'. By contrast the International represented by De Stijl 'does not consist of

Plate 3.25 Theo van Doesburg and Cornelis van Eesteren, model for a private house, 1923 (reconstructed 1983), Plexiglass, 65 × 70 × 45 cm. Collection of the Gemeentemuseum Den Haag. NAI, Rotterdam/collection EFL Foundation, The Hague.

words but of creative deeds and internal force. Spiritual force. With this a new world order is being formed.'[26] Here lies the contradiction of avant-garde art: on the one hand, a rhetorically expressed desire to change the world; on the other, an equally vehement denunciation of the principal contemporary attempt actually to do so in the wake of the Russian Revolution.

10 Unovis and Constructivism

Unsurprisingly, the avant-garde aspiration both to participate in and to lead the construction of a new world reached its fullest development in the early Soviet Union. Two conflicting avant-garde formations developed. One, with Malevich in a leading role, calling itself 'Unovis' (usually translated as 'supporters', or 'followers of the new art'), was broadly comparable to De Stijl and similar groups in the west. The

fundamental idea consisted in using researches into autonomous art forms as a kind of test-bed for projects ranging all the way from domestic utensils to exhibition stands, from buildings to whole cities (see Plate 3.26).

A second, and opposing, formation was specific to the Soviet situation. More overtly practical, more sceptical of the claims of 'spiritual' transformation, and committed to the idea of building a socialist society, this group had initially formed around Vladimir Tatlin (1885–1953). Even before the war, Tatlin had developed a resolutely materialist art, following the example of some now lost three-dimensional paper constructions by Braque, and others of wood, string and cardboard by Picasso. In a series of unprecedented 'counter-reliefs' Tatlin developed a 'culture of materials' that stretched the limits of a traditional sense of art, beginning to articulate constructions of forms in real space (see Plate 3.27). We have already seen how the example of music provided a powerful stimulus for the idea of an independent abstract 'composition',

Plate 3.26 Kasimir Malevich, *Architekton*, *c.*1923–27 (reconstructed 1978 by Poul Pedersen), plaster, 85 × 48 × 58 cm. Musée National d'Art Moderne, Paris, AM1978-878. Photo: © Collection Centre Pompidou, Dist. RMN/Jacques Faujour.

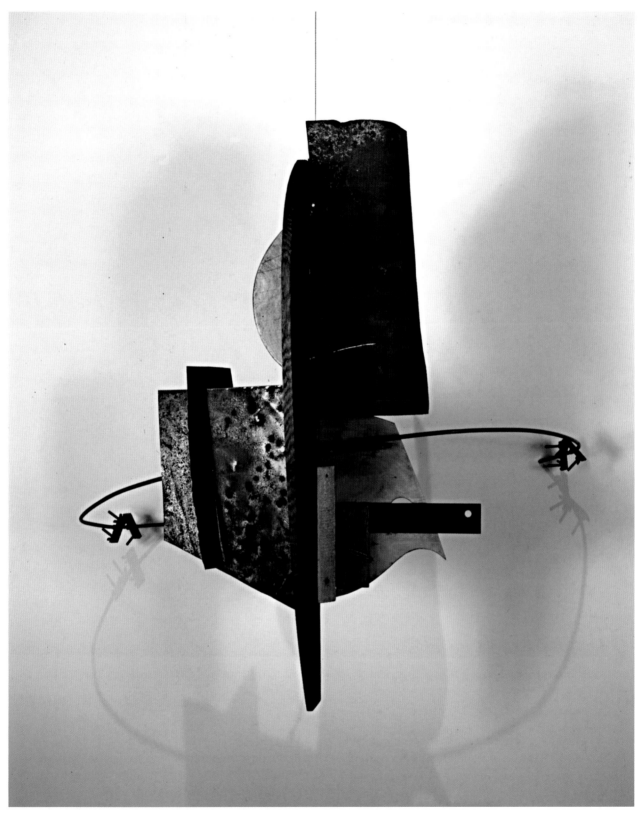

Plate 3.27 Vladimir Tatlin, *Corner Counter Relief*, 1915 (first edition reconstructed 1966 by Martyn Chalk), iron, wood and wire, 79 × 80 × 70 cm. Photo: courtesy Annely Juda Fine Art, London. © Martyn Chalk.

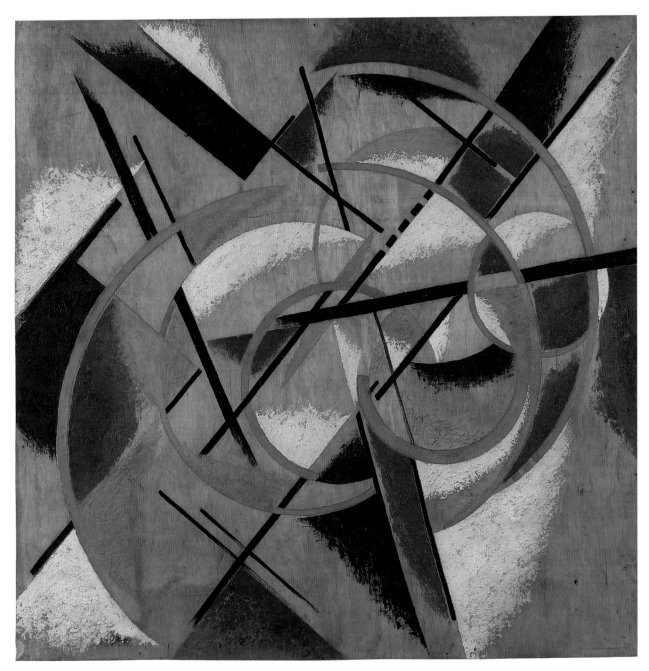

Plate 3.28 Lyubov' Popova, *Space-Force Construction*, 1921, oil with wood dust on plywood, 112 × 113 cm. Greek State Museum of Contemporary Art, Thessaloniki – George Costakis Collection. Photo: Greek State Museum of Contemporary Art.

however long that was in coming. In the hands of Tatlin and his followers, increasingly so after the Revolution of 1917, the metaphor shifted. The project became one of 'construction'. Partly literal, partly metaphorical – 'constructing' an object, 'constructing' a building, 'constructing' a new social order – such ideas were elaborated in the programme of the Constructivist group in 1921. The model for Tatlin and other Constructivists became not the composer, but the engineer: something hinted at by the placing of a set square over an artist's palette in the bottom right of the *Corner Counter Relief*.

In the stringent conditions of war communism, many among the revolutionary Soviet avant-garde, now committed to fusing their 'laboratory researches' with the actual building of a new society, took on leading roles in newly organised cultural institutions under the umbrella of Narkompros, the 'Commissariat of Enlightenment'. Within Vkhutemas, the 'State Higher Artistic and Technical Workshops', the materialist group that had initially coalesced around Tatlin expanded into the 'First Working Group of Constructivists' which 'set itself the task of finding

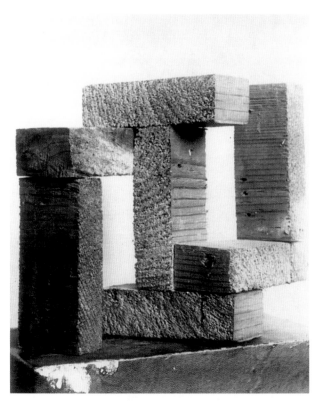

Plate 3.29 Aleksandr Rodchenko, *Spatial Construction No. 25* (from the third series of 'Equal Forms'), *c.*1921, gelatin-silver print, mounted by the artist. The original no longer exists. Galerie Gmurzynska, Zurich own a reconstruction: 2001, wood, 15 × 16 × 10 cm. © Rodchenko & Stepanova Archive, DACS, RAO, 2012.

the communistic expression of material structures'.[27] Leading figures included Aleksandr Rodchenko (1891–1956) and Lyubov' Popova (1889–1924). In the early post-Revolutionary period, they continued to make both two- and three-dimensional constructions which resembled abstract painting and sculpture. But now these were no longer conceived by the Constructivists as artworks but as experiments in the combination of materials (see Plates 3.28 and 3.29). Shortly after, under the slogan 'art into production', instead of using artistic research as a model for practical projects, these 'utilitarian Constructivists' now sought to dissolve art altogether. Abstract art mutated into practical design, such as screen-printing:

> [T]he belief is growing that the picture is dying, that it is inextricably bound to the forms of the capitalist system, to its cultural ideology, and that the calico-print [i.e. screenprint] is now moving into the centre of creative attention ...

> Forward! – to the union of artist and factory.[28]

The task became explicitly that of designing structures and buildings described as 'social condensers': the scientific metaphor implied that out of the experience of living and working in new spaces, there would be 'precipitated' new forms of social life, in effect new people with a new social consciousness.[29]

Some of these projects were relatively practical and in the parlous circumstances of the time did indeed hold out some prospect of realising their goals. Among them were Rodchenko's design for a workers' reading room, shown at the Paris international exhibition in 1925. Other projects that were actually realised included Konstantin Mel'nikov's (1890–1974) extraordinarily advanced design for a workers' club, involving sports facilities and theatres, the Rusakov Club (Plate 3.30). The Narkomfin apartment building, or 'collective housing' project, which involved designs for modular living units, was less successful. Partly because of inherent tensions in the ideal of collective living, partly because of the exigencies of overcrowding and lack of proper facilities, although built, it never worked properly. It now stands in early twenty-first century stridently capitalist Moscow, a semi-derelict hulk on the point of falling down completely, a poignant and macabre monument to a failed revolution.

Conclusion: Abstraction-Création

Despite Stalinism and Hitler's Nazism, whose advent put an end to avant-garde abstraction in Russia and Germany, despite also the economic crisis which gripped the capitalist democracies of the west during the 1930s, abstract art as a whole did not die. 'Productivism' – the dissolution of art into production – had been entirely a creature of the Soviet circumstance. As the Revolution ossified into the bureaucracy of Stalinism, so the space for such radicalism disappeared. By the early 1930s, with the partial exception of propaganda posters and photographs, the Soviet avant-garde was effectively dead, replaced by the official art of Socialist Realism. In Germany, from 1933 onwards, the Nazis persecuted the avant-garde. Once again, with certain exceptions in the field of design, modernism foundered. Symbolically, the Bauhaus was closed down and many of those associated with it were forced into exile. On a theoretical plane, too, abstract art had been subject to criticism. This emanated not merely from overtly academic or conservative positions but from many on the left who feared that abstraction played into the hands of those who preferred to draw a veil

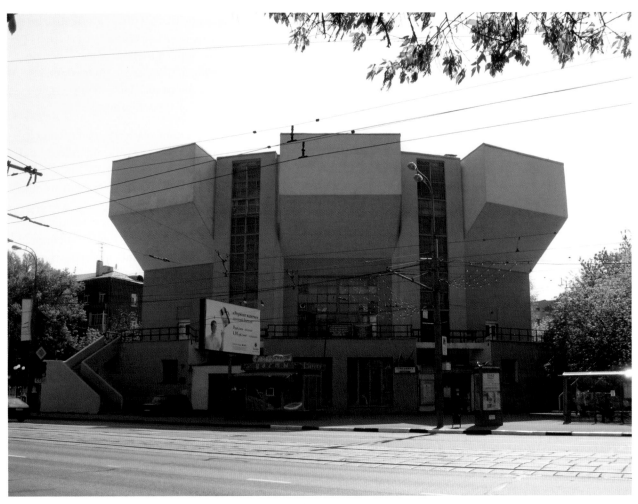

Plate 3.30 Konstantin Mel'nikov, Rusakov Club, Moscow, 1929. Photo: © Paul Wood, 2010.

over the actual conditions of life in capitalist society. In the Soviet Union as early as 1922, the Association of Artists of Revolutionary Russia had declared their opposition to 'abstract concoctions discrediting our revolution'.[30] German communist artists and writers, including George Grosz (1893–1959) and Bertolt Brecht (1898–1956), were also opposed. Both utilised modernist devices of collage and montage in their own work, but drew the line at a complete evacuation of the image. Grosz wrote that an exclusive focus on form and colour amounted to a renunciation of 'all the artist's possibilities of ideological influence' and reduced such artists to the condition of 'wanderers into the void'.[31]

Nonetheless, despite such a broad spectrum of opposition, in western Europe abstraction survived, sometimes inflected more narrowly towards the production of aesthetic harmony rather than practical design, but almost always retaining aspects of that utopianism which had informed abstract art in the twenties.

In London, Ben Nicholson produced technically innovative all-white relief constructions in the mid-1930s which represent an extreme development of the 'aestheticist' side of abstraction (see Plate 3.31). Yet as late as 1941, even Nicholson wrote of abstract art that: 'I have not yet seen it pointed out that this liberation of form and colour is closely linked with all the other liberations one hears about. I think it ought, perhaps, to come into one of our lists of war aims.'[32] In Poland, Katarzyna Kobro and Władysław Strzemiński (1893–1952), having worked with Unovis in the early Soviet Union, continued to produce abstract art in the 1930s. Kobro made painted metal sculptural constructions that sought to articulate open abstract forms with the space that both surrounded and penetrated them (see Plate 3.3). Strzemiński developed the concept of 'Unism' to emphasise the necessary unity of the artwork, for example in a series of *Architectural Compositions* whose internal relations were deduced from their external shape to avoid aesthetic 'arbitrariness' (see Plate 3.32).

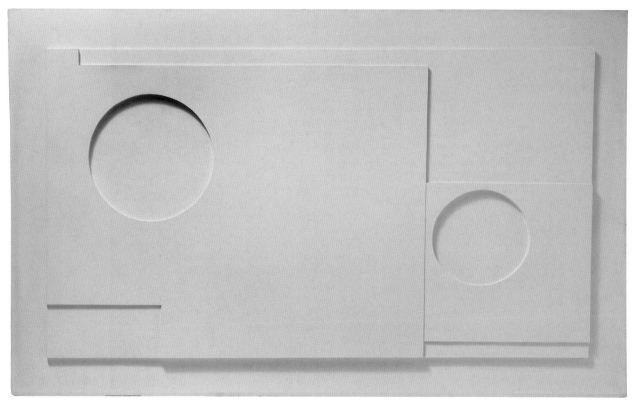

Plate 3.31 Ben Nicholson, *1935* (white relief), painted wood, 102 × 166 cm. Tate, London, T00049. Photo: © Tate, London, 2012.
© Angela Verren Taunt, 2102. All rights reserved, DACS.

Thus he wrote that: 'The aim of a work of art is unity of composition. The greater this unity, the more we approach the aim. Independently of this, a work of art and its fragments can be beautiful. But this is only a question of chance, this is not the aim of art.'[33] This commitment ultimately gave rise to a series of *Unistic Compositions*, rigorously abstract and impersonal, almost monochrome paintings, built up out of methodical brushstrokes yet bodying forth a curiously fragile beauty (see Plate 3.33). Subsequently, after many years of occlusion by the post-war partition of Europe, these works have come to be regarded as distant precursors of a newly emergent radical avant-garde in the 1960s. As Strzemiński himself presciently wrote in the journal *Forma* in 1935: 'Only further development of art can justify the abstract art of today.'[34]

In Paris in 1931, the Association Abstraction-Création was founded as an umbrella organisation to mount 'manifestations' of abstract art, including the work of artists now silenced or exiled from their own countries. Both Nicholson and Strzemiński were members. In

tune with, indeed perhaps offering a stimulus to, Barr's later position as already quoted from *Cubism and Abstract Art*, one of the Association's hallmarks was the equation of 'abstraction' with 'freedom'. As the Editorial to the organisation's second *Yearbook* stated in 1933, it 'appears at a moment when free thought is being fiercely contested, in many ways, on all levels, in some countries more successfully than in others, but everywhere'.[35] The 1930s knocked the stuffing out of utopia; the tone is now defensive. But precisely because of that, because of the critical situation that obtained, it is worth restating that the work of abstract artists in such circumstances remained a response to 'the cultural demands of the era', and not at all, as Nicholson underlined, 'the withdrawal of the artist from reality, into an ivory tower'.[36] As the Abstraction-Création editorial statement concluded: 'Any attempt to limit artistic efforts according to considerations of race, ideology or nationality is intolerable. We commit this second journal to total opposition to all oppression, of whatever kind.'[37]

Plate 3.32 Władysław Strzemiński, *Architectural Composition 10c*, 1929, oil on canvas, 96 × 60 cm. Muzeum Sztuki, Łódź, inv. no: MS/SN/M/174. Photographed by Piotr Tomczyk. Photo: © Muzeum Sztuki/Piotr Tomczyk.

Plate 3.33 Władysław Strzemiński, *Unistic Composition*, 1932, oil on canvas, 51 × 30 cm. Collection Kröller-Müller Museum, Otterlo, The Netherlands.

Notes

[1] Barr, 1974 [1936], pp. 11, 13.

[2] Ibid., p. 18.

[3] These included constructions such as Vladimir Tatlin's *Monument to the Third International* and Kurt Schwitters' *Merzbau*; Marcel Duchamp's 'readymades'; and various multimedia performances ranging from the Futurist 'soirées', briefly touched on in chapter 1, to the Dada 'Cabaret Voltaire'. Except for a short discussion of the 'readymade', all of these fall outside the scope of the present chapter.

[4] Discussed in more detail in chapter 4.

[5] Bell, 1987 [1914], chapter IV.I 'The debt to Cézanne', p. 207.

[6] Cézanne, letter to Joachim Gasquet, 26 September 1897, cited in House, 2008, p. 35.

[7] The literature on Cézanne is extensive. Useful introductions include: Smith, 1996; Shiff, 1984. Cézanne's own words can be found in Kendall, 2004.

[8] Denis, 1998 [1890], p. 863.

[9] Matisse, 2003 [1908], p. 70.

[10] My principal sources for the discussion of Cubism that follows are: Cottington, 2004; Antliff and Leighten, 2001.

[11] Some of the post-Cubist avant-garde manifestations mentioned in note 3 do seem to have tested, suspended, challenged or denied the idea of aesthetic resolution, on the grounds of its supposedly bourgeois provenance. Duchamp's 'readymades' offer one kind of example; the Dadaist employment of chance offers another; Futurist noise machines, a third; and so on. In Cubist art, even in collages which proceed by way of something akin to visual discords through the device of 'adjacency' – that is, the sharp juxtaposition of different materials or types of surface decoration – the composition as a whole seems always, to this viewer at least, to remain subject to aesthetic resolution. It is strange how, with the passage of the years, a Picasso collage that must once have verged on the incomprehensible, an apparently anarchic affront to 'taste', has now resolved into an austere modernist classicism fit to be set alongside Poussin.

[12] Krauss, 1998. This example is taken from 'The circulation of the sign', pp. 25–85, especially pp. 27–33.

[13] Antliffe and Leighten, 2001, pp. 177–84.

[14] Greenberg, 1993 [1959], p. 62.

[15] Wood, 2002, pp. 215–28. See also Wood, 1999.

[16] Cottington, 2004, pp. 133–5.

[17] Barr, 1974 [1936], p. 122.

[18] Duchamp, 2003 [1917], p. 252.

[19] Discussed further in chapter 6.

[20] Johns, 2003 [1968], p. 761.

[21] Piet Mondrian, reply to a question in the journal *Abstraction-Création* No.3, 1934, cited in *Mondrian/De Stijl: L'exposition – The exhibition*, 2011, p. 21.

[22] Bois, 1994, p. 315.

[23] van Doesburg, 2003 [1918], p. 281.

[24] van Doesburg, 2003 [1919], p. 283.

[25] van Doesburg, 2009 [1922], p. 125.

[26] van Doesburg, 2009 [1921], p. 125.

[27] Rodchenko and Stepanova, 2003 [1922], p. 341.

[28] Brik, 2003 [1924], pp. 349, 351.

[29] Kopp, 1970, chapter 7 '1925–1932: New social condensers'.

[30] AKhRR, 2003 [1922], p. 403.

[31] Grosz and Herzfelde, 2003 [1925], p. 468.

[32] Nicholson, 2003 [1941], p. 399.

[33] Strzemiński , 2003 [1933], p. 377.

[34] Strzemiński, 'Discussion between L. Chwistek and W. Strzeminski' [1935], cited in Jedlinski, 1993, p. 16.

[35] Association Abstraction-Création, 2003 [1932/33], p. 375.

[36] Nicholson, 2003 [1941], p. 399.

[37] Association Abstraction-Création, 2003 [1932/33], p. 375.

Bibliography

AKhRR (2003 [1922]) 'Declaration' in Harrison and Wood (2003), IVB2, p. 403.

Antliffe, M. and Leighten, P. (2001) *Cubism and Culture*, London, Thames & Hudson.

Association Abstraction-Création (2003 [1932/33]) 'Editorial statements' in Harrison and Wood (2003), IVA4, pp. 374–6.

Barr, A.H. (1974 [1936]) *Cubism and Abstract Art*, New York, Museum of Modern Art (exhibition catalogue).

Bell, C. (1987 [1914]) *Art*, Oxford, Oxford University Press.

Bois, Y.-A. (1994) 'The iconoclast' in Bois, Y.-A. et al. (eds) *Piet Mondrian 1872–1944*, The Hague, Gemeentemuseum, p. 315 (exhibition catalogue).

Brik, O. (2003 [1924]) 'From picture to calico-print' in Harrison and Wood (2003), IIID11, pp. 348–52.

Cottington, D. (2004) *Cubism and its Histories*, Manchester, Manchester University Press.

Denis, M. (1998 [1890]) 'Definition of Neo-Traditionism' in Harrison, Wood and Gaiger (1998), VC10, pp. 862–9.

Duchamp, M. (2003 [1917]) 'The Richard Mutt Case' in Harrison and Wood (2003), IIIB2, p. 252.

Gaiger, J. (2003) 'Interpreting the readymade: Marcel Duchamp's *Bottlerack*' in Gaiger, J. (ed.) *Frameworks for Modern Art*, London, Yale University Press, pp. 56–103.

Greenberg, C. (1993 [1959]) 'The pasted-paper revolution' in O'Brian, J. (ed.) *Collected Essays and Criticism*, vol. 4: *Modernism with a Vengeance*, Chicago, IL, Chicago University Press, pp. 61–6.

Grosz, G. and Herzfelde, W. (2003 [1925]) 'Art is in danger' in Harrison and Wood (2003), IVC7, pp. 468–70.

Harrison, C. and Wood, P. (eds) (2003) *Art in Theory 1900–2000: An Anthology of Changing Ideas*, Oxford, Blackwell.

Harrison, C., Wood, P. and Gaiger, J. (eds) (1998) *Art in Theory 1815–1900: An Anthology of Changing Ideas*, Oxford, Blackwell.

House, J. (2008) 'Cézanne's project: the "harmony parallel to nature"' in *The Courtauld Cézannes*, London, Courtauld Gallery, pp. 27–47 (exhibition catalogue).

Jedlinski J. (1993) 'To construct a seeing' in *Władysław Strzemiński 1893–1952: On the 100th Anniversary of his Birth*, Łódź, Muzeum Sztuki, pp. 12–21 (exhibition catalogue).

Johns, J. (2003 [1968]) 'Obituary of Marcel Duchamp' in Harrison and Wood (2003), VIA23, pp. 760–1.

Kendall, R. (ed.) (2004) *Cézanne by Himself*, New York, Time Warner.

Kopp A. (1970) *Town and Revolution: Soviet Architecture and City Planning 1917–1935*, London, Thames & Hudson.

Krauss, R. (1998) *The Picasso Papers*, London, Thames & Hudson.

Lodder, C. (1983) *Russian Constructivism*, London, Yale University Press.

Matisse, H. (2003 [1908]) 'Notes of a painter' in Harrison and Wood (2003), IB6, pp. 69–75.

Mondrian/De Stijl: L'exposition – The exhibition (2011), Paris, Centre Pompidou (exhibition guide).

Nicholson, B. (2003 [1941]) 'Notes on abstract art' in Harrison and Wood (2003), IVA14, pp. 398–401.

Rodchenko, A. and Stepanova, V. (2003 [1922]) 'Programme of the First Working Group of Constructivists' in Harrison and Wood (2003), pp. 341–3.

Shiff, R. (1984), *Cézanne and the End of Impressionism*, Chicago, IL, Chicago University Press.

Smith, P. (1996) *Interpreting Cézanne*, London, Tate Publishing.

Strzemiński , W. (2003 [1933]) 'Statement' in Harrison and Wood (2003), IVA5, pp. 376–8

van Doesburg, T. (2003 [1918]) '*De Stijl*: "Manifesto 1"' in Harrison and Wood (2003), IIIC4, p. 281.

van Doesburg, T. (2003 [1919]) 'From *Principles of Neo-Plastic Art*' in Harrison and Wood (2003), IIIC5, pp. 281–4.

van Doesburg, T. (2009 [1921]) 'Manifesto III: Towards a new world plasticism' in *Van Doesburg and the International Avant-Garde* (2009), p. 125.

van Doesburg, T. (2009 [1922]) 'From "Declaration of the International Faction of Constructivists at the First International Congress of Progressive Artists"' in *Van Doesburg and the International Avant-Garde* (2009), p. 125.

Van Doesburg and the International Avant-Garde: Constructing a New World (2009) London, Tate Publishing (exhibition catalogue).

Wood, P. (ed.) (1999) *The Challenge of the Avant-Garde*, London, Yale University Press in association with The Open University.

Wood, P. (2002) 'Modernism and the idea of the avant-garde' in Smith, P. and Wilde, C. (eds) *A Companion to Art Theory*, Oxford, Blackwell, pp. 215–28.

Wood, P. (2004) 'The idea of an abstract art' in Edwards, S. and Wood, P. (eds) *Art of the Avant-Gardes*, London and New Haven, CT, Yale University Press in association with The Open University, pp. 228–71.

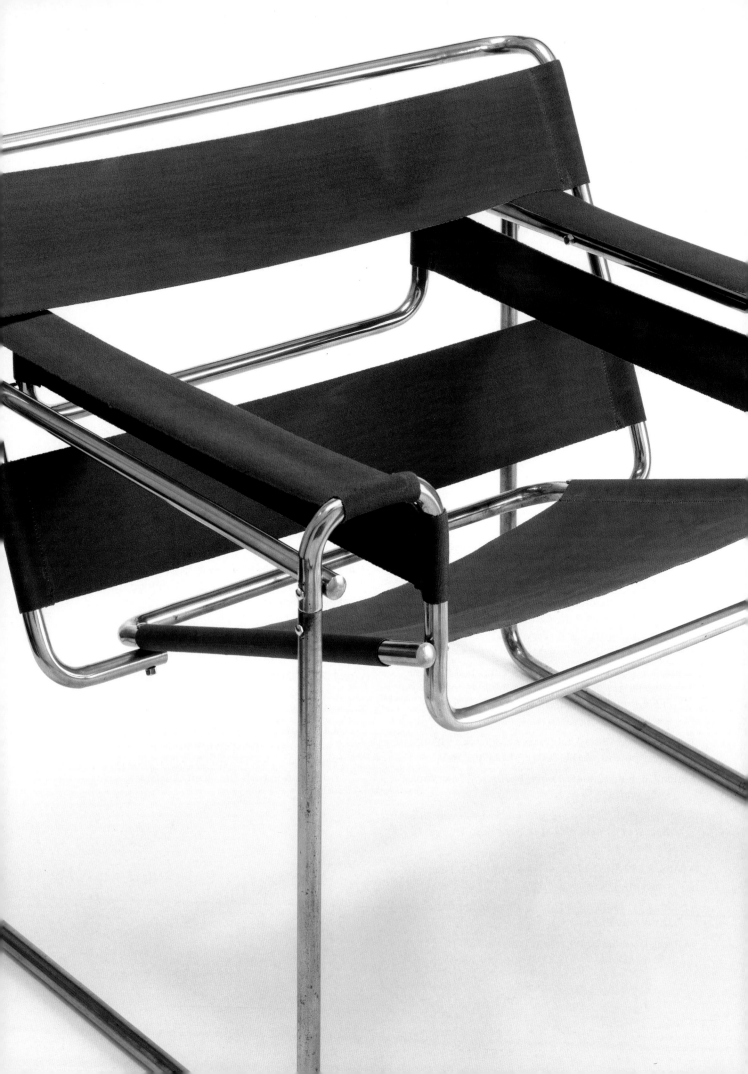

Chapter 4

Modernism in architecture and design: function and aesthetic

Tim Benton

Introduction

Should architects and designers attempt to make art out of their work, or should architecture and design simply be useful? These questions are particularly relevant to a discussion of twentieth-century architecture and design, since one of the most common criticisms of modern architecture and design was that it was simply 'functional', cold and unconcerned with beauty. For instance, in a BBC radio debate published in *The Listener* on 29 November 1934, the British architect Reginald Blomfield (1856–1942) asserted, '"Efficiency equals beauty" is the war-cry of the modernismists, their one attempt in theory to justify their strange aberrations.'[1] Blomfield invented the word 'modernismists' to imply a foreign influence, and wrote a book entitled *Modernismus* in the same year to argue that new trends in all the arts derived from Russian and German

Bolshevism.[2] Although Blomfield was by no means insensitive to the modern world – he designed Lambeth Bridge in London (1929–32) and the pylons used in the 1930s to develop the electricity grid in Britain – his favourite period of architecture was the seventeenth and eighteenth centuries, and many of his buildings are in the so-called 'Wrenaissance' style (Plate 4.2). His opponent in this debate was a young architect from New Zealand, Amyas Connell (1901–80), who had just spent three years in Rome as winner of the prestigious Rome prize in architecture in 1926. His work was very different from Blomfield's. The house he designed for the distinguished archaeologist Sir Bernard Ashmole, director of the British School at Rome, has a flat roof, concrete construction and horizontal windows set flush in the white walls (Plate 4.3).

Plate 4.1 (Facing page) Marcel Breuer, Wassily armchair (detail from Plate 4.22).

Plate 4.2 Reginald Blomfield, Lady Margaret Hall, Oxford, 1926. Photo: © Lady Margaret Hall, Oxford.

An early but representative example of modernism in architecture and design was the Weissenhof Siedlung exhibition (see Plates 4.4 and 4.5). In the summer of 1927, an international exhibition of 'demonstration' houses was built in a suburb of Stuttgart. Architects from Austria, Belgium, Germany and Switzerland were invited to design houses which could be thought of as mass housing prototypes, using new and experimental constructional techniques. This well-attended exhibition helped to form an idea of what modern architecture and design was about. The exhibition prompted lively debate and a fair amount of hostile criticism. Modernist critics picked up on the technical and design failures, but the majority view was that these buildings were merely 'functional' and lacking in human warmth and beauty. The debate was heavily politicised, with nationalist and right-wing movements in Germany labelling modern architecture 'Jewish' and 'Bolshevik'. A photomontage postcard would be printed later showing the Weissenhof Siedlung as an Arab village, complete with dromedaries. In

1933, the National Socialist government put almost a complete stop to architecture and design in the modern style, except in some practical fields, such as factory buildings and industrial design. At around the same time, the Soviet Union turned its back on the daring Constructivist experiments in art, design and architecture, introducing an academic style for virtually all public buildings. In most other countries, a stripped-down version of academic classicism continued to be used for all important public buildings and vernacular styles for domestic housing.

Nowadays, choosing between 'modern' and traditional architecture, furniture and fittings is a matter of taste. Some people live in houses built of stone or brick with a pitched roof and traditional furniture and decorations. Others live in blocks of flats or houses with flat roofs, large windows and sparsely decorated interiors. You can buy 'modern' tubular steel chairs or traditional wooden ones. The word 'modern' is still sometimes used to describe these differences,

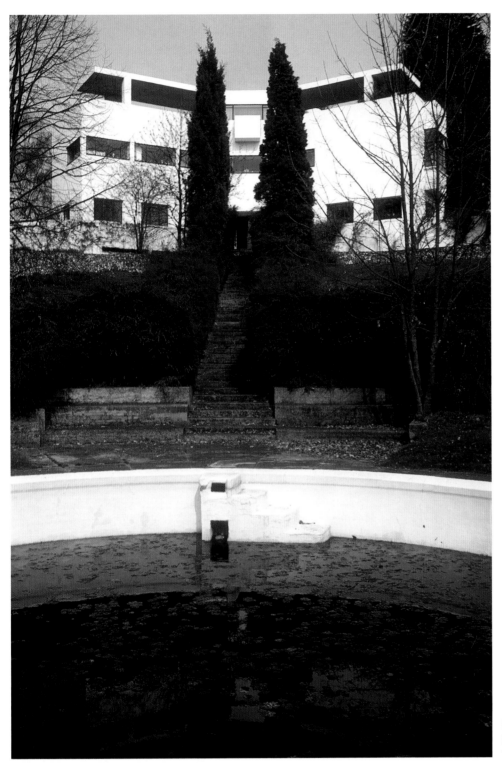

Plate 4.3 Amyas Connell, High and Over, Amersham, 1930. Photo: © Tim Benton.

although the 'modernity' to which it refers usually dates back to the 1920s. Today the decision arouses little passion, but in the 1920s it implied a choice between two fundamentally different ways of living and self-perception. A way of appreciating this is to look at how modern design was displayed in exhibitions, often in radically un-bourgeois settings. The photograph by Gustav Hassenpflug (1907–77) of a room designed by

Marcel Breuer (1902–81), complete with his tubular steel furniture, shows two young women in sportswear apparently listening to a gramophone (another symbol of modernity) in an otherwise bare room (Plate 4.6).

In this chapter, I will look at the origins of this concept of the 'modern' in architecture and design. How did these buildings come about, on what theories were they

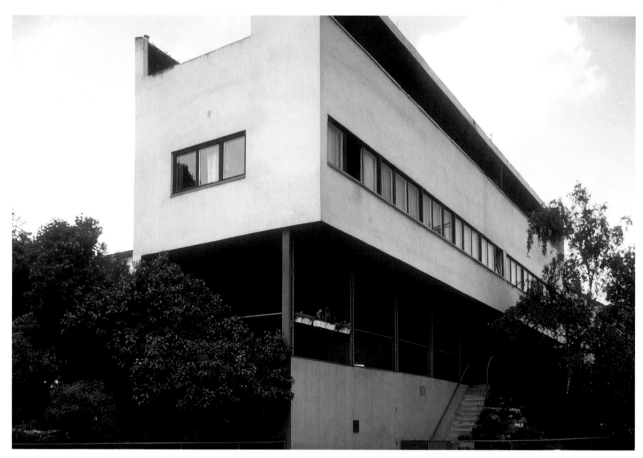

Plate 4.4 Le Corbusier and Pierre Jeanneret, single and double houses, Weissenhof Siedlung, Stuttgart, 1927. Photo: © Tim Benton.

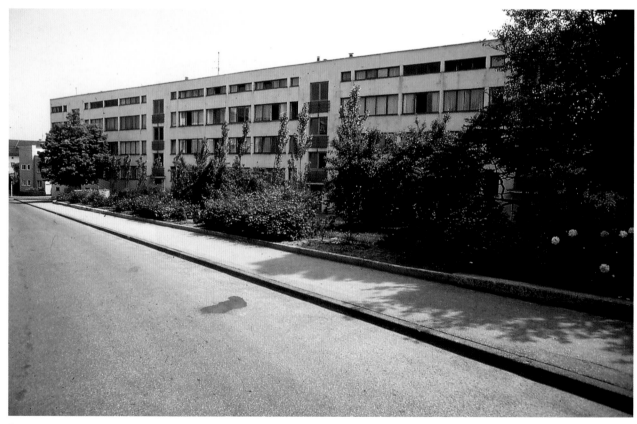

Plate 4.5 Ludwig Mies van der Rohe, apartment block, Weissenhof Siedlung, Stuttgart, 1927. Photo: © Tim Benton.

Plate 4.6 Marcel Breuer and Gustav Hassenpflug, gymnastics room in a sports teacher's home, Berlin, 1930. Photographed by Wanda von Debschitz. Photo: Bauhaus-Archiv Berlin. © Beate Ziegert, Toronto.

based and how were they received? I will focus on the ideas and work of the Swiss-born French architect Le Corbusier (1887–1965), which I will compare with the rather different direction taken by Central European architects and designers. Although my main emphasis will be on architecture, I will look as well at the issue of interior decoration and the design of furniture and household objects.

1 Modernism in architecture and design

By 'modernism', I mean a set of ideas in architecture and design which had its origins in the nineteenth century but which came together in dogmatic form in the 1920s. This term has been borrowed from post-war American art history, where it was used to describe the evolution of a 'pure', autonomous and non-representational abstract art.[3] In the 1920s, modern architecture was variously described as 'the modern movement', '*neues Bauen*', '*razionalismo*' and '*l'architecture moderne*'. It was usually thought of as the product of a rational, unsentimental, socially committed and cosmopolitan approach. This was an international movement with its heartland in Germany, Holland, Switzerland and France in the early 1920s. By 1928, the international organisation CIAM (Congrès internationaux de l'architecture moderne) had been set up and, from 1930, the style had spread to the Soviet Union, Britain, Italy, Spain, the USA and South America. We will look into all the underlying ideas more deeply later; at the risk of simplification, they can be summarised like this:

- The world had been transformed by industrialisation (the 'machinist era'), therefore architecture and design had to change too. These changes were understood as being not only material but spiritual (the 'spirit of the age' or Zeitgeist argument). In other words, there was thought to be a new mentality. The Zeitgeist argument, which derived from the tradition of post-Hegelian idealism, is not taken seriously today as an explanation for cultural changes, but it was almost universally evoked in the 1920s and 1930s.

- New materials and building methods had become available, therefore architecture had to change by making proper use of these materials (the structural rationalism argument). The new structural materials should not only be used,

but be seen to be used. The strength of a steel or reinforced concrete beam could be used to support part of a building and project it beyond the line of the supports, creating an effect of weightlessness. The consequence was a plentiful use of overhangs, long windows which 'turned the corner' of a building, and overhanging (or cantilevered) roof slabs, balconies and canopies.

- Society was transforming itself in the direction of a more egalitarian distribution of human rights and resources, therefore the prime duty of architects was to assist this process and cater for the needs of the greatest number, if necessary by revolutionary means (the social imperative). Most modernists considered that the overriding duty of any architect was to devise new forms of economical housing to accommodate the masses of newcomers to cities, who were scandalously ill-housed in slums.

- A consequence of these premises was the assumption that there was no place for ornament and decoration in modern architecture and design. Given these conditions, architecture and design had, above all, to be functional, if necessary by abandoning aesthetic pretensions (the functionalist argument).

None of these arguments are as simple as I have presented them here, and all might be considered contentious. Not all members of the modern movement accepted all these ideas, especially the last.

The academies and the historic styles

Let us flesh these ideas out a little, to see how they fit together. The first thing to understand is what modernism opposed. The main targets of modernist rhetoric were the academies, eclecticism and nationalism or regionalism. The academies of architecture in Europe and North America taught a set of rules and techniques based on the styles of the past, most typically classicism, for which architects like the above-mentioned Blomfield stood. These rules and practices, especially as enshrined in the French Beaux-Arts system, were extremely knowledgeable, sophisticated and surprisingly flexible. Architects had adapted the historical styles to the completely new functions of the modern world – banks, office buildings, even factories and railway stations – and had learned to use different styles to express different functions. Gothic was typically used for churches,

Neo-classicism for banks, government buildings and so on, associating these building types with different values. Giving a building a façade in a classical or neo-Gothic style was wrong, according to modernists, both because of structural rationalism (the façade did not reflect the modern materials of which the building was constructed) and because it did not reflect the Zeitgeist. Most modernists would have put this in ethical terms: the eclectic façade was a lie. We will return to structural rationalism, but first we must grapple with the idea of the Zeitgeist and the idea of style.

The Zeitgeist and a style for the age

The Zeitgeist argument against eclecticism was of two kinds, material and spiritual. The material argument was based on the inconsistency between the facts of modern life (standardisation, industrialisation, transportation, urbanisation) and the use of techniques and forms based on the pre-industrial world. The spiritual argument is harder to pin down. Many people believed that in earlier times a natural unity of taste and sensibility associated the physical world and the world of the imagination. People in this mythical period were thought of as being in tune with their times and with nature. Industrialisation had destroyed this unity by separating people from their natural environment. In certain peasant communities, untouched by industrialisation, this unity might still exist, evolving slowly and naturally over time. But, following the rupture of a living tradition based on craftsmanship, architects had turned to the styles of the past, which remained as fossilised and nostalgic remnants of another age.

The question of style, however, is problematic. Architectural style can be defined as a way of building which reflects similar ideas and adopts a recognisably similar set of forms. From this description, the modern movement can properly be described as a style. Modernist architects shared many convictions, and most of their buildings look similar, having flat roofs, open plans, clear-cut forms (often white and devoid of ornament), large expanses of glass and thin columns or piers made of concrete to support the structure. But such was the antipathy of modernists to the styles of the past that they always denied that modernism was a style. And yet most architects and theorists in the 1920s believed in the concept of a style that expressed the ideas and material conditions of any given period. To copy the styles of the past was wrong, but to try to be of one's time was right. As Le Corbusier put it,

'The "styles" are a lie. Style is a unity of principle that animates all the works of an era and results from a distinctive state of mind.'[4] What Le Corbusier meant by this is that at any one time the 'spirit of the age' should guide the imagination of all creative artists to produce work which has a coherent and recognisable quality to it ('style'), and which is distinctive and unique to that period. For example, it was often said that the ecclesiastical architecture of the Middle Ages expressed the fundamental striving towards salvation expressed in the Christian faith. The towering verticality of many Gothic cathedrals could be understood in these terms. For some modernists, a distinctive feature of the twentieth century 'spirit of the age' was a new sense of space. The German architect Ludwig Mies van der Rohe (1886–1969) gave the most evocative definition of the Zeitgeist principle in July 1923: 'Building art is the spatially apprehended will of the epoch. Alive. Changing. New.'[5] Unfortunately, according to Le Corbusier, most people were blind to the changing world around them and preferred the 'lies' of past styles.

The Zeitgeist and fashion

Another difficulty arising from the notion of style was that it could be confused with fashion. This was a common tactic in support of the Zeitgeist argument. In the words of the influential Austrian architect Otto Wagner (1841–1918):

> A man in a modern travelling suit, for example, fits in very well with the waiting room of a train station, with sleeping cars, with all our vehicles; yet would we not stare if we were to see someone dressed in clothing from the Louis XV period using such things? ...
>
> It is simply an artistic absurdity that men in evening attire, in lawn tennis or bicycling outfits, in uniform or chequered breeches should spend their life in interiors executed in the styles of past centuries.[6]

Sensibility in fashion, it was argued, automatically changes to meet new conditions, whereas most architects are somehow insensitive to the world around them. The trouble with the appeal to fashion, with its frivolous connotations, was that architects liked to think that admiration of their work would last longer than the twists and turns of fashion. The benefit of appealing to the universal values of antiquity and past styles, as the academies did, was that it encouraged architects to believe that their work would last as long in public estimation. Otto Wagner wrote an important

book called *Moderne Architektur* (1896), which was reprinted several times.[7] In this book, he argued forcefully that architects should abandon the styles of the past and reflect the conditions of modernity. In 1914, however, he changed the title to *Die Baukunst unsere Zeit* ('Contemporary building art'), because he felt that the word 'modern' was contaminated by the root 'mode' (fashion) and therefore lacked sufficient seriousness of purpose. We will see, below, how Le Corbusier struggled with this dilemma.

The origins of modernism

It should be clear by now that the arguments supporting modernism tended towards the idea that architecture and design were strictly determined by changing conditions in the world, and that therefore the autonomy of the architect and designer to design freely was increasingly constrained. Industrialisation brought this issue to the fore for very specific reasons. The economies of scale of standardisation meant that hand-craftsmanship was everywhere threatened by machine-made products. The English Arts and Crafts movement in the 1880s and 1890s had simply tried to resist this trend, but others, especially in Germany, realised that the solution was not to fight the machine but to control it. In 1907, a group of industrialists and architects formed the Deutscher Werkbund (German Trades Association) in Munich. The Deutscher Werkbund was a state-funded organisation which, with its yearbook, played a potent role in arguing for a fundamental change in attitude and aesthetic in architecture and design. For example, in the *Deutscher Werkbund Jahrbuch* of 1913, the German architect Walter Gropius (1883–1969) published a set of photographs of grain silos and industrial buildings, arguing that these represented the true spirit of the age.[8] Other articles argued for a substantial simplification of design, not only to make industrial production easier, but more importantly to reflect social trends. In 1915, a similar British organisation, the Design and Industries Association, was established in London.

The problem of ornament

Architects and designers had always used ornament to add meaning to their work. But, in the modern world, hand-craftsmanship was too expensive and machine-produced ornament was crude and 'inauthentic'; better to do without ornament at all. The Austrian critic and architect Adolf Loos (1870–1933) went further. In a famous article written in 1908, 'Ornament und Verbrecken' ('Ornament and crime'), Loos argued that the development of civilisation went hand in hand with an elimination of ornament.[9] Papuans, he said, were entitled to cover their bodies with tattoos, but a man of the twentieth century who did so was either a degenerate or a criminal. Needless to say, current fascination with body piercing and tattoos was not shared by polite society at the beginning of the twentieth century. Modern man and woman, he argued, took satisfaction from the higher arts – philosophy, poetry, art and music – and had no need to express themselves through the crafts. Instead of surrounding themselves with decorated *objets d'art*, the modern patron should sit on simple, well-made chairs and contemplate art, read a book or listen to music. The model for male fashion, he claimed, was not the product of over-decorated Viennese fashions, but the well-made, simple suit of the English gentleman. The aim of the English, he believed, was to be inconspicuous in their clothes, leaving it to the individual to express his or her personality in other ways. Loos's arguments are tendentious and extreme, but he had a big influence in all the German-speaking world, and his articles were translated and published in French journals in the 1920s. The rejection of ornament and decoration became one of the fundamental tenets of modernism in architecture and design.

L'Esprit nouveau and the Zeitgeist

We will now look in more detail at Le Corbusier's ideas about design and architecture. Le Corbusier was the nom de plume adopted by Charles Edouard Jeanneret in 1920 for a set of articles on architecture which he later published as a book, *Vers une architecture* (*Toward an Architecture*), in 1923.[10] Jeanneret adopted this name formally in 1930. He was born in the Swiss watch-making city of La Chaux-de-Fonds, high in the Swiss Jura mountains. In 1911, he wrote a report on the development of new ideas in industrial design in Germany and he was present at the first conference of the Deutscher Werkbund in Cologne, in 1914. This enabled him to follow closely the debates about industrial design and the need to create standardised prototypes which could be mass-produced. Discussion about the place of the machine in design was more fully developed in Germany before the war than anywhere else in Europe.

By the time Jeanneret moved to Paris in 1917, he had built six houses, in a range of styles, and begun to invent on paper radically new forms for construction in reinforced concrete. In 1918, he met the painter

Amédée Ozenfant (1886–1966) and they formed an art movement, which they called Purism, with a first exhibition and book – *Après le Cubisme* – launched in the same year. In 1920, with the help of an experienced journalist, Paul Dermée, they founded a magazine called *L'Esprit nouveau*, which ran, on and off, for five years. The journal's title, 'The New Spirit', is a direct reference to the Zeitgeist. The articles Jeanneret wrote in this journal, at first under the pseudonym Le Corbusier-Saugnier and then as Le Corbusier, launched the career of Le Corbusier the architect and were reprinted in five books, the first of which – *Vers une architecture* – became the most published book on architecture of the twentieth century.

The title page of the first issue of *L'Esprit nouveau* states the aims of the review:

> To make the spirit which animates the contemporary era comprehensible; to grasp the beauty of this period, its originality and spirit; to demonstrate that this era is as beautiful as those of the past in which we might have wished to live.
>
> To demonstrate the unified spirit which animates the elites of our society in their investigations.[11]

L'Esprit nouveau did not look like a conventional art journal. Relatively small (25 cm × 16.5 cm), it included articles on politics, economics, psychology, literature, music, popular culture and film as well as art and architecture. It was aimed at bankers, industrialists and intellectuals who wanted to keep abreast of a wide range of intellectual and artistic activity. The dominant argument was that of the Zeitgeist.

> There is a new spirit; it is a spirit of construction and synthesis directed by a clear concept. Whatever one thinks, it animates, today, most of human activity. ... *A great epoch has just begun* [original emphasis], since every form of human activity is being organised under the same principle. ... But we must help this new spirit, which only exists in the arts among some people – the best ones – to triumph spectacularly.
>
> Evolution can be accelerated by a well-calculated intervention.[12]

It is worth reflecting on this statement, which demonstrates many of the problems of the Zeitgeist theory. On the one hand, it looks like a determinist theory, one that suggests that changes in the material world automatically have an influence on the arts. But the second half of the extract demonstrates that this is

not the case. Only 'the best ones' – defined elsewhere by Le Corbusier as poets and prophets – are sensitive to the new spirit. Everyone else must be helped to understand the spirit of the age. Le Corbusier entitled a later set of three articles in *L'Esprit nouveau* 'Eyes which do not see' (concerning, respectively, liners, aeroplanes, automobiles). He hoped that by illustrating modern machines he could persuade his readers that modern architecture too should be radically different. Architects were being trained to apply form and ornament to structures. Engineers did not work like this, not because they did not want to, but because the rigours of their profession stripped design to the bone. An aeroplane covered with carved ornament is unlikely to fly. Material has to be used economically and efficiently in a bridge, for example, based on a geometrical arrangement which often communicates the tension between structure and load in a satisfying way. As a result, the products of the modern world were often (but not necessarily) beautiful, except where architects or designers had distorted them.

Functionalism and the spiritual

We need to look closely now at the argument of functionalism. Modern architecture is routinely described as 'functionalist' and yet very few modernist designers or architects could properly be so described. There are a number of ways of thinking about functionalism. The radical functionalists believed that everything should be sacrificed to utilitarian necessity, to meet the needs of society. If beauty suffered, so be it. The formula of the Swiss architect Hannes Meyer (1889–1954; director of the Bauhaus from 1928 to 1931) was brutally simple: 'All things in this world are a product of the formula: (function times economics).'[13] For radical functionalists, life was more important than art. The functionalist aesthetic is different, arguing that what is functional necessarily becomes beautiful.

Le Corbusier coined a phrase which has often been misunderstood as functionalist: 'the house is a machine for living in'. But what does this sentence mean? In one sense, it is obviously true. Houses and machines have many things in common: they are inanimate constructions with working parts designed to serve some practical purpose. But the sentence still appears shocking because it is often taken to be an exhaustive definition: a house is nothing but a machine. We normally distinguish between 'house' and 'home', associating the intimate human aspects of where we live with the latter rather than the former. Clearly, the sentence 'the home is a machine for living in'

would be even more controversial and indeed highly questionable. Le Corbusier very frequently and explicitly dismissed the premises of functionalism:

> You work with stone, with wood, with concrete; you make them into houses and palaces; this is construction. Ingenuity is at work.
>
> But suddenly you touch my heart, you do me good, I am happy, I say: 'It is beautiful.' This is architecture. Art is present.[14]

In other words, satisfying functional and utilitarian requirements is only part of the work of the architect. And he described the highest aspirations of architecture, which he associated with the Parthenon in Athens, as 'Architecture, pure creation of the mind.'[15]

The organic metaphor

The organic metaphor was very commonly used in the twentieth century, arguably much more so than it was in the nineteenth. The German architect and theorist Hugo Häring (1882–1958), who shared an office with Mies van der Rohe for several years, believed that the job of the architect was to try to imitate the way that forms evolve in nature.

> There is a path to form, followed by all [natural] things, even crystals and geometrically shaped ones, which allows each to develop according to its own inner plan, while on that other path [the geometric], things have their forms bestowed on them from without, which contradicts this innate tendency … there is no other way forward but consciously to act as nature acts, consciously ordering things in a way that allows their individuality to unfold, while this unfolding also serves the life of the whole. This whole is the form [*Gestalt*] of our life.[16]

He criticised architects who imposed what he called 'geometric' form on a building, instead of seeking to interpret its 'innate tendency'. He meant by 'innate tendency' something rather more than the sum of its functions and the materials of which it was constructed. His idea was that buildings had a kind of inner spirit or essence and it was the architect's job to be sensitive to this. Häring's organic functionalism might appear to be a rather extreme and irrational idea, but many architects, Mies van der Rohe included, held similar views. For example, Mies's favourite author, Raoul H. Francé (1874–1943), wrote a series of books designed to show how forms evolve in nature and arguing for a return to a more natural relationship with

the environment.[17] Francé argued against the cult of the individual, derived in part from Friedrich Nietzsche (1844–1900). He believed that men and women could only find happiness by subjecting themselves to the laws of nature and dominating their individual will. This almost religious asceticism explains some of the motivation for stripping away ornament and detail, and concentrating on the basic elements of construction and enclosure.

Beyond function

A major flaw with the Zeitgeist idea was that it appeared to be a theory of progress. Machines and tools, like animals and plants, naturally evolve progressively to adapt better and better to their environment.

> The tools of man mark the stages of civilization, the Stone Age, the Bronze Age, the Iron Age. Tools advance by successive improvements; they are the sum of the work of generations. Tools are direct and immediate expressions of progress … We throw old tools onto the scrap heap: the blunderbuss, the culverin, the carriage and the old locomotive. This gesture is a manifestation of health, of moral health, also of morality; we do not have the right to produce badly because of bad tools. …
>
> But men live in old houses and have not yet dreamed of building their own houses.[18]

A new machine or work of engineering is better than an old one. If progress made old tools redundant, did it devalue all the architecture of the past? Le Corbusier did not think so. Although the conditions of an age created the need for new functions, materials and forms, these remained at the level of building until they had been refined and perfected. This process of perfection Le Corbusier called the refinement of the 'standart', which he curiously spelled with a 't', perhaps because he thought he was referring to an English word associated with Henry Ford and the perfection of standardised products.

In a famous double-page spread, Le Corbusier compared two Greek temples, above, with two motor cars, below (Plate 4.7). This layout is usually interpreted as challenging the reader to accept that motor cars are the equivalent of Greek temples. This is absolutely not what Le Corbusier intended. He considered the Parthenon to be the most supreme example of architecture. His point was rather that just as the design of Doric temples (given a set of constraints imposed by the time) improved between the creation of Paestum and the

PAESTUM, *de 600 à 550 av. J.-C.*

Il faut tendre à l'établissement de *standarts* pour affronter le problème de la *perfection*.

Le Parthénon est un produit de sélection appliquée à un standart établi. Depuis déjà un siècle le temple grec était organisé dans tous ses éléments.

Lorsqu'un standart est établi, le jeu de la concurrence immédiate et violente s'exerce. C'est le match ; pour gagner, il faut faire mieux que l'adversaire *dans toutes les parties*, dans la ligne d'ensemble et dans tous les détails. C'est alors l'étude poussée des parties. Progrès.

Cliché de La Vie Automobile. HUMBERT, 1907.

Cliché Albert Morancé. PARTHÉNON, *de 447 à 434 av. J.-C.*

Le standart est une nécessité .

Le standart s'établit sur des bases certaines, non pas arbitrairement, mais avec la sécurité des choses motivées et d'une logique contrôlée par l'expérimentation.

Tous les hommes ont même organisme, mêmes fonctions.

Tous les hommes ont mêmes besoins.

Le contrat social qui évolue à travers les âges détermine des classes, des fonctions, des besoins standarts donnant des produits d'usage standart.

La maison est un produit nécessaire à l'homme.

DELAGE, *Grand-Sport* 1921.

Plate 4.7 Le Corbusier, Parthenon-Delage, double-page spread from 'Des yeux qui ne voient pas, III', *L'Esprit nouveau*, vol. 10, July 1921, pp. 62–3. Photo: Fondation Le Corbusier. © FLC/ADAGP, Paris and DACS, London 2012.

Parthenon, so motor car design was evolving towards a gradual perfection of form:

> The Parthenon is a product of selection applied to an established standard ... When a standard has been established, direct and fierce competition comes into play. It's a 'match'; to win, you must do better than your adversary *in all the parts*, in the general lines and in all the details. Progress.
>
> …
>
> So let us put the Parthenon and the automobile on show to make it clear that it's a question here, in different domains, of two products of selection, the one having reached its outcome, the other still progressing.[19]

How could a theory of progress, with its necessary dependence on material factors, accommodate questions of value? If responding to the conditions of the age was necessary for a healthy society, it was not sufficient to produce architecture of high quality. Le

Corbusier therefore sees a double process at work. First, open your eyes to the world around you, understand the new structural possibilities, the new technologies, the new social needs. Then, once you have established a 'standart' which satisfies these requirements, set about refining, improving and perfecting the 'standart' until you have produced a work of architecture. Le Corbusier believed in a separate sphere of the spirit, linked to but not dependent on the physical world. It is for this reason that Le Corbusier called his book *Vers une architecture* (*Toward an Architecture*) and not, as the English language edition of 1928 had it, *Towards a New Architecture*. Again and again, Le Corbusier separates architecture from building. He contested the view held by many modern architects, that even if function is not always necessarily beautiful, it is more important than aesthetic appeal. What society needs, the functionalists argued, is not more beauty but more useful buildings to meet the needs of the mass of society. But, for Le Corbusier, the aim for every architect should be 'architecture':

ARCHITECTURE is an artistic fact, an emotional phenomenon that is outside questions of construction, beyond them. Construction: THAT'S FOR MAKING THINGS HOLD TOGETHER; Architecture: THAT'S FOR STIRRING EMOTION. ... Architecture is a matter of 'relationships', a 'pure creation of the mind'.[20]

And in the first of the essays he wrote in *L'Esprit nouveau* (October 1920) he wrote: 'Architecture is the masterful, correct and magnificent play of volumes brought together in light.'[21] So, Le Corbusier was never a functionalist, and the title of his book, *Toward an Architecture*, meant exactly that: how to create architecture which would be at one and the same time 'modern' and universal (good).

It should be clear by now that the founding arguments of modernism in architecture and design were not as simple as they might appear and leave plenty of room for disagreement. In fact, soon after 1928, a major split occurred within architectural modernism, between those dubbed 'lyrical' or 'formalist', who were determined to retain the concept of architecture as art, and the functionalists, who wanted to make architecture and design strictly functional. The Czech artist and architect Karel Teige (1900–51), who had been a sincere admirer of Le Corbusier's work in the early 1920s, published a stinging criticism in 1929. By then, Teige espoused a fully fledged functionalist aesthetic, stating:

> Constructivism acknowledges the antique truth: 'the useful (i.e. the perfect) is beautiful.' Beauty is nothing but an epiphenomenon of functional and objective perfection which stimulates in us the sensation of harmony and equilibrium ... Beauty is like a chemical reaction: the fusion of form and function.[22]

Teige accused Le Corbusier of 'lofty speculation', 'idealism' and 'unrealizable utopia'.[23] For Teige, monumental buildings in themselves were an irrelevant distraction from the vital objectives of life, and Le Corbusier's use of systems of geometrical proportion in his plans compounded the error. Le Corbusier wrote to Teige in August 1929 and sent him a long piece entitled 'Defence of architecture', which was eventually published in the Czech journal *Mousaion* and in the French magazine *L'Architecture d'aujourd'hui*.[24] In it, Le Corbusier insisted that ordering of forms required composition and imagination and that the useful could never be automatically beautiful. This very public exchange marked the definitive split between the 'functionalists' and the 'formalists' within modernism.

2 Le Corbusier's architecture

How did Le Corbusier's ideas play out in his architecture? Between 1922 and 1929, he designed a number of buildings in the Purist manner, most of which conform to five principles of design, the 'five points for a new architecture' which he formulated in 1927 (indicated in bold below). The structure (in the form of thin concrete struts, which he called **pilotis**) should be visible and should be exploited to create **long windows**. These windows might stretch from end to end of a building, with the line of pilotis set back from the façade and supporting floor slabs from which the wall above the windows could be hung. The grid of thin pilotis would create the **open plan**, because walls were no longer needed to support the floors. Similarly, the **free façade** resulted from the fact that the façade itself was not structural, but suspended from the floor slabs. Finally, the flat roof, dictated by the use of a constructional system of pilotis supporting floor slabs, created the potential for a **roof garden**. Thus, according to Le Corbusier, much of the space underneath the house could be used, as well as all the space above it.

The last of these buildings of the 1920s, the Villa Savoye, designed by Le Corbusier and Pierre Jeanneret, presents these ideas in an almost diagrammatic form (Plates 4.8 and 4.9). Part of the ground floor is scooped out in a 'U' shape, so that cars can drive in between the pilotis and deposit visitors at the front door. The metaphor of vehicular transportation is continued with a ramp which rises up through the building. Each floor plan is different. The façades consist of four long windows which stretch almost to each corner. The first floor is opened out to create a terrace and the top floor includes a solarium. The Villa Savoye is one of the defining buildings of 1920s modernism. Its abstract clarity, open spaces and light-filled interiors may seem impractical but they perfectly symbolise the desire to live a different, purer and more ascetic life.

Le Corbusier himself, however, lost interest in Purism and the five points for a new architecture at exactly the time the Villa Savoye was being built. There are a number of reasons for this, but the main one is that Le Corbusier saw that a fashion for a reductive form of functionalist architecture was spreading quickly in Europe and he believed that architecture must recapture its roots in craftsmanship and respect for natural materials. We will see that a similar reaction occurred in the field of furniture design. He began designing buildings with walls of rough stone or brick, plywood

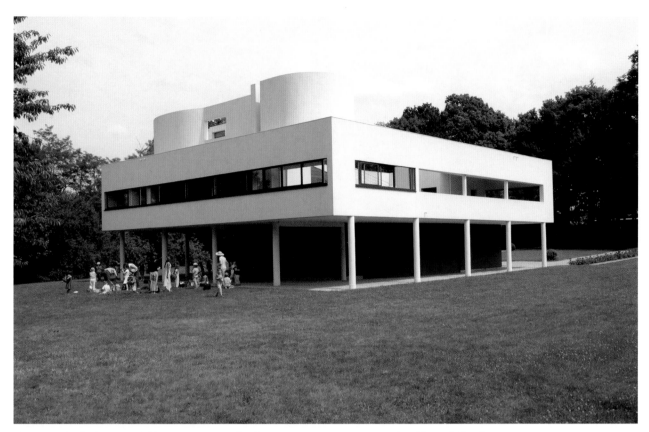

Plate 4.8 Le Corbusier and Pierre Jeanneret, Villa Savoye, Poissy, 1928–30, exterior. Photo: © Tim Benton.

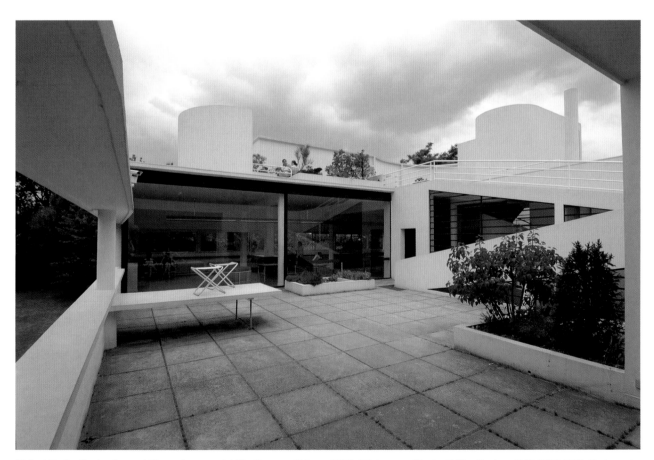

Plate 4.9 Le Corbusier and Pierre Jeanneret, Villa Savoye, Poissy, 1928–30, terrace. Photo: © Tim Benton. © FLC/ADAGP, Paris and DACS, London 2012.

Plate 4.10 Le Corbusier and Pierre Jeanneret, house for Albin Peyron, 'Le Sextant', Les Mathes, near Bordeaux, 1935. Photo: © Tim Benton.

wall surfaces, arches and vaults, and translucent glass bricks. In 1935, he designed two small houses, one in a suburb of Paris and one by the Atlantic coast north of Bordeaux (Plate 4.10).

The client was Albin Peyron (1870–1944), commander of the Salvation Army in France, for whom Le Corbusier had designed three works in Paris, from 1927 to 1930. Peyron wanted a simple, cheap holiday home in a pine forest near the beach, and Le Corbusier provided him with the kind of summer house he liked himself – informal, simple and built by local labour. For many years, Le Corbusier and his wife Yvonne had taken their summer holidays in the Bassin d'Arcachon, near Bordeaux, staying in a simple wooden house and spending most of their time out of doors. Le Corbusier never lost the admiration he felt for simple vernacular buildings that he had acquired in his youth. The house, 'Le Sextant', as Peyron dubbed it, has no trace of modernist doctrine about it. The 'five points of a new architecture' are completely missing. Like a number of other 'pioneer' modernists, Le Corbusier had become a critic of the 'pure' modernism he had helped launch in the 1930s, but this takes us beyond our subject.

3 Structural rationalism

Architects had often argued, since antiquity, that a building should express its structure in its form. The example of Gothic architecture was often cited, where the use of slender stone piers, flying buttresses and rib vaults allowed for the opening up of large expanses of glass. In a Gothic cathedral, it was argued, the structure was the building, and its aesthetic appeal depended in large measure on the dramatic opposition of weight and resistance. Instead of arguing that Gothic architecture was driven by religious yearning (the Zeitgeist argument), structural rationalists would claim that it was the masons' desire to develop the possibilities of stone structures to the limit which determined their forms. With the development of steel and concrete structural methods, it was argued, a new architecture should be developed which reflected the new materials.

The requirement to respond to the potential of the new materials was given an ethical character by some architects. When the German Expressionist architect Erich Mendelsohn (1887–1953) visited America in 1924, he was fascinated by the contrast between the steel

Plate 4.11 Erich Mendelsohn, Schocken department store, Stuttgart, 1928. Photo: © Bildarchiv Foto Marburg.

skeletons of the soaring skyscrapers in construction and the disappointing effect (for him) once the cladding had been added. In his book *Amerika* (1926) he captioned such a photograph 'The "X-Ray" of the finished building'.[25]

Mendelsohn understood the structure as the hidden 'truth' inside the building. In his architectural practice, he set about expressing this 'truth' in his buildings. For example, in one of a series of department stores for the Schocken company, he exposed the steel structure in the staircase tower and used the structure to expose large expanses of glass for the shop windows (see Plate 4.11). Two years later, in an influential book, *Bauen in Frankreich: Bauen in Eisen, Bauen in Eisenbeton* (*Building in France: Building in Iron, Building in Ferroconcrete*), the Swiss critic Sigfried Giedion (1888–1968) went further:

Construction based entirely on provisional purposes, service, and change is the only part of building that shows an unerringly consistent development. Construction in the nineteenth century plays the role of the subconscious. Outwardly, construction still boasts the old pathos; underneath, concealed behind facades, the basis of our present existence is taking shape.[26]

The moral duty of the modernist architect was to heal the pathology of the modern world by making the repressed visible. This is the intellectual context for statements such as that of Mies van der Rohe when he summed up his creed in 1923 as 'absolute truthfulness and rejection of all formal cheating'.[27]

4 The industrial aesthetic and transparency

One of the important changes in the early twentieth century occurred when architects and others began to look again at railway viaducts, train sheds, grain silos and factories and to see them not only as functional but also as beautiful. We will see that there were two main ways to interpret these great functional structures as aesthetically satisfying. One was to consider them as pure form – 'volumes brought together in light' – whose aesthetic potential lay in their primary geometric forms.

Empathy

Le Corbusier argued, for example, that the beauty of certain concrete grain silos or aircraft hangars was derived from the fact that the calculations that engineers used led to pure geometric forms which had universal aesthetic appeal (see Plate 4.12). Behind this argument was a belief that certain lines, colours and forms had a direct, physiological effect on the senses, automatically producing sensations of calm, agitation or excitement in the beholder. The search for an understanding of the effect of form on the emotions had been explored in laboratory conditions in Germany at least since Wilhelm Wundt's establishment of the first laboratory for experimental psychology in Leipzig in 1873. The aim was to understand how pure form might trigger emotional states, either directly, in the mimetic movement of muscles and organs of the body (the so-called James–Lange theory),[28] or through stimulating memories of physical sensations. Partly captured by the concept of *Einfühlung* (empathy), first coined by Robert Vischer (1847–1933)[29] and theorised by Theodor Lipps (1851–1914),[30] these theories were hotly debated in the international journals between 1890 and 1920. Ozenfant and Le Corbusier certainly shared some of these ideas and published in *L'Esprit nouveau* magazine in 1921 a series of articles by the scientist and aesthetician Charles Henry (1859–1926) which had originated in work published in 1885.[31] These purported to explain the impact of different angles of lines (and many other aspects of form and colour) on the viewer.

If Le Corbusier looked to the formal properties of works of engineering, others celebrated the fragility and transparency of steel structures. The new works of engineering – suspension bridges, cranes, large sheds – had been admired in the nineteenth century for their structural daring but had generally been regarded as lacking aesthetic qualities. The Eiffel Tower (1887), which split opinion among modernists and traditionalists alike, is a case in point. This began to change at the end of the nineteenth century. Several books and articles written in Germany before the First World War extolled the virtues of engineering works. For example, the Austrian historian Joseph August Lux published an influential book in 1910 entitled *Ingenieur-Aesthetik* ('The aesthetic of engineering'). The change of attitude is revealed in his declaration, 'Artistic form must be discovered anew from the new elements [of construction].'[32] The photographs in this book dramatised the sublime cantilever of a crane, the transparency of a lattice of steel, the endless expanses of glass and the graceful curve of a concrete vault. But it required a new way of looking at things to make these works seem aesthetically satisfying.

Transparency

The quality of transparency epitomised this different way of seeing things, which was supported and stimulated by 'the new photography'. Designers, painters, photographers and others, including László Moholy-Nagy (1895–1946), Aleksandr Rodchenko and Sigfried Giedion, took photographs from unusual angles in order to create an abstract effect (see, for example, Plate 4.13). These photographs emphasised what you could see beyond the structure as much as the structure itself. The essential experience of great engineering works was not their rationality but the giddy sense of vertigo induced by looking down through the maze of girders whose fragmentation of the surrounding world created a sensation of space akin to that of Cubism.[33]

> By their design, all buildings today are as open as possible. They blur their arbitrary boundaries. Seek connection and interpenetration.
>
> In the air-flooded stairs of the Eiffel Tower, better yet, in the steel limbs of a *pont transbordeur* [transporter bridge], we confront the basic aesthetic experience of today's building: through the delicate iron net suspended in midair stream things, ships, sea, houses, masts, landscape, and harbor. They lose their delimited form: as one descends, they circle into each other and intermingle simultaneously.[34]

trois rappels à
MM. LES ARCHITECTES

L'architecture n'a rien à voir avec les « styles ».

Les Louis XV, XVI, XIV ou le Gothique, sont à l'architecture ce qu'est une plume sur la tête d'une femme ; c'est parfois joli, mais pas toujours et rien de plus.

L'architecture a des destinées plus graves ; susceptible de sublimité elle touche les instincts les plus brutaux par son objectivité ; elle sollicite les facultés les plus élevées, par son abstraction même. L'abstraction architecturale a cela de particulier et de magnifique que se racinant dans le fait brutal, elle le spiritualise, parce que le fait brutal n'est pas autre chose que la matérialisation, le symbole de l'idée possible. Le fait brutal n'est passible d'idées que par l'ordre qu'on y projette. Les émotions que suscite l'architecture émanent de conditions physiques inéluctables, irréfutables, oubliées aujourd'hui.

Plate 4.12 Opening page of Le Corbusier, 'Trois rappels à MM les architectes', *L'Esprit nouveau*, vol. 1, October 1920, p. 91. Fondation Le Corbusier, Paris. Photo: Fondation Le Corbusier. © FLC/ADAGP, Paris and DACS, London 2012.

Abb. 63. Blick vom Pont Transbordeur Marseille auf Häuser

Plate 4.13 László Moholy-Nagy, 'Blick vom Pont Transbordeur Marseille auf Häuser' ('Transporter bridge, Marseilles'), from Siegfried Giedion, *Bauen in Frankreich, Bauen in Eisen, Bauen in Eisenbeton*, Leipzig, Klinkhardt & Biermann, 1928, n.p. Photo: Deutsche Nationalbibliothek. © Hattula Moholy-Nagy/DACS 2012.

Giedion used the German word '*Durchdringung*' (through-penetration) to suggest that this openness of space within a structure had also a social aspect to it: buildings were no longer to be enclosed and hierarchic, but open to all to see.

The idea of architecture as the composition of space rather than of masses has its roots in a number of different ideas. Before 1900, the idea gained currency that space should not be thought of as a negative 'emptiness' but as a positive value.[35] This idea had particular currency when discussing the dramatic spatial effects of Baroque architecture, and it is noteworthy that many of the historians who became defenders of modern architecture had begun by researching Baroque architecture. This was the case with Giedion, who also added an understanding of the effects of Cubist painting, in which the illusion of a fixed three-dimensional space is replaced by a more ambiguous representation. It seemed that to be modern, architects not only had to clean up their architecture to express its spatial qualities, they also had to open up their interiors to the exterior. Transparency of the enclosing volume appeared to create an ambiguity of form comparable to Cubism.

The idea of transparency therefore had a number of elements to it. The ethical argument claimed that to cover up the steel or concrete skeleton which supported the building was morally wrong. Making this skeleton visible could involve the use of walls of glass and, therefore, transparency.

Moholy-Nagy and the search for transparency

In an important book entitled *Von Material zu Architektur* ('From material to architecture'), published in 1928, the Hungarian designer, artist and photographer László Moholy-Nagy summarised the relationship between different kinds of materials and sculptural form.[36] According to Moholy-Nagy, sculpture develops necessarily through a succession of stages. In the first stage, form is fully rounded, while, in the second, form is partially hollowed out. By the third stage, this hollowing has led to the perforation of the form, which includes assemblages of materials. The future of sculpture, he claimed, would involve an as yet incomprehensible fourth and fifth stages. In the fourth stage, sculptural form would become detached

abb. **141** n. gabo 1922
kinetische plastik (pendel)

ein stiel aus draht, oben mit einem ge-
wicht, wird durch eine uhrfeder in schwin-
gung gebracht.
die unscharfe fotografie zeigt mehrere-in-
einandergewischte bewegungsfasen. (was
sonst als fehlaufnahme galt, ist hier gute
demonstration des bewegungsvorganges, des
entstandenen virtuellen volumens.)

156

klischee: „i 10"

Plate 4.14 Naum Gabo, *Dynamic Sculpture*, from László Moholy-Nagy, *Von Material zu Architektur*, Munich, A. Langen, 1929, p. 156. Photo: Deutsche Nationalbibliothek. The Work of Naum Gabo © Nina & Graham Williams.

from its fixed base and float in the air. Moholy-Nagy admitted that, in reality, such sculptures would rely on illusion. Either hidden wires would have to hold the thing in place or transparent materials such as Perspex or glass could provide the illusion of suspension in space. The fifth stage would involve the dimension of time. Virtual forms would be created by movement. Moholy-Nagy illustrated this idea using photographs

abb. **209** „architektur"

foto: jan kamman / schiedam

aus zwei übereinanderkopierten fotos (negativ) entsteht die illusion räumlicher durchdringung, wie die nächste generation sie erst — als glasarchitektur — in der wirklichkeit vielleicht erleben wird.

236

Plate 4.15 Superimposed photographs, credited to Jan Kamman, from László Moholy-Nagy, *Von Material zu Architektur,* Munich, A. Langen, 1929, p. 236. Photo: Deutsche Nationalbibliothek. © Hattula Moholy-Nagy/DACS 2012.

of 'virtual volumes' – the illusion of a three-dimensional form created by a spinning carousel captured in a time-lapse photograph. The sculptor Naum Gabo (1890–1977) created a virtual sculpture by rotating a wire fast enough for the eye to blend its movement into a shape (Plate 4.14). Behind the search for transparency lies a yearning for spiritual release, for an escape from the mundane laws of physics.

Applying this reasoning to architecture, Moholy-Nagy deduced that the higher forms of architecture consisted of compositions of space. Drawing up a list of evolutionary forms, from the closed cell to the completely liberated space, Moholy-Nagy suggested that the future of architecture belonged to an increasingly transparent and diaphanous architecture. The last illustration in his book tried to indicate the way forward. Two negative images of a modern building – the much admired Van Nelle factory in Rotterdam – were superimposed to create an illusion of a dynamic and insubstantial spatial composition (Plate 4.15). Moholy-Nagy associated this move towards transparency and dynamism in architecture with a social agenda. Buildings should serve the needs of all society, and the openness and transparency he sought were seen as essentially socialist attributes, reducing the hierarchy of the traditional architectural styles.

It should be clear from this description of Moholy-Nagy's ideas that, although he was committed to a social agenda and determined to use the hard and cold materials of modern industrial production in his work, Moholy-Nagy was an artist whose aims were aesthetic rather than functionalist. His vision was of a world in which modern materials and techniques, once they had transformed people's sensitivity, could be used to transcend their materiality and create a new kind of spiritual freedom.

Sigfried Giedion's book *Building in France*[37] is interesting because it brings together both aspects of modernist aesthetics: the transparency of steel structures and the formal qualities of reinforced concrete. The section of the book on concrete focused on Le Corbusier and tried to integrate his work with the overall argument about transparency.

> He attempts to translate into the housing form that suspended equilibrium, that lightness and openness that iron constructions of the nineteenth century express abstractly. He has shown us how one must mold the house throughout – below, above, on the sides – in order to relieve its weight.[38]

Giedion was capable of criticising Le Corbusier. For example, he warned of the dangers of 'luxury' in the design of large villas for wealthy clients. In the end, he argued, even the generous use of space in a house could be classed as luxurious. Modern architects should concentrate on the needs of the greatest number. He also included a sentence which might appear to be functionalist: 'There is also a certain danger [in the work

of Le Corbusier] of a strong, aesthetic impulse, which today's architects understandably fear.'[39] But Giedion was no functionalist. He was against monumentality (at least in the 1920s and 1930s), and was prepared to identify the word 'architecture', critically, with the monumentality of past styles of masonry buildings. His ideal, like that of Moholy-Nagy, was a greater spiritual liberation from the physical and social constraints of the modern world. The interior should be purified and simplified, to allow freedom of movement and thought processes uncluttered by superfluous possessions. The forms used for bourgeois villas should be the same as those used in workers' housing, and any symbolic expressions of difference should be minimised. The play of light, open space, good proportions and simple contrasts of colour or tone should be enough to create beautiful architecture. It was at this level of generality that the message of modernism passed into the 1930s and on into the period after the Second World War, even though the actual forms used and much of the detailed argumentation changed radically and varied from country to country.

5 Mies van der Rohe and architecture of space

If Le Corbusier's Villa Savoye represents one strand of modernist architecture, a contemporary building in Barcelona by Mies van der Rohe represents the other main variant (Plate 4.16). Mies van der Rohe was commissioned by the German government to design the national pavilion at the international exhibition held at Barcelona in the summer of 1929. Although the function of the pavilion was purely ceremonial, he decided that it should take the form of a kind of house. But this is a house with no fixed functions and virtually no furniture.

The pavilion consists of a grid of thin cross-shaped girders, sheathed in chrome, supporting a roof slab. The spaces are demarcated by glass or straight stretches of wall which are lined with marble or onyx. This is Mies van der Rohe's version of the free plan. There is total separation of structure from space dividers. The walls of glass allow a complete sense of transparency and there is no fixed enclosure. To close the pavilion at night, screens of glass had to be brought out and fixed in place. Mies van der Rohe is here expressing that sense of *Durchdringung* advocated by Giedion. The Barcelona pavilion is an attempt to create architecture from space. The nine photographs taken of this structure before it was destroyed were republished in every book on

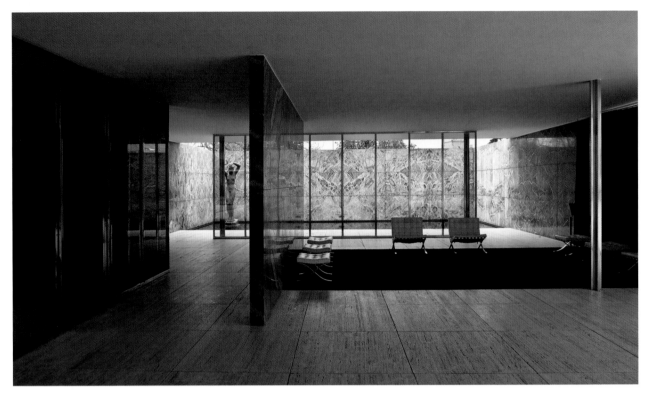

Plate 4.16 Ludwig Mies van der Rohe, German pavilion, International Exhibition, Barcelona, 1929 (reconstructed). Photo: www.bildarchiv-monheim.de/Schütze-Rodemann.

modern architecture and have become icons of the modern movement. The pavilion was recently rebuilt, on its original site, as a tribute to its significance.

Mies van der Rohe developed the language of the Barcelona pavilion in a luxurious house for the Tugendhat family in Brno, Czechoslovakia (1929), which is currently being restored, and in two demonstration houses at the Deutsche Bauausstellung, Berlin, in 1931 (see Plate 4.17). Later, in America, he built one of the most extreme examples of the transparent home, the Farnsworth house. The client for this building, a university professor, became distressed at the lack of privacy afforded by Mies van der Rohe's glass walls, and finished up suing the architect.[40] And this raises the question of the humanity, or lack of it, in modernist architecture, returning us to the theme of functionalism. In their different ways, modernist architects were sensitive to this question. For Le Corbusier, as we have seen, the language of his Purist villas was abandoned, after 1929, for a more organic, warm and textured environment. Mies van der Rohe tackled it by introducing life-size sculptures into his houses, symbolically putting the human body back into his abstract spaces. In the Barcelona pavilion, a nude figure of Dawn by the sculptor Georg Kolbe, is placed in a small reflecting pool, surrounded by green marble

and open to the sky. This figure, seen through the green glass walls of the pavilion, provides a much needed point of reference for the visitor. But the challenge to modernism remains.

Was it functionalism or a desire to live a different kind of life which motivated these architects? My view is that many of these buildings have the potential to stimulate the imagination and be truly inspirational, but they require a certain kind of lifestyle, which doesn't suit everyone. The same is true of most ambitious forms of architecture. It was the eighteenth-century poet and critic Alexander Pope who commented wryly that modern patrons were 'proud to catch cold at a Venetian door'.[41] Pope was referring to the high ceilings, draughty rooms and classical porticos of the style of neo-Palladian architecture patronised by Lord Burlington. But whereas the discomfort of classical architecture has always been accepted as a natural accompaniment of grandeur, the functionalist rhetoric of some modern architects has laid them open to criticism on practical grounds. There is a certain kind of heroism of modern life which demands renunciation of one idea of comfort for a more intellectual and refined aesthetic. It is this choice which is presented by architectural modernism, rather than a choice between function and beauty. It was during the 1930s,

Plate 4.17 Ludwig Mies van der Rohe, bachelor's apartment at the Deutsche Bauausstellung (German building exhibition), Berlin, 1931, as shown on front cover of *Die Form*, 15 June 1931. Photo: © Tim Benton.

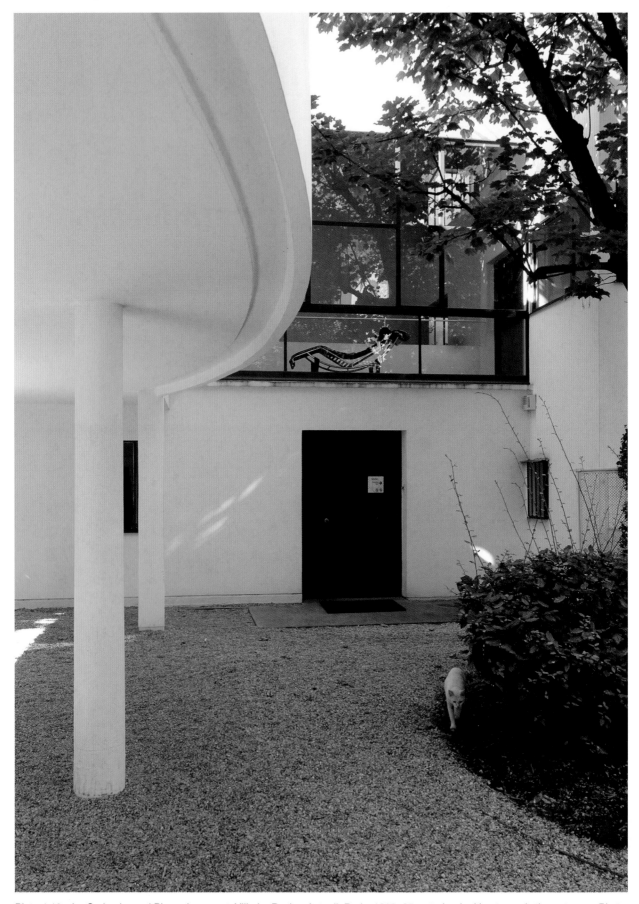

Plate 4.18 Le Corbusier and Pierre Jeanneret, Villa La Roche, Auteuil, Paris, 1923–25, exterior, looking towards the entrance. Photo: © Tim Benton.

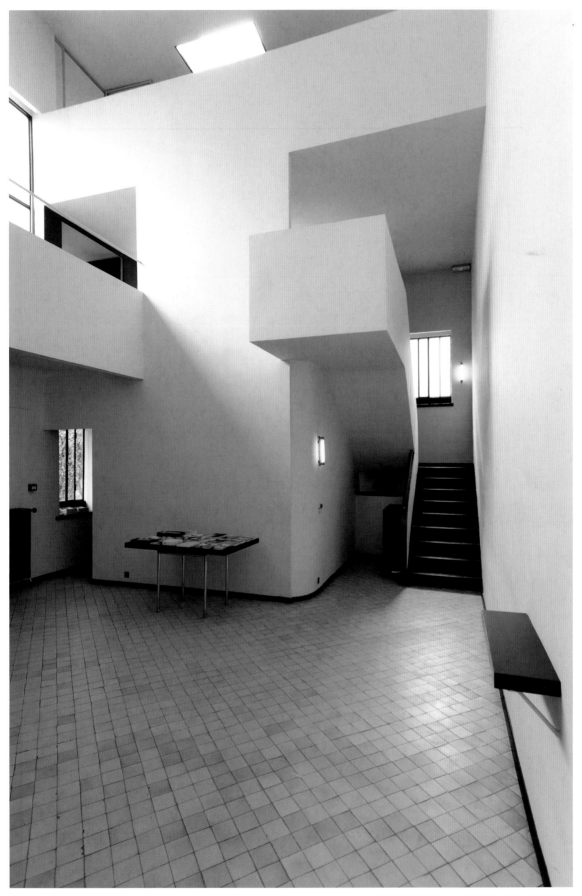

Plate 4.19 Le Corbusier and Pierre Jeanneret, Villa La Roche, Auteuil, Paris, 1923–25, interior, hall looking towards the main staircase. Photo: © Tim Benton. © FLC/ADAGP, Paris and DACS, London 2012.

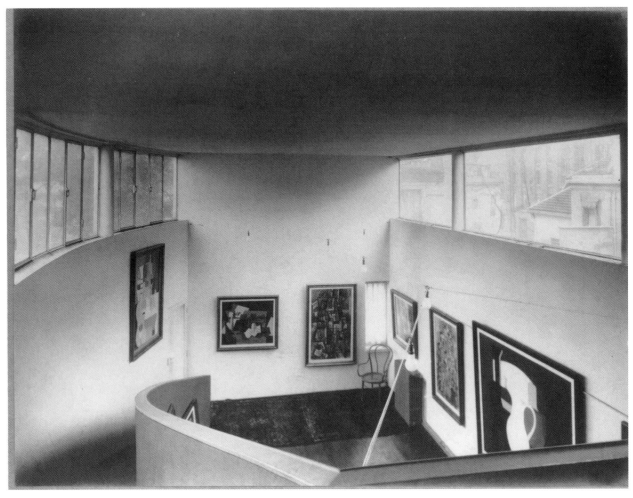

Plate 4.20 Le Corbusier and Pierre Janneret, Villa La Roche, Auteuil, Paris, 1923–25, interior, gallery showing paintings from the La Roche collection. Fondation Le Corbusier, Paris, L2-12-148. Photo: Fondation Le Corbusier. © FLC/ADAGP, Paris and DACS, London 2012.

when many of the first protagonists of modernism were moderating their views, that the spread of modernist theory and dogma reached its height among young architects all over the world. When these young men and women suddenly found themselves in positions of authority after the Second World War, few of them had been able to learn much from experience, since the establishment had generally limited their access to ambitious building projects. Some of the worst excesses of modernist housing and town planning followed from a too rapid execution of ideas formulated twenty years earlier.

To draw together the issues of lifestyle, function, a modernist aesthetic based on form and one based on transparency, look at Plates 4.18–20, which illustrate one of Le Corbusier's first successful modernist houses, the Villa La Roche, in Paris, of 1923–25. This house was designed for Le Corbusier's friend and patron Raoul La Roche. Le Corbusier and Ozenfant had helped to build a unique collection of Cubist art for La Roche, and the

house was intended to accommodate this collection and make it available to visitors on some days of the week. The house had a complicated design history, passing through several stages, but the key thing to understand is that most of the living functions of the house are in the part you can't see in Plate 4.19. This part contains the bedroom, bathroom, dining room and servants' quarters and is connected to the 'public' part of the house by a bridge (on the left in Plate 4.19). Most of the paintings were exhibited in the gallery (Plate 4.20), where a curved ramp on the left of the photograph leads up to a library, at the top of the house and open to the three storey height space of the hall.

6 Modernism and furniture

To sum up the rise and fall of modernism in its purest form, the case of tubular steel furniture is instructive. Between 1925 and 1930, virtually every modern architect designed at least one piece of tubular steel

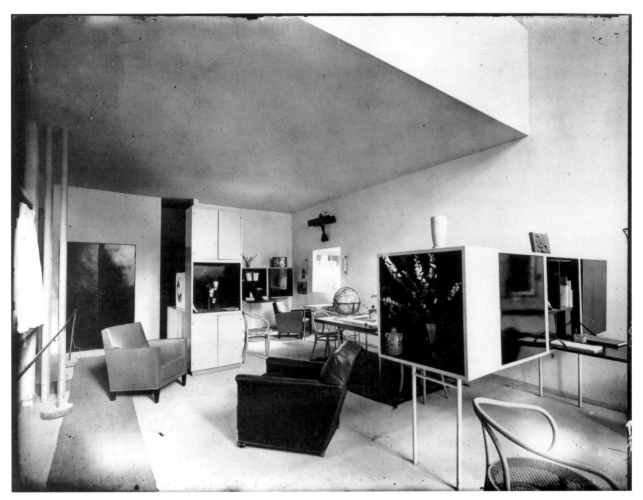

Plate 4.21 Le Corbusier and Pierre Jeanneret, Pavillon de l'Esprit Nouveau, interior, at the Exposition des arts décoratifs et industriels modernes, Paris, 1925. Fondation Le Corbusier, Paris, L2-13-32. Photo: Fondation Le Corbusier. © FLC/ADAGP, Paris and DACS, London 2012.

furniture, which came to symbolise modernism in the interior. Quite soon in the 1930s, however, this fashion passed, and tubular steel furniture became, on the one hand, a little noticed appendage of the modern interior or, more commonly, a despised example of cheap and functional equipment for village halls and schools.

Le Corbusier had designed furniture – chairs, sideboards, lamps and cupboards – in La Chaux-de-Fonds for his first clients. But, in Paris in the 1920s, he followed the theory expounded by Adolf Loos, who insisted that artists and architects had no business designing objects of use. Leave these to the craftsmen or the industrialists who know what they are doing. Loos was also a fan of Thonet, the Viennese manufacturer of mass-produced bentwood chairs, the cheapest and simplest chairs available at the turn of the twentieth century.

Until 1928, Le Corbusier furnished his Purist houses with expensive Maples leather armchairs and cheap

bentwood Thonet chairs. It was with these chairs that he presented the Pavillon de l'Esprit Nouveau, the pavilion he contributed to the Exposition des arts décoratifs et industriels modernes in Paris in 1925 (Plate 4.21). This exhibition was the product of a massive investment by the French government to demonstrate that French craftsmanship in the luxury trades (furniture, textiles, metalwork, and so on) could stand up to competition from England and, above all, Germany. The 1925 exhibition included the word 'modern' in its title, but the majority of the buildings and items exhibited were lavishly finished and decorated in the style that has since come to be known as Art Deco.[42]

Le Corbusier fundamentally rejected the underlying principle of the decorative arts (that artworks could be produced by the application of artistic judgement to craft products), and wrote a series of articles in *l'Esprit nouveau* in the run-up to the exhibition attacking

them. He later published these as a book entitled *L'Art décoratif d'aujourd'hui* (1925).[43] His pavilion was not a showcase for his designed objects, but rather a prototype housing unit which was intended to be stacked in apartment blocks. It was a point of honour, then, that the furniture should not be 'designed', but simply bought.

Ironically, most of these chairs, including the bentwood chairs, belonged to the wealthy banker Raoul La Roche, for whom Le Corbusier had just designed a house to display his superb collection of Cubist art.

Tubular steel furniture

In 1928, however, Le Corbusier's attitude changed and, with the help of a young designer, Charlotte Perriand (1903–99), whom he recruited into his studio expressly for this purpose, he designed three chairs and a number of other pieces of 'modern' furniture. The reason for this is that, since the young Hungarian designer Marcel Breuer had begun designing tubular steel chairs at the Bauhaus in 1925, it suddenly became necessary for every modern architect to design furniture in this

medium. At the Weissenhof Siedlung exhibition in 1927, Le Corbusier was almost alone among the leaders of modernism not to put tubular steel chairs on display. It is worth looking at the fashion for tubular steel, which lasted for only five years among modernists, in more detail.

In 1919, the German architect Walter Gropius was appointed the joint head of an art school and a crafts college in Weimar and founded the Bauhaus. In 1923, László Moholy-Nagy came to teach at the Bauhaus. His approach was Constructivist rather than Expressionist. More importantly, he synthesised a number of avant-garde art movements – Cubism, Constructivism, Suprematism, de Stijl – to propose a general theory of the evolution of sculptural form (and by implication architecture). For him, the Zeitgeist argument was paramount. It was unacceptable to try to recreate the primitive conditions of the Middle Ages or enclose oneself in subjective individualism. In a mechanised world, artists and designers should work with the materials of industrialisation and the new machine aesthetic. Appointed head of the foundation course and the metal workshop, he introduced a wholly new

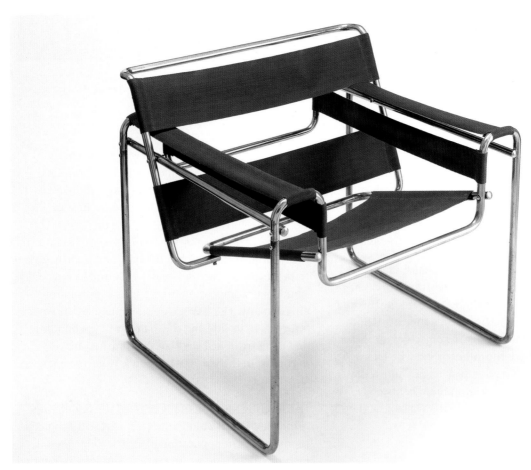

Plate 4.22 Marcel Breuer, Wassily armchair, 1925, nickel-plated tubular steel, screwed together, with cotton canvas upholstery. Victoria and Albert Museum, London, W.2-2005. Photo: © Victoria and Albert Museum, London.

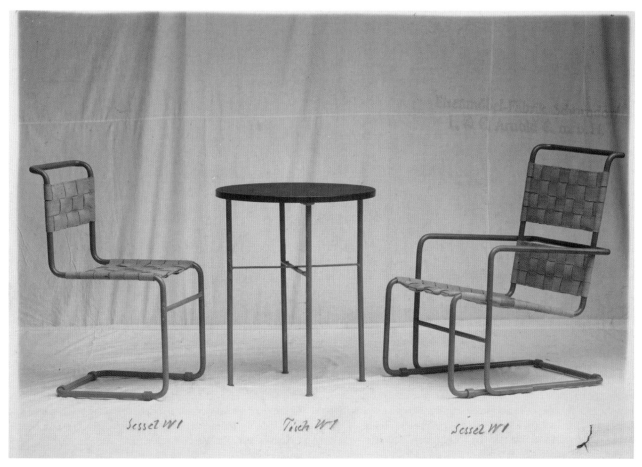

Plate 4.23 Mart Stam, cantilever chairs designed for a house at the Weissenhof Siedlung, Stuttgart, 1927. Photo: © Deutsches Architekturmuseum, Frankfurt am Main.

approach. Under his influence, one of the first pupils at the Bauhaus, fellow Hungarian Marcel Breuer, who had begun making wooden furniture in the Expressionist vein, turned his hand to tubular steel.

In 1925, Breuer designed an armchair, dubbed the 'Wassily' chair because one of the prototypes was owned by the painter Wassily Kandinsky (Plate 4.22). In this chair, Breuer used thin steel tubes to trace the outlines of a comfortable leather club armchair. Instead of thick padding and leather covering, the tubular design enclosed only air. Instead of sprung and upholstered seat and back, there was stretched canvas. This chair can be thought of as a modern commentary on a traditional design. But Breuer soon went further. To understand why this came about, we have to understand the properties of tubular steel.

The first kinds of industrial steel tubes consisted of strips rolled and welded to form a tube. These were heavy and stiff and lacked elasticity. In the late nineteenth century, the German Mannesmann company began making high-tensile, seamless chrome molybdenum tubing. Mannesmann's cold-drawn seamless tubing was lighter, much stronger and more elastic than welded tubing. The company had originally developed the material for steam pressure pipes, but tubular steel was given a boost during the war, when it was used for the chassis of the deadly Fokker DVII (1918) fighter plane and several other high-performance machines, including bicycles. It was the Mannesmann company which supplied the materials for the Wassily chair, but the elastic properties of the material were not fully exploited.

Breuer decided that, just as the introduction of steel and reinforced concrete required architects to adopt a new approach to architectural structure, so chrome molybdenum tubing required a new approach to furniture. At the same moment, in 1924 or 1925, a Dutch architect, Mart Stam (1899–1986), had come to the same conclusions. He designed a chair in which the weight of the sitter was not supported by four legs, but by a bent loop of tubing forming a cantilever (see Plate 4.23).

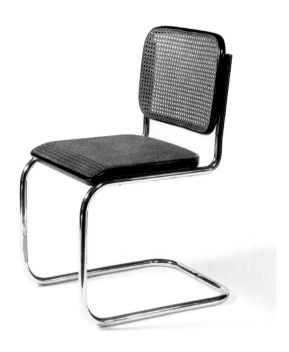

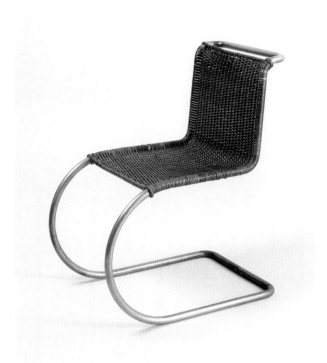

Plate 4.24 Marcel Breuer, B32 cantilever chair, 1928, chromium plated tubular steel, bent beechwood, caning. Victoria and Albert Museum, London, W.10-1989. Photo: © Victoria and Albert Museum, London. Manufactured by Thonet after 1930; later manufactured as the Cesca chair.

Plate 4.25 Ludwig Mies van der Rohe, MR cantilever chair, 1927, chromium plated tubular steel, caning. Musée National d'Art Moderne, Paris, AM1993-1-818. Photo: © Collection Centre Pompidou, Dist. RMN/Jean-Claude Planchet.

Much debate, and two legal battles, have turned on the question of precedence. Stam's prototype chair was made of stiff gas piping with elbow joints, but he soon devised a version made of a loop of high tensile steel tube. This was manufactured from 1927 by L. and C. Arnold, a firm which specialised in hospital equipment. Meanwhile, Breuer made a number of working prototypes of tables and chairs and set up a company, Standard Möbel in Berlin, to manufacture them (see Plate 4.24). Although Breuer seems to have patented his tubular steel chairs in Germany in 1926, the patent letter included no drawings. It was Mies van der Rohe, who designed his 'MR' cantilever chairs only in 1927, who first patented the principle of a 'legless' cantilevered chair relying on the elasticity of high-quality tubular steel both for support and to give a measure of springing to the sitter (see Plate 4.25). At the 1927 Weissenhof Siedlung exhibition, a number of tubular steel cantilevered chairs were on show alongside traditional and modernist wooden designs, and, in 1928, a major exhibition of chairs in Stuttgart showed a bewildering array of different designs (see Plate 4.26).

In addition to showing off the structural properties of high-tensile tubular steel (the structural rationalist argument), steel chairs were also conceived as offering the opportunity of mass production – like the bentwood Thonet chairs – which would allow for the reduction of unit costs and make the chairs affordable. But in the 1920s and 1930s, none of the famous tubular steel designs were produced in quantity, due to the high cost of the materials and workmanship in dressing the welded joints. In England, the best-selling tubular steel chair was the very modest RP6, manufactured by PEL (a subsidiary of the tubular steel company Accles & Pollock) in the 1930s, which used much cheaper and thinner tubing and did not require any cantilever. Some of us remember uncomfortable hours sitting on these chairs, with their canvas seats and backs. It was only after the Second World War that large-scale production of some of the 1920s designs brought them within range of the everyday consumer. Many people who have bought the Cesca chairs are unaware that they were designed by Marcel Breuer in 1928.

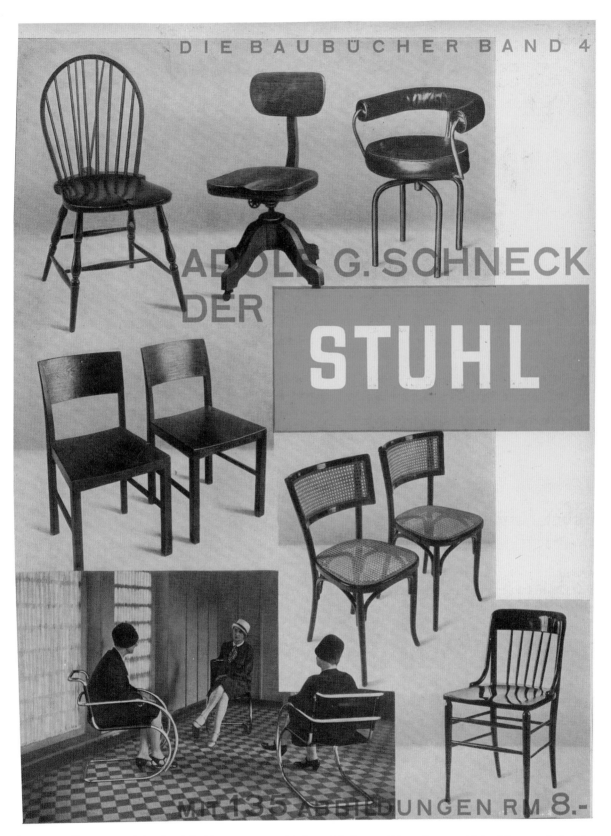

Plate 4.26 Front cover of *Der Stuhl: Stuhltypen aus verschiedenen Ländern und Versuche neuzeitlicher Lösungen in Ansichten und Masszeichnungen*, based on an exhibition put on in Stuttgart by Adolf Schneck, Stuttgart, Julius Hoffmann Verlag, 1928. Photo: Deutsches Nationalbibliothek, Leipzig.

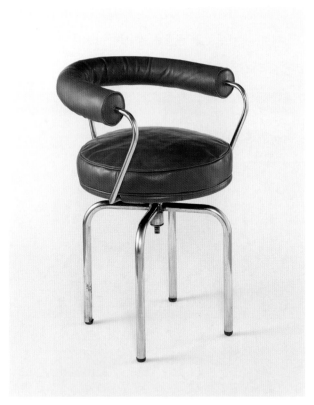

Plate 4.27 Charlotte Perriand, swivel armchair, 1928, tubular steel and leather. Victoria and Albert Museum, London, W.35.1-3-1987. Photo: © Victoria and Albert Museum, London. Manufactured by Thonet, Gebrüder, 1930–33.

Le Corbusier and tubular steel furniture

On the cover of the catalogue of the 1928 exhibition reproduced in Plate 4.26, a chair by Charlotte Perriand is illustrated top right (see also Plate 4.27) and Mies van der Rohe's chairs are shown bottom left, on a spread which includes a traditional English Windsor chair, an American typist's stool and three designs of modern wooden chairs.

Perriand was the most brilliant of her class at the School of Decorative Arts in Paris, earning plaudits for the exhibition of part of her own apartment in 1927 at the Salon des Artistes Décorateurs. Her chair had a richly upholstered seat, usually covered in red leather, and a curving armrest largely imitated from one of the Thonet bentwood designs. Le Corbusier invited her to join his studio as an expert in interior furnishings and furniture design, with the unique privilege of retaining her rights in any interiors she designed for the partnership. He decided that the 'adventure of furniture' (the title of one of his lectures) had to be addressed. In his lecture (published later in a book called *Précisions sur un état*

présent de l'architecture et de l'urbanisme, 1930), he challenged the listener/reader to look round his or her room and make a judgement: 'what does all this signify? What is the reasoning behind it all?'[44] Later, he asks, rhetorically:

> What, then, is furniture?
>
> '*The means by which we make known our social rank.*'
>
> This, very precisely, is the mentality of royalty: Louis XIV was brilliant at it! Do we claim to be Louis XIV? There would be lots of us. If there were millions of Louis XIVs around, there would be no more Sun King.[45]

His argument is that, in a democratic society, furniture can no longer make claims for social superiority and uniqueness. Furniture should cease from being a status symbol and become something useful, an extension of our bodies and an interface between ourselves and our homes. Of course, we might well argue the opposite, that the consumption and display of objects, including modernist ones, has always served, and always will serve, precisely to communicate something special about ourselves, or about our ideas. Indeed, this was precisely the point about the tubular steel chair: it communicated a modernist conviction that lifestyle should echo the spirit of the 'machine age'.

Le Corbusier then subtly shifts his ground, by calling on men to consider the case of women's fashions.

> Woman has preceded us. She has realised the reform of her costume. She was in a quandary: to follow current fashion meant giving up the benefits of modern techniques, modern life [which he glosses as sport, employment, driving a car or taking public transport]. So woman cut off her hair, shortened her skirts and sleeves. She goes around bare-headed, with bare arms and legs. And in five minutes she's dressed. And she is beautiful; she seduces us with her charms.[46]

So we come back to fashion again. Le Corbusier upheld the individual's right to express his or her individuality in any number of ways – for example with their personality, their conversation, the choice of books to read and paintings to put on the wall – but believed that furniture provided functions which were more or less standard. Individuals are unique but bodies are roughly comparable. We all have basic needs – for sitting and working, sitting and reading, sitting and eating – and furniture should address these standard functions.

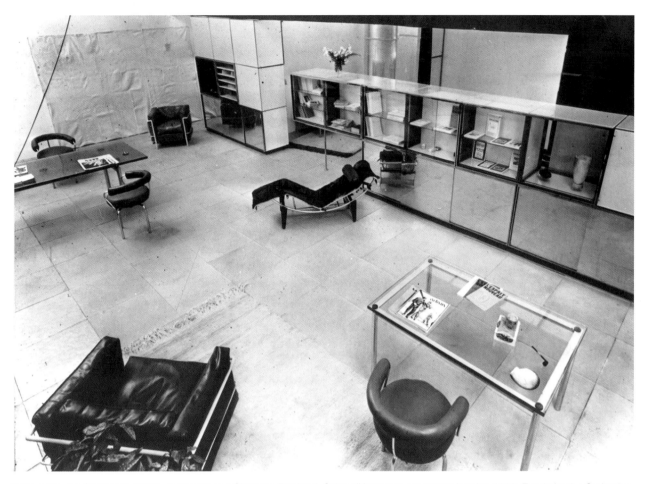

Plate 4.28 Le Corbusier, Pierre Jeanneret and Charlotte Perriand, Salon d'Automne, apartment interior, 1929. Fondation Le Corbusier, Paris, L1-20-3. Photo: Fondation Le Corbusier. © FLC/ADAGP, Paris and DACS, London 2012.

Nevertheless, Le Corbusier's approach to furniture was very different from that of the Germans and the Dutch. Instead of trying to design a single type for all uses, he sought to express the different moods and feelings of the home dweller in three quite different kinds of chair. One chair, like the Wassily chair, would take as its starting point the comfortable Maples leather club armchair. This so-called 'grand confort' chair had a tubular steel frame into which luxurious cushions of kapok-filled Morocco leather would be placed. This was for sitting and reading. Another, more active, chair, was based on a wooden 'Safari' chair which consisted of a wooden frame and leather straps for seat and armrests. This 'chaise à dos basculant' had a tubular steel frame (complete with four conventional legs) and leather seat, tilting back and armrests. The third chair was designed, according to Le Corbusier, to imitate the image of the western cowboy, leaning back in his chair with his heels on the desk. It is probable that Le Corbusier was also influenced by a patent lounge chair designed, rather like a dentist's chair, to be moveable from the vertical to the horizontal positions. In this chaise longue, a completely independent curving frame is covered in

leather or cow hide and supported on an 'H' shaped pedestal base.

These three chairs were made up by Charlotte Perriand, using her favourite craftsmen and exhibited in a stand representing an apartment interior at the Salon d'Automne in Paris in 1929 (see Plate 4.28).

The three chairs were also incorporated in the music pavilion designed for the American couple Henry and Barbara Church, between December 1928 and May 1929 in the grounds of their house in the suburb of Ville d'Avray, Paris (since destroyed) (Plate 4.29). It is noteworthy that, unlike the German and Dutch designers, Le Corbusier by this stage had become uninterested in demonstrating the principles of structural rationalism and more concerned to design furniture which he thought of as reflecting the human body and the different activities of the day.

Just as Le Corbusier abandoned the pure white concrete look of his 1920s buildings, many modernists abandoned tubular steel furniture shortly after 1930. Perriand herself began designing rustic tables and

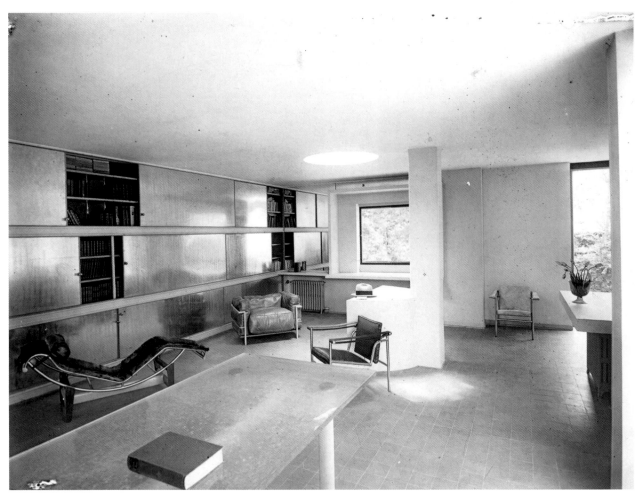

Plate 4.29 Le Corbusier, Pierre Jeanneret and Charlotte Perriand, Villa Church (demolished), 1929, interior of the library in the music pavilion. Fondation Le Corbusier, Paris, L3-7-97. Photo: Fondation Le Corbusier. © FLC/ADAGP, Paris and DACS, London 2012.

chairs in wood. The Finnish architect Alvar Aalto (1898–1976) attracted worldwide attention with his comfortable and aesthetically very pleasing bentwood designs (see Plate 4.30). When Breuer emigrated to England in 1930, he too began designing furniture in bentwood. Although his and Aalto's chairs and tables are modernist in their innovatory and untraditional approach, they mark a decisive step away from the cold rationalism which had attracted criticism from within and outside the modern movement. Nevertheless, tubular steel chairs and tables continued to stand for a modernist approach to interior design throughout the 1930s.

Exercise

Looking back over this study of furniture, what similarities do you see with the guiding principles of modernist architecture discussed in the first part of the chapter?

Discussion

In both cases, there is a strong idea that the modern world – its machines, industrial methods and standardisation – should cause architects and designers to make fundamental changes (the Zeitgeist argument). In both cases there is the idea that the use of a modern structural method (steel or reinforced concrete in the case of architecture, tubular steel for furniture) should not only change the way buildings and things are made, but also determine in part its form. In both cases it was assumed that a modern lifestyle required radically new accoutrements. Conventional 'comfort' should be exchanged for a more dynamic, harder and more exciting way of living. In both cases, we saw a reaction against these ideas quickly setting in around 1930. Both in Le Corbusier's rediscovery of natural materials and hand craftsmanship and in the wider rejection of tubular steel in favour of

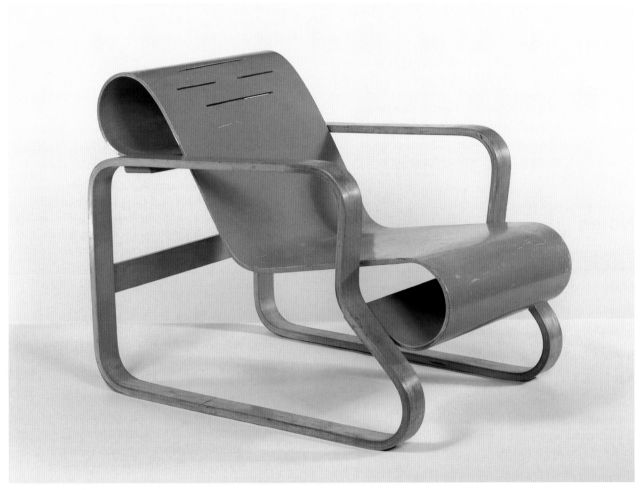

Plate 4.30 Alvar Aalto, Paimio armchair, 1930, birch plywood and solid birch. Victoria and Albert Museum, London, W.41-1987. Photo: © Victoria and Albert Museum, London.

bentwood furniture, we saw an attempt to retain the fundamental ideas of modernism but make them more human and more accessible.

Conclusion

The movement of ideas and practice which developed in the 1920s in Europe has been frequently misunderstood as a single-minded move towards functionalism and against human sentiment and an aesthetic ideal. It should be clear, however, that the modernists were driven by idealistic and aesthetic principles. Their aim was to discover a new kind of beauty, not to replace the search for beauty by function.

It is true that architects and designers tried to replace the imitation of past styles by a back-to-basics approach that relied on using the new materials of steel, reinforced concrete and glass. Most modernists claimed

to be against any idea of style, and yet the logic of their theories – and especially the reliance on the idea of the Zeitgeist – drove them towards the creation of a new style, whose forms could be imitated. Now that modernist architecture is readily accepted as one of the styles that can be imitated by contemporary architects, it is difficult to appreciate the radical implications of getting rid of 'the styles' and starting anew. Many modernist buildings and pieces of furniture may be criticised for their austerity, their lack of human warmth and sense of enclosure, but the best work still has the ability to inspire and to satisfy.

The ideas discussed in this chapter are hotly debated even today. The reaction to modernism, which set in first in the 1930s in some countries, and then with a vengeance in the 1960s, created a movement – 'post-modernism' – which claimed to put complexity, humour, ornament, references to the traditional styles and a more human approach at the heart of architecture. A new set of ideas created lively debates,

which, in turn, stimulated some extremely interesting work. But, once again, imitation and the development of tawdry clichés took over the mainstream, so that many buildings of the 1980s and 1990s offer little to admire.

The main aim of this chapter has been to show how ideas inform the practice of architecture and design, and, by implication, how an understanding of these ideas adds meaning for those who look closely at the built environment.

Notes

[1] From a debate between the modern architect Amyas Connell and Reginald Blomfield, 'For and against modern architecture', cited in Benton, 1975, p. 94.

[2] Blomfield, 1934.

[3] Greenberg, 1961, pp. 101–8.

[4] Le Corbusier, 2007 [1923], p. 87.

[5] Mies van der Rohe, 'Office building', 1923, cited in Neumeyer, 1991, p. 241.

[6] Wagner, 1988 [1896], p. 77, cited in McLeod, 1994, p. 53. Similar arguments were used in nearly all the textbooks on modernism.

[7] For an excellent English edition, see Wagner, 1988.

[8] Gropius, 1913.

[9] Loos, 1998 [1908].

[10] See Le Corbusier, 2007 [1923], for an English translation.

[11] L'Esprit nouveau (1968), no. 1, unnumbered pages, translated by Tim Benton.

[12] Ibid., p. 4, translated by Tim Benton.

[13] Hannes Meyer, 'Bauen', 1928, in Bauhaus, vol. 2, no. 4, cited in 50 Years Bauhaus, 1968, p. 162.

[14] Le Corbusier, 2007 [1923], p. 195.

[15] Ibid., p. 231.

[16] Häring, 1925, translated by and cited in Blundell-Jones, 2001, pp. 36–7.

[17] Neumeyer, 1991.

[18] Le Corbusier, 2007 [1923], pp. 93–4.

[19] Ibid., pp. 180–5.

[20] Ibid., p. 97.

[21] Ibid., p. 102.

[22] Teige, 1928–29.

[23] Teige, 1974 [1928–29], pp. 83–91.

[24] Le Corbusier, 1933.

[25] Mendelsohn, 1926, p. 170.

[26] Giedion, 1995 [1928], p. 87.

[27] Mies van der Rohe, 'Gelöste Aufgaben. Eine Forderung an unser Bauwesen', 1923, Bauwelt, vol. 14, p. 719, cited in Neumeyer, 1991, p. 24.

[28] The American psychologist William James and the German physiologist Carl Lange independently developed theories of physiological causes of emotional states (see James, 1890). Among those who refined and developed the James–Lange theory was Karl Groos with his concept of Innere Nachahmung (Groos, 1911a, b). Groos was an influence on Vernon Lee and indirectly on Geoffrey Scott.

[29] See his doctoral dissertation at Leipzig: Vischer, 1873.

[30] Lipps and Werner, 1890; Lipps, 1897, 1900, 1903.

[31] Henry, 1885.

[32] Lux, 1910, p. 4, translated in Georgiades, 1995, p. 31.

[33] Giedion was later explicit about the connection between Cubist space and the transparency of modernist buildings. In his book Space, Time and Architecture, 1941, pp. 298–9, Giedion juxtaposed Picasso's L'Arlesienne next to a photograph of Gropius and Meyer's Bauhaus building, Dessau, 1925–26, in the context of a discussion of theories of relativity and what he called 'the artistic equivalent of space-time' (Giedion, 1941, p. 14).

[34] Giedion, 1995 [1928], p. 91.

[35] Among the relevant sources are Adolf Hildebrand's Das Problem der Form in der bildenden Kunst ('The problem of form in the fine arts', 1893), August Schmarsow's lecture 'Das Wesen der architektonischen Schöpfung' ('The essence of architectural creation', 1893) and Theodor Lipps's, 'Raumästhetik und Geometrisch-Optische Täuschugen' ('Aesthetics of space and geometric-optical illusions,' 1893–97). These sources are cited and discussed in Forty, 2000, pp. 260–1.

[36] A revised and condensed version of this book was published in America: Moholy-Nagy and Hoffmann, 1932 [1928].

[37] Giedion, 1995 [1928].

[38] Ibid., p. 186.

[39] Ibid.

[40] Friedman, 1996.

[41] Pope, 1988 [1731], 'Epistle IV: To Richard Boyle, Earl of Burlington' ('On the use of Riches'), line 36. Pope made fun of the Earl of Burlington's re-creation of the Palladian style in eighteenth-century Britain, but this line also encapsulates the sacrifices made by architectural patrons in having their ideal home designed by an architect.

[42] Benton, Benton and Wood, 2003.

[43] Available in an English edition: Le Corbusier, 1987.

[44] Le Corbusier, 1930, p. 105, translated by Tim Benton.

[45] Ibid., p. 108, translated by Tim Benton.

[46] Ibid., pp. 106–7, translated by Tim Benton.

Bibliography

50 Years Bauhaus (1968) London, Royal Academy of Arts (exhibition catalogue).

Benton, C. (ed.) (1975) *Documents*, Buckingham, Open University Press, p. 94.

Benton, C., Benton, T. and Wood, G. (eds) (2003) *Art Deco, 1910–1939*, London, V&A Publications.

Blomfield, R. (1934) *Modernismus*, London, Macmillan.

Blundell-Jones, P. (2001) *Hugo Häring and the Secret of Form*, London, RIBA (exhibition catalogue).

L'Esprit nouveau (1968) New York, Da Capo Press.

Forty, A. (2000) *Words and Buildings: A Vocabulary of Modern Architecture*, London, Thames & Hudson.

Friedman, A.T. (1996) 'Domestic differences: Edith Farnsworth, Mies van der Rohe, and the gendered body' in Reed, C. (ed.) *Not at Home: The Suppression of Domesticity in Modern Art and Architecture*, London, Thames & Hudson, pp. 179–92.

Georgiades, S. (1995) 'Introduction' in Giedion, S. (1995 [1928]), pp. i–ix.

Giedion, S. (1941) *Space, Time and Architecture*, Cambridge, MA and London, Harvard University Press and H. Milford, Oxford University Press.

Giedion, S. (1995 [1928]) *Building in France: Building in Iron, Building in Ferroconcrete* (trans. J.D. Berry), Santa Monica, CA, Getty Center for the History of Art and the Humanities.

Greenberg, C. (1961) 'Modernist painting', *Arts Yearbook*, vol. 4, pp. 101–8.

Groos, K. (1911a) 'Das aesthetische Miterleben', *Zeitschrift für Aesthetik*, vol. 4, no. 2.

Groos, K. (1911b) *Das Seelenleben des Kindes*, Berlin, Verlag von Reuther & Reichard.

Gropius, W. (ed.) (1913) *Die Kunst in Industrie und Handel*, Jahrbuch des Deutschen Werkbundes, II Abbildungen/Tafeln 1–108, Diederichs, Jena, pp. 1–7 (unnumbered).

Häring, H. (1925) 'Wege zur Form', *Die Form*, vol. 1, October, p. 4.

Henry, C. (1885) *Introduction à une esthétique scientifique*, Paris, Revue Contemporaine.

Henry, C. (1921) 'La lumière, la couleur et la forme', *L'Esprit nouveau*, no. 6, pp. 605–23; no. 7, pp. 729–36; no. 8, pp. 948–58; no. 9, pp. 1068–75.

James, W. (1890) *The Principles of Psychology*, London, Macmillan.

Le Corbusier (1930) *Précisions sur un état présent de l'architecture et de l'urbanisme avec un prologue américain et un corollaire brésilien suivi d'une température parisienne et d'une atmosphère moscovite*, Paris, G. Crès et cie.

Le Corbusier (1933) 'Défense de l'architecture', *Architecture d'aujourd'hui*, vol. 6, no. 10, pp. 38–64.

Le Corbusier (1987) *The Decorative Art of Today*, Cambridge, MA, MIT Press.

Le Corbusier (2007 [1923]) *Toward an Architecture* (intro. J.-L. Cohen; trans. J. Goodman), Los Angeles, CA, Getty Research Institute.

Lipps, T. (1897) *Raumästhetik und geometrischoptische Täuschungen*, Leipzig, J.A. Barth.

Lipps, T. (1900) 'Aesthetische Einfühlung', *Zeitschrift für Aesthetik für Psychologie und Physiologie der Sinnesorgane*, vol. 22, p. 439.

Lipps, T. (1903) *Aesthetik: Psychologie des Schonen und der Kunst*, Hamburg and Leipzig, L. Voss.

Lipps, T. and Werner, R.M. (1890) *Beiträge zur Ästhetik*, Hamburg and Leipzig, L. Voss.

Loos, A. (1998 [1908]) 'Ornament and crime', in Loos, A. and Opel, A. *Ornament and Crime: Selected Essays*, Riverside, CA, Ariadne Press, pp. 167–76.

Lux, J. A. (1910) *Ingenieur-Aesthetik*, Munich.

McLeod, M. (1994) 'Undressing architecture: fashion, gender and modernity' in Fausch, D. and Singley, P. (eds) *Architecture in Fashion*, Princeton, NJ, Princeton University Press.

Mendelsohn, E. (1926) *Amerika*, Berlin, Rudolf Mosse Buchverlag.

Neumeyer, F. (1991) *The Artless Word: Mies van der Rohe on the Building Art*, Cambridge, MA, MIT Press.

Moholy-Nagy, L. and D. Hoffmann (1932 [1928]) *The New Vision: From Material to Architecture*, New York, Brewer, Warren & Putnam.

Pope, A. (1988 [1731]) 'Epistle IV: To Richard Boyle, Earl of Burlington' in *An Essay on Criticism; The Rape of the Lock; and Epistles to Several persons [Moral Essays]* (ed. R. Southall et al.), Plymouth, Northcote House.

Teige, K. (1928–29) 'K teorii konstruktivismu', *Stavba*, vol. 7, pp. 7–12, 21–4. (Revised version included as the final chapter 'Toward a theory of Constructivism' in Teige, K. (2000 [1930]) *Modern Architecture in Czechoslovakia and Other Writings*, Santa Monica, CA, Getty Research Institute, pp. 287–99.)

Teige, K. (1974 [1928–29]) 'Mundaneum', *Stavba*, no. 7, pp. 145–55, translated in *Oppositions*, vol. 4, pp. 83–91.

Vischer, R. (1873) *Uber das optische Formgefühl: ein Beitrag zur Aesthetik*, Leipzig, Hermann Credner.

Wagner, O. (1988 [1896]) *Modern Architecture: A Guidebook for His Students to this Field of Art*, Santa Monica, CA and Chicago, IL, Getty Center for the History of Art and the Humanities, distributed by the University of Chicago Press.

Part 2

From modernism to globalisation

Introduction

During the period immediately after the Second World War, whereas official culture in the USSR turned its back on modern art in favour of a 'romantic realism', New York inherited the mantle of Paris as the capital of modernism. This is not to say that modern art became the official art of the western hegemon, as it did in the later 1950s or 1960s, or that nothing happened elsewhere, but New York became a magnet for modernist artists in the way Paris had once been. Not least it drew in Surrealists and other exiles from Paris, who fled from war-ravaged Europe.

The period after the war was a time of heightened global contradictions. A new affluence and consumerism took off in the USA and spread to Britain and Germany; somewhat later, the 'economic miracle' in southern Europe transformed relatively poor peasant economies. At the same time, the USSR extended its influence in eastern Europe, and revolutions in China and Cuba gave new vitality to what seemed to many people an alternative to American capitalism, while anti-colonial movements transformed the geo-political landscape. Throughout this era, memories of the Nazi extermination camps and Hiroshima, and the possibility of imminent nuclear annihilation, hung in the air. Under these conditions, the cultural mood ranged from euphoria to fear of impending doom. Figurative and abstract artists working in Europe and North America during this volatile period attempted to register the tensions and threats in their work.

The 1960s and 1970s witnessed a renewed phase of experimentation and a batch of new 'movements' and modes of art practice: Minimalism, Fluxus, Conceptual Art, performance, earth art and then the catch-all 'postmodernism'. At this time, there was a fundamental shift away from the traditional media of painting and sculpture to new ways of working involving photography, video, film and installation. This shift – sometimes characterised as the 'expanded field' in art or, alternatively, the 'post-medium condition' – continues apace. The artists involved often associated their work with radical politics. During the 1980s, the progressive mood allied with this art drained away. On the back of economic and political crises, a new conservative hegemony took hold. With gathering momentum after the end of the Cold War and the collapse of the Soviet Union, a wave of capitalist expansion began to transform wide areas of the world, drawing relatively independent economic zones into the world system of deregulated markets and 'structural adjustment' measures tied to financial bailouts and loans. In art, this involved a rapid expansion of the international exhibition circuit and the opening up of the art world to artists and experiences from beyond the western power centres, arguably as fuel for the art market. The period we call 'globalisation' was upon us.

The opening chapter of Part 2, Brendan Prendeville's 'Modernism and figuration', spans the period from the 1920s to the 1970s. We concluded Part 1 with a discussion of modernism in art and architecture. Some conventional narratives of modern art often leap from there directly into post-war abstract painting in the USA, but Prendeville reminds us that figurative art retained a lively presence all through this period. He suggests that figurative painting in the post-war period engaged with many of the same issues that preoccupied abstract painters. In the process, he considers the artist's encounter with another human body and the ways this has been translated into art. This consideration of figurative art thus serves as a transition between Part 1 and Part 2 and acts as a reminder of the persistence of themes and concerns across these apparent watersheds.

Chapter 6, 'From Abstract Expressionism to Conceptual Art: a survey of New York art c.1940–1970', by Michael Corris, surveys important changes in post-war modern art. This chapter is structured around two exhibitions: one dedicated to American abstract painting, the other to the emergence of Conceptual Art. Corris provides a multifaceted introduction to the New York School, including the views of influential critics, before considering the breakdown of this paradigm and the emergence of new forms of art not rooted in painting and traditional sculpture. This transition has been characterised as the emergence of the 'expanded field' in art. Conceptual Art was at the heart of this new set of concerns, detaching art as idea from 'medium specificity' and judgements of taste.

Chapter 7, 'Border crossings: installations, locations and travelling artists', by Gill Perry, opens in 1967 in Rio de Janeiro. This already signals a change in the story of modern art centred on Paris and New York. Perry considers the emergence of 'installation art' – a new way of conceiving art that immersed viewers in constructed spaces. She examines definitions of 'installation' and considers some significant examples. There are many different ways of envisioning this practice, but they all share a sense of the importance of space, whether the installation is constructed in

a gallery or responds to a place outside the museum. Installation art is often associated with 'site specificity' – the engagement with a particular locality. This concern with unique places, she argues, results in geographical dispersal and the necessity of travel for artist and committed viewer alike.

The final chapter in Part 2, 'Global dissensus: art and contemporary capitalism', by Gail Day and Steve Edwards, examines art produced since the mid-1990s. The authors suggest that, in this period, artists once more turned to social and political themes in their work as the consequence of economic globalisation and increasing geopolitical conflicts. In the first section of their chapter, they look at recent international mega-exhibitions, the concerns that animate them and some of the themes treated. In the remainder of the chapter, they consider two characteristic practices at the centre of contemporary art: 'relational aesthetics' and 'realism'.

The book concludes with a short 'Afterword' by Leon Wainwright.

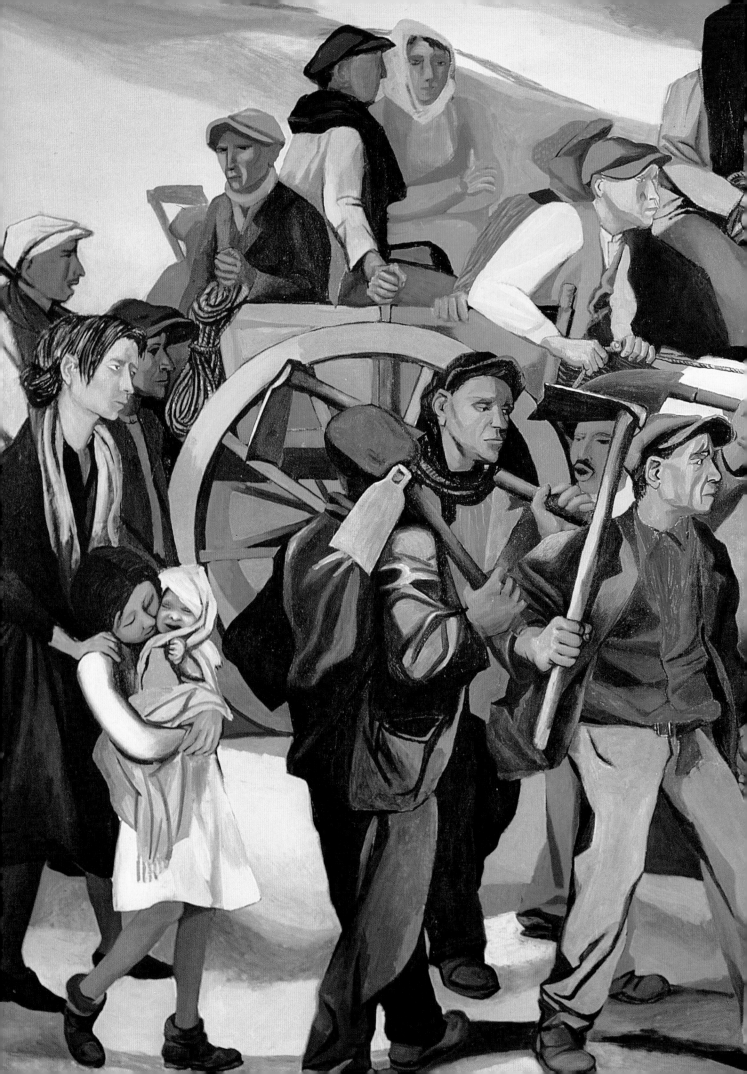

Chapter 5

Modernism and figuration

Brendan Prendeville

Introduction

It was only in the mid twentieth century, with the rise to international pre-eminence of American abstract art of the New York School (which is discussed in the next chapter), that the term 'figurative art' came into use, there having been no need for it hitherto. Avant-garde art of the earlier twentieth century had not invariably been abstract, and such key figures as Picasso and Matisse produced no completely abstract work. Many of their pictures were of course 'abstracted' from some recognisable motif, in the sense of containing figures that were distorted or which departed in some other way from conformity to appearance. But they were not completely 'abstract' in the sense associated with the work of Mondrian or Malevich; Picasso and Matisse did not compose their paintings out of wholly abstract elements such as circles or rectangles. There are, it seems, two senses to the term 'abstract': a strong sense that excludes all figuration, and a weaker more broadly applicable sense whereby figurative elements persist, but in ways that depart from traditional illusionism and emphasise the physical and 'expressive' properties of the painted surface or the sculpted object. The term 'modernism' gained what is now its most familiar definition during the 1940s and 1950s, through the critical writings of Clement Greenberg,[1] a proponent of abstraction and an early supporter of Jackson Pollock and of what became known as Abstract Expressionism (also discussed in chapter 6). For Greenberg, the common tendency shown by innovative artists of the late nineteenth and early twentieth centuries to give prominence to the constitutive elements of their given medium – the painted surface itself, in the case of painting – was the defining feature of modernism. Implicit in it was a development towards increased abstraction. If painting and sculpture were to become more purely themselves, take full possession of the medium, it was necessary to eliminate illusionism in representation. In the Greenbergian schema, representation was 'admissible', as he put it, only to the extent that it did not detract from 'literal, sensational concreteness'.[2] It was of reduced importance, inessential.

Plate 5.1 (Facing page) Renato Guttuso, *Occupation of Uncultivated Land in Sicily* (detail from Plate 5.24).

It might equally be claimed, however, that by emphasising the painted surface or the sculpted object, the artists in question actually put representation – or figuration – on a new footing. From this point of view, it is not so much a question of figuration's *decline* in importance, as a question of its taking on a new *kind* of importance. To show the legitimacy of this alternative view, I will look at some salient treatments of the figural in early modernism, and in art of the inter-war period, before turning to focus on figuration during the 1940s and 50s – the era of high modernism. This chapter suggests that figuration was a significant aspect of modernism, and that it was as innovative in its own terms as abstraction. Artists who combined figuration with a critical attention to the concrete, immediate properties of their medium did more than take a step towards abstraction: they gave expression to new kinds of content and meaning, notably in the case of artists whose work addressed the complexity of our own bodily or perceptual relation to the world. In short, I propose to disagree with Greenberg, but on his own ground, since his general definition of modernism is the one I will use.

1 Prototypes of modernist figuration: subject and surface

Art history has given us two broad ways of understanding depicted subject matter, namely the naturalistic and the iconographic. Between the Renaissance and the mid nineteenth century, all European art presented some combination of these two ways of rendering a subject, and what we can say in both cases is that what is represented stands at an illusionistic or conceptual distance from the material surface of the work.

What I mean by the distinction is this. Take a painting of a bowl of fruit and a candle. When I say that a work may be 'naturalistic', I mean that the colours, tones and shapes on the flat surface of the canvas produce an illusion of a bowl of fruit and a candle. However, many paintings have another layer of meaning. This I refer to as 'iconographic'. For example, within the conventions of still-life painting, there was the sub-genre known as *memento mori*; that is to say, a reminder of the brevity of human life. If our still-life showed, for example, flies on the fruit, or a patch of mould, if it showed a half-peeled lemon, if the candle flame was guttering, then a knowledgeable spectator would be able to read it as not just a still life, but a coded *memento mori*. In both cases, to appreciate the illusion, or apprehend the literary subject, we must to some extent overlook what

Greenberg called 'literal, sensational concreteness'; that is, the fact that, in the last instance, the painting is literally a flat surface covered with colours. Now, as you will have seen from previous chapters, the work of Manet, Monet, the Post-Impressionists and the Symbolists all gave evidence of precisely that new insistence on the immediate materiality of the artwork's surface that Greenberg defined as an identifying characteristic of modernism. As Paul Wood has shown in chapter 1, this did not entail an abandonment of subject matter, but what we can certainly say is that, in the work of these French artists, the 'absent' representational dimensions, be they iconographic or naturalistic, came to be associated in a new and particularly close way with immediate materiality. Subject came to be tied more closely to surface than had previously been the case, if only because that surface was now too obtrusive to be overlooked.

A complaint this change in practice often drew from contemporary critics concerned the difficulty of seeing what the subject of a given work actually was. For the typical nineteenth-century viewer, the principal job of a painting was to describe a scene or tell a story; the role of a sculpture was to represent a specific mythical figure, or embody an allegory, or portray a celebrated individual. This is why – to take a sculptural example – *The Age of Bronze* (Plate 5.2) by Auguste Rodin (1840–1917) caused such controversy when he exhibited a plaster cast of it in the Paris Salon of 1876.[3] The figure is naked, yet the sculpture portrays an individual, instead of the idealised heroic type that convention demanded. The person portrayed is not famous, and the subject indicated by the title is extremely vague. Rodin's sculpture presented a nakedness that stood for nothing other than itself; no story, legend or symbolism distracted the viewer's attention from the sensuously modelled surface. Rodin was accused of casting from the model, and although the accusation was false, it surely arose from recognition of an essential quality in the sculpture, namely a particularly close association between the sculptural material and what it represents: living flesh. Rodin set his model in a pose suggestive of subtle or restless motion, one hand resting on top of the head, tilted back; he chose that the lips be parted and the eyes shut, to evoke breathing and to suggest that attention has turned inwards, towards bodily self-awareness. In modelling, what he sought was continuity, giving unflagging attention to every contour as he worked his way around and over the modelled surface, since continuity of form imparted the sense of life. Rodin's essential subject, here as elsewhere, might be termed 'the living and passionate body'.

Plate 5.2 Auguste Rodin, *The Age of Bronze*, 1875–76, bronze; 181 × 54 × 64 cm. Leeds City Art Gallery. Photo: David Ward, *Casting the Die (Rodin)*, 1995, silver gelatin print, 61 × 51 cm. From a portfolio of seven photographs in the collection of Leeds Museums and Galleries. Published in *Casting the Die: The Age of Bronze in Leeds*, Henry Moore Institute, 1996. Photo: © David Ward.

Rodin's near-contemporary Paul Cézanne, whose work had a catalytic role in the gestation of early twentieth-century modernism, painted a series of monumental canvases late in life that were known only as scenes of *baigneuses* – female bathers. Like Rodin, he took up an established traditional form, in this case the large figure composition, and divested it of its typical subject matter. The *Bathers* in the London National Gallery (Plate 5.3) evokes grand figure painting in the Venetian tradition, yet omits the framework of myth and allegory essential in the work of Titian and his successors. There is no way of accounting for this assembly of naked women, nothing to draw attention away from the hatchings and strong contrasts of the

painted surface, the disjunctions and distortions in the figures.[4] If Rodin's sculpture gives us a sense of aliveness, the qualities that critics have often found in Cézanne have been solidity, in his figures and objects, and strong coherence, in his compositions. The disjunctions and distortions I mentioned are characteristic of all his mature work, and we might wonder how they are to be reconciled with a sense of coherence. There is in fact a logic to the distortions in *Bathers*: the figures that are seated or reclining appear to swell, and they assume the colour of the earth they rest on, while those that stand have more of the sky's blue in their bodies. The bathers, in their nakedness, thus appear, in a kind of primal scene, as the connection between sky and

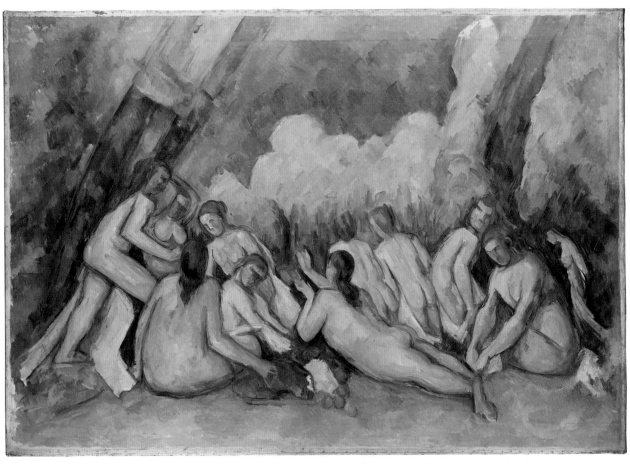

Plate 5.3 Paul Cézanne, *Bathers* (*Les Grandes Baigneuses*), *c.*1894–1906, oil on canvas, 127 × 196 cm. National Gallery, London. Purchased with a special grant and the aid of the Max Rayne Foundation, 1964, acc. no. 1559. Photo: © 2011 The National Gallery/ Scala, Florence.

earth, comprising an ordered whole made from distinct parts. Cézanne has compacted the angular figures into two coherent masses: an upright cone on the left, an inverted one on the right, as if the bodies were so many building-blocks.

Both Rodin and Cézanne influenced early twentieth-century modernism, but it was Cézanne's work that stimulated the most decisive modernist movement, Cubism. What Picasso and Braque found in Cézanne – precisely because of the duality of fragmentation and order I have just described – was the possibility of making a composition that comes apart and reassembles itself as you look at it. This became in their hands a kind of game about representation, a dismantling and recombining of illusionistic conventions. In 1910, Picasso painted a portrait of the dealer Ambroise Vollard (Plate 5.4), whom Cézanne himself had painted. The portrait subject is distributed

Plate 5.4 Pablo Picasso, *Portrait of Ambroise Vollard*, 1910, oil on canvas, 92 × 65 cm. State Pushkin Museum of Fine Arts, Moscow. Photo: The State Pushkin Museum of Fine Arts. © Succession Picasso/DACS, London 2012.

Plate 5.5 Constantin Brancusi, *Torso of a Young Man [1]*, *c.*1917–22, maple on limestone base, sculpture 48 × 32 × 19 cm, base 22 cm. Philadelphia Museum of Art, The Louise and Walter Arensberg Collection, 1950, inv. 1950-134-17. © ADAGP, Paris and DACS, London 2012.

2 Inter-war 'realisms': metaphysical and political

After the First World War, figurative art movements arose whose principal common denominators were realism and order, or formal rigour. As we shall see, however, these traits had widely contrasting connotations in different contexts, from one country to another and also politically, for the movements in question grew up not only in Europe but also in the newly constituted Soviet Union, and in North and Central America.

In France, during the First World War, French critics, including Guillaume Apollinaire and Jean Cocteau (1889–1963), had called for a renewal of French classical traditions, as a reaffirmation of national values in contrast to German 'barbarism' (an allusion to the term used by ancient Romans to describe the Germanic tribes). In 1926, Cocteau gave the title *Le Rappel à l'ordre* (*A Call to Order*) to a collection of his critical writings,[6] and this phrase has since been used to label one important tendency in art of the period, which we might designate as modernist traditionalism. In this respect, developments in France and Italy were closely interlinked. The French painter André Derain (1880–1954), who had contributed to the creation of Cubism (though his association with Maurice de Vlaminck, 1876–1958, and Matisse is better known), and who remained close to Picasso and Braque, started, around 1912–13, to effect a new synthesis of Cubism and Cézanne with art of the late Middle Ages and early Renaissance. The Italian painters Giorgio de Chirico (1888–1978), who was Greek by birth, and Carlo Carrà (1881–1966) admired Derain's work and, like him, looked to past art through the prism of Cubism. All three influenced the Neo-classical, Realist and Objectivist styles of the 1920s. Derain and de Chirico shared dealers, and had the support of leading writers, notably Apollinaire and, later, André Breton (1896–1966), the founder and leading light of the Surrealist movement.

De Chirico studied art at the Munich Academy, and at first painted visionary scenes influenced by German and Swiss painters whose work was grounded in art of the Renaissance and the Romantic period. Arriving in Paris in 1911, where he was to stay until 1914, he encountered Cubism, and the outcome of this meeting is evidenced in paintings such as *The Enigma of a Day* (Plate 5.6). In slightly later paintings, de Chirico fragmented space, but even here we sense the influence of Cubism in the rendering of light and shade as a flat surface pattern, overriding the exaggerated perspective vista. The painting incongruously juxtaposes a Renaissance arcade

over the canvas like a dismantled jigsaw puzzle, instead of appearing as if present behind the surface; gradations of tone, outlines of features and angular indications of three-dimensional space are all present, though in a jumbled (but not incoherent) manner.

For contemporaries – as for the artists themselves – Cubism had connotations of both order and anarchy. On the one hand, it inspired the Futurists and Dadaists; on the other, it could inform works such as *Torso of a Young Man* (Plate 5.5), by the Romanian sculptor Constantin Brancusi.[5] Brancusi found in Cubism, in its semi-geometric remaking of the human image, the means to sculpt a figure no longer based on modelling from nature. The contrast with Rodin – whose work had initially inspired him – was deliberate. Cubism, in so far as it provided the model for an order independent of nature and observation, came to inform the manifold preoccupation with order in art of the inter-war period.

Plate 5.6 Giorgio de Chirico, *The Enigma of a Day*, 1914, oil on canvas, 186 × 140 cm. Museum of Modern Art, New York, 1211.1979. Photo: © 2011 The Museum of Modern Art/Scala, Florence. © DACS 2012.

and factory chimneys, lit like a stage set from an unseen source. Characteristically, de Chirico denotes action via a lifeless figure, the statue with a raised arm; the moribund tradition of the civic monument that Rodin had sought to revitalise, de Chirico here invokes, in its very deadness, thus imparting a sense of enigma.

The figurative styles that emerged in the 1920s were indeed poles apart from Rodin – though it was only Brancusi, whose sculptures of the inter-war period reduced human and animal subjects to semi-abstract and machine-like forms, who conceived his own work in deliberate contrast to Rodin's. Brancusi often remarked

that he wanted to get rid of *bifteck* (beefsteak), meaning Rodin's fluently modelled surfaces. During the 1920s, artists carried forward from Cubism a tendency to formal severity, and an emphasis on the artificial as against the living and natural. Images of mannequins populated the paintings of the Italian painters de Chirico, Carrà and Giorgio Morandi (1890–1964). Elsewhere, as we shall see, human figures came to be aligned with machines, or were portrayed in some other essentially lifeless guise. The general tendency to depict illusionistic scenarios that stood at a remove from everyday reality was a stimulus to the Surrealist paintings of René Magritte (1898–1967) and Salvador Dalí (1904–89).

Plate 5.7 André Derain, *Harlequin and Pierrot*, *c.*1924, oil on canvas, 175 × 175 cm. Musée de l'Orangerie, Paris, collection Jean Walter and Paul Guillaume, inv. RF1960-41. Photo: © RMN (Musée de l'Orangerie)/Hervé Lewandowski. © ADAGP, Paris and DACS, London 2012.

Derain's *Harlequin and Pierrot* (Plate 5.7) presents exactly such a scene of uncertain reality.[7] Clearly defined in shade and outline, and casting dark shadows, the figures appear nonetheless insubstantial, as they dance weightlessly, like marionettes, against what looks like a stage backdrop. Harlequin and Pierrot are characters from the Italian *commedia dell'arte*, an improvised theatrical performance with fixed roles, dating back to the sixteenth century. Other artists had painted such figures in the preceding years, most notably Picasso. Both Derain and Picasso had been involved

with stage design, through work for the impresario Sergei Diaghilev (1872–1929) and his troupe the Ballets Russes, one of whose productions, *Pulcinella*, was based on the *commedia*. Derain's composition, inspired by seventeenth-century engravings of these characters, is highly formal, the performers being presented frontally, the angles of limbs and instruments carefully harmonised, and the whole framed within a square. The figures are miming, the instruments being stringless, and this contributes to the dream-like sense of unreality. Derain's paintings were exhibited in

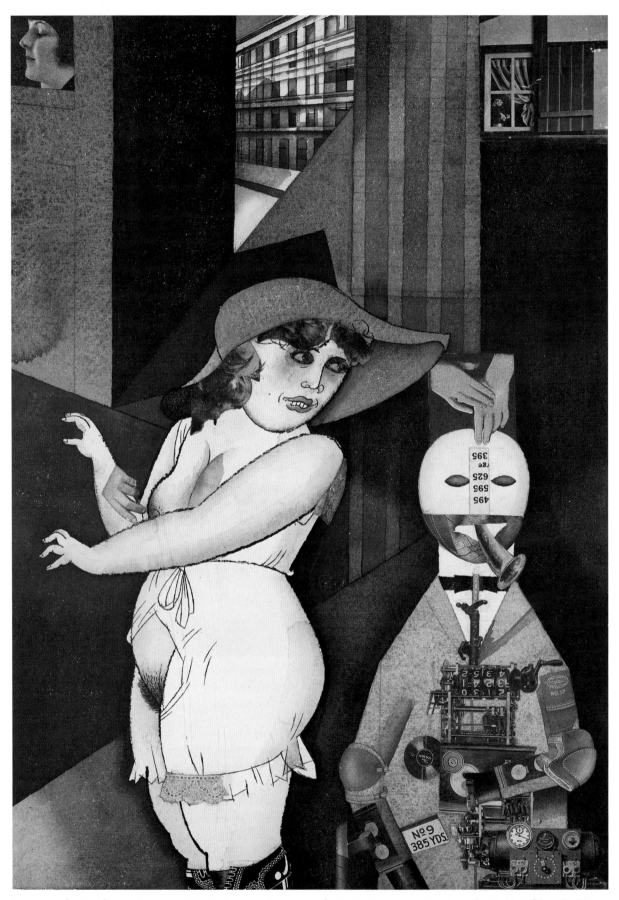

Plate 5.8 George Grosz, *'Daum' Marries her Pedantic Automaton 'George' in May 1920, John Heartfield is Very Glad of it (Meta-Mech. Constr. after Prof. R. Hausmann)*, 1920, watercolour over ink, collage on card, 42 × 30 cm. Berlinische Galerie, Berlin. Photo: © akg-images/Erich Lessing. © DACS 2012.

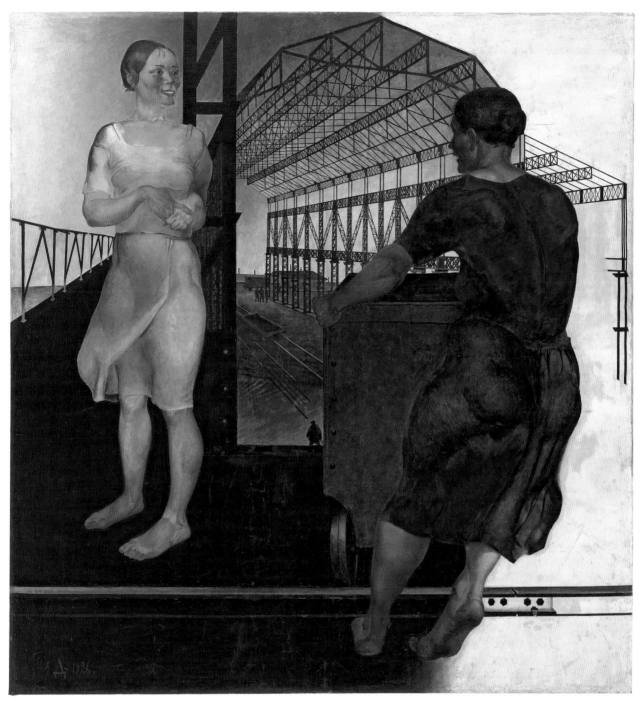

Plate 5.9 Aleksandr Deineka, *Building New Factories*, 1926, oil on canvas, 209 × 200 cm. State Tretyakov Gallery, Moscow. Photo: © State Tretyakov Gallery, Moscow.

Germany in the 1920s, as was the work of de Chirico and Carrà, members for a brief period of a self-proclaimed 'metaphysical' school of painting. By choosing this title they indicated that their paintings, like those of Derain, depicted a higher reality.

At this time – and later – German citizens were embroiled in reality of a more immediate kind, through revolution, economic hardship and political conflict. When the curator Gustav Hartlaub (1884–1963) staged

an exhibition of current German art, in 1925, under the title *Neue Sachlichkeit* ('New objectivity'), he identified two distinct and novel figurative tendencies, classicism and verism, the latter term implying a concern with truth. The kinds of truths that engaged artists such as George Grosz and Otto Dix (1891–1969), both 'verists' in Hartlaub's categorisation, were social, not eternal. Commenting, in an article of 1920, on the harshness of working-class life, the need to toil long hours to meet even basic needs, Grosz scathingly wrote that 'in

Plate 5.10 Arkady Plastov, *Collective Farm Festival*, 1937, oil on canvas, 188 × 307 cm. State Russian Museum, St Petersburg. Photo: culture-images/Lebrecht.

the face of all these horrifying truths, art seeks to lead [the working man] into an ideal world where they do not apply'.[8] Grosz was responding to an open letter written by the painter Oskar Kokoschka (1886–1980), who voiced concern at the fact that a famous painting by Rubens in the Dresden Picture Gallery had been damaged by gunfire during a demonstration in which the army had killed and wounded many demonstrators. Grosz wrote that he was delighted to see galleries being shot up, rather than the homes of the workers.

Grosz is best known for his graphic work, since, as a communist (until he left the Party in 1922) and a member of the Berlin Dada movement with strong anti-art opinions, he preferred to work for reproduction. His was an art of satire and attack, in a political cause, and he held that his work could have an impact only through publication. He did indeed get a reaction, being prosecuted twice in the 1920s, first for defaming the army, then for obscenity. One of the co-accused was Wieland Herzfelde (1896–1989), who ran the leftist publishing company Malik Verlag. Herzfelde's brother, who adopted the anglicised name John Heartfield (1891–1968), published satirical photomontages, which equalled Grosz's drawings in their bite and forcefulness. Grosz himself had anglicised (or rather de-Germanised)

his first name, Georg, and this fact is signalled, together with reference to Heartfield, in the long title of a work of 1920: *'Daum' Marries her Pedantic Automaton 'George' in May 1920, John Heartfield is Very Glad of it (Meta-Mech. Constr. after Prof. R. Hausmann)* (Plate 5.8).

Grosz had indeed married, 'Daum' being an anagram of Maud, his renaming of his wife Eva. A mixture of collage and watercolour, *'Daum'* is entirely consistent with his graphic work, since it is no more affirmative of art than of the bourgeois institution of marriage. The bride stands exposed and the artist, portrayed as a robot, has produced a 'meta-mechanical construction' (the title alludes to dehumanised heads assembled by the Dadaist Raoul Hausmann, 1886–1971). Grosz wrote regarding such images at the time: 'man is no longer shown as an individual, with psychological subtleties, but as a collectivistic, almost mechanical concept. The fate of the individual no longer counts.'[9]

Grosz's emphasis on construction reflects awareness of the constructivist movement in the Soviet Union. At the Berlin Dada-fair of 1920, he appeared with a placard in praise of 'Tatlin's machine art'; he was referring to Vladimir Tatlin, one of several Russian artists who had been influenced by Cubism, and who

Plate 5.11 Pablo Picasso, *Guernica*, 1937, oil on canvas, 349 × 777 cm. Museo Naçional Reina Sofia, Madrid. Photo: akg-images/Erich Lessing. © Succession Picasso/DACS, London 2012.

used the term 'construction' to link their creation of a radically abstract art with the construction of a new society and a new humanity. Such aspirations are very clearly embodied in *Building New Factories* by Aleksandr Deineka (1899–1969) (Plate 5.9). Even though this is a figurative oil painting and not an abstract construction, it shows kinship compositionally to abstraction and photomontage. The woman on the right, a life-size figure, pulls her load towards the viewer, away from and as if out of the perspective vista. Beyond her outline, the painting appears incomplete, as though she herself were producing the image through her action.[10]

The machine image could thus carry either critical or utopian connotations, as with Grosz and Deineka, respectively. Artists found that Cubism, with its quasi-geometric formal rhythms, yielded a means to represent processes of mechanisation that were increasingly manifest in industrial production and in the organisation of mass society. Soviet political leaders, however, failed to see 'Tatlin's machine art' as embodying any of this, or indeed anything at all. By 1921, Leon Trotsky (1879–1940) – the most cultivated and least conservative among them – was calling for an art that recognisably represented reality. Diverse art organisations and tendencies persisted, however, until the early years of Stalin's rule, and Socialist Realism, proclaimed as the required style in 1934, was only vaguely defined: all work should be intelligible to the masses, evidently serve the Party's aims, and embody its ideology.

Arkady Plastov (1893–1972) made *Collective Farm Festival* (Plate 5.10) to these broad specifications. A monumental canvas, like Deineka's, it is quite without trace of Cubist or Constructivist influence, being wholly a reworking of nineteenth-century naturalism. In its profusion of lively incident, it might appear more human or humane than Deineka's portrayal of labour, were it not for our knowledge that Stalin's programme of farm collectivisation was disastrous, and implemented ruthlessly. Surmounting the group is a portrait of Stalin, with a slogan that reads 'Living has got better, living has got merrier!' Perhaps it is, by contrast, a virtue of Deineka's painting that labour is undisguised.

During the inter-war period, the need to address political issues strikingly and communicate to a wide public led to the production of many large-scale paintings in which the figure is foremost, among the best-known of these being the works of Diego Rivera (1886–1957) and other Mexican muralists. Yet the work that most stands for us as a monument to its time is, aptly, a tragic drama. *Guernica* (Plate 5.11), exhibited at the Spanish pavilion at the Paris International Exhibition in June 1937, in commemorative protest at the dive-bombing of the Basque town of that name by German planes acting for the fascist insurgents, was to become the main prototype for artists on the left seeking to reconcile explicit political commitment with modernist formal means. This was not reconciliation merely for its own sake: the torn and twisted forms in Picasso's paintings embody the agony they signify.

3 Figuration in the era of high modernism

A human world?

In the years immediately following the Second World War, many artists felt impelled to address the question posed by experience of the war and knowledge of the death camps – the question, namely, of what it is to be human. The French philosopher Maurice Merleau-Ponty (1908–61) wrote, in the preface to his book *Sense and* *Non-Sense*, published in 1948: 'Just as Cézanne wondered whether what came from his hands had any meaning and would be understood, just as a man of good will comes to doubt that lives are compatible with each other when he considers the conflicts of his own particular life, so today's citizen is not sure whether a human world is possible.'[11]

Plate 5.12 Alberto Giacometti, *Man Walking* (in progress), 1947, plaster. Photographed in the studio by Patricia Matisse, *c.*1948. Photo: courtesy of The Pierre and Tana Matisse Foundation. © Fondation Alberto & Annette Giacometti, ARS, London – Succession Alberto Giacometti; ADAGP, Paris and DACS, London 2012.

The most striking and characteristic human images of the period betray a comparable insecurity, evidently grounded in shared historical experience. Indeed, painters and sculptors now came to address experience, and the encounter with reality, with a new urgency and by radical means. The sculptures, paintings and drawings of Alberto Giacometti (1901–66) epitomise this development in particularly telling ways, and through concentration on the human figure and image.

It was during the war years that Giacometti, who had turned away from his earlier Surrealism, embarked on a practice tied to the rendering of observed reality, sculpting small figures that diminished almost towards disappearance as he worked on them, thus imparting a sense of perceived distance. In the sculptures that were to make him celebrated soon after the war, such as *Man Walking* (Plate 5.12), this tendency to reduction persisted, though without his taking it to such extremes. In order to discern the motivation for what might perhaps appear a mannerism, it is essential to understand the ideas concerning the perception of reality, and its representation in art, that formed a link between Giacometti and contemporary philosophers whom he knew well – Jean-Paul Sartre (1905–80), Simone de Beauvoir (1908–86) and Merleau-Ponty.

'You never copy the glass on the table; you copy the residue of a vision.'[12] Remarks such as this reveal Giacometti's intellectual kinship with the philosophical movement to which those philosophers belonged, namely phenomenology. As Merleau-Ponty put it, the world is 'not in front of me', like an object for detached observation, for 'I live in it from the inside; I am immersed in it.'[13] How, though, might this immersion – corporeal, sensory, emotional, social and so forth – actually be captured in art? *Man Walking* holds an answer, for it evokes the bodily awareness that informs our perception of another human being. In reducing *Man Walking* to the step he takes, in relieving the sculpted matter of its weight, Giacometti makes manifest the forward orientation of the alert, active body, which summons a world for its action, one appearing in response to its movements, needs and desires. With still figures and portraits, he pares the clay back, incising and subtracting so that the part that faces and gazes outward rises narrowly and weightlessly from a basal mass of feet or shoulders. In this way, he re-enacts the process whereby, continually, we 'produce' a world in the phenomenological sense, as beings at once physical and psychical. 'In space there is too much': these are Giacometti's words, quoted by Sartre in 'Search for the absolute', his essay for the artist's 1948

exhibition in New York.[14] They refer, I think, to matter in so far as it passively fills space – sheer stuff – and in his work Giacometti at once addresses and enacts the human effort directed at emancipation from the inertia of matter. As he reduces and lightens the figure, it rises, gazes, advances. The sculpture's two aspects, materiality and aliveness, are utterly interdependent, yet they never merge and neither predominates; herein lies a contrast both with Rodin's fleshed-out naturalism and, differently, with Brancusi's near-abstraction.

For the phenomenologists, the artist represents visible reality through the mediation of signs. For them – as for Giacometti – these signs have an existential status, and the world itself is mediated – sustained – through our individual and collective purposes, actions and desires. Merleau-Ponty wrote of the prehistoric painted animals at Lascaux that they were not 'there' in the same way as the crevices and protrusions of the rock itself. Yet neither are they *elsewhere*. They have a shifting status. This unplaceability of the visual image epitomised, for him, the pictorial sign.[15] What corresponds to it, in our apprehension of the world, is the 'horizon'. In phenomenological usage, this means not merely the furthest distance away from the viewer but the shifting limits of our perceptual engagement with the given. These limits are not in things themselves, nor merely in our perceiving acts, and yet are inseparable from both. The manifold incisive pencil lines of Giacometti's drawings, as in his 1954 portrait *Annette* (Plate 5.13), are idiosyncratic pictorial signs that mobilise or retrace this mediation of the world continually meeting and responding to our questing, demanding gaze.

In defining affinities between art and contemporary philosophy in the 1940s and 1950s, I do not want to give the impression that artists merely took their cue from philosophers or made work that illustrated philosophical themes; it is fundamentally a question of shared concerns. French philosophers, writers and artists all lived through and responded to the same historical events and circumstances, from the pre-war era of anti-fascism and the Popular Front, through war and occupation, and these common experiences informed diverse fields of practice. Giacometti, like his friend Francis Gruber (1912–48), Jean Hélion (1904–87), Jean Dubuffet (1901–85) and others, arrived at the aspiration to concentrate on the human image and on essential aspects of common experience. This interest arose partly as a consequence of the war, but also derived from heated debates about Realism in France in the 1930s. Leftist values favoured a turn towards the figurative and the concrete, as opposed

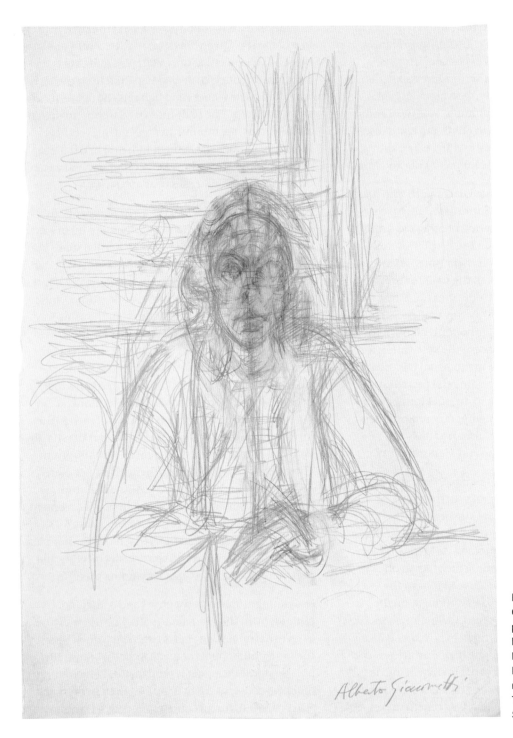

Plate 5.13 Alberto Giacometti, *Annette*, 1954, pencil on paper, 42 × 30 cm. Museum of Modern Art, New York, The Sydney and Harriet Janis Collection, acc. no. 602.1967. Photo: © 2011 The Museum of Modern Art/ Scala, Florence.

to the abstract or ideal. Yet this did not merely result in the artistic style of Social Realism. The artists closest to phenomenology sought in their paintings and sculptures to embody the complex and shifting character of our relationship with reality. The philosophers, in their own terms, and partly through comparable political sympathies, came to focus intensely on human subjectivity, bodily awareness and sociality. As Merleau-Ponty wrote: 'Our own body is in the world as the heart is in the organism: it keeps the visible spectacle constantly alive, it breathes life into it and sustains it inwardly, and with it forms a system.'[16]

It would be a tall order for a painter or sculptor to address such invisible dimensions of experience directly, and it is in this respect that the mediation of signs was a crucial factor, for thereby Giacometti or Gruber could do more than represent external appearance. The network of lines in a Giacometti portrait ties the outward gaze of the depicted face, as

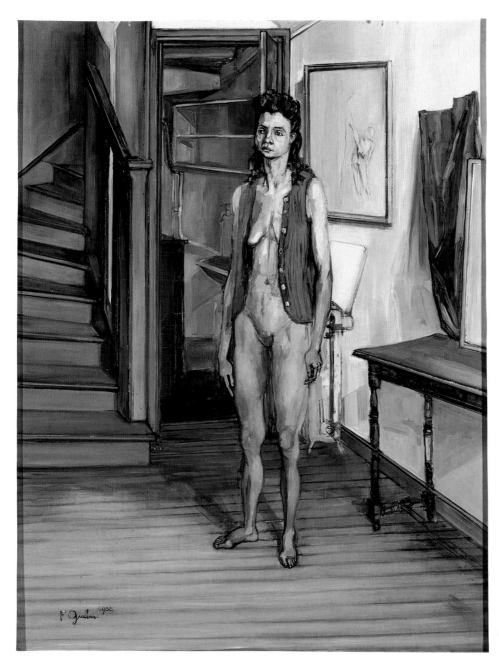

Plate 5.14 Francis Gruber, *Nude in a Red Waistcoat*, 1944, oil on canvas, 115 × 86 cm. Musée d'Art Moderne de la Ville de Paris. Photo: © RMN/Agence Bulloz. © ADAGP, Paris and DACS, London 2012.

I have said, to the probing attention of the observer, evoking the sense in which, as Merleau-Ponty wrote, we 'haunt' each other.[17] It is not simply the subjectivity of the other that is in question, but rather an interplay of subjectivities – 'intersubjectivity', as the phenomenologists called it. Such complexity is less immediately apparent in Francis Gruber's *Nude in a Red Waistcoat* (Plate 5.14), which ostensibly presents its subject in straightforward terms: there is no marked distortion, and the indications of spatial depth are less unconventional than in Giacometti. Gruber, however, is as attentive to the material surface of his painting as any modernist and, just as Giacometti pared back

his sculpted figures, so Gruber uses black outlines and schematic modelling to render woman and setting alike as lean, bare and angular. This is not mere stylisation, for the evidence of Gruber's searching contact with model and painting is pronounced. With model *and* painting: the viewer's attention, like that of the painter, cannot simply plunge into the depth of this painting, but must trace its contents though the mesh of pictorial signs that intervene. By imaginatively feeling the qualities of the surface as well as seeing the image, we may apprehend the painting as a reduction to bareness in every sense.

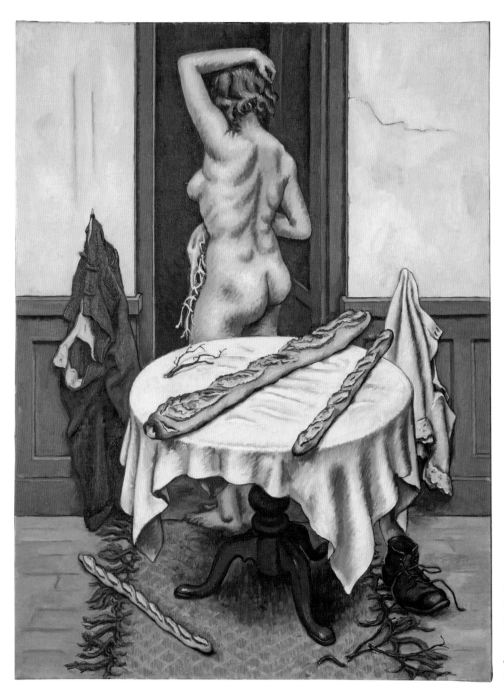

Plate 5.15 Jean Hélion, *Nude with Loaves*, 1952, oil on canvas, 130 × 97 cm. Tate, London, inv. T05497. Photo: © Tate, London, 2012. © ADAGP, Paris and DACS, London 2012.

These artists, working out of – and often addressing – a contemporary experience of poverty and want, and practising techniques of reduction, arrived at distilled or intensified portrayals of reality. Jean Hélion's friend, the poet Francis Ponge (1899–1988), summarised the literary equivalent of their approach: 'parti pris des choses *égale* compte tenu des mots' (taking the side of things *equals* taking account of words).[18] His experiments in writing on simple objects, such as a piece of soap or bread, make vivid the actuality of the thing while simultaneously presenting language freshly to view. In *Nude with Loaves* of 1952 (Plate 5.15),

Hélion, who had been an abstract painter before the war, disposes figures and objects in an evidently non-naturalistic and formalised way. In affording visual parallels between disparate entities – a twig, a fringe of carpet and a shoelace; the crusted ridges of a loaf and the model's back; a man's clothing and the woman's body – the painter sets in play an interchange of signs through which each element takes on a hallucinatory actuality. Hélion's notes on this painting conclude 'the burnt end of bread is also a bud ... the tip of the breast etc.' – a surrealistic alliance of ambiguity and sexuality, afforded by the play of signs.[19] What I call the sign is

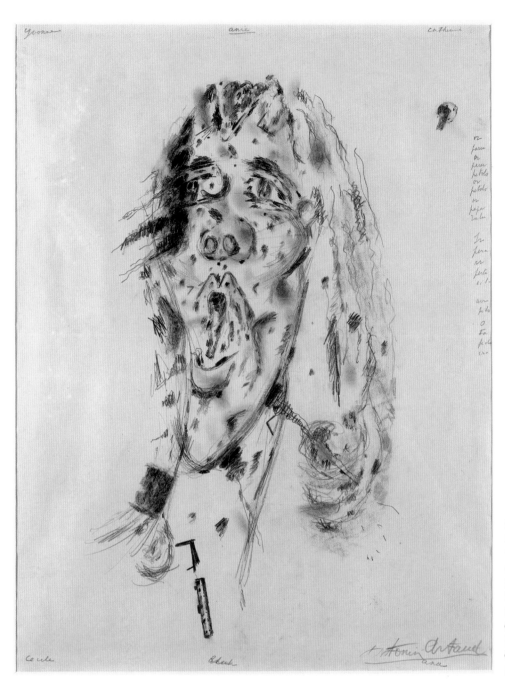

Plate 5.16 Antonin Artaud, *Blue Head* (*La Tête bleue*), 1946, pencil and coloured chalk on paper, 63 × 48 cm. Musée National d'Art Moderne – Centre Georges Pompidou, Paris. Photo: © Collection Centre Pompidou, Dist. RMN/Philippe Migeat. © ADAGP, Paris and DACS, London 2012.

the hinge between the two aspects I referred to earlier – matter and image, surface and subject – while being itself neither purely material nor wholly imaginary: not there, not elsewhere. It is in art thus divided between modernism and figuration that the sign in Merleau-Ponty's sense comes to stand out in its very ambiguity.

The bequest of Surrealism to French post-war artistic and literary culture was profound, and may be seen both in Hélion's making-strange of the ordinary and, more widely, in a many-sided contemporary preoccupation with insanity. Antonin Artaud (1896–1948), an actor and radically original dramatic

theorist, made drawings during his long confinement in an asylum at Rodez, where he received electric shock treatment of some severity. He drew *Blue Head* (Plate 5.16) shortly before his release in 1946, and the tormented head, with its mouth forming a scream, its neck pierced by a sharp instrument, enacts the pain he had experienced – though this is not a self-portrait. During the months remaining to him (he died in Paris in 1948), he drew many portraits of friends, as well as self-portraits, at times pressing the pencil so hard as to tear the paper. Here, his emotional identification with the subject, and his creative energy, are evident in the range and intensity of graphic notations.

Plate 5.17 Jean Dubuffet, *Monsieur Plume with Creases in his Trousers (Portrait of Henri Michaux)*, 1947, oil and grit on canvas, 130 × 97 cm. Tate, London, inv.T03080. Photo: © Tate, London, 2012. © ADAGP, Paris and DACS, London 2012.

Jean Dubuffet was among those who supported Artaud in his last years. He had formulated, during the 1940s, a concept of 'Art Brut' ('brut' here means, literally, raw or rough; metaphorically, unpolished or untutored). Dubuffet used this term initially to refer to the art of schizophrenics, which he had started to collect in 1945, but he soon sought to capture their effects in his own work. In *Monsieur Plume with Creases in his Trousers (Portrait of Henri Michaux)* (Plate 5.17), he endows the medium with a rawness that accords with the graffiti-like figure. Whereas in Giacometti the sign is always in tension with matter (his pencil or brush lines are rarefied), Dubuffet exploits the connotations of graffiti

to assert materiality itself, in its crude state. Dubuffet, as if anticipating the anthropologist Mary Douglas's famous definition of dirt as 'matter out of place',[20] conceived his paintings as anomalous matter, in ironic defiance of culture and order – and orderliness. In 1947, Artaud wrote *Van Gogh: le suicidé de la société* (published in translation as *Van Gogh: The Man Suicided by Society*), in vehement opposition to psychiatry, which he saw as curtailing those who spoke out of order, 'emitting insupportable truths'.[21] Van Gogh, he wrote, had internalised nature and 're-perspired it and made it sweat'.[22] The eruptive, insurgent sense of matter and nature evident in Artaud's writing and drawings brings

Plate 5.18 Germaine Richier, *Storm Man* (*L'Orage*), 1947–48, bronze, 190 × 77 × 55 cm. Louisiana Museum of Modern Art, Humlebaek, Denmark. Donation: The Richier Family. © ADAGP, Paris and DACS, London 2012.

him into association with contemporaries such as Dubuffet and also the sculptor Germaine Richier (1904–59), whose bronze figures of the late 1940s include *Storm Man* (Plate 5.18), in which matter rises up and takes a lurching step.

Exercise

How does Giacometti render the human form in ways that can be described as modernist?

Discussion

Definitions of modernism vary. I said at the beginning that the term 'figurative' came into use in art criticism only in the mid twentieth century, but the same could almost be said of 'modernism', for Greenberg's was the first – arguably the only – comprehensive critical definition of the term to gain wide currency. I have adopted a key aspect of it, namely, the tendency in modernism to give prominence to the medium itself – and to the immediate materiality of the work, in the case of visual art. This evidently holds for Giacometti. His *Man Walking* (Plate 5.12) is almost as starkly material as Brancusi's *Torso* (Plate 5.5). Yet – and here he differs from Brancusi – the specific qualities of his materials, typically those of a modeller (clay, plaster, bronze), do not concern him. In this he resembles Rodin, and indeed *Man Walking* is one of several works based on Rodin. Whereas Rodin portrays flesh, however, Giacometti causes his materials to embody matter in general. His process is one of reduction, a variant of modernist abstraction. He reduces away from appearance, cutting matter down to a core, to figure forth the essential dimensions of bodily being: the erect posture, feet planted, balanced, having a front and a back – fundamental dimensions of the human world.[23]

Art and the Cold War: figuring collective life

I have sought to show how the qualities of 'literal, sensational concreteness' identified by Greenberg as being essential to modernism may be recognised even in works as distinctly representational as those discussed in the preceding section. Greenberg himself, while supporting chiefly the abstract art of his own time, conceded on seeing work by Dubuffet in 1946 that 'easel painting with explicit "subject matter" may have won a new lease of life'.[24] He would not, however, have made any such concession where Gruber or Hélion were concerned, and, in the same review, he criticised Picasso for '[clinging] to the representational ... [in] his desire to answer current history with an art whose evocation of violence and terror will be unmistakeable'. Picasso, he continued, was at fault in

Plate 5.19 Pablo Picasso, *Charnel House, Monument for Spaniards who Died for France*, 1945, oil and charcoal on canvas, 200 × 250 cm. Museum of Modern Art, New York, Mrs Sam A. Lewisohn Bequest (by exchange) and Mrs Marya Bernard Fund in memory of her husband Dr Bernard Bernard and anonymous funds, acc. no. 93.1971. Photo: © 2011 The Museum of Modern Art/Scala, Florence. © Succession Picasso/DACS, London 2012.

defying 'the inherent logic of his course as an artist [which] draws him toward the abstract'.[25] Greenberg's summation of Picasso's intentions in *Guernica* and kindred work is accurate, and he identifies a potential source of conflict in politically engaged art: could any artist reconcile a radical concern with questions of form with the demands of conveying a subject, and a political commitment, in terms that were, indeed, 'unmistakeable'? This issue was at the heart of the argument about Realism which had arisen in the inter-war period and which resurfaced now, in the post-war years.

During the 1920s and 1930s, as we have seen, painters such as Deineka had, like Picasso himself, sought to combine a modernist attention to form and surface with political and social content. In the same years, the

Soviet state, by contrast, framed artistic and cultural policy in opposition to modernism. In 1946, Andrei Zhdanov, Stalin's principal spokesman in matters of Party doctrine, including cultural policy, reasserted the principles of Socialist Realism. The following year, in a speech to the Cominform, he defined the 'two camps' into which the world was now divided. The Cold War thus provided the setting for an ideological polarisation between modernist abstraction on the one hand – which came to be identified with an American political rhetoric of 'freedom' – and, on the other, an overtly politicised Socialist Realism that expressly advocated the values of the Soviet Union.[26]

Given the situation thus outlined, Picasso, as the prototypical 'formalist', made, in 1945, a rather incongruous recruit to the Communist Party. The vast

Plate 5.20 Fernand Léger, *The Construction Workers* (*Les Constructeurs*), 1950, oil on canvas, 300 × 228 cm. Musée National Fernand Léger, Biot, inv. MNFL94001. Photo: © RMN/Gérard Blot. © ADAGP, Paris and DACS, London 2012.

canvas he exhibited at the *Art et Résistance* exhibition in Paris in 1946, *Charnel House, Monument for Spaniards who Died for France* (Plate 5.19), was allusive rather than illustrative or descriptive. It evoked documentary images of piled-up bodies, in the formal language and photograph-like tonalities of *Guernica*. In the rather different case of Fernand Léger, a painter of the Cubist generation who had also joined the Communist Party, modernist form carried a generalised connotation of the utopian transformation of society. In *The*

Construction Workers (Plate 5.20), manual labour features both as toil and as the cooperative bond that will enable workers to transform their situation.

The painters who produced the most prominent political art in the post-war years were all members of the Communist Party, but were by no means alike with respect to methods or strategy. Not only did Picasso and Léger diverge markedly from each other, but both differed in turn from the most prominent west European communist painters of the next generation,

Plate 5.21 Renato Guttuso, *Peasant Marseillaise* (*Marsigliese Contadina*), 1947, oil on canvas, 150 × 202 cm. Szépmüvészeti Múzeum, Budapest. © DACS 2012.

Renato Guttuso (1912–87) and André Fougeron (1912–98). These painters, Italian and French, respectively, worked in the countries in western Europe that had the largest Communist Parties. Both drew on Picasso, Fougeron in early work and Guttuso more consistently, and this because – as already noted – the torn and conflicted formal language of *Guernica* lent itself to narratives of struggle and contention. Thus, Guttuso painted a series of canvases on the battles of Sicilian peasants faced with deprivation and oppression, the most Picassoid of which is *Peasant Marseillaise* (Plate 5.21), whose central figures allude to Delacroix's *Liberty Leading the People*, of 1830. Both Guttuso and Fougeron painted in diverse styles throughout their careers, and during the first Cold War years this fluctuation reflected precisely the conflict between (modernist) form and (social) content that I referred to as underlying the 'argument about Realism'.

It is important to emphasise that, despite Soviet promulgations of aesthetic doctrine, reaffirmed in turn by national central committees, there was no strict uniformity in practice, even in the Soviet Union, and there were many nuances and divergences in critical outlook. On the death of Stalin in 1953, the poet Louis Aragon (1897–1982), editor of the communist literary journal *Les Lettres françaises*, published a formalised Picasso drawing of a strangely youthful Stalin that was criticised by Fougeron and the Party leadership. Aragon apologised as follows: 'I'm used to seeing a Picasso as a Picasso and hadn't thought what the reader would see,

without attention to style and technique. That's my error and I've paid dearly.'[27] Fougeron's then recent paintings, based on a tour of the mining districts of northern France, were by contrast quite unambiguous as to meaning and intention. The harshly graphic style of *The Judges* (Plate 5.22), modelled on the satirical Realism of the Germans Otto Dix and George Grosz, manifestly serves the subject: victims of bad working conditions who stand as accusers. Yet in the very year in which he criticised Aragon, Fougeron painted *Atlantic Civilisation* (Plate 5.23), which Aragon himself criticised for employing multiple perspectives; Fougeron explained and apologised in turn. Guttuso too veered between the relatively disjunctive, as in *Peasant Marseillaise*, and much clearer visual narration, as with a series of works on the subject of the occupation by Sicilian peasants of uncultivated land.[28] In practice, then, and however orthodox their declarations, communist painters negotiated the conflicting demands of form and content on a continually changing basis, and in response to subject and circumstance, and intelligent critics recognised as much. Writing on Guttuso, Richard Wollheim and the Marxist (but not Party) critic John Berger expressed the familiar dilemma in subtle and contrasting ways. For Wollheim, Guttuso 'grasped one of the most important and revolutionary lessons of Cubist painting: namely that the realism of a picture can be enhanced by emphasising the reality of the painting'.[29] Berger, on the other hand, stressed the social imperative: Guttuso 'has always understood that the

Plate 5.22 André Fougeron, *The Judges*, 1950, oil on canvas, 130 × 195 cm. Musée National d'Art Moderne, Paris, inv. AM1983-365. Photo: © Collection Centre Pompidou, Dist. RMN/rights reserved. © ADAGP, Paris and DACS, London 2012.

Plate 5.23 André Fougeron, *Atlantic Civilisation*, 1953, oil on canvas, 380 × 560 cm. Tate, London, inv. T07645. Photo: © Tate, London, 2012. © ADAGP, Paris and DACS, London 2012.

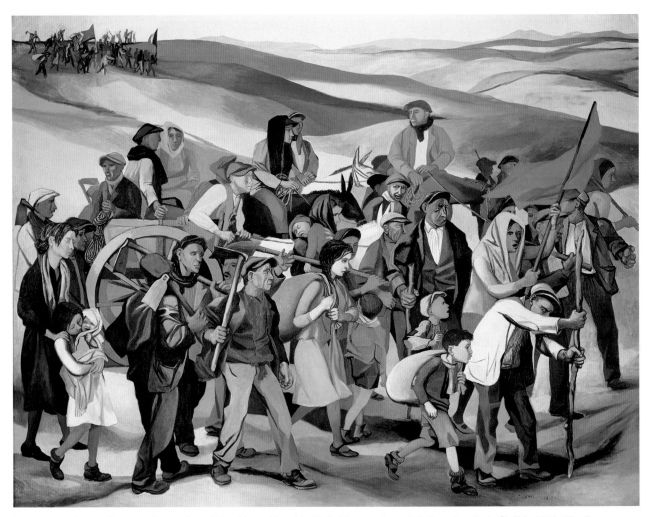

Plate 5.24 Renato Guttuso, *Occupation of Uncultivated Land in Sicily* (*Occupazione delle terre incolte in Sicilia*), 1949–50, oil on canvas, 265 × 344 cm. Akademie der Künste, Kunstsammlung, Berlin, inv. E11. Photo: © Akademie der Künste, Kunstsammlung, Berlin/ The Bridgeman Art Library. © DACS 2012.

artist's responsibility is not only to what his brush does to his canvas, but also what his canvas does to those who gaze at it'.[30]

Exercise

How might we apply Berger's and Wollheim's criteria to Guttuso's *Peasant Marseillaise* (Plate 5.21) and to the vast *Occupation of Uncultivated Land in Sicily* (Plate 5.24)?

Discussion

Both paintings use a processional motif, which conveys solidarity, but in the first case principally through formal repetition, and in the second more through depictive or descriptive means. Given that the earlier work is principally emblematic, while the second refers to actual events, the respective approaches appear equally appropriate. And now

Berger's criteria seem more to the point than do Wollheim's, in that Berger invites us to think of the response being aimed at: perhaps a generalised exhilaration in the first case, a sense of common cause in the second.

In the Soviet Union, where miners and peasants certainly suffered as much as those in France and Italy, only on a vaster scale, painters could not address such concerns in their art. The safest subject matter, for artists wanting to deal with actual experience, was that concerning the Great Patriotic War against fascism, and the sufferings of the Russian people. Socialist Realism, it has been pointed out, with its emphasis on *narodnost* (people-mindedness), readily mutated along nationalist lines.[31]

Gely Korzhev (b. 1925) is one of the most interesting of the painters who emerged in the Khruschev era (1953–64). Nikita Khruschev had denounced Stalin after he

Plate 5.25 Gely Korzhev, *The Artist*, 1960, oil on canvas, 159 × 195 cm. State Tretyakov Gallery, Moscow. Photo: © State Tretyakov Gallery, Moscow.

was safely dead, and held out a momentary hope that the Soviet Union would prosper economically, and that past sufferings would not have been in vain. Socialist Realism remained in place, but it now became possible for one critic publicly to advocate an opening towards 'a contemporary style in painting' and, after Deineka's example, suggest 'more synthetic, generalised solutions ... more laconic and expressive form', rather than 'an empirical fragment of the seen'.[32] Korzhev's paintings might seem to exemplify the latter more than the former, yet they are highly constructed, being framed like film stills and presenting an idiosyncratic cast of individuals: a battle-scarred soldier who has lost an eye; a worn-out pair of middle-aged lovers stretched out on stony ground beside a battered motorbike; a young pavement artist and his girl (*The Artist*, Plate 5.25). These narrative glimpses afford a quite material sense of the texture of a weary and depleted reality in the interval between Stalinism and the long Brezhnev years of corruption and decay.

New images of man: figuring matter

The paintings by Guttuso, Fougeron and Korzhev discussed in the preceding section have two striking features in common, arising from Social Realism: they quite evidently have subjects, and are narrational. Even if, in Korzhev's case, we can't be sure what story he is telling, we can see plainly that there actually *is* a story. As the formulators of Socialist Realism were all too aware, the expectations of the public at large with respect to art had remained unchanged since the nineteenth century: every picture (or sculpture) should tell a story. Faced with even figurative images that involved distortion, or a building up of surface matter, viewers demanded guidance: 'What am I supposed to be looking at? What does it mean?' From the inception of modernism, art critics responded to this demand, as did artists themselves, through interviews, statements, manifestos and so forth. Museum curators came to play a particularly significant role in this interpretative process from the early twentieth century onwards; the synoptic, themed exhibition served to signal new developments in art and explain them to a wide public (such exhibitions often have the word 'new' in the title, as with *Neue Sachlichkeit*, mentioned earlier). In 1959, a then recently appointed curator, Peter Selz, mounted an exhibition at the Museum of Modern Art in New York that bears centrally on the topic of modernist figuration, titled *New Images of Man*.[33]

Selz intended to offer a corrective to the dominance of Abstract Expressionism and of abstraction in general,

Plate 5.26 Leon Golub, *Reclining Youth*, 1950, lacquer on canvas, 200 × 415 cm. Collection Museum of Contemporary Art Chicago, gift of the Susan and Lewis Manilow Collection of Chicago Artists, 1979.52. Photo: © Museum of Contemporary Art Chicago. © Estate of Leon Golub, DACS, London/VAGA, New York 2012.

by mounting a show comprising works that were unmistakably modern, and yet figurative, and which disclosed, he claimed, a common contemporary frame of reference. He wrote in his introduction that 'new human imagery unique to our century has been evolved'; the artists he selected had built on Picasso's investigation of 'the reality of form', by constructing 'a similarly shallow space in which they explore *the reality of man*'.[34] He chose a mixture of American and European artists. The predominant general characteristics were a tendency to informal composition, an assertion of materiality and an identification of image with matter.

Selz writes of the American figurative painter Leon Golub (1922–2004) that in his *Reclining Youth* (Plate 5.26) – a vast canvas whose figure is based on a dying Gaul in the relief sculptures on the altar of Zeus at Pergamon (*c.*180 BCE) – the 'brutalised', 'mutilated and … gnawed' appearance of the body is achieved by elaborate technical means: 'Golub applies successive coats of lacquers, carves into the surface with a sculpture tool, removes the pigments with solvents, rebuilds and recoats until he achieves his texture.'[35] While Selz was able to be precise with respect to technique, he found it harder to define the subject where, as in this case, it was not self-evident and the representation not detailed or closely descriptive. His remarks in this connection are vague, particularly when it comes to linking the obtrusive material qualities to subject matter. A text written by Golub prefaces Selz's entry, and here the artist confronts

the problems of interpretation (one risks either being too vague or too prescriptive) by stating that his recent paintings can be seen in various ways and then setting out four numbered and forthright statements, possible perspectives. The fourth of these reads:

> The figures are implacable in their appearance and resistance, stance or stare. They are implacable in the compacted wearing down of surfaces and forms to simpler forms but with more complicated surfaces. They are implacable as they take on the resistance of stone as against the undulations of flesh. They are implacable as they know an absolute state of mind (on the edge of nothingness) just as they know a nearly absolute state of massiveness.[36]

Golub and Selz had a friendship dating back to the time when both had been art history students at the University of Chicago. Golub had subsequently enrolled at the Art Institute of Chicago, and had become the leading figure in a group of Chicago artists also to be included in *New Images of Man* (Golub's wife, Nancy Spero, 1926–2009, was not selected). It was Selz who introduced Golub and Spero to the work of Dubuffet, a formative influence on both artists.[37] The shared enthusiasm among the Chicago group for Dubuffet and the idea of Art Brut, as well as for Francis Bacon (1909–92) and Giacometti, is also reflected in Selz's selection. More fundamentally relevant, however, was Golub's

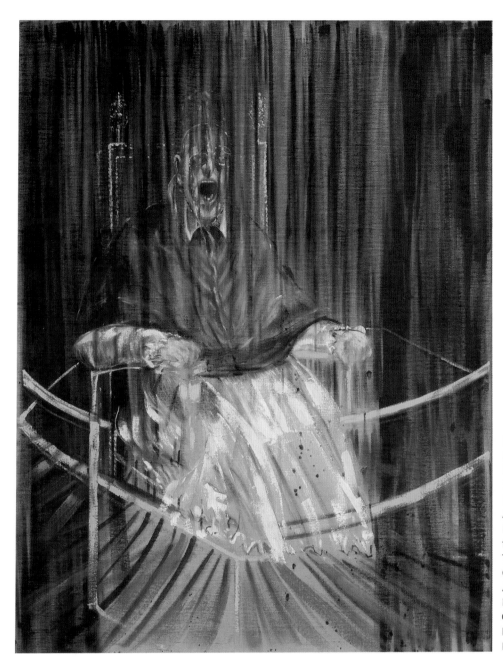

Plate 5.27 Francis Bacon, *Study after Velázquez's Portrait of Pope Innocent X*, 1953, oil on canvas, 153 × 118 cm. Des Moines Art Center, Des Moines, Iowa. Purchased with funds from the Coffin Fine Arts Trust; Nathan Emory Coffin Collection of the Des Moines Art Center, 1980.1. Photo: Des Moines Art Center. © The Estate of Francis Bacon. All rights reserved. DACS 2012.

criticism of Abstract Expressionism for – as he saw it – turning away from reality, together with his ambition to nonetheless achieve a fully contemporary mode of expression in his own terms. He wrote in 1950, in the catalogue of a show he himself had organised, 'peculiar to the contemporary artist is his conscious effort to seek those modes of thought and meaning that are the necessary symbols of the time'.[38] This might equally have stood as the epigraph for *New Images of Man*.

If Golub was central to the exhibition, he was also one of the artists whose work was to continue to evolve significantly, in ways consistent with the exhibition's ethos. Another was Bacon. Golub and Bacon had something essential in common, for both were primarily originators of 'new images of man' in the quite specific sense of maleness. The title of one of Golub's exhibits might stand as emblematic for each of them: *Damaged Man* (1955). This painting, in which a face is superimposed on a flayed skin, immediately evokes the mythical contest between Apollo, god of reason and order, and Marsyas, the satyr whom the god stripped of his skin. Selz referred to the myth at the beginning of his catalogue essay. Apollonian Athens, he wrote, 'set the standard for the tradition of Western art. But always there was the undercurrent of Marsyas' beauty struggling past the twisted grimaces of a satyr. These strains have their measure not in the rational world of geometry but in the depth of man's emotion.'[39]

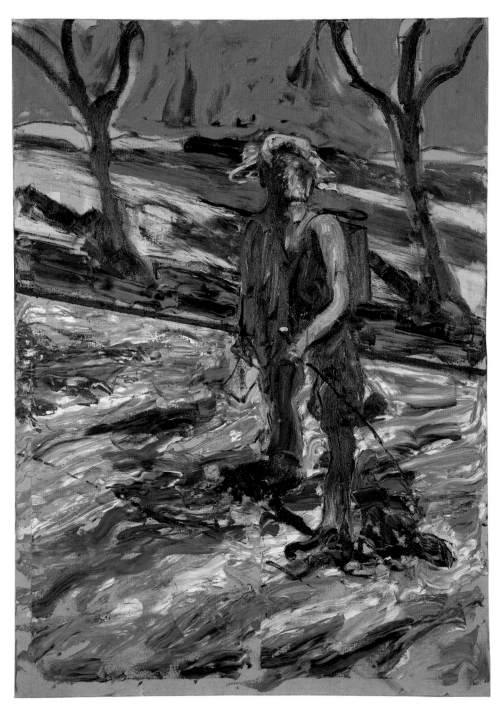

Plate 5.28 Francis Bacon, *Study for a Portrait of van Gogh III*, 1957, oil and sand on linen, 198 × 143 cm. Hirshhorn Museum and Sculpture Garden, Smithsonian Institution, Washington, DC. Gift of the Joseph H. Hirshhorn Foundation, 1966, inv. 66.186. Photography by Lee Stalsworth. © The Estate of Francis Bacon. All rights reserved. DACS 2012.

If we think of 'man's emotion' here as being specifically male, and as bearing connotations of violence and conflict, we may define a motif common to Golub and Bacon, though pursued along idiosyncratic lines by both artists. The paintings by Bacon exhibited in the show all depicted male figures – indeed, it was only later, in his paintings of Isobel Rawsthorne and Henrietta Moraes, that female images appeared in his work. All pictures save one reflect his early practice of painting sparely on either raw canvas or a dark ground. They include two highly characteristic works, *Man in a Blue Box* (1949) and *Study after Velázquez's Portrait of Pope Innocent X* (Plate 5.27), both of which portray male figures redolent of authority, their mouths agape. Bacon plays with the post-Renaissance convention of the 'speaking likeness', whereby the portrait subject appears to encounter the viewer, as if momentarily meeting one's gaze. The painterly practice of Titian, Velázquez and Rembrandt contributed fundamentally to this achievement, since oil paint, in its malleability, could stand at once for the substantiality of flesh and, as a trace, for the passage of time. Bacon plays with

a schematic version of this painterly practice, also maintaining the illusion of presence, the suggestion that the depicted figure inhabits a space of its own – physical and emotional – from which it looks back.

Most relevant here is that these figures connote power, that the power is male, and that this male power is seen simultaneously to intensify – as if flaring up – and to disintegrate (a flame does both), within its own confinement. The possession of power is isolating, the throne a kind of trap, the gaping mouth at once a violent command and a scream. Such images are familiar, less so the exception among the Bacon exhibits, *Study for a Portrait of van Gogh III* (Plate 5.28). No. 1 in this series, painted a year earlier, was also shown, but it lacks the distinctive technical features of the other variants, for with the sequence of van Gogh paintings that he executed rapidly in 1957, Bacon broke new ground. What remained constant, however, was the motif of an assertive and powerful maleness inherently undermined, damaged.

That this painting in particular should have been shown in an exhibition responding to Abstract Expressionism, and placed alongside paintings by Willem de Kooning (1904–97) and Jackson Pollock – artists known under that heading and included in *New Images of Man* – was wholly appropriate. As in other paintings of this 1957 series, Bacon for the first time applied paint thickly, and with evident impetus and pressure, covering the background almost as densely as the figure. He deployed, as a critic observed, 'the postwar paintbrush',[40] as if he was indeed taking on Abstract Expressionism, or 'Action Painting', as the critic Harold Rosenberg called it. Rosenberg drew on existentialism in interpreting the work of Pollock, de Kooning and others, highlighting as significant the record of the painter's action, and defining what we might now call the performative dimension of this work. Bacon himself, writing on the English painter Matthew Smith (1879–1959) in 1953, had asserted that painting with a highly activated surface

> tends towards a complete interlocking of image and paint ... Consequently, every movement of the brush on the canvas alters the shape and implications of the image. That is why real painting is a mysterious and continuous struggle with chance – mysterious because the very substance of paint, when used in this way, can make such a direct assault upon the nervous system ... I think that painting today is pure intuition and luck and taking advantage of what happens when you splash the stuff down.[41]

He could equally have been writing about de Kooning. It is as if, under pressure, as he in fact was, to get work together rapidly for an exhibition, he took a cue from such work as de Kooning's to live up to his remarks on Smith. In choosing to reinterpret a famous (lost) van Gogh, Bacon chose an appropriately intrepid artist, one given to impulse and ventures of chance, and the use of a loaded brush. All the existential connotations of 'Action Painting' are at hand: daring, urgency, impulse and risk. Bacon spoke of his long fascination with 'that haunted figure in the road ... a phantom of the road'.[42] Perhaps another painter too haunts the work, namely Pollock, who had died the year before. It is a large painting, like an Abstract Expressionist canvas, employing the baroque full-length portrait scale he had long since adopted. The figure, arrested, looks out. Quite unlike van Gogh's jaunty self-portrait, it is heavy, dark and gaunt, with a death's head face: amidst connotations of heroism, a damaged male.

Modernism and portraiture

In two famous essays on modernity in art, Walter Benjamin defined the cultural consequences of technological change in terms of a 'decline of the aura'. The experience of the aura, he wrote, arose from a transferral to objects – specifically, paintings – of the sensation proper to the human encounter, namely that 'the person we look at ... looks at us in return'.[43] What is auratic in this is the sense, simultaneously, of distance and attraction. Paintings are auratic because they 'reflect back at us that of which our eyes will never have their fill'.[44] Since photography, as a mechanical and factual record, cannot do this, it is utterly unlike painting. Benjamin's distinction is too categorical, but it helps us understand why modernism should have accommodated portraiture instead of eliminating it. As I showed with Giacometti, modernist attention to surface configuration made it possible to move beyond factual portrayal towards the complex and intangible in the apprehension of the other. Painters taking up portraiture in these terms necessarily diverged markedly, both in aims and means. Alice Neel (1900–84), Lucian Freud (1922–2011) and Frank Auerbach (b. 1931) stand out among portraitists of the second half of the twentieth century, and the work of each brings to light a significant aspect of the problem of modern portraiture.

With these painters, we leave the immediate post-war period. Of the three, Freud shows the least connection to modernism; there are Surrealist aspects to his early work of the 1940s and 1950s, but few identifiably modernist traits in paintings of later decades. Yet his

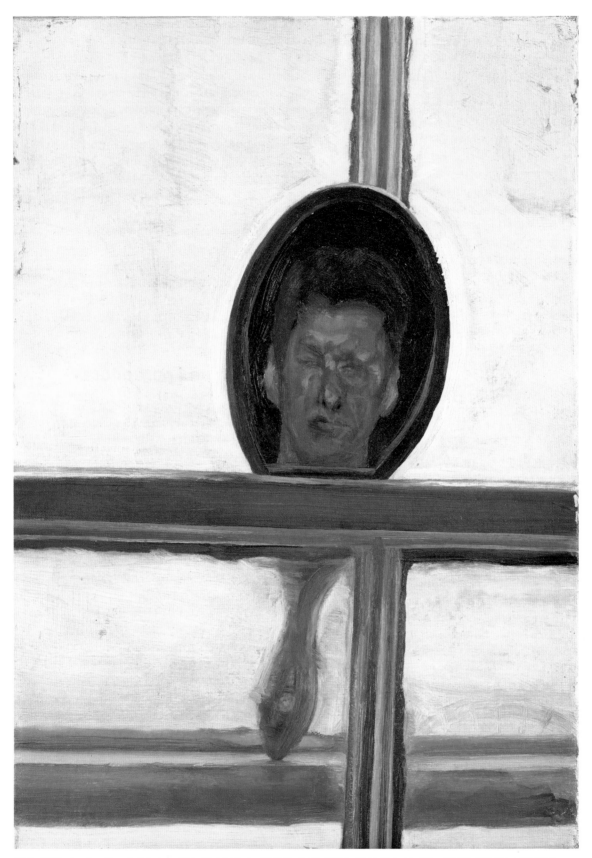

Plate 5.29 Lucian Freud, *Interior with a Hand Mirror (Self-Portrait)*, 1967, oil on canvas, 26 × 18 cm. Private collection.
Photo: © Private collection/The Bridgeman Art Library. © The Estate of Lucian Freud.

underlying strategies benefit from modernism, and *Interior with a Hand Mirror (Self-Portrait)* (Plate 5.29) is comparable to Giacometti, in that he combines evidence of intense scrutiny with a stress on the opacity and materiality of the medium. Propped in the frosted glass of a bathroom window, the mirror frames his squinting face against white light. Freud interprets the elusiveness of portrayal (self-portrayal in this case) in terms less mysterious than Benjamin. His painting puts me in mind of the plain fact that I always see myself the wrong way round, while only others see my face as it is, see directly parts of my body I cannot. It also reminds me that, however hard I stare, the face that looks back in the mirror does not necessarily correspond with my sense of self, for I cannot see the selfhood I feel. In other words, Freud's painting denies the reciprocating gaze Benjamin had attributed to the 'auratic' medium of painting. It is notable that many of his portrait subjects appear half-asleep or stare vacantly.

Modernist tendencies are more outwardly manifest in the work of Neel and of Auerbach, though in utterly contrasting ways. Alice Neel's *The Soyer Brothers* (Plate 5.30) evokes a history of resistance to the formalist imperative in modernism, while also showing modernist traits. Born a year before Neel, the Soyer twins, Raphael (1899–1987) and Moses (1899–1974), had been Social Realist painters in the 1930s, painting in ways largely informed by nineteenth-century Realist styles and by the American Ashcan School Realism of the earlier twentieth century. Neel had, like them, enlisted in the government-funded Federal Art Project of the Depression years, but was more stylistically adventurous, using extremes of distortion and reduction in works that dealt with painful personal experience.[45] Having worked largely in isolation and obscurity through the 1940s and 1950s, she made a deliberate entry into the modernist-dominated New York art scene of the 1960s. Painting fluently, in modernist-like flattish areas of generally saturated colour, sometimes leaving patches of canvas uncovered, she captured, almost caricaturally, the distinctive physical presence of her sitters and, through that, their posture towards the world. Her portraits are mainly full-length, as Freud's have often been, but differ markedly from his in their instantaneousness. She painted her subjects exactly as they chose to dispose themselves, in a fairly rapid and unhesitating way, portraying people in all stages of life – in this case, in old age. Neel observed to Patricia Hills, 'old age by itself is poignant. But the struggle. Look at Raphael's face. See how he struggles. Both of them.'[46] Moses (on the right) died a

year later. The old men shrink a bit inside their suits, the one pensive, the other watchful. Both, like Neel herself, had indeed struggled at times throughout their lives, having arrived with their family, aged twelve, as Jewish refugees from persecution in tsarist Russia. During the dominance of Abstract Expressionism, Raphael founded a magazine, *Reality*, to promote the cause of representational artists, who felt disregarded and excluded. (Edward Hopper was among those who joined him.)

However formal her means, Neel's art was antithetical to Greenbergian modernism in its insistence on the specific, a tendency evidently intensified in the heat of battle, as it were, as she asserted her practice against prevailing abstraction.[47] Yet surely such an emphasis is essential to all portraiture? If so, then is this drawing of Catherine Lampert by Frank Auerbach (Plate 5.31) a portrait at all? Auerbach's method of drawing in charcoal on thick paper, successively erasing and redrawing, connects his practice with that of the teacher who most influenced him (and others), namely David Bomberg (1890–1957). Bomberg, who gave famously inspirational life-drawing classes at Borough Polytechnic in London in the 1940s and early 1950s, had been a leading participant in the early modernist Vorticist movement, turning later to landscape painting. In his teaching, he sought to redirect students from observation to intuition, in order that they might achieve, on the flat sheet, an apprehension of what he called 'mass'. He would refer to Cézanne, and to the eighteenth-century philosopher George Berkeley, who held that perception of depth derived from tactile experience. We learn the world by bodily contact, through crawling, Auerbach has observed.[48] Auerbach's drawing is unlike Bomberg's, save in the employment of charcoal, but there is an evident (and acknowledged) continuity of principle. Auerbach looks at his sitter, but instead of seeking to match his visual perception to marks on the paper, he allows his arm and hand to make, with this soft medium, a felt response, or perhaps an enactment. He looks at his drawing to appraise it as it stands, independently of observation, and to erase and redraw until he sees the emergence of something having the sense of a person, with depth or mass, but without illusion or description. Seeing must, throughout, negotiate with feeling.

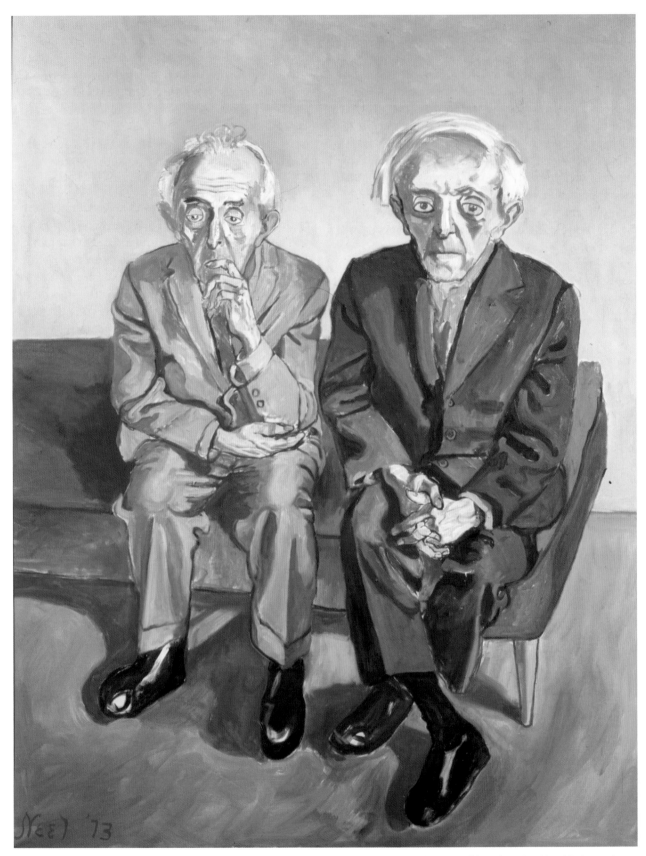

Plate 5.30 Alice Neel, *The Soyer Brothers*, 1973, oil on canvas, 152 × 117 cm. Whitney Museum of American Art, New York; purchase, with funds from Arthur M. Bullowa, Sydney Duffy, Stewart R. Mott and Edward Rosenthal 74.77. Photography by Geoffrey Clements. © The Estate of Alice Neel. Courtesy David Zwirner, New York.

Plate 5.31 Frank Auerbach, *Head of Catherine Lampert VI*, 1980, chalk and charcoal on paper, 77 × 58 cm. Museum of Modern Art, New York, 436.1981. Photo: © 2011 The Museum of Modern Art/Scala, Florence. © Frank Auerbach.

Conclusion: figuration after modernism?

From the 1960s onwards, the Greenbergian concept of modernism came under increasing attack and, at the same time, art came to diverge technically through the introduction of new mediums and modes of practice. A concern with content and meaning, rather than form, came to be increasingly predominant through the last decades of the century. As painting and sculpture diminished in importance relative to new forms of art, and as abstraction ceased to be paramount, figuration and modernism no longer either argued with or spoke to each other; the latter had left the scene, and the former came to mean too many different things. More fundamentally, the aspiration to universality characteristic of both Abstract Expressionism and the figurative art I have discussed (and the rhetoric of 'man') came under challenge. If early modernism was figurative as a matter of course, the era of high modernism was, in a more positive sense, a moment in which, in the urgency of their concern to reformulate the human image, some artists enlisted modernist means to a figurative end.

Notes

[1] Greenberg, 1961a.

[2] Greenberg, 1961b, p. 139.

[3] On *The Age of Bronze*, see Butler, 1993, pp. 99–123; Elsen, 1974, pp. 21–4.

[4] For an interesting discussion of distortion in Cézanne, see Shiff, 1991.

[5] On *Torso of a Young Man*, see Geist, 1983, p. 58; Miller, 1995, p. 172.

[6] Cocteau, 1926.

[7] See the entry on this painting in Lee, 1990, pp. 95–6.

[8] The article, 'The art scab', was published in the journal *Der Gegner*; for a translation, see Grosz and Heartfield, 1997 [1920].

[9] 'On my new paintings', written in 1920, was published in January 1921 in the journal *Das Kunstblatt*; for translation, see Grosz, 1997 [1921]. The passage quoted is on p. 36.

[10] For a stimulating critical discussion of Deineka, see Kiaer, 2006.

[11] Merleau-Ponty, 1964b, p. 5.

[12] Cited in Sylvester, 1965, n.p.

[13] Merleau-Ponty, 1964a, p. 178.

[14] Cited in Sartre, 1948, p. 6.

[15] Merleau-Ponty, 1964a, p. 164.

[16] Merleau-Ponty, 1962 [1945], p. 203.

[17] Merleau-Ponty, 1964a, p. 161.

[18] Ponge, 1961, p. 20.

[19] Cited in Morris, 1993, p. 136.

[20] Douglas, 1966.

[21] Artaud, 1947, p. 15; translated in *The Tiger's Eye*, New York, 1949 – for extracts, see Artaud, 2003 [1947], pp. 608–11.

[22] Artaud, 1947, p. 45.

[23] For a discussion of the phenomenology of bodily orientation, see Merleau-Ponty, 1962 [1945], pp. 203–6; Todes, 2001, pp. 49–50.

[24] Greenberg, 1961c [1946], p. 123.

[25] Ibid., p. 122.

[26] For Socialist Realism, see Cullerne Bown, 1998; for US Cold War cultural policy, see Guilbaut, 1983.

[27] Cited in Wilson, 1981, p. 212.

[28] For a discussion of these paintings, see Pucci, 2008.

[29] Cited in Whitfield, 1996, p. 31.

[30] Cited in Hyman, 1996, p. 45.

[31] See Cullerne Bown, 1998, p. 383.

[32] Nina Dimitrieva, writing in 1958, cited in Cullerne Bown, 1998, p. 387.

[33] Selz, 1959.

[34] Ibid., pp. 11–12; Selz's italics.

[35] Ibid., p. 79.

[36] Cited in ibid., p. 76.

[37] See Bird, 2000, p. 14.

[38] Cited in ibid., p. 11.

[39] Selz, 1959, p. 11.

[40] Alloway, 1957, p. 48. I discuss this series of paintings in Prendeville, 2004.

[41] Bacon, 1953, p. 12.

[42] Cited in Russell, 1971, p. 91.

[43] Benjamin, 1979, p. 190.

[44] Ibid., p. 189.

[45] On Neel's portraits in the context of Social Realism, see Allen, 1995, pp. 118–21, and *passim*; for the American context in general, see Hemingway, 2002.

[46] Cited in Hills, 1983, pp. 143–4.

[47] For a sense of the combative context, see Nochlin, 1973; Neel painted Nochlin's portrait in that year.

[48] See Hughes, 1990, p. 32.

Bibliography

Allen, P. (1995) *Pictures of People: Alice Neel's American Portrait Gallery*, Hanover, NH, Brandeis University Press.

Alloway, L. (1957) 'Art news from London', *Art News*, vol. 56, no. 3, p. 48.

Artaud, A. (1947) *Van Gogh: le suicidé de la société*, Paris, K Éditeur.

Artaud, A. (2003 [1947]) 'From *Van Gogh: The Man Suicided by Society*' in Harrison and Wood (2003), VB5, pp. 608–11.

Bacon, F. (1953) 'Matthew Smith – a painter's tribute' in *Matthew Smith: Paintings from 1909 to 1952*, London, Tate Gallery, p. 12 (exhibition catalogue).

Benjamin, W. (1979) 'On some motifs in Baudelaire' in *Illuminations* (trans. H. Zohn), London, Fontana/Collins, pp. 157–202.

Bird, J. (2000) *Leon Golub: Echoes of the Real*, London, Reaktion.

Butler, R. (1993) *Rodin: The Shape of Genius*, New Haven, CT and London, Yale University Press.

Cocteau, J. (1926) *Le Rappel à l'ordre*, Paris, Stock; translated as *A Call to Order* (trans. R.H. Myers), London, Faber and Gwyer.

Cullerne Bown, M. (1998) *Socialist Realist Painting*, New Haven, CT and London, Yale University Press.

Douglas, M. (1966) *Purity and Danger: An Analysis of Concepts of Pollution and Taboo*, London, Routledge and Kegan Paul.

Elsen, A.E. (1974) *Rodin*, London, Secker and Warburg.

Geist, S. (1983) *Brancusi: A Study of his Sculpture*, New York, Hacker Art Books.

Greenberg, C. (1961a) *Art and Culture: Critical Essays*, Boston, MA, Beacon Press.

Greenberg, C. (1961b) 'The new sculpture' in Greenberg (1961a), p. 139.

Greenberg, C. (1961c [1946]) 'The School of Paris, 1946', in Greenberg (1961a), pp. 120–3.

Grosz, G. (1997 [1921]) 'On my new paintings' in Whitford (1997), pp. 35–6. (Reprinted as 'My new pictures' in Harrison and Wood (2003), IIIB13, pp. 272–4.)

Grosz, G. and Heartfield, J. (1997 [1920]) 'The art scab' in Whitford (1997), pp. 32–4.

Guilbaut, S. (1983) *How New York Stole the Idea of Modern Art: Abstract Expressionism, Freedom and the Cold War*, Chicago, IL and London, University of Chicago Press.

Guttuso (1996) London, Whitechapel Art Gallery (exhibition catalogue).

Harrison, C. and Wood, P. (eds) *Art in Theory 1900–2000: An Anthology of Changing Ideas*, Oxford, Blackwell.

Hemingway, A. (2002) *Artists on the Left: American Artists and the Communist Movement, 1926–1956*, New Haven, CT and London, Yale University Press.

Hills, P. (1983) *Alice Neel*, New York, Abrams.

Hughes, R. (1990) *Frank Auerbach*, London, Thames & Hudson.

Hyman, J. (1996) 'A "pioneer painter": Renato Guttuso and Realism in Britain' in *Guttuso* (1996), pp. 39–53.

Kiaer, C. (2006) 'Was Socialist Realism forced labour? The case of Aleksandr Deineka in the 1930s', *Oxford Art Journal*, vol. 28, no. 3, pp. 321–45.

Lee, J. (1990) *Derain*, Oxford, Phaidon.

Merleau-Ponty, M. (1962 [1945]) *Phenomenology of Perception* (trans. C. Smith), London, Routledge.

Merleau-Ponty, M. (1964a) 'Eye and mind' in *The Primacy of Perception* (trans. J.M. Edie), Evanston, IL, Northwestern University Press, pp. 159–90. (Extract reprinted in Harrison and Wood (2003), VIB3, pp. 767–71.)

Merleau-Ponty, M. (1964b) *Sense and Non-Sense* (trans. H. Dreyfus and P. Dreyfus), Evanston, IL, Northwestern University Press.

Miller, S. (1995) *Constantin Brancusi: A Survey of his Work*, Oxford, Clarendon Press.

Morris, F. (ed.) (1993) *Paris Post-War: Art and Existentialism 1945–55*, London, Tate Gallery (exhibition catalogue).

Nochlin, L. (1973) 'The Realist criminal and the abstract law', *Art in America*, no. 67, pp. 54–61; no. 68, pp. 97–103.

Ponge, F. (1961) 'My creative method' in *Méthodes*, Paris, Gallimard, pp. 8–43.

Prendeville, B. (2004) 'Varying the self: Bacon's versions of van Gogh', *Oxford Art Journal*, vol. 22, no. 1, pp. 23–42.

Pucci, L. (2008) '*Terra Italia*: the peasant subject as the site of national and social identities in the work of Renato Guttuso and Giuseppe de Santis', *Journal of the Warburg and Courtauld Institutes*, vol. 71, pp. 315–36.

Russell, J. (1971) *Francis Bacon*, London, Thames & Hudson.

Sartre, J.-P. (1948) 'Search for the absolute' in *Alberto Giacometti: Sculptures, Paintings, Drawings*, New York, Pierre Matisse Gallery, pp. 2–22 (exhibition catalogue). (Extract reprinted in Harrison and Wood (2003), VB6, pp. 611–16.)

Selz, P. (1959) *New Images of Man*, New York, Museum of Modern Art (exhibition catalogue).

Shiff, R. (1991) 'Cézanne's physicality' in Kemal, S. and Gaskell, I. (eds) *The Language of Art History*, Cambridge, Cambridge University Press, pp. 129–80.

Sylvester, D. (1965) *Alberto Giacometti*, London, Arts Council of Great Britain (exhibition catalogue).

Todes, S. (2001) *Body and World*, Cambridge, MA and London, MIT Press.

Whitfield, S. (1996) 'Seeing red', in *Guttuso* (1996), pp. 25–37.

Whitford, F. (1997) *The Berlin of George Grosz*, New York and London, Yale University Press.

Wilson, S. (1981) in *Paris-Paris, créations en France, 1937–1957*, Paris, Centre Georges Pompidou (exhibition catalogue).

Chapter 6

From Abstract Expressionism to Conceptual Art: a survey of New York art *c.*1940–1970

Michael Corris

Introduction

This chapter aims to provide a brief introductory survey of key figures and central debates that shaped the production of the most significant avant-garde art made in New York, from the beginning of the Second World War to the late 1960s. While we will discuss the artists associated with the movement commonly referred to as Abstract Expressionism, any adequate account of American post-war art – specifically the art produced by artists living and working in New York – must be more than a story of the ascendancy of American painting or an inventory of individual artists, each with their unique style of painting or sculpture. The reason is that other histories of post-war American art reveal aesthetic concerns and values that diverge significantly from those generally associated with Abstract Expressionism. The notion that all post-war American art worth knowing about considered the act of painting to be one

of independence or autonomy is simply one point of view. It is a theory of the development of art constructed from the application of a particular set of assumptions about what constitutes great art. When we apply other criteria to post-war American art, a range of diverse artistic practices comes into view. We encounter mixed-media constructions using found objects, figurative painting of commonplace subjects, performances and installations. Marching to the beat of a different drummer, artists nurtured in New York during the later part of the twentieth century devised radically different positions on the nature of the discrete art object and its relation to society.

Two exhibitions, which occurred almost simultaneously towards the end of the period under consideration, offer a snapshot of contrasting approaches to the making and display of art in post-war America.

Plate 6.1 (Facing page) Jackson Pollock, *Number 1A, 1948* (detail from Plate 6.3).

Plate 6.2 Entrance to *New York Painting and Sculpture: 1940–1970*, Metropolitan Museum of Art, New York, 1969, photograph. Photo: © The Metropolitan Museum of Art.

1 Crosstown traffic: a tale of two New York exhibitions

New York Painting and Sculpture: 1940–1970

For much of his career, the curator Henry Geldzahler (1935–94) was known as one of the most powerful and controversial figures in art in New York. At a relatively young age, Geldzahler became the first appointee to the post of curator of twentieth-century art at the Metropolitan Museum of Art. His formidable reputation as a tastemaker rested principally on his achievement of having organised, at the age of thirty-three, the Metropolitan Museum's centennial exhibition, *New York Painting and Sculpture: 1940–1970* (Plate 6.2). The exhibition displayed 408 works by 43 artists whom Geldzahler identified as the key innovators of post-war art in New York. Geldzahler's exhibition was an epic proclamation on American culture in the middle decades of the twentieth century. 'The art of the New York School stands', Geldzahler enthused, 'as the most recent in the grand succession of modern movements from Impressionism through Cubism and Surrealism.'[1]

Plate 6.3 Jackson Pollock, *Number 1A, 1948*, 1948, oil and enamel paint on canvas, 173 × 264 cm. Museum of Modern Art, New York, 77.1950. Purchase. Photo: © 2011 The Museum of Modern Art/Scala, Florence. © The Pollock–Krasner Foundation/ARS, NY and DACS, London 2012.

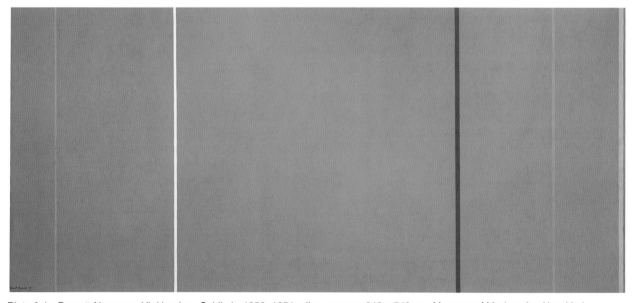

Plate 6.4 Barnett Newman, *Vir Heroicus Sublimis*, 1950, 1951, oil on canvas, 242 × 542 cm. Museum of Modern Art, New York, 240.1969. Gift of Mr and Mrs Ben Heller. Photo: © 2011 The Museum of Modern Art/Scala, Florence. © 2011 The Barnett Newman Foundation, New York/DACS, London.

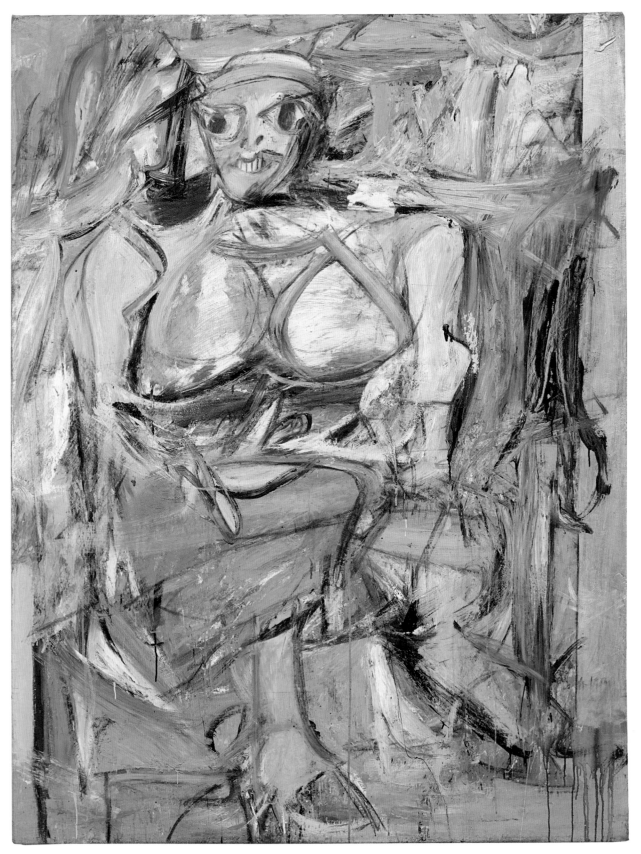

Plate 6.5 Willem de Kooning, *Woman I*, 1950–52, oil on canvas, 193 × 147 cm. Museum of Modern Art, New York, 478.1953. Purchase. Photo: © 2011 The Museum of Modern Art/Scala, Florence. © The Willem de Kooning Foundation, New York/ARS, NY and DACS, London 2012.

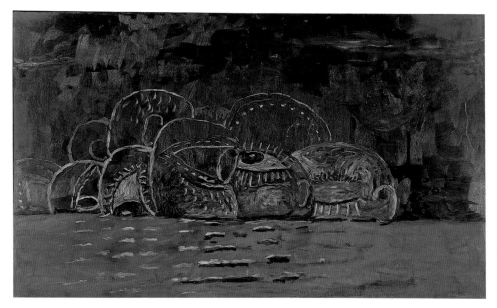

Plate 6.6 Philip Guston, *Cabal*, 1977, oil on canvas, 68 × 116 cm. The Whitney Museum of American Art, New York, 81.38; 50th Anniversary Gift of Mr and Mrs Raymond J. Learsy. Photograph courtesy of the McKee Gallery, New York.

The exhibition celebrated the work of a group of predominantly male artists, including Jackson Pollock, Willem de Kooning, Mark Rothko and Barnett Newman (1905–70). Although their individual styles differed markedly – from the dynamic skeins of Pollock to the relatively unmodulated colour fields of Newman – all were subsumed under the label of Abstract Expressionism. Many critics at the time regarded this exhibition as nothing less than proof of the end of American provincialism in art relative to that of Europe. The time had come for New York to displace Paris as the centre of contemporary art in the west.

The aspects of post-war New York art that distinguish it from contemporaneous European art were identified by Geldzahler as the abandonment of the human figure in a narrative setting and the making of large-scale painting. These two characteristics – size and the absence of figuration – gave rise to works of art that demanded of the viewer a different relation to the painting and opened up a vast field of problems and possibilities for painters of the post-war era. Works such as Pollock's *Number 1A, 1948* and Newman's *Vir Heroicus Sublimis* are enormous paintings (Plates 6.3 and 6.4). Early in his career, Pollock announced his intention to make paintings that were somewhere between the dimensions of an easel painting and a mural; these large-scale works were often referred to by critics as portable murals. When you view the painting at a relatively intimate distance, the work completely fills your visual field. The experience is one of being 'in' the painting. Because of this, the painting no longer functions exclusively as a picture; rather, it exists as a field. The viewer confronts the painting as an actor

in relation to a stage set. Scale enables this relation between viewer and artwork to be read as one of intense drama. 'Anyone standing in front of my paintings', declared Newman in his rather ponderous fashion, 'must feel the vertical dome-like vaults encompass him to awaken an awareness of his being alive in the sensation of complete space'.[2] Rothko directly and elegantly stated that he painted large works in order to 'be very intimate and human. To paint a small picture is to place yourself outside your experience … however you paint the larger picture, you are in it.'[3]

Not every artist of note included in Geldzahler's exhibition expressed interest in large-scale paintings or displayed a consistent attitude towards abstraction. The controversial series of paintings of women done by de Kooning during the early 1950s drew upon imagery sourced from magazine advertisements that employed female models to hawk toothpaste and beer (Plate 6.5). By 1970, the figure – drawn from the disparate aesthetic worlds of early twentieth-century Expressionism and 1960s underground comics – would reappear in the disturbing and poignant work of Philip Guston (1913–80), another artist of de Kooning's generation who refused to view painting as a practice defined by the terms abstraction or figuration (Plate 6.6). Robert Rauschenberg (1925–2008) – an artist associated with the reaction against Abstract Expressionism that gathered force during the mid-1950s – likened the world to an enormous montage. In a work like *Rebus*, Rauschenberg invites us to consider painting as a marvellous hodgepodge of images, paint and objects (Plate 6.7).

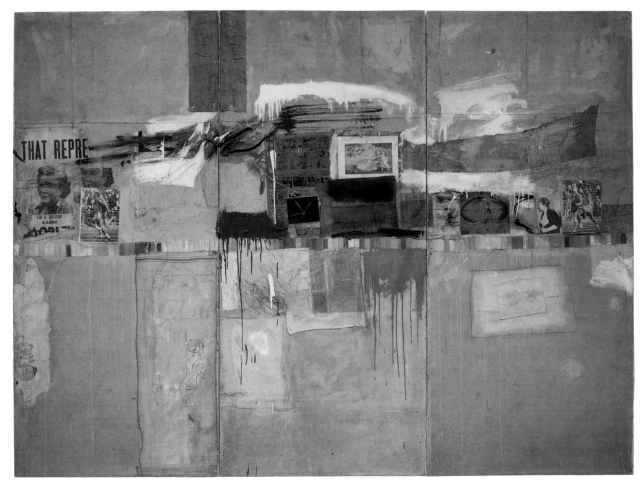

Plate 6.7 Robert Rauschenberg, *Rebus*, 1955, oil, synthetic polymer paint, pencil, crayon, pastel, cut-and-pasted printed and painted papers, and fabric on canvas mounted and stapled to fabric, three panels, 244 × 333 cm. Museum of Modern Art, New York, 243.2005.a-c. Partial and promised gift of Jo Carole and Ronald S. Lauder and purchase. Photo: © 2011 The Museum of Modern Art/Scala, Florence. © Estate of Robert Rauschenberg. DACS, London/VAGA, New York 2012.

The variety of post-war American art presented in *New York Painting and Sculpture: 1940–1970* challenged an influential account of modern art articulated most strongly by the critic Clement Greenberg. Greenberg had emphasised the development of a tradition, which he characterised as the modernist 'mainstream', descending from Cézanne through Cubism and earlier European abstract art to the 'all-over' abstraction of Pollock and his contemporaries. His account emphasises the autonomy of painting and grounds this freedom in the notion of medium specificity. According to Greenberg, purging those elements that are regarded as extraneous to the material reality of painting itself creates the most advanced art. The illusion of three-dimensional space and the notion of a painting as a picture or a 'window on the world' were to be set aside so that the artist could concentrate on the basic resources of painting at his or her disposal; namely, the rectilinear ground of the canvas or painting substrate and the physical qualities of paint as they are deposited

on a flat surface. These properties led Greenberg to single out for praise artists who concentrated on the expressive possibilities of the medium of paint itself and produced an art of purified colour and openness of effect.

The diverse art assembled by Geldzahler presents a paradoxical declaration of independence at odds with the doctrine of purity in art proposed by Greenberg. Earlier, during the 1930s, artists including Pollock, de Kooning and Arshile Gorky (1904–48) had conducted an intense engagement with the European avant-garde. This engagement took on a more ambivalent tone after the end of the Second World War and encouraged much hyperbole on the part of artist-spokespersons deeply committed to the New York scene. As Newman wrote in 1948, 'I believe that here in America some of us, free from the weight of European culture, are finding the answer, by completely denying that art has any concern with the problem of beauty and where to find

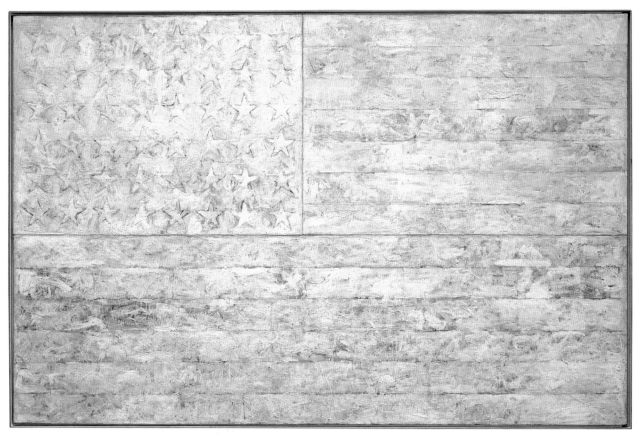

Plate 6.8 Jasper Johns, *White Flag*, 1955, encaustic, oil, newsprint and charcoal on canvas, 199 × 307 cm. Metropolitan Museum of Art, New York, 1998.329. Purchase, Lila Acheson Wallace, Reba and Dave Williams, Stephen and Nan Swid, Roy R. and Marie S. Neuberger, Louis and Bessie Adler Foundation Inc., Paula Cussi, Maria-Gaetana Matisse, The Barnett Newman Foundation, Jane and Robert Carroll, Eliot and Wilson Nolen, Mr. and Mrs. Derald H. Ruttenberg, Ruth and Seymour Klein Foundation Inc., Andrew N. Schiff, The Cowles Charitable Trust, The Merrill G. and Emita E. Hastings Foundation, John J. Roche, Molly and Walter Bareiss, Linda and Morton Janklow, Aaron I. Fleischman, and Linford L. Lougheed Gifts, and gifts from friends of the Museum; Kathryn E. Hurd, Denise and Andrew Saul, George A. Hearn, Arthur Hoppock Hearn, Joseph H. Hazen Foundation Purchase, and Cynthia Hazen Polsky and Leon B. Polsky Funds; Mayer Fund; Florene M. Schoenborn Bequest; Gifts of Professor and Mrs. Zevi Scharfstein and Himan Brown, and other gifts, bequests, and funds from various donors, by exchange. Photo: © 2011 The Metropolitan Museum of Art/Art Resource, NY/Scala, Florence. © Jasper Johns/VAGA, New York/DACS, London 2012.

it.'[4] It is important to grasp that the position towards European art remained complex for these artists; their self-proclaimed independence was a repudiation of European avant-garde art coupled with the desire to sit astride the figures that comprised the pantheon of modern art: namely, Matisse, Picasso, Braque and Mondrian. This defining moment of a specifically American avant-garde called for an intense solidarity on the part of New York artists devoted to working in – and through – a modernist idiom. The most ambitious American artists of the 1940s felt compelled to purge their work of European influences while setting about the construction of their own aesthetic agenda.[5]

New York Painting and Sculpture: 1940–1970 does not make an issue of the internal contradictions that surely animated the post-war milieu of New York art, even though they are hiding, so to speak, in plain view. While we may criticise Geldzahler's account for failing to present a more critical view of these three crucial decades of New York art, that would be to miss the point of the exhibition. *New York Painting and Sculpture: 1940–1970* is an example of the power of the museum to influence the critical debate on the interpretation of modern art. If we consider the Abstract Expressionist artists who were included in the exhibition, we find a grouping whose composition and significance would remain more or less unchallenged by mainstream art historians until the early 1980s. The greatest achievement of *New York Painting and Sculpture: 1940–1970* – its clearest message – remains the part it played in the ratification of the new American 'tradition' of post-war art.

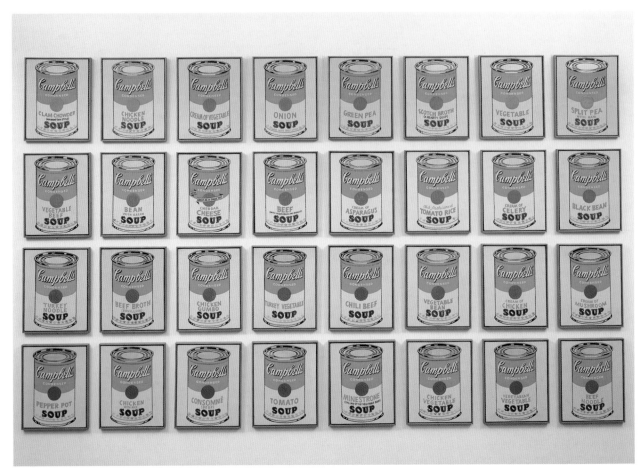

Plate 6.9 Andy Warhol, *Campbell's Soup Cans*, 1962, oil on canvas, thirty-two panels, each 51 × 41 cm. Museum of Modern Art, New York, 476.1996.1-32. Gift of Irving Blum; Nelson A. Rockefeller Bequest, gift of Mr. and Mrs. William A.M. Burden, Abby Aldrich Rockefeller Fund, gift of Nina and Gordon Bunshaft in honour of Henry Moore, Lillie P. Bliss Bequest, Philip Johnson Fund, Frances Keech Bequest. Photo: © 2011 The Museum of Modern Art/Scala, Florence. © The Andy Warhol Foundation for the Visual Arts/Artists Rights Society (ARS), New York/DACS, London 2012.

The beginning of the 1950s saw those practices of painting and sculpture that had defined some art of the immediate post-war period coming increasingly under attack. By the 1960s, Abstract Expressionism was the mainstream and other criteria of artistic practice materialised in New York: Pop Art, 'happenings', the work of the Fluxus group, performance art, Minimal Art and Conceptual Art. Some addressed art's autonomy, instituting new modes of artistic production; all engaged critically with the received ideas and aesthetic values promoted by Abstract Expressionism. Key figures included the musician John Cage (1912–92), who made visual art and music using chance operations, and the painter Jasper Johns, whose subjects included targets, the American flag, the alphabet and numerals (see Plate 6.8). Using a technique combining collage, encaustic and oil painting, Johns painstakingly constructed images of objects (targets, flags) and

signs (letters of the alphabet and numbers) that simultaneously refer to and exemplify the depicted subject. The art of Andy Warhol (1928–87) and Frank Stella (b. 1936) presented a further amplification of painting. Delving into the vast terrain opened up by Rauschenberg and Johns, Warhol introduced a realism that focused on the imagery of everyday life – from the banal commodity of a Campbell's soup can (Plate 6.9) to the iconic image of a Hollywood star such as Marilyn Monroe. Stella repudiated the metaphysical baggage that an artist like Newman saddled painting with, producing instead works that were highly reductive and self-referential (see Plate 6.10). The art of other figures, which I shall discuss in more detail below, speaks to what some considered to be the essential features of art and the obligations of the artist as a producer of culture. This latter group of artists – Ed Ruscha (b. 1937) and Joseph Kosuth (b. 1945), for example – viewed

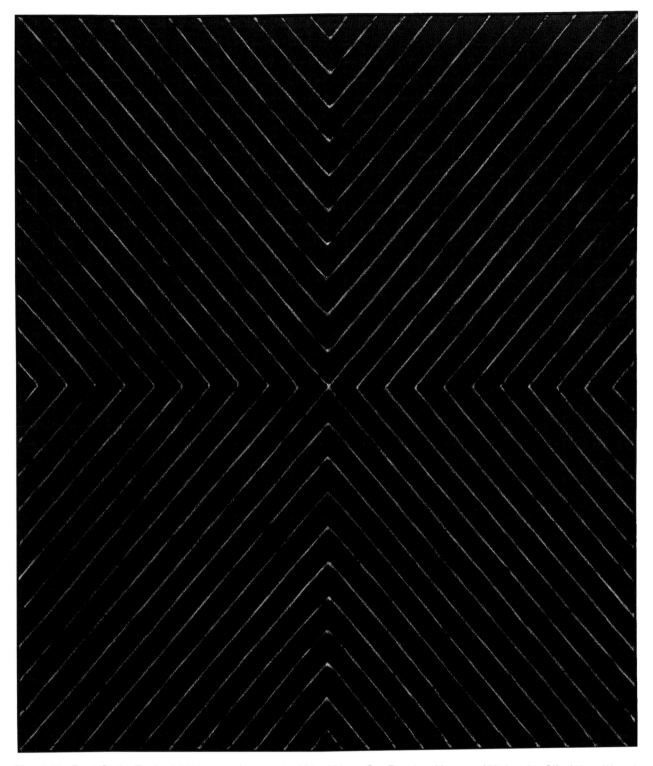

Plate 6.10 Frank Stella, *Zambezi*, 1959, enamel on canvas, 231 × 200 cm. San Francisco Museum of Modern Art. Gift of Harry W. and Mary Margaret Anderson. © ARS, NY and DACS, London 2012.

the conventional notion of medium specificity as largely irrelevant to their concerns. They employed photography and mixed media while drawing on methods of production and visual display utilised by industry, advertising, science and the burgeoning world of information management and computing (see Plate 6.11).

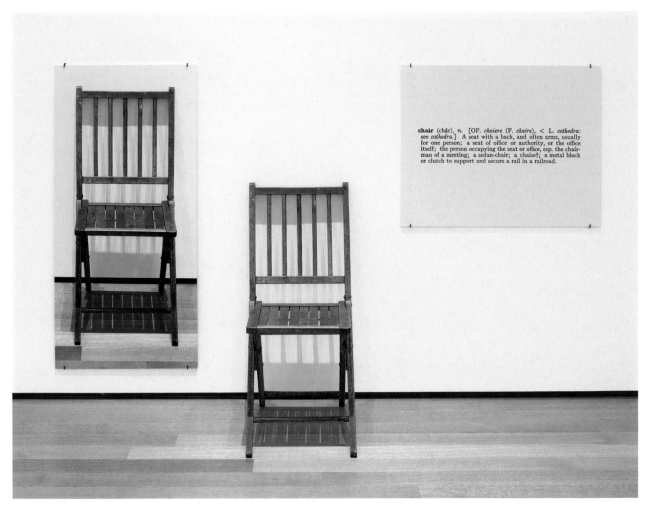

Plate 6.11 Joseph Kosuth, *One and Three Chairs*, 1965, mounted photograph of a chair, wood folding chair, and photographic enlargement of a dictionary definition of 'chair', photographic panel 92 × 61 cm, chair 82 × 38 × 53 cm, text panel 61 × 61 cm. Museum of Modern Art, New York, 393.1970.a-c. Larry Aldrich Foundation Fund. Photo: © 2011 The Museum of Modern Art/Scala, Florence. © ARS, NY and DACS, London 2012.

Information

These new means were at the heart of a great deal of artwork visible in New York from the late 1950s onwards and were very much in evidence in a number of exhibitions that opened in New York during the spring and summer of 1970. Nevertheless, representative works of these new tendencies were conspicuously absent from the Metropolitan Museum's exhibition. The exhibition that introduced the general public to this new art – so distant from the aesthetic values of *New York Painting and Sculpture: 1940–1970* – was mounted by the Museum of Modern Art (MoMA) and titled, simply, *Information*. This was a vivid, sprawling rejoinder to Geldzahler's project, a negation of all that was held dear by Abstract Expressionism (see Plates 6.12 and 6.13).

Information was organised by Kynaston McShine (b. 1935), who tactfully framed his exhibition proposal to the museum's board of directors as 'a report on new international art'. McShine's exhibition placed the institution of the museum, rather than the city of New York, at the centre of attention. Artists from abroad were invited to transmit their work as information via various means to the museum. The function of the museum would be expanded, as McShine re-imagined New York's foremost institution of modern art as a clearinghouse for information about contemporary art and current events. Ironically, the need to be geographically proximate to an urban centre was considered to be largely irrelevant by those artists and

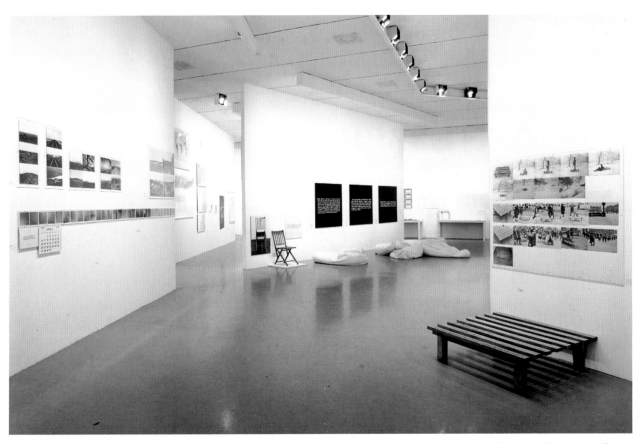

Plate 6.12 View of *Information* exhibition at Museum of Modern Art, New York, 1970. Photo: © 2011 The Museum of Modern Art/Scala, Florence.

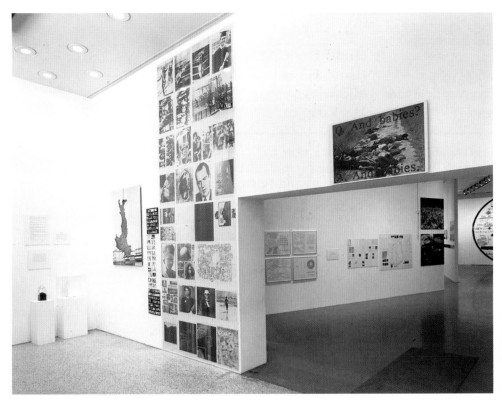

Plate 6.13 View of *Information* exhibition at Museum of Modern Art, New York, 1970. Photo: © 2011 The Museum of Modern Art/ Scala, Florence.

VOLUME 1 NUMBER 2 FEBRUARY 1970

Art-Language

Edited by Terry Atkinson, David Bainbridge
Michael Baldwin, Harold Hurrell
American Editor Joseph Kosuth

CONTENTS

Art-Language is published three times a year by
Art & Language Press 26 West End, Chipping Norton, Oxon.,
England, to which address all mss and letters should be sent.

Price 12s.6d. UK, $2.50 USA All rights reserved

Reprinted 1972 by W.H.Sharpe (Printers) Ltd., 83-87 Cambridge Street, Coventry

Plate 6.14 Front cover of *Art-Language*, vol. 1, no. 2, February 1970.

curators who had laboured under the spell of Marshall McLuhan's recently coined vision of the world as a 'global village'.[6]

Information presented mobile and politically inflected works of art that incorporated a range of media. Works concerned with framing situations and which utilised alternative means of dissemination intended to challenge the stable, commodity form of art. According to McShine, the artists in *Information* were:

> part of a culture that has been considerably altered by communications systems such as television and film, and by increased mobility. Therefore, photographs, documents, films, and ideas, which are rapidly transmitted, have

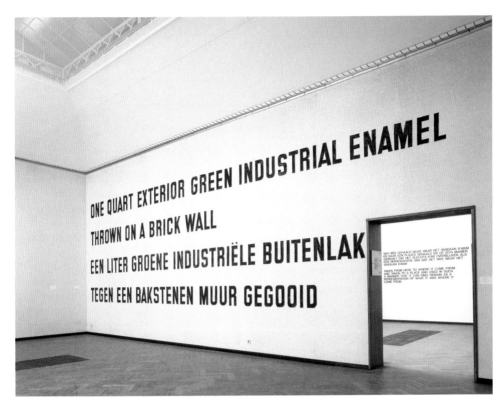

Plate 6.15 Lawrence Weiner, *One Quart Exterior Green Industrial Enamel Thrown on a Brick Wall*, Catalogue #002, 1968, medium: language and materials referred to, installation view at *Lawrence Weiner: Works from the Beginning of the Sixties Toward the End of the Eighties* exhibition, Stedelijk Museum, Amsterdam, 1988–89. Photo: courtesy of Moved Pictures, NYC. © ARS, NY and DACS, London 2012.

become an important part of this new work. This has led to an intellectual exchange and an international community of artists.[7]

The level of craftsmanship displayed in such work was often deliberately informal. Artists such as those who formed the British collective Art & Language or the American Joseph Kosuth displayed texts that engaged with the current discourse in philosophy in a most un-academic fashion (see Plate 6.14). While much of the work found in *Information* could be seen in art galleries and museums in Europe, other processes and forms of dissemination were favoured that had little to do with these conventional institutions of artistic display. These included the use of hoardings, Xerox copy machines, limited-edition pamphlet-sized publications known as 'artist's bookworks' and the postal service. The lustre of high art was brought sharply down to earth; there was much talk about the democratisation of art. Artists such as Lawrence Weiner (b. 1942) argued that their art was more democratic because it undermined the hierarchies that sustained the elitism of high art. The rarefied materials of high art and the values attached to them were rejected vigorously. Weiner went further and simply specified the material or process and described the physical act that would produce the desired result. Weiner's artworks of the late 1960s consist of bland statements that recount the dispersal of paint or the

performance of an ordinary physical event like the removal of a section of plasterboard or carpet. The title of the work served as both the name of the work of art and an exhaustive account of the content. A typical example is Weiner's work *One Quart Exterior Green Industrial Enamel Thrown on a Brick Wall* (Plate 6.15).

The art we are discussing was termed 'Idea Art' or 'Conceptual Art'. For the most part, it was constructed with the materials of everyday life, from handwritten notes to photographic snapshots to the ephemera of the office environment. In the *Information* catalogue, the artist Robert Barry (b. 1936) is represented by a work titled *Art Work* (Plate 6.16). It exists simply as a series of typewritten sentences.

Barry's work strains our credibility: where is the aesthetic content? How can these phrases, which suggest poetry or some form of avant-garde literature, be considered visual art at all? Aside from the visual aspect of the typewritten text, what about this work commends us to consider it as art? Is the text an image of the work of art, or the work of art itself, as the influential Conceptual Art curator Seth Siegelaub suggests?[8] By employing language in this way, Barry compels the spectator to become a reader of textual matter as well as a viewer of art. The experience of his art is the act of reading and the mental imagery that the phrases elicit. Barry's work at this point

ART WORK. 1970 ROBERT BARRY

IT IS ALWAYS CHANGING.

IT HAS ORDER.

IT DOESN'T HAVE A SPECIFIC PLACE.

ITS BOUNDARIES ARE NOT FIXED.

IT AFFECTS OTHER THINGS.

IT IS AFFECTED BY OTHER THINGS.

IT MAY BE ACCESSIBLE BUT GO UNNOTICED.

PART OF IT MAY ALSO BE PART OF SOMETHING ELSE.

SOME OF IT IS FAMILIAR.

SOME OF IT IS STRANGE.

KNOWING OF IT CHANGES IT.

RB

Plate 6.16 Robert Barry, *Art Work*, 1970, ink on paper (catalogue page), 20 × 23 cm. Collection of Phoenix Art Museum, The Dorothy and Herbert Vogel Collection: Fifty Works for Fifty States, a joint initiative of the Trustees of the Dorothy and Herbert Vogel Collection and the National Gallery of Art, with generous support from the National Endowment for the Arts and the Institute for Museum and Library Services. Accession: 2008.215. Photographed by Ken Howie. Used with permission of Gallery Yvon Lambert and the artist.

has little to do with concrete poetry; rather, he 'communicates conditions'.[9]

The condition that Barry wishes to draw our attention to is nothing less than the position of the artist in a world deprived of internal differentiation. Barry's invitation to the spectator to participate in the completion of the work's meaning illuminates another aspect of what we might call the *social* dimension of Conceptual Art. We do not really know what 'meaning' signifies in this performative context, but we can sketch out the issue that concerned so many conceptual artists of the 1960s. It may be characterised as the problem of intentionality. In one sense, this problem owes its prominence to the tacit acceptance by artists and critics of the late 1960s of the proposition that the importance of the object in art could be reduced to the point of perceptual nullity. The physically diminished object of art apparently convinced some artists that they had exited from the circuit of modernist culture. The intangibility of the work of art announced the liberation of the artist from the constraints of the past. (This degree of idealism, of course, was quickly endowed with a commercial face.) To communicate this sense of cultural freedom, the artist must stage a different set of conditions of engagement with art.

The spectator, for his or her part, must be prepared to do other sorts of work, whether it be reading a text, carrying out an action, or imaginatively completing a situation. With no fixed object to consume, other protocols for the engagement with art can be introduced. One of the problems encountered by artists was how to ensure that the resulting situation was still recognisable as art. Not all Conceptual Art lived up to this requirement; some endeavoured to suspend the resolution of this question – a question of many parts that invites us to consider whether we can speak sensibly of the essential nature of the work of art or dispense altogether with specialisation.

Many young artists of the mid-1960s believed that a critical attitude towards the immediate past, coupled with a fertile imagination and an understanding of the role of the media in contemporary life, was far more important to the success of an artist than the mastery of traditional skills such as drawing, painting or sculpting. This view of art proclaimed that no form or intention that led to art-making was necessarily superior to any other.

Information introduced to the public the diverse approaches to be found in Conceptual Art made not

only in New York but also throughout the world. This work valued viewer engagement, communication and topicality over the attentiveness and promise of consummation offered by the work of Rothko or Newman. *Information* was but one of several important international exhibitions, mounted from the late 1960s onwards in Europe and North America, that began to chip away at the dominance of late modernist painting and sculpture. The pride of Geldzahler's *New York Painting and Sculpture: 1940–1970* exhibition was considered by some artists and critics at the time to exemplify a form of art unresponsive to cultural change and, in the most damning of critical accusations, complicit with the political and social conservatism of the establishment.

The development of modern art in New York during the mid twentieth century is partially the result of intense debates and rivalries that engulfed all participants in what began as a relatively compact art milieu. Each of the exhibitions discussed above was exceptional in the way it illustrated and made tangible profound changes in the conditions and possibilities of art since 1945. *New York Painting and Sculpture: 1940–1970* and *Information* captured an exciting, dynamic moment in the history of art in New York. Each in its own way engaged in myth-making. Geldzahler served up an account of art in New York since 1940 as a continuous line of aesthetic progress; McShine offered a utopian vision of a politically liberal transnational creative commons facilitated by the museum.

The following sections explore more fully some of the key aspects of art that emerged in New York during the 1940s and flourished throughout the 1950s. They trace the rise of Abstract Expressionism while indicating how successive generations of artists responded to the dominance of that movement. This will set the stage for our return to the issues and artists that defined the period of the mid- to late 1960s as one of resurgence with respect to avant-garde activity in New York – an avant-garde that would be increasingly characterised as *international* rather than one linked solely to a particular city or nation.

2 Abstract Expressionism as a name: definitions and objections

The term 'Abstract Expressionism' – coined in 1946 – designates a specific group of painters and sculptors whose mature styles developed during the 1940s. Some of the key figures include the painters Jackson Pollock, Willem de Kooning, Mark Rothko, Adolph Gottlieb (1903–74), Lee Krasner (1908–84), Barnett Newman and Clyfford Still (1904–80), and the sculptor David Smith (1906–65) (see Plates 6.17 and 6.18). A cursory look at the works produced by these artists is sufficient to suggest that the term 'Abstract Expressionism' – like the designation the 'New York School' – is problematic. It does not refer to a single identifiable style of painting or sculpture.

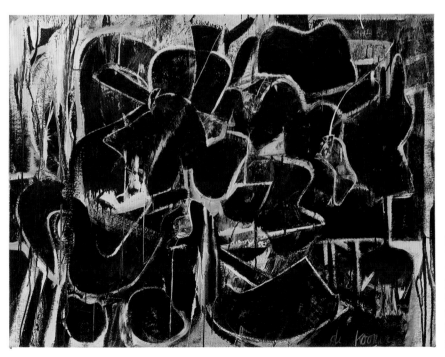

Plate 6.17 Willem de Kooning, *Painting*, 1948, enamel and oil on canvas, 108 × 143 cm. Museum of Modern Art, New York, 238.1948. Purchase. Photo: © 2011 The Museum of Modern Art/ Scala, Florence. © The Willem de Kooning Foundation, New York/ARS, NY and DACS, London 2012.

Plate 6.18 Clyfford Still, *Painting, 1951-T, No. 2*, 1951, oil on canvas, 237 × 193 cm. The Detroit Institute of Art, Founders Society purchase, W. Hawkins Ferry fund. Photo: © The Bridgeman Art Library. © Clyfford Still Estate.

It has been pointed out by numerous historians of art that a persistent feature of every survey of Abstract Expressionism is its opening disclaimer concerning the explanatory adequacy of the very term that frames its subject. As we have seen, there is reason enough to question the coherence of such a label when we begin to examine what artists routinely associated with Abstract Expressionism made and said about their work. Each opportunity that enabled or compelled New York avant-garde artists to collectively assert their position in opposition to the prevailing cultural and aesthetic norms was coloured by an undercurrent

of ambivalence – if not sheer hostility – towards this basic act of self-identification. During a series of three meetings convened in late April 1950, a group of artists – including key figures such as Willem de Kooning, Robert Motherwell (1915–91) and Ad Reinhardt (1913–67) – disagreed over the question of community. The painter Motherwell pointed out the dialogue's emphasis on the question 'What is it that binds us together?' In the discussions that followed, participants were keen to talk about their relation to the European tradition, the variety of techniques used in the making of their art, and what could be said about the nature of content or subject matter in the context of abstraction. When Alfred H. Barr, Jr, the founding director of the Museum of Modern Art, and the only non-artist participant in these roundtable discussions, asked 'What is the most acceptable name for our direction or movement?', de Kooning famously quipped, 'It is disastrous to name ourselves.'[10]

So why do we persist in using the term 'Abstract Expressionism'? The use of a rough and ready label does not preclude historically and theoretically informed analysis of the work under study. 'Abstract Expressionism' is a term of convenience rather than a condensed thesis of explanatory power. It is also a cultural artefact; for better or worse, a term that has historical currency and is still applied by critics and museums in order to facilitate their work. It is both possible and necessary to identify common – if changing – points of reference within this diverse group of artists. These artists can be said to have been engaged intensely in dialogue with each other, not simply in an abstract sense but through their artwork, through social and political activity mediated by jointly authored manifestos, through teaching, through the publication of small magazines, and through the institution of a regular forum for the presentation and discussion of works.

There were many common points of reference; these were aesthetic and formal, to be sure, but the artists also shared world views, philosophical interests, interests in material technique and a strong concern with art that aimed to say something profound about the state of 'Modern Man' and the suitability of society's dominant social values. Many of the artists associated with Abstract Expressionism took pride in their unconventional lifestyle, occupying the fringes of respectable middle-class society. They imagined their concerns as artists and human beings to be peripheral to the conservative, materialist values of post-war America while somehow managing to believe

in the agency of their art to address and transform the universal condition of modern humankind. The fabric of everyday life in the city of New York sustained their studio work and their conversations.

I am now going to consider two ways of thinking about these 'common points of reference' for the Abstract Expressionists: first, the question of their antecedents; second, the question of the effects of their works, of what they believed was particular about the experience their art provoked.

3 The origins of a new American avant-garde

The art critic Dore Ashton has argued that what really distinguishes the period under discussion and sets it apart from earlier periods of art in the USA is the existence of an artistic milieu; a social and cultural buffer that separated society and the artist to the benefit of the latter.[11] This milieu spoke to itself through a range of small publications, including *Tiger's Eye* and *Possibilities*. Such an expectation of artistic community has its origins in the Great Depression of the 1930s and the political response to it in the form of Roosevelt's 'New Deal'. It was nurtured and grew within the setting of artists' organisations, shaped in turn by the government's Federal Art Project of the Works Progress Administration (WPA).

Philip Leider – the first editor of the influential journal *Artforum* – offers this polemical reconstruction of the history of American art from the 1930s to the 1960s:

> The problem of American painting had been a problem of subject matter. Painting kept getting entangled in the contradictions of America itself. We made portraits of ourselves when we had no idea who we were. We tried to find God in landscapes that we were destroying as fast as we could paint them. We painted Indians as fast as we could kill them. And during the greatest technological jump in history, we painted ourselves as a bunch of fiddling rustics. By the time we became Social Realists, we knew that American themes were not going to lead to a great national art. Not only because the themes themselves were hopelessly duplicitous, but because the forms we used to embody them had become hopelessly obsolete. Against the consistent attack of Mondrian and Picasso, we had only an art of half-truths lacking all conviction. The best artists began to yield rather

than kick against the pricks. And it is exactly at this moment, when we finally abandon the hopeless constraint to create a national art, that we succeed for the first time in doing just that. By resolving a problem forced on painting by the history of French art, we create for the first time a national art of genuine magnitude. And if one finally had to say what it was that made American art great, it was that American painters took hold of the issue of abstract art with a freedom they could get from no other subject matter and finally made high art out of it.[12]

Leider alludes to a host of factors to explain how Abstract Expressionism emerged in New York during the 1940s and went on to become 'a national art of genuine magnitude'. Framing the development of American art as a quest for cultural identity owes much to the writings and statements of the American artists and critics of the time. Yet it is important not to underestimate the value of the dialogue that took place in New York during the war years between American and European artists.

Many factors contributed to the transformation of New York into an exceptionally rich environment for producing art from the late 1930s onwards. One of the most important is the significant influx of émigré artists from Europe escaping the fascist onslaught. The work of the European avant-garde had first been seen in America as early as 1913 at the 'Armory Show' in New York. During the 1920s, American artists hungry for contact with the avant-garde travelled to Paris and other European cities to learn their craft. The subsequent rise of Nazism, with its related attacks on avant-garde art as 'degenerate', forced many European artists to seek exile in America. These included the senior figure of Fernand Léger, who had participated in the development of Cubism with Picasso and Braque before the First World War, and who had gone on to try to square the circle of a technically radical modern art and pressing social concerns during the 1930s. Another arrival to Manhattan was the Dutch artist Piet Mondrian, one of the pioneers of geometric abstract painting. Other exiles drawn from a younger generation included the Surrealists André Breton, André Masson (1896–1987), Roberto Matta (1911–2002) and Max Ernst (1901–76).

Museums and galleries also played an important role in the dissemination of European modernism in New York. Artists living and working in New York during the 1930s had access to works by important European modernists, including Kandinsky, Picasso, Braque, Matisse, Mondrian and others, thanks to the collections and special exhibitions mounted by the Museum of Modern Art, the Guggenheim Museum, and A.E. Gallatin's Museum of Living Art. This wealth of opportunities to view European modern art first-hand was supplemented during the 1940s by the international programme of gallery owners like Peggy Guggenheim, Valentine Dudensing, Sidney Janis and Samuel Kootz. By the end of the 1940s, New York had become a truly cosmopolitan centre of art and culture.

Another strand of foreign influence derived from the succession of Mexican muralists working in New York from as early as the late 1920s on public commissions and other projects. From about 1923, Mexico was the site of a renaissance of public mural painting by artists who were attempting to unite avant-garde technical innovations with social content. Diego Rivera and José Clemente Orozco (1883–1949) are key figures in this regard. David Alfaro Siqueiros (1896–1974), in particular, exerted a lasting influence on the work of Jackson Pollock. In 1936, Siqueiros established a workshop at 5 West 24th Street, Manhattan, to explore new techniques and materials in the service of a popular, revolutionary art. Both Pollock and his brother Sande McCoy worked alongside Siqueiros to produce floats for the 1936 General Strike for Peace and the May Day parade. Pollock also produced a number of easel paintings using techniques taught at the workshop as well as materials that fell outside the normal range of 'fine art' resources. Siqueiros was renowned for his enthusiasm for a common brand of household enamel paint, 'Duco', the very same paint that figured in the making of Pollock's ground-breaking 'drip' and 'pour' paintings of 1947–50.

The encounter with Surrealism during the late 1930s and early 1940s by many key figures of Abstract Expressionism has been claimed to be crucial to their subsequent development. How credible is this claim? Seeking to liberate the unconscious from what they regarded as the restrictive control of the rational mind, the émigré Surrealists experimented with psychoactive drugs and chance operations to produce a spontaneous painting known as 'psychic automatism'. For Breton, all of this linked to a wider project to free the mind from the constraints of bourgeois society. While American artists such as Pollock, Gorky, Rothko, Gottlieb and Newman borrowed some of the strategies of Surrealist art, they reconfigured these techniques for new and, as some commentators contend, decidedly *American* ends (see Plates 6.19 and 6.20).

Plate 6.19 Arshile Gorky, *The Betrothal II*, 1947, oil on canvas, 129 × 97 cm. The Whitney Museum of American Art, New York, 50.3. Purchase. Photo: © 2011 DeAgostini Picture Library/Scala, Florence. © ADAGP, Paris and DACS, London 2012.

Surrealism introduced the American artists to several key concepts, such as the unconscious, automatism and myth. The methods underpinning Surrealist visual art captivated some young New York artists, but their engagement soon gave way to a more practical assessment of the utility of these unusual resources of expression. As Robert Motherwell remarked in 1944, 'to give oneself over completely to the unconscious is to become a slave'.[13] Motherwell was quick to recognise the need to translate the psychic

Plate 6.20 Adolph Gottlieb, *Night Voyage*, 1946, oil on canvas, 96 × 76 cm. Hirshhorn Museum and Sculpture Garden, Smithsonian Institution, Washington, DC, 66.2159. Gift of Joseph H. Hirshhorn, 1966. © Adolph and Esther Gottlieb Foundation/DACS, London/VAGA, New York 2012.

automatism of Surrealism into a gesture less beholden to the unconscious. In so doing, he gave the name 'plastic automaticism' to this revised version of a central Surrealist process. In Motherwell's view, this technique freed line from its descriptive functions (see Plate 6.21). The 'liberated' line formed the basis for a means to make a painting from the ground up through improvisation. One begins by inscribing a gesture on

Plate 6.21 Robert Motherwell, *Mallarmé's Swan*, 1944, collage using gouache, crayon and paper on cardboard, 111 × 90 cm. Contemporary Collection of the Cleveland Museum of Art, Ohio, 1961.229. © Dedalus Foundation, Inc./DACS, London/VAGA, New York 2012.

canvas, without preparatory sketches or plans of any kind. This attention to the material qualities of line over and above the more conventional use of line to depict form suggests a greater attention to the play of materials and an exploration of their particular qualities as such. Evidence of this Surrealist-derived directness of engagement with materials is readily found in the works of Pollock, Still, Newman and Rothko.

4 The experience of Abstract Expressionism

Let us consider what qualities made Abstract Expressionism distinctive. Cultural power after 1945 shifted dramatically from one side of the Atlantic to the other. The emergence of the United States as the leading economic and political world power after the Second World War was a causal factor in the rise of New York as the centre of avant-garde art. Some might say the new dominance of the USA demanded nothing less.

The USA possessed the most advanced technology on earth and was poised to enjoy a boom in which the values of material well-being and consumption were paramount. While it would be difficult to separate this overarching condition from the subsequent 'triumph of American painting' (as it was termed by the historian Irving Sandler),[14] it was scarcely the cultural space occupied by the artists of the New York School in the years after the war.

The emergence during the 1940s and 1950s of independently published small literary and art magazines that focused on issues germane to these artists encouraged and explored the depths of their profound alienation from mainstream society. This cultural difference forged a negative identity of resistance. As Philip Guston so graphically put it, 'you didn't know what you wanted to do, but you knew what you didn't want to do'. These artists felt as though they were being 'driven into a corner against the wall with no place to stand'.[15] The chant of the individual versus society – a society of consumption and superficiality from which many of the artists recoiled – became a recurrent theme in the discourse of Abstract Expressionism.

We tend to think of avant-garde painting in New York during the post-war period as being insistently an art of *abstraction*. Yet, what sort of abstraction? Towards the end of 1947, Adolph Gottlieb wrote:

> Today when our aspirations have been reduced to a desperate attempt to escape from evil, and times are out of joint, our obsessive, subterranean and pictographic images are the expression of the neurosis which is our reality. To my mind certain so-called abstraction is not abstraction at all. On the contrary, it is the realism of our time.[16]

The modes of abstraction that artists such as Pollock or Newman had in mind would need to move beyond the strong examples provided by European modernism of the first four decades of the twentieth century. In an important article summarising his view of the development of modernist painting in America since the 1940s, Clement Greenberg lays bare the theoretical basis for this sense of urgency towards the redefinition of painting outside the historical tug of Paris. Greenberg's defence of abstract art and of avant-garde culture is crystallised by his assertion that only through a 'process of self-purification' will painting be able to eliminate its 'expendable conventions' and thereby 'renew the vitality of art in the face of a society bent in principle on rationalizing everything'.[17] By 'expendable conventions', Greenberg means every effect in painting that contradicts its essential nature as an art of pigment on a two-dimensional plane.

Here Greenberg is giving an account of Abstract Expressionist art as essentially *abstract*: a formal configuration of shapes and colours on a two-dimensional plane. The other great critical defender of Abstract Expressionism, Harold Rosenberg, emphasised the *performative* aspect of expression. Rosenberg singled out painters who shared a characteristic of thinking through their painting on the canvas. If one has to identify a common thread that unites this heterogeneous grouping of artists, it would be, according to Rosenberg, 'its special motive for extinguishing the object'.[18] The traditional aesthetic concerns of painting – form, composition, drawing and colour – are all subordinated to the central *act* of painting.

Despite their differences, Rosenberg and Greenberg both championed Abstract Expressionist art, and the Abstract Expressionist artist, as fulfilling an elevated and socially crucial role, not at all undermined, but in fact underpinned, by their specialisation and concentrated focus on the matter of art-making itself. In a sense, the Abstract Expressionists embodied perfectly the modernist ethos of the artist as hero. The New York artists rebelled against aesthetic and societal conventions, created new and innovative art, and took art deadly seriously, dedicating their lives to the creation of monumental artworks. They thus shared a belief in what might be called the modernist 'religion' of art – the doctrine of the artist as genius and hero – while they undertook the quest to impart a contemporary visual form to truths about humanity they had nurtured as universal and timeless.

Exercise

Look at the illustrations of Jackson Pollock's *Number 1A, 1948* (Plate 6.3 and the detail in Plate 6.1). Try to think about both how Pollock made such a painting and what might be the effect of encountering the finished work in a museum or gallery.

Discussion

The painting *Number 1A, 1948* is one of the groundbreaking series of works – the so-called 'drip paintings' – completed by Pollock between 1947 and 1951. It is important to understand how he produced these paintings, since this knowledge will help us to understand the significance of these paintings to the history of art. No reproduction can ever substitute for the experience of viewing a work of art first-hand; Pollock's works of this period are no exception. The first thing to take into account is their size. The artist spoke of working at a scale that was somewhere between that of an easel painting (roughly, a canvas of a size that could be manipulated by an individual with relative ease) and a mural. If we consider how these paintings were made, the need for a robust scale becomes clear. The effect of viewing a Pollock painting like *Number 1A, 1948* is to be encompassed by its scale and enchanted by the complexity of its surface. The second aspect to consider is that Pollock produced these paintings with the canvas on the floor. 'My painting is direct', he said. 'I usually paint on the floor ... Having the canvas on the floor, I feel nearer, a part of the painting ... similar to the Indian [Navaho] sand painters of the West.'[19] In a photographic and filmic record of the artist at work captured in 1950 by Hans Namuth (1915–90), we see Pollock during the act of painting literally racing around all four sides of the canvas, stepping in and out of the painting.[20]

According to Lee Krasner, Pollock painted 'using sticks and hardened or worn-out brushes (which were in effect like sticks) and basting syringes ... His control was amazing. Using a stick was difficult enough, but the basting syringe was like a giant fountain pen. With it he had to control the flow of the paint as well as his gesture.'[21] One might say that Pollock was *performing* painting rather than constructing a picture of anything. Indeed, the crucial point about Pollock's work of this period is that it is not a picture in the conventional sense, meaning a representation of an absent object or figure. Rather, it is an index or trace of the very actions that generate its form. One often finds Pollock's handprints in the works of this period, as if to underscore the presence or 'touch' of the artist. Above all, this painting charts the *temporality* of its making. Pollock expressed the desire to allow the painting the freedom to develop as it was being made; as much as possible, the artist stressed the autonomy of the *act* of painting – 'I want the painting to live.'[22]

At various times during the process of painting, Pollock would add other materials to the painting, such as sand, small pieces of hardware, pebbles and string, to emphasise the 'thingness' of the work and to point out that the work was no mystical icon removed from the world; rather, the painting was *of* the world. The 'all-over' pattern speaks of a point of view that is universal, rather than particular. The implication here is that the artist – the maker of the work and also representative as the first beholder of the work – maintains a privileged viewpoint or worldview. When we examine in detail the overall pattern or skein we see that it consists of several layers distinguished through their colour, which serves to suggest a visual space that appears infinitely deep yet shallow at the same time. In the presence of a Pollock of this period, close up so that our visual field is bounded literally by the canvas, we can play the game of tracing this or that arabesque across the field. Critics often speak of the quality of line in Pollock's works in terms of metaphors drawn from choreography. Thus, we refer to the balletic movements that characterise Pollock's act of painting. These were generated as a kind of drawing in space, as Pollock's painting tools rarely make contact with the surface of the canvas in this series of works. These gestures of Pollock would continue without interruption for a period of time, perhaps 20 or 30 minutes or more. At the end of each session, from an external vantage point, the artist would be in a position to consider what he has made and to gauge the visual effect of the tracery. The most successful paintings in this series are extraordinarily lyrical. As a practical matter owing to the size of the work relative to the dimensions of his studio, Pollock would hang unfinished paintings on the wall while another was initiated on the floor of the studio. The unfinished canvas would undergo intense scrutiny by Pollock. When he was satisfied that he understood his next moves, the canvas would be returned to the floor and the painting would be completed.

In a painting like *Number 1A, 1948,* Pollock would have valued highly the control that he could exert on the paint against the force of gravity. While the painting is spontaneous in terms of its overall composition, which developed during the course of the painting – Pollock was quick to say that he did not work from drawings or colour sketches – it is not entirely accidental. Finally, the form of painting exemplified in *Number 1A, 1948* challenges the works of earlier modern artists like Picasso by masking or negating the image and thereby denying us the ground of our experience of pictorial art. 'I want to express my feelings', Pollock declared, 'rather than illustrate them.'[23] Contemporary critics found Pollock's paintings to be truly challenging, stretching their comprehension and forcing them into the territory of extreme, florid metaphor. The notion of a 'picture' of subjectivity seems to be particularly problematic, but time and again critics fall back on that assumption. The apparent lack of conventional artistic competences on Pollock's part encouraged unsympathetic critics to dismiss Pollock as a charlatan. Where, they ask, is the draughtsmanship, the evidence of composition, or recognisable images that one can hang one's hat on and thereby fix the meaning of the work? Pollock countered by asserting that technique is also a means by which to arrive at a meaningful statement through art. The radical break with previous pictorial art that Pollock realised during this relatively brief period of three years did not go unnoticed by his peers. Arguably, these works by Pollock altered the course of painting for the next decade and were at the centre of a lively and varied painterly dialogue engaged in by other significant artists, such as Lee Krasner (Plate 6.22). By the early 1950s, Pollock seemed to have reached the limit of achievement using this technique; the recurrence of figuration in his final works is often taken as evidence that he had exhausted the potential of gestural painting as he had envisioned it. Nevertheless, works like *Number 1A, 1948* are paradigmatic of Pollock's achievement and demonstrate what is possible through this approach to painting.

The tragic and serious nature of the subject tackled by Pollock was not unique among the artists of New York during the post-war era. Descriptions of Rothko's paintings of the 1950s onwards are generally freighted with the language of transcendence; accounts of looking at his paintings often read like an epiphanic confession. The artist himself tended to anthropomorphise his works, speaking about them as if they were personages. 'A picture lives by companionship expanding and quickening in the eyes of the sensitive observer. It dies by the same token.'[24] In his essay 'The Romantics were prompted', Rothko conceived of his pictures as 'dramas', wherein shapes are 'organisms with volition and a passion for self-assertion'.[25] This account of the experience of looking attentively at Rothko's *Number 10, 1950* (Plate 6.23), taken from James Breslin's comprehensive biography of Rothko, is both refreshing and instructive. At the very least, it shows how the intimate bond forged by the artist between art and language often underpins one's contemporary interpretation of art:

> At first we are drawn to the dramatic yellow rectangle – by its intense, glowing color, its greater size, its dominant position. The rectangle contains – nothing – and so, weightless, it rises and floats out from the picture plane *toward* the viewer. Yet its golden surface is also translucent and we look *into* this spacious rectangle – like looking into the sun, except that this sun will not blind or burn; it is a humanized sun, powerful, yet warm and embracing. Filled with a deep yellow light, the surface of this rectangle constantly fluctuates as varying densities of paint change the hue from golden to a dark orange where a brownish-red area beneath, still visible as a fringe around the yellow, pushes through to create mysterious shadowy presences that form and dissolve as our eye, with nothing definite to arrest it, keeps moving around inside this inviting shape.[26]

Breslin takes pains to narrate the experience of looking. As Rothko and his colleagues never tired of noting, it is the experience of looking assiduously at the work that constitutes the only adequate explanation of a painting. 'No possible set of notes can explain our paintings. Their explanation must come out of a consummated experience between picture and onlooker.'[27]

Rothko christened this experience 'tragic freedom'; the phrase refers to the painting's failure to be still, to present itself to the spectator as a fixed image. We might also consider the importance to Rothko of the experience of attentive looking as an expression of critical resistance to modern culture's celebration of transience. Rothko's notes serve as an introduction, a guide to the spectator coming to this art for the first time. Rothko's paintings, such as *Number 10, 1950*, may be understood as a diagnostic ground against which the capacity for sustained looking by the spectator is revealed and assessed. The relation that the artist

Plate 6.22 Lee Krasner, *Untitled*, 1949, oil on composition board, 122 × 94 cm. Museum of Modern Art, New York, 500.1969. Gift of Alfonso A. Ossorio. Photo: © 2011 The Museum of Modern Art/Scala, Florence. © ARS, NY and DACS, London 2012.

intends to establish between the spectator and the work of art cannot be adequately described by resorting to generalised terms like 'abstraction' or 'picture'. We encounter a Rothko painting as a field whose meaning is tied to our temporal, visual and physical orientation towards it.

Plate 6.23 Mark Rothko, *Number 10, 1950*, 1950, oil on canvas, 230 × 145 cm. Museum of Modern Art, New York, 38.1952. Gift of Philip Johnson. Photo: © 2011 The Museum of Modern Art/Scala, Florence. © 1998 Kate Rothko Prizel & Christopher Rothko ARS, NY and DACS, London.

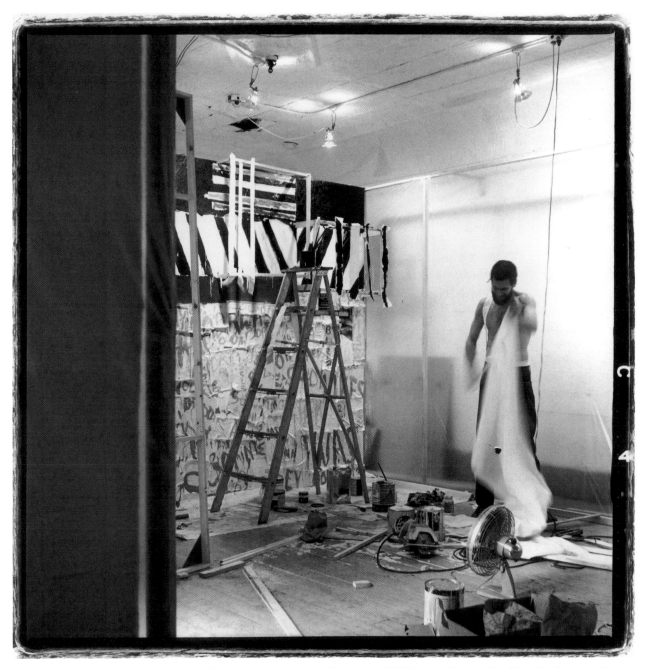

Plate 6.24 Allan Kaprow prepares for *18 Happenings in 6 Parts*, 10 September 1959, Reuben Gallery, New York. Photographed by Fred W. McDarrah. Photo: © Fred W. McDarrah/Getty Images.

5 'Ecstatic blindness': an alternative tradition

In the opening discussion of two pivotal, coincidental New York exhibitions on the cusp of the 1970s, I alluded to an alternative tradition that emerged during the 1950s and 1960s. In striking contrast to the modernist emphasis on medium specificity, purification and autonomy, this new tendency in art emphasised a diversity of approaches and heterogeneity of media while insisting on a more obvious reference to the world outside art. While the new art represented a break in so many ways with post-war painting, it was strongly linked in at least one instance to the work of Jackson Pollock.

Allan Kaprow (1927–2006) is widely acknowledged as one of the principal innovators of performance art. His scripted performances – or 'happenings' – of the late 1950s and 1960s demand the active participation of the audience and suggest a form of art that would herald the 'death' of the spectator (see Plate 6.24). Kaprow wrote intelligently on art and took pains to construct a credible historical context for his happenings, which he conceived as a further development of the twentieth-century avant-garde. For Kaprow, Pollock's immersive engagement in the act of painting signalled a break in the history of pictorial art and projected a new horizon for artistic practice as 'a sort of ecstatic blindness'.[28]

Kaprow grasped Pollock's legacy as one where the art of painting is pushed to its breaking point; a 'return to the point where art was more actively involved in ritual, magic and life than we have known it in our recent past'.[29] Artists wishing to go beyond a mere rehearsal of Pollock's style will have to face the possibility of abandoning the making of paintings as planar, portable objects. They will turn their attention equally to '"things" and the *relations* between them'.[30] Kaprow's sense of what might emerge from this new warrant for art released a flood of talking points for the making of 'new concrete art'. It is a prescient inventory of environmental triggers that would soon become central to the aesthetic sensibility that underpinned so many radical art practices of the 1960s:

> Pollock, as I see him, left us at the point where we must become preoccupied with and even dazzled by the space and objects of our everyday life, either our bodies, clothes, rooms, or, if need be, the vastness of Forty-Second Street. Not satisfied with the *suggestion* through paint of our other senses, we shall utilize the specific substances of sight, sound, movements, people, odors, touch. Objects of every sort are materials for the new art: paint, chairs, food, electric and neon lights, smoke, water, old socks, a dog, movies, a thousand other things which will be discovered by the present generation of artists.[31]

Pollock came to represent a bridge for Kaprow and others, a precursor who enabled subsequent practices in art that oddly bore no direct relation to painting. As Kaprow wrote in 1958, 'The younger artist of today need no longer say "I am a painter" or "a dancer." He is simply an "artist".'[32]

6 Attitudes, form and 'conceptual-type' art

The cultural landscape of the 1960s was marked by loosely affiliated groups of artists, such as the Fluxus group, active in western Europe and New York, that were interested in a model of practice that embraced audience participation, spontaneity and an interest in chance as a means to drive artistic decisions. Many in the emerging Conceptual Art movement, including the Art & Language group that by the end of the decade was active in both England and New York, also valued collaboration and worked together as a collective where the group name, rather than any particular individual, assumed public authorship of the work of art. In this context, the phenomenon of collective activity signals a strong critique of the individualism that was so deeply entrenched in the post-war culture of art thanks to the tireless statements and publications of the Abstract Expressionists and their commentators.

Conceptual Art and its cognates critically engaged with the aesthetic tenets of modernist art and the institutions that supported that art. The Art & Language group wrote in 1969, 'a number of artists have developed projects and theses ... which were initially housed pretty solidly within the established constructs of visual art. Many of these projects, etc. have evolved in such a manner that their relationship to visual art conventions has become increasingly tenuous.'[33] Throughout the late 1960s and early 1970s, New York artists such as Joseph Kosuth exhibited art that reflected on its status as art. This so-called 'theoretical' strand of Conceptual Art was connected to the analytical philosophy of language and ideas found in the late writings of the Austrian philosopher Ludwig Wittgenstein (1889–1951). Using these intellectual resources, Kosuth wished to show the tautological nature of the concept of art and thereby dispel the mystifications swirling about art. Kosuth's work of the mid- to late 1960s utilises photography, text and, in some instances, objects, to shift the focus of art from an aesthetic to an intellectual encounter. For Kosuth, the artist is defined as a *thinker* who must reflect critically on the fundamental nature of art as a form of meaning. His work asks us to consider what is essential and what is merely conventional with respect to the concept of art.

Exercise

Look at the reproduction of Joseph Kosuth's *One and Three Chairs* (Plate 6.11). What points do you think Kosuth might be making about representation and reality?

Discussion

One and Three Chairs is a multimedia work of art consisting of an actual folding chair, a life-sized black and white photograph of this precise chair, and a smaller photographic print of the dictionary definition of the word 'chair'. The language of the dictionary definition in this instance is English; the artist will alter this language depending on the language of the country in which the work is exhibited. As a work of art, *One and Three Chairs* contains elements that link it to an earlier period of the avant-garde. The wooden folding chair evokes the mass-produced objects selected by Marcel Duchamp around 1914 and called 'Readymades' (Plate 6.25; see also chapter 3, Plates 3.22 and 3.23). Duchamp was the first modern artist to consider the way in which linguistic conventions could form a context within which an object would be understood to be a work of art. Kosuth acknowledges this precedent, and invites us to consider some of the components of this work in such a manner. Why does Kosuth insist on presenting a chair through this redundant system? We have the chair as a physical object that is flanked by both a photographic and linguistic representation of itself. Does the object provide more information about the chair than the photograph? Or the dictionary definition? In this work, the significance of these three elements is more than a self-evident duplication of the same information. What Kosuth wishes to demonstrate is the equivalence of sign systems and to suggest that our preference for one over the other is arbitrary. If there is no reason to value the 'real thing' over the picture or the exposition of how the concept is used in language, then none should be looked upon as more significant or meaningful than the other. Yet the meaning of this work is not quite exhausted through that conclusion. Kosuth is more cunning, and if we attend to the nature of the 'real' chair and the photographic representation, we realise that the image of the chair is an image of *that particular chair*. The dictionary definition, however, provides us with the concept for *all* chairs; indeed, for any conceivable chair. Thus, the linguistic

Plate 6.25 Marcel Duchamp, *In Advance of the Broken Arm*, 1964 (fourth version after lost original of 1915), wood and galvanised-iron snow shovel, height 132 cm. Museum of Modern Art, New York, 690.2006. Gift of the Jerry and Emily Spiegel Family Foundation. Photo: © 2011 The Museum of Modern Art/ Scala, Florence. © Succession Marcel Duchamp/ADAGP, Paris and DACS, London 2012.

representation of the *concept* of chair subordinates both the specific instance of a chair and a pictorial representation of that chair. *One and Three Chairs* thereby becomes something other than a multimedia work of art; it becomes a demonstration of the relation between concepts and the objects and images that such concepts are capable of generating within a particular philosophical system.

UNION, NEEDLES, CALIFORNIA

Plate 6.26 Ed Ruscha, *Union, Needles, California*, 1962, from *Twentysix Gasoline Stations*, 1963. © Ed Ruscha. Courtesy Gagosian Gallery.

The published writings by conceptual artists – such as Kosuth, Sol LeWitt (1928–2007) and Weiner, to name but a few – provided artists and critics of the 1960s with the means to frame and legitimise new models of art. Texts such as Kosuth's three-part essay 'Art after philosophy' or LeWitt's 'Sentences on Conceptual Art' argued the case for the primacy of a linguistic model of art.[34] That is, the notion that visual art is language-like. In this vein, Kosuth has written, 'The art I call conceptual is such because it is based on an inquiry into the nature of art ... Fundamental to this idea of art is the understanding of the linguistic nature of all art propositions, be they past or present, and regardless of the elements used in their construction.'[35]

A new generation of art dealers and curators – notably Seth Siegelaub in New York and Harald Szeeman in Switzerland and Germany – enjoyed the support of art critics like Lucy Lippard, Gregory Battcock and Ursula Meyer. All published reviews or compiled important anthologies that documented the rise and extent of artistic practices that could be called Conceptual Art, both in the USA and elsewhere. Like their predecessors in the avant-garde milieu of post-war New York, the artists, critics and curators of the late

1960s often worked in tandem to establish a ground for the critical reception of new, potentially difficult, art. In 1968, Lippard and the artist John Chandler predicted that the artist's studio would shift from being a site of production of art objects to something closer to a centre for research and the management of production that took place elsewhere. At the same time, they argued that Conceptual Art's diminished interest in the specificity of the art object would have profound consequences for the hitherto separate roles of artist and critic: 'sometime in the near future it may be necessary for the writer to be an artist as well as for the artist to be a writer'.[36] This was born out in the succeeding years, when artists increasingly took control of the dissemination and interpretation of their work. As conceptual artists were accustomed to remark, they were keen to eliminate the middle-man (the critic or curator) and to bring their art, suitably wrapped in commentary, directly to the audience.

One of the most significant models for the dissemination of art to be introduced during the 1960s was the revised format of the artist's book. In general, the period of the mid- to late 1960s and into the 1970s witnessed an extraordinary rise in the self-

STANDARD, AMARILLO, TEXAS

Plate 6.27 Ed Ruscha, *Standard, Amarillo, Texas*, 1962, from *Twentysix Gasoline Stations*, 1963. © Ed Ruscha. Courtesy Gagosian Gallery.

publication activities of artists. Earlier, I touched on the importance of independent publications, such as *Tiger's Eye*, *Possibilities* and others, to the dissemination of informed criticism of the art of post-war New York. Likewise, conceptual-type art was also responsible for a number of significant journals of criticism and reportage, such as *Art-Language* (1969) and *Avalanche* (founded 1968, first publication 1970). The do-it-yourself publication produced with a photocopier or the modest pamphlet commercially printed on an offset lithography press represented something other than a means of critical exegesis for many artists who emerged during the 1960s. Though modest in size, limited in print run and indifferent to luxurious production values, the artist's bookwork announced itself by the end of the decade as an inexpensive, accessible and ubiquitous form of art.

The Los Angeles artist Ed Ruscha, who was tagged 'the artist of the city as Manet was the artist of Paris', is widely regarded as the innovator of the contemporary artist's bookwork built around the photographic image.[37] Ruscha's bookworks are a central model for artists of the 1960s; particularly those who sought to employ photography in a documentary or narrative

format. Ruscha's first publication – *Twentysix Gasoline Stations* (1963) – depicts the petrol stations that were found along the celebrated American highway Route 66 (Plates 6.26 and 6.27). This was the road that Ruscha travelled as he drove back and forth to visit his home in Oklahoma. According to Ruscha, the title for the book came first, and the pictorial content followed once the structure of the book had been decided upon. LeWitt's injunction to the conceptual artist to follow the concept to the end without hesitation or revision is thus anticipated by Ruscha's initial foray into publishing. 'The first book came out of a play with words', admits Ruscha. 'The title came before I even thought about the pictures.'[38]

Twentysix Gasoline Stations is nothing like the deluxe artist's books of the early twentieth century that were produced in response to literary texts or in collaboration with poets. Ruscha's book was self-initiated and mass produced. Nor was it a book of fine-art photography; rather, the images in Ruscha's book were meant to be viewed as 'nothing more than snapshots'.[39] Subsequent photographically based publications by Ruscha mirrored the worldwide explosion of interest by artists in photography as a recording device.

Plate 6.28 Carolee Schneemann, *Meat Joy*, 1964, performance: raw fish, chickens, sausages, wet paint, plastic, rope, paper scrap. Photographed by Al Giese. © Carolee Schneemann.

By the late 1960s and throughout the 1970s, photography became a central element of conceptual-type practices in art. Walter De Maria (b. 1935), James Turrell (b. 1941), Nancy Holt (b. 1938) and Michael Heizer (b. 1944) were employing photography as a form of documentation of relatively inaccessible Land Art works sited in the American southwest. Photography would also become the medium of choice to document happenings and performances. For Allan Kaprow, Yoko Ono (b. 1933), Carolee Schneemann (b. 1939) and others, the iconic photographic image would become the sole record of the event – proof, as it were, of the artist's presence (Plate 6.28; see also chapter 7, Plates 7.8 and 7.16).

Neither these artists, nor the conceptual artists we have discussed, would admit to having much interest in photography as a *fine-art* medium. 'Some artists use photography as a medium', remarks Ruscha, 'which is almost not photography. I mean they're not speaking to photographers.'[40] As the British art critic John Roberts argues, the presence of the photographic image in much Conceptual Art is paradoxical, given the fact that key artists associated with that trend eschewed the pictorial in art, in favour of the display of theoretical texts. The presence of the photographic image in Ruscha's work reunites modes of spectatorship – 'reading' and 'looking' – that had previously been experienced as the separate domains of the artist and critic, respectively. But it also announces the centrality of mass-media forms to the artistic practices that emerged during the 1960s. While artists of the 1950s and early 1960s – notably Rauschenberg and Warhol – incorporated media images into their work, conceptual artists using photography sourced from, or mimicking, its use in mass media were unconcerned about aestheticising the borrowed imagery. Earlier, the well-established 'art' practice of painting had contextualised Rauschenberg's and Warhol's serigraphic reproduction of photographic imagery. In contrast, Ruscha's reproduction of his own snapshot documentation of Los Angeles had no such grounding; it was motivated almost entirely by the ubiquitous culture of the automobile.

Conclusion

During the 1960s, Pollock's name would be invoked repeatedly by artists like Robert Morris (b. 1931) and Robert Smithson (1938–73) in writings that introduced new dialects into the conversation on contemporary art. Artists began to speak the languages of structuralism, geology and physical chemistry while lacing these insights together using the literary forms of science fiction or academic philosophical papers in order to justify new approaches to sculpture that included installation, Land Art and systems theory. Other artists, such as Lynda Benglis (b. 1941) and Richard Serra (b. 1939), using poured polyurethane and flung molten lead, respectively, mimicked Pollock's technique of dripping, pouring and flinging paint (see Plates 6.29 and 6.30). These works formed of unconventional materials aimed to translate the experience of directness and immediacy that Pollock valued into a material idiom appropriate to sculpture. For Serra, the artist's vitality as a physical being coupled with the material qualities of molten lead guaranteed a spectacular display of that material's nature. The *act* and its consequence on matter bear the lion's share of responsibility for the meaning of the work. In the case of Benglis, the use of an entirely different sort of fluid medium – one capable of producing voluptuous, multicoloured flows – parodied the masculinist cast of Action Painting while making the same point.

Such fruitful 'misreadings' of Pollock have transformed the significance of the work of this most iconic of post-war painters, thereby altering irrevocably the relation between key figures of American avant-garde painting and sculpture of the late 1940s and the emerging generation of ever-more 'radical' artists of the 1950s. Kaprow and those who followed announced that no medium of representation or expression could henceforth be considered as *the* privileged medium of serious art. It would be a relatively short journey from this aggressive conceptual conversion of Pollock to the summative attitude of the decade of the 1960s that declared: 'art now has no object in view'.[41]

Plate 6.29 Lynda Benglis, *Fallen Painting,* 1968, pigmented latex rubber, 902 × 176 cm (irregular). Albright-Knox Art Gallery, Buffalo. Gift of Michael Goldberg, Lynda Benglis and Paula Cooper. Photo: © 2011 Albright-Knox Art Gallery/Art Resource, NY/Scala, Florence. © Lynda Benglis. DACS, London/VAGA, New York 2012.

Plate 6.30 Richard Serra, *Gutter Corner Splash: Night Shift*, 1969/1995, lead, 48 × 274 × 455 cm. San Francisco Museum of Modern Art, Gift of Jasper Johns. © ARS, NY and DACS, London 2012.

Even more than the diminished importance of the object, the aura of the 'homemade' permeates the work exhibited in early surveys of Conceptual Art. Much of the art of the late 1960s and beyond seems to present a parody of the commonly held view of the artist as skilled craftsperson. This general lack of aesthetic finish was intentional and highly symbolic; it was meant to indicate a break with the methods and meanings of modernist painting and stage Conceptual Art and its cognates as a more democratic, accessible type of artistic practice. The sense of 'democracy' as it is being used here refers to the possibility that the production of art is open to all, regardless of one's ability to master the inventory of skills associated with medium-specific art.

Notes

[1] Geldzahler, 1969, p. 15.

[2] Newman, 1962, p. 86.

[3] Rothko, 1951, p. 104.

[4] Newman, 1948, p. 53.

[5] Contemporary research in art history is continually constructing more complex accounts of the American assimilation of European avant-garde art, a process of translation and hybridisation that involves cosmopolitan émigrés with specific knowledge of visual and cultural resources drawn from Latin America. See Kroiz, 2010, pp. 337–63.

[6] In, for example, *The Gutenberg Galaxy*, McLuhan, 1962.

[7] McShine, 1970, p. 1.

[8] Siegelaub, 1973.

[9] Cited in Lippard, 1989, p. 121.

[10] Goodnough, 1951, pp. 17, 21–2.

[11] Ashton, 1983, p. 14.

[12] My transcription of Philip Leider's prologue to Emile de Antonio's documentary film *Painters Painting* (1972). Henry Geldzahler's exhibition *New York Painting and Sculpture, 1940–1970* is the putative subject of de Antonio's film; most of the artists interviewed by de Antonio were included in Geldzahler's survey.

[13] Motherwell, 1944, p. 13; cited in Guilbaut, 1983, p. 81.

[14] Sandler, 1970.

[15] Philip Guston, transcript of remarks at a public forum chaired by Joseph Ablow, at Boston University, Boston, MA, 1966; reprinted in Ross, 1990, p. 64.

[16] Gottlieb, 1947, p. 573.

[17] Greenberg, 1955, p. 179.

[18] Rosenberg, 2003 [1952], p. 589.

[19] Pollock's words are taken from his commentary in Hans Namuth's film *Jackson Pollock, 51* (1951).

[20] For example, *Jackson Pollock, 51* (1951).

[21] Friedman, 1969, pp. 7–10.

[22] In *Jackson Pollock, 51* (1951).

[23] Ibid.

[24] Rothko, 1947a, p. 44.

[25] Rothko, 1947b, p. 84.

[26] Breslin, 1993, p. 277.

[27] Gottlieb and Rothko, with Newman, 2003 [1943], p. 568.

[28] Kaprow, 1958, pp. 24–6, 55–7.

[29] Ibid., p. 25.

[30] Ibid., p. 25.

[31] Ibid., pp. 55–7.

[32] Ibid., p. 57.

[33] Art & Language, 1969, p. 1. In 1969, the Art & Language group comprised Terry Atkinson, Michael Baldwin, David Bainbridge and Harold Hurrell.

[34] Kosuth, 1969; LeWitt, 1969.

[35] Kosuth, 1970, pp. 2, 3.

[36] Lippard and Chandler, 1968, p. 36.

[37] Schjeldahl, 1993 [1985], p. 40.

[38] Coplans, 1965, p. 25.

[39] Bourdon, 1972, p. 33.

[40] Barendse, 1981, p. 10.

[41] Harrison, 1970, p. 42.

Bibliography

Art & Language (Atkinson, T., Baldwin, M., Bainbridge, D. and Hurrell, H.) (1969) 'Introduction', *Art-Language: The Journal of Conceptual Art*, vol. 1, no. 1 (May), p. 1.

Ashton, D. (1983) *The New York School: A Cultural Reckoning*, Harmondsworth, Penguin.

Barendse, H.-M. (1981) 'Ed Ruscha: an interview', *Afterimage*, vol. 8, no. 7 (February), pp. 9–10, 33.

Bourdon, D. (1972) 'Ruscha as publisher (or all booked up)', *Art News*, vol. 71, no. 2 (April), pp. 32–6.

Breslin, J.E.B. (1993) *Mark Rothko: A Biography*, Chicago, IL, University of Chicago Press.

Coplans, J. (1965) 'Concerning *Various Small Fires*: Edward Ruscha discusses his perplexing publications', *Artforum*, vol. 3, no. 5, pp. 24–5.

Friedman, B.H. (1969) 'An interview with Lee Krasner Pollock' in *Jackson Pollock: Black and White*, New York, Marlborough-Gerson Gallery, pp. 7–10 (exhibition catalogue).

Geldzahler, H. (1969) *New York Painting and Sculpture: 1940–1970*, New York, Metropolitan Museum of Art/Dutton (exhibition catalogue).

Goodnough, R. (ed.) (1951) 'Artists' sessions at Studio 35' in Motherwell, R., Reinhardt, A. and Karpel, B. (eds) *Modern Artists in America*, New York, Wittenborn.

Gottlieb, A. (1947) 'The idea of art', *Tiger's Eye*, vol. 1, no. 2 (December), p. 43. (Reprinted as 'Statement' in Harrison and Wood (2003), VA7, p. 573.)

Gottlieb, A. and Rothko, M., with Newman, B. (2003 [1943]) 'Statement', in Harrison and Wood (2003), VA2, p. 568.

Greenberg, C. (1955) '"American type" painting', *Partisan Review*, vol. 22, pp. 179–96.

Guilbaut, S. (1983) *How New York Stole the Idea of Modern Art: Abstract Expressionism, Freedom and the Cold War* (trans. A. Goldhammer) Chicago, IL, University of Chicago Press.

Harrison, C. (1970) 'Notes towards art work', *Studio International*, vol. 179, no. 919 (February), pp. 42–3.

Harrison, C. and Wood, P. (eds) (2003) *Art in Theory 1900–2000: An Anthology of Changing Ideas*, Oxford, Blackwell.

Jackson Pollock, 51 (1951) film, directed and filmed by Hans Namuth, USA.

Kaprow, A. (1958) 'The legacy of Jackson Pollock', *Art News*, vol. 57, no. 6 (October), pp. 24–6, 55–7.

Kosuth, J. (1969) 'Art after philosophy', *Studio International*, vol. 178, nos 915–17, pp. 134–7, 160–1, 212–13. (Extract reprinted in Harrison and Wood (2003), VIIA11, p.852.)

Kosuth, J. (1970) 'Introductory note by the American editor', *Art-Language*, vol. 1, no. 2 (February), pp. 1–4.

Kroiz, L. (2010) 'Breeding modern art: criticism, caricature, and condoms in New York's avant-garde melting pot', *Oxford Art Journal*, vol. 33, no. 3, pp. 337–63.

LeWitt, S. (1969) 'Sentences on Conceptual Art', *Art-Language*, vol. 1, no. 1 (May), pp. 11–13. (Reprinted in Harrison and Wood (2003), VIIA9, p. 849.)

Lippard, L.R. (1989) 'Robert Barry at Yvon Lambert' in *L'Art conceptuel: une perspective*, Paris, Musée d'Art Moderne de la Ville de Paris, p. 121 (exhibition catalogue).

Lippard, L. and Chandler, J. (1968) 'The dematerialization of art', *Art International*, vol. 12, no. 2 (February), pp. 31–6.

McLuhan, M. (1962) *The Gutenberg Galaxy: The Making of Typographic Man*, Toronto, University of Toronto Press.

McShine, K. (ed.) (1970) *Information*, New York, Museum of Modern Art (exhibition catalogue).

Motherwell, R. (1944) 'The modern painter's world', *Dyn*, vol. 1, no. 6 (November), pp. 9–14. (Extract reprinted in Harrison and Wood (2003), VC3, pp. 643–5.)

Newman, B. (1948) 'The sublime is now', *Tiger's Eye*, vol. 1, no. 6 (December), pp. 51–3. (Reprinted in Harrison and Wood (2003), VA11, pp. 580–2.)

Newman, B. (1962) 'Interview with Dorothy Seckler', *Art in America*, vol. 50, no. 2, pp. 83, 86–7. (Reprinted in Harrison and Wood (2003), VIB7, pp. 783–5.)

Painters Painting (1972) film, directed by Emile de Antonio, USA, New Yorker Films.

Rosenberg, H. (2003 [1952]) 'From *The American Action Painters*' in Harrison and Wood (2003), VA16, pp. 589–92.

Ross, C. (ed.) (1990) *Abstract Expressionism: Creators and Critics. An Anthology*, New York, Harry N. Abrams.

Rothko, M. (1947a) 'Statement', *Tiger's Eye*, vol. 1, no. 2 (December), p. 44. (Reprinted in Harrison and Wood (2003), VA6, p. 573.)

Rothko, M. (1947b) 'The Romantics were prompted', *Possibilities*, vol. 1, p. 84. (Reprinted in Harrison and Wood (2003), VA5, p. 571.)

Rothko, M. (1951) 'Statement 1951', *Interiors*, vol. 110, no. 10 (May), p. 104.

Sandler, I. (1970) *The Triumph of American Painting: A History of Abstract Expressionism*, New York, Praeger.

Schjeldahl, P. (1993 [1985]) 'Ed Ruscha: traffic and laughter', in Wilson, M. (ed.) *The Hydrogen Jukebox: Selected Writing of Peter Schjeldahl, 1978–1990*, Berkeley, CA, University of California Press, pp. 239–47.

Siegelaub, S. (1973) 'On exhibitions and the world at large' in Battcock, G. (ed.) *Idea Art*, New York, Dutton, pp. 165–73.

Chapter 7

Border crossings: installations, locations and travelling artists

Gill Perry

Introduction

In 1967, the Brazilian artist Hélio Oiticica (1937–80) filled a gallery of the Museum of Modern Art (Museu de Arte Moderna) in Rio de Janeiro with sand, gravel, pebbles, parrots, tropical plants, toys, sachets scented with patchouli oil or sandalwood, bits of carpet, curtains made of fabric and plastic strips and wooden partitions (see Plates 7.2 and 7.3). As the spectator entered the gallery space, they had to negotiate a labyrinthine path around two panelled wooden constructions, which the artist called his *Penetrables PN2* and *PN3*, in pursuit of a dark inner sanctum containing a television set. This early example of installation art, called *Tropicália,* was crowded, noisy and filled with tacky, brightly coloured objects, resonant of popular religious festivals and carnivals. It evoked the sensory effects of walking into the notorious slums of Rio de Janeiro and was one of a series including Oiticica's constructed environments or decorated plywood cabins (*Penetrables*) that viewers were required

to 'penetrate' physically. They were invited to enter and walk around the space of *Tropicália*, to cast off shoes and feel the sand and pebbles underfoot, play with toys or lie on mattresses, and absorb the smells and a cacophony of sounds. Oiticica's work was underpinned by a strong desire to encourage more spectator involvement in the viewing and understanding of art works. He was working against an idea of art involving, as he saw it, a 'passive' form of viewing, whether the work was two-dimensional, such as paint on canvas, or three-dimensional, such as a sculpture on a plinth. As we shall see, this insistence on the viewer who interacts physically with the work is widely identified as one of the key characteristics of so-called 'installation art'.

In this chapter, I aim to explore some of the different examples and characteristics of this versatile practice as it has developed from the 1960s and 1970s to the present, and examine its ubiquitous international status.

Plate 7.1 (Facing page) Do Ho Suh, *Fallen Star 1/5* (external view) (detail from Plate 7.28).

Plate 7.2 Hélio Oiticica, *Tropicália, Penetrables PN2* and *PN3*, 1967, installation view at *Nova Objetividade Brasileira* exhibition, Museu de Arte Moderna do Rio de Janeiro, 1967.

In the first section, I will consider some different ways in which installations have been interpreted, and their status as works of art and as forms of art practice which have addressed topical issues such as politics, identity and location. This leads on to an exploration in sections 2 and 3 of what we understand by ideas of site-specificity, place and location when applied to artworks and their possible meanings. Section 4 is concerned with the role of installation art in the so-called 'globalisation' of the art world over the last few decades. The successful modern artist has increasingly become what is loosely defined as a 'global nomad', or 'travelling artist', whose work is known and exhibited on an international circuit, and who regularly travels to and works in different countries and contexts. Her/his income and reputation is often dependent on his/her international visibility and marketability. The global nature of art markets and their increasing dependence on international art events and biennales will be explored in chapter 8, so this section will focus on an associated question: how have recent patterns of artistic migration and a globalised art culture informed the nature or content of installation art, and how have cultural and geographical mobility influenced artistic practices? I will explore what a geographical 'border' might mean both when it becomes the theme of an artwork and when it is seen in the broader context of modern social migration. Ironically, one of the results of increased global interconnections

Plate 7.3 Hélio Oiticica, *Tropicália*, *Penetrables PN2* and *PN3*, 1967, installation view at Centro de Arte Hélio Oiticica, Rio de Janerio, 1997. Photo: César Oiticica Filho. Courtesy Projeto Hélio Oiticica. Used with the permission of Projeto Hélio Oiticica.

and international movement is the proliferation of borders and security checkpoints. As we shall see, while artists are increasingly crossing international borders, there are many social and ethnic groups who are unable to do so.

1 Locating installation art

Oiticica's *Tropicália* covered 80 square metres and was designed to provoke multiple sensory experiences, stimulating a range of associations. So how should we read or understand this work? It can be seen as an installation with several functions and meanings. First, it is both sculptural and architectural, consisting of open and closed constructions with their own formal qualities, shapes and bright colours. It also utilised a combination of different media, including plywood structures, sand, sound and everyday objects. Second, the work requires that the *embodied* viewer 'penetrates' the space, moves around it and enjoys various sensory experiences, including touch, sound and sight. Oiticica deliberately used sensory stimuli and local Brazilian images in this work as a reaction against the clichéd imagery presented by American Pop Art. Third, this embodied experience is designed to suggest an association with local Brazilian

culture – the construction could be seen to evoke the crude architectural shapes of local shanty towns or *favelas*, and the many objects, noises and social activities crowded into these slums.[1] By the 1960s, these makeshift communities had become notorious for having changed the urban landscapes around the fringes of Brazilian towns. Moreover, Oiticica was working during a period of state repression in Brazilian cultural history; a military dictatorship under General Castello Branco had seized control in 1964, and by 1968 had introduced a repressive programme of political and cultural censorship and had suspended constitutional rights. But the associations of *Tropicália* are also deliberately ambiguous or playful. They do not convey a clear political message, thus avoiding the censor's scrutiny. The playfulness of these structures, and the accumulation of cheap mass-produced commodities within them, suggested rather than directly announced a critique of 1960s Brazilian culture. We have shifted our focus here from the New York art world (of the preceding chapter) to the Latin American context of Brazil. This case study, and the chapter as a whole, explores a different kind of internationalism. We are concerned here with a range of modern or avant-garde practices with more fluid borders, and which originate from – or travel between – many global contexts.

Plate 7.4 Allan Kaprow
rehearses *18 Happenings
in 6 Parts*, 1959, Ruben
Gallery, New York.
Photographed by Fred W.
McDarrah. Photo: © Getty
Images. Courtesy Allan
Kaprow Estate and Hauser
& Wirth.

The 1960s is generally seen as the period in which
the term 'installation art' was first employed in art
journals and criticism (in the English-speaking world
and beyond) to describe a hybrid art form produced
for particular sites or alternative exhibition spaces,
often underpinned by a radical agenda for social and
cultural reform. It is usually seen as a key development
in the so-called 'expanded field' of art of the 1960s
and 1970s, when the traditional categories of painting,
sculpture and architecture were increasingly being
replaced by more varied and hybrid forms of art, such
as installation, land art and performance art, and
new media such as photography, video and film.[2] The
breakdown of medium-specific art and the growth of
new technologies in the 1960s provided opportunities
for works to engage the viewer in different ways. During
this period, the term 'installation art' often described
works that encouraged or suggested a critical awareness
of political or cultural contexts, as with *Tropicália*.
Many artists in Europe and the Americas at this time
were inspired by the growing anti-war, anti-colonial
and civil rights movements, student rebellions, race
riots and the emerging Women's Movement. Although

the majority of large-scale installations from this
period were produced by male artists with access to the
resources and studio space required, women artists have
increasingly adopted the genre, encouraged by feminist
debates and growing educational, exhibiting and
curatorial opportunities. As we shall see in this chapter,
many women working over the last few decades have
used installation art to make large-scale works that are
both aesthetically engaging and invite reflection on
some pressing social and cultural issues.

In the 1960s, the term 'installation art' was first used
to distinguish some of the experimental practices
of American Minimal Art, including assemblages of
found or constructed objects by artists such as Carl
Andre (b. 1935) and Donald Judd (1928–94), from
the so-called 'environments' and 'happenings' of the
preceding period. Allan Kaprow had famously staged
the latter in 1959 in his *18 Happenings in 6 Parts*, a series
of multimedia events that involved the participation
of the spectators (see Plate 7.4). By the 1970s and early
1980s, installation art had become a very versatile genre
that often involved the display and arrangement of

Plate 7.5 Mary Kelly, *Post-Partum Document: Documentation 1 Analysed Fecal Stains and Feeding Charts*, 1974, Perspex units, white card, diaper linings, plastic sheeting, paper, ink, installation view at Generali Foundation, Vienna, 1998. © Generali Foundation. Photo: Werner Kaligofsky. Reproduced with permission of the artist.

diverse media and objects. This genre has since been absorbed into mainstream museums and galleries. One might even say that it has become the modern 'default format', ubiquitous in contemporary art across the world and highly visible in international art fairs and biennales.[3] For example, installation art has had a prominent role in the best-known international art events, including the Venice Biennale, of the last two decades.

The term is generally used today to describe an arrangement of objects that may include architectural or sculptural constructions and/or a wide range of materials and media, and can be sited in urban or rural locations; they can be placed outside or within a gallery, or can be moved between galleries or exhibition spaces. Installation art may include industrial or everyday materials, ready-made or natural objects, and films, video and photography – and even smells. Most art critics and art historians now emphasise the importance of the viewer's role in installation art. It is an art form which has lost a single frame; the viewer is invited to experience it from a variety of angles and positions, to move around the work, and, as with *Tropicália*, literally to enter the space of the installation. Claire Bishop has written: 'The insistence on the literal presence of the viewer is arguably the key characteristic of installation art.'[4]

It is also worth noting here that many women artists took up installation art in the 1970s precisely because of its ability to engage and activate the viewer, producing what has been called a 'decentred' subject. Some women have been attracted to the ways in which installation art, along with performance art, can invite multiple viewing perspectives and fluid meanings, thus challenging the authority of modernist notions of autonomy. It has been argued that the traditional single-point perspective is an established art-historical convention with a patriarchal lineage, and installation art offers a challenge to this predominantly 'masculine' way of constructing the viewer. This opinion was articulated by the British artist Mary Kelly (b. 1941) in her defence of her famous *Post-Partum Document* 1973–77 (Plate 7.5), which consisted of over 135 framed works placed around a gallery space, including her sons' dirty nappies and vests, combined with complex diagrams. Kelly argued that the unfolding of the work within the gallery installation enabled multiple viewpoints and an accumulation of different experiences, some of which had historically been associated with 'women's experience'.[5] Of course, many male artists have also challenged this historical convention, and these are much debated arguments. That said, several women artists, including Susan Hiller (b. 1942) in Britain, and Judy Chicago (b. 1939), Yayoi Kusama (b. 1929) and Adrian Piper (b. 1948) in the USA, worked with

installation art in the 1970s, identifying a broader 'emancipatory' potential in this art form. Terms such as 'radical' or 'emancipatory' have often been used to describe aspects of early installation art, and may refer to a wide range of social, gendered and political concerns. Some of the on-going debates about these social and cultural functions of installation art will be examined in this and the following chapter.

2 The work and the site

I chose to open this chapter with Oiticica's *Tropicália* not only because it provides a vivid example of an early 'participatory' installation inviting various sensory experiences, but also because this was a form of installation art which (in various transformations) travelled across borders and helped to win an international reputation for the artist in the 1960s and 1970s. In 1969, he constructed a related work at the Whitechapel Gallery in East London called the 'Whitechapel Experiment' or the 'Whitechapel Experience', in which an enclosure called *Eden* formed the centrepiece. He transformed the whole ground floor of the Whitechapel Gallery into a crowded environment which included sand, tropical plants, parrots, carpets, hay and dry leaves, and plywood boxes or cabins (*Penetrables* and *Nest-Cells*). Viewers were encouraged to relax in these enclosures, conceived as spaces for reverie (see Plates 7.6 and 7.7). Oiticica gave the installation the subtitle 'an exercise for the creleisure and circulations', echoing an essay written in 1969 in which he invented the composite term 'creleisure' to mean a mixture of creation, pleasure, belief and leisure, and referencing the creolisation of language, first demonstrated (he claimed) in this Whitechapel *Eden*.[6] He was influenced by the writings of the German cultural theorist Herbert Marcuse (1898–1979), who argued that leisure activities under capitalism were in fact forms of 'repressive sublimation'. In his 1965 essay 'Repressive tolerance', Marcuse argued that capitalist democracies could have totalitarian aspects.[7] Following Marcuse's arguments, Oiticica identified forms of oppression in the ordered leisure patterns of weekends and holidays, proposing instead popular involvement in more unstructured, collective forms of pleasure. Such utopian ideas were common currency among some radical artists in the 1960s, who sought to change the ways in which preceding forms of (modernist) art had been consumed. He wanted the viewer to collaborate in activities within his installations, encouraging forms of leisure which would enable individual or communal creativity. They were conceived as open-ended projects which required the participation of the spectator to develop their meanings. The terms 'participatory'

and 'participation' are now often used to describe an interactive and collaborative involvement which, it is argued, is invited by some forms of installation art. Oiticica encouraged this participatory engagement in his works, in the hope that it would emancipate his viewers, enabling them to reflect critically on their own social and political contexts. This notion of 'participation' extends, but is different from, the idea of the embodied viewer who is able to move around the work, and experience it from multiple viewpoints, and will be explored more fully in chapter 8.

The Whitechapel Experiment was not a direct copy (or transplanting) of *Tropicália*, although (as we have seen) it used similar objects and evoked aspects of the original Brazilian context. But located within a London gallery, it suggested some more localised meanings. In fact, the artist described some of his enclosed cabins or *Nests* as spaces for reverie that might provide sensory, womb-like warmth to counter London's cold, repetitive streets.[8] This work, then, raises questions of replication and reproduction which directly concerned Oiticica. He sought to undermine the idea of a unique art object which acquires an exalted – often highly priced – mythical status, and wanted many of his works to be re-created. The art critic Guy Brett, who curated the Whitechapel Experiment, has argued that Oiticica was particularly concerned with the 'after-life' of such works, 'Not only the existence they might have posthumously but how they would continue to live, retain their vitality and efficacy during his lifetime.'[9] But such issues can be contradictory. The artist's emphasis on public involvement gives these installations a performative aspect (that is, they involve some sort of enacted performance by the viewer through time), which cannot be completely reproduced. And he even wrote of the Whitechapel Experiment 'It would be a mystification to "repeat" through Europe the same show, unless those works or propositions could take on a new sense, which I doubt.'[10] So we might see Oiticica as wanting to demystify the idea of an unrepeatable, unique work, while also acknowledging that different locations contributed to the particular (or unrepeatable) meanings suggested by different installations. These are confusing issues that have haunted the history of installation art.

The problem of whether or not the work can be repeated is, then, directly related to the site. During the 1970s, the term 'site-specific' was increasingly used to describe works which were tied to a specific location. Although some critics have sought to separate out the idea of 'site-specific' work from that of 'installation art', I am using the latter term as a broader, inclusive label which can encompass a relationship with the chosen site. Much

Plate 7.6 Hélio Oiticica, *Eden*, 1969, installation view at Whitechapel Gallery, London. Photo: Whitechapel Gallery Archive. Used with the permission of Projeto Hélio Oiticica.

Plate 7.7 Hélio Oiticica, *Eden*, 1969, installation view at Whitechapel Gallery, London, with members of the public. Photo: Whitechapel Gallery Archive/Alpha Press. Used with the permission of Projeto Hélio Oiticica.

has now been written about the history of site-specific work and its importance in the early development of an expanded field of art in the 1970s. During this period, the idea implied being grounded in an actual physical location, whether in urban or rural settings, or in a specific gallery space, and usually invited the physical presence and participation of the spectator. As Miwon Kwon has written, this conception of site-specific art was 'composed of a unique combination of physical elements: length, depth, height, texture and shape of walls and rooms, scale and proportion of plazas, buildings or parks, existing conditions of lighting, ventilation, traffic patterns, distinctive topographical features and so forth'.[11]

Exercise

Look at the three illustrations of installation works constructed over the last 40 years (Plates 7.8–7.10), and consider the following questions. In each case I have provided short notes to help you contextualise the works.

To what extent does each work appear to be grounded or located in a specific physical site? Given the information provided so far in this chapter, does each seem to you to fit the broad definition of installation art discussed?

Robert Smithson, *Partially Buried Woodshed*, 1970 (Plate 7.8)

Notes: The American artist Robert Smithson conceived and executed this work while a visiting artist at Kent State University in January 1970. Smithson is now seen as one of the most important American artists of the 1960s and 1970s to break down the boundaries between sculpture and the natural landscape, creating a series of works which have been variously described as 'earth works' or 'land art'. *Partially Buried Woodshed* was intended to demonstrate his theory of 'entropy' or natural disintegration and metamorphosis, and twenty truckloads of earth were dumped on an empty shed until the central beam collapsed. Before Smithson left the campus, the piece was valued at $10,000. A few months after the piece was erected, four student

Plate 7.8 Robert Smithson, *Partially Buried Woodshed*, 1970, one woodshed and twenty truckloads of earth, 561 × 304 × 1372 cm, Kent State University, Ohio. © Estate of Robert Smithson/ DACS, London/VAGA, New York 2012. Image courtesy James Cohan Gallery, New York/Shanghai.

Plate 7.9 Felix Gonzalez-Torres, *'Untitled' (Public Opinion)*, 1991, black rod licorice candies individually wrapped in cellophane, endless supply, ideal weight 700 lbs, dimensions variable with installation, installation view at Solomon R. Guggenheim Museum, New York, purchased with funds contributed by the Louis and Bessie Adler Foundation, Inc., and the National Endowment for the Arts Museum Purchase Program, 91.3969. Photo: David Heald © Solomon R. Guggenheim Foundation, New York. © The Felix Gonzalez-Torres Foundation. Courtesy Andrea Rosen Gallery, New York.

Plate 7.10 Doris Salcedo, *Shibboleth*, October 2007 – April 2008, concrete and metal, length 167 m, Turbine Hall, Tate Modern, London. Photo: © Tate, London, 2012. Courtesy of Alexander and Bonin, New York.

protestors were shot dead by police in the Kent State massacre on 4 May 1970. Soon afterwards someone painted the words 'May 4 Kent 70' on the main beam of the shed. Today the remains are overgrown and mostly hidden in a grove of trees.

Felix Gonzalez-Torres, *'Untitled' (Public Opinion)*, 1991 (Plate 7.9)

Notes: Felix Gonzalez-Torres (1957–96) was born in Cuba, grew up in Puerto Rico and migrated to the USA, where he died in 1996. He became best known for his paper stacks, strings of light bulbs and candy spills of the 1990s. The latter are large piles of sweets, varying from Baci chocolates, liquorice and lollipops to Bazooka bubble gum, sometimes displayed in corner piles or like carpets within gallery spaces. For this work, the artist has specified that it should consist of around 700 pounds of 'black rod licorice candies', individually wrapped in cellophane, of which there must be an 'endless supply'. Viewers are allowed to help themselves to the sweets, which are replenished by gallery staff. *'Untitled' (Public Opinion)* was included in his retrospective in the American pavilion of the Venice Biennale, 2007.

Doris Salcedo, *Shibboleth*, 2007 (Plate 7.10)

Notes: Doris Salcedo (b. 1958) was born in Colombia and is renowned for her installations, sited in many international gallery spaces, which address (indirectly) issues from Colombian political history. *Shibboleth* was one of a series of works by various artists commissioned specifically for the Turbine Hall since the opening of Tate Modern in 2002, in which the artist was asked to work with and/or intervene in the space. Salcedo created a large crack that ran the length of the concrete floor of the Turbine Hall. The walls of this chasm were covered by a steel mesh fence. A 'shibboleth' is a custom, phrase or mode of dress which distinguishes a particular social group or class, and can be used to define social or racial exclusion. The work could be seen in the Turbine Hall from October 2007 to April 2008.

Discussion

These works are tied to their locations in different ways. Truckloads of local earth were brought in artificially for Smithson's *Partially Buried Woodshed*. The earth was designed to interact over time with the structure of the Ohio woodshed. Like his famous *Spiral Jetty* in the Great Salt Lake in Utah of 1970, this might be seen as an example of land art or even an outdoor 'installation' distinguished by its physical presence in the landscape (or site); both involve architectural constructions or interventions which

subsequently interact, disintegrate or evolve with nature. The *Woodshed* appears to be a construction in reverse, or what has been called an example of 'reverse archaeology'. Rather than uncovering or revealing the architectural form of the shed, Smithson buries it, creating an alternative, partly hidden structure which will slowly change with nature. Although one might justifiably argue that this should be described as site-specific 'land art', it shares some characteristics of installation art; it undermines traditional ideas of sculpted objects on plinths or ideal positions for viewing subjects, includes a construction and a pile of earth, and invites the viewer to move around it and explore its changes over time.

That said, we see from the information provided above that the work also became a commemorative (albeit decaying) 'building' on the Kent State University site. *Partially Buried Woodshed*, then, is a site-specific work which has acquired the status of a historical monument, evocative of ruins and political memories.

Gonzalez-Torres's *'Untitled' (Public Opinion)* does not fit easily into the category of site-specific work. Like many of his so-called candy spills, this is an installation which has been displayed in different international gallery locations, and has been presented both as a corner pile (as in Plate 7.9) and as a carpet (Venice, 2007). From the information provided above, you will see that the artist has given some instructions on how the work should be displayed, but he has also specified that the curator can decide how large or small to make the work.[12] So the physical relationship of this installation with the gallery site will depend largely on curatorial decisions and positioning, rather than on any inherent relationship conceived or constructed by the artist. But the work is designed to relate to the gallery space. It is carefully positioned in specific gallery spaces or corners; and as museums usually do not allow viewers to touch objects on display, Gonzalez-Torres made works which invited visitors to touch and even eat the work. Clearly this is not physically rooted or constructed in a specific site, like the Smithson or the Salcedo, but the meanings of *'Untitled'* depend on a particular relationship with a gallery site or sites.

This work also raises questions about what is meaningful or 'artistic' in installation art. *'Untitled'* deploys cheap, everyday objects which can be consumed. Does it matter, we might ask, that all the pieces can be removed and then replenished? Is it still an artwork if it can be

replaced and assembled somewhere else? As we have seen, since its earliest days, installation art has often included banal, mass-produced objects from everyday life. But these sweets are there to be removed and thus have no clear status as part of an artistic construction. The work can therefore be seen to question the idea of the unique or original art object. It is concerned rather with endless repetition. Yet the repetition of these black liquorice rods gives it a dark, almost sinister appearance. Although many of his candy spills are given the blank title of 'Untitled', they are also each accompanied by a subtitle in parenthesis (Public Opinion) which can suggest other meanings. According to critics and friends of Gonzalez-Torres, he saw the liquorice rods as resembling missiles – black, shiny and sinister. Produced in 1991, he hoped that the work might be seen as an oblique, even mischievous, protest against military action and the wave of American nationalism which he witnessed during the first Gulf War. By choosing his subtitle, he also hoped to suggest that owing to heavy censorship, the American public was not as informed about political and military developments as he might have hoped. Of course, such associations are difficult to read out of the work without prior knowledge of the artist's intentions. But a critical aspect of Gonzalez-Torres's work is that it should encourage viewer involvement; we are invited to take the sweets and change the appearance of the installation, to become actively engaged with the work. Through these candy spills, the artist was suggesting a broader or more flexible definition of installation art to encompass on-going change. We saw earlier that Oiticica was also concerned with ideas of reproducibility, undermining the idea of the unique art object. This concern constituted one of the radical aims behind the early development of installation art.

Salcedo's *Shibboleth* raises some interesting questions about how we read the meanings of site-specific works when they are displayed in – or are literally part of – a contemporary museum of modern art which is enticing a mass audience. By making the floor, rather than a construction or assemblage of objects, the focus of this work, the artist redirects our expectations of both the Turbine Hall and what an installation might be. Instead of drawing our attention to the height and size of this monumental, awe-inspiring space, Salcedo directs us towards a badly damaged floor, evoking metaphors of shaky foundations.

The Tate Turbine Hall commissions have been accused of seducing audiences to see modern art as awe-inspiring spectacle, such as *Marsyas* by Anish Kapoor (b. 1954), from October 2002 to April 2003, or jokey forms of play involving spectator participation, such as the slides installed by Carsten Höller (b. 1961), from October 2006 to April 2007 (Plate 7.11). And such works have helped to generate a mass audience for installation art. I see *Shibboleth* as a more puzzling and challenging form of installation art (if we can justifiably call it that). Salcedo's crack suggests an assault on the actual building, on the structure and integrity of the Turbine Hall – itself the scaled-up entrance to what is now one of the most successful museums of modern art in the world.[13]

You might want to argue that this is not really an installation; it is more like a sculpted cut, and that if it were a real, structural crack or assault on the building, it would not, of course, have been allowed. But knowledge of the building processes involved in the work suggests a major construction. Each section of the crack, which widens and deepens as it runs the length of the hall, was cut out of the floor and re-set in cement blocks. The sides of the chasm, which resemble rough cliff faces, were then covered in wire mesh.

This work clearly derives a large part of its identity, structure and meaning from its site – the massive Tate Turbine Hall. But Salcedo also intended the work to suggest other meanings unconnected to this British location. I would not expect you to know this, but her title was intended to evoke associations with years of racism and colonial exploitation, which have underpinned 'western' ideas of modernity and progress. Of course, if an artist claims that her/his work means something, this does not guarantee that the viewer will interpret it as such. But some knowledge of the artist's interests and concerns can inform the viewer's ability to make imaginative or symbolic associations. Thus the powerful image of cracked foundations could evoke the (shaky) economic and political underpinnings of the modern art world and western colonial culture. It is not without significance that the toxic foundations of the international banking world were being revealed in the global financial crisis of 2007–08 while this work was on display. And the broader implications of the word 'shibboleth' suggest an artistic project which seeks to engage with social and racial exclusions beyond borders, a theme we explore later in this chapter.

Plate 7.11 Carsten Höller, *Test Site*, October 2006 – April 2007, five slides, steel, longest slide: length 55.5 m, Turbine Hall, Tate Modern. Photo: © Tate, London, 2012. © 2012 Carsten Höller.

Plate 7.12 Richard Serra, *Tilted Arc*, 1981, steel, 120 ft (37 m) × 12 ft (4 m), Federal Plaza, New York. Photo: © David Aschkenas.

3 Location, location, location

The gallery works by Oiticica and Gonzalez-Torres discussed above do not really conform to the idea of site-specific installations as rooted in a particular location, but suggest works designed for multiple sites, from which they may acquire new meanings. In this section, I will explore some of the shifting meanings of the term 'site-specific' and related ideas of 'location' and 'place'. The notion of site-specific work has been much debated and reworked since Smithson constructed his influential examples of land art in the 1960s and 1970s, and the range of definitions can be confusing. In fact, Smithson had proposed his own definitions of the word 'site' when he produced a series of so-called *Non-Sites* in 1968, in which materials collected from various outdoor sites and deposited in bins were placed in a gallery with information on the area from which they had been collected. By calling these *Non-Sites*, the artist was claiming that the site from which they had been taken was absent or elsewhere.[14] Details about the site were provided in the form of maps and geographical information. This process shows us how confusing the implications of 'site' can be, as it might be argued that in providing details of the original site, the artist somehow builds it into the work as an absent presence. What we can

say, however, is that Smithson was concerned to expose the limits of the operation of the gallery space and its conventional displays of unique works on plinths.

Smithson was one of several artists working in the 1960s and 1970s who felt that the site-specific project offered some resistance to modernist 'autonomy'. In other words, they believed that an installation that was tied to its location, or determined by it, was very different from a moveable, placeless sculptural object which could be displayed in any gallery space. The American artist/sculptor Richard Serra reinforced this idea when he responded to the removal of his controversial steel sculpture *Tilted Arc* (1981–89) from its position at the centre of the Federal Plaza in New York (Plate 7.12). This was a huge, leaning wall of steel – 120 ft (37 m) long by 12 ft (4 m) high – that seemed to dissect the plaza. At the same time, Serra had deliberately sought sites for his work which would frustrate viewers' perception of any obvious links between the sculpture and the character of the setting. Federal Plaza is a part of a complex of government and office buildings, and the perceived lack of fit between this site of federal authority and Serra's bold, abstract curtain of steel was exploited

by local bureaucrats who argued for its removal. Serra emphasised that *Tilted Arc* had been commissioned for this specific site, and 'to remove the work is to destroy the work'.[15] In the wake of the controversy that caused its removal from the square, he continued to argue against relocation, writing that *Tilted Arc* was 'not meant to be "site-adjusted" or "relocated". The scale, size, and location of site-specific works are determined by the topography of the site, whether it be urban or landscape or architectural enclosure.'[16]

Despite Serra's assertion, there are several senses in which this notion of site-specific art has been challenged or reworked over the last few decades. First, there have been increasing numbers of 'travelling' site-specific works that have been reconstructed to interact with different sites; they have become more nomadic projects, moving between locations. Oiticica's various versions of *Tropicália* might be seen as gallery-based examples of this. Second, a more conceptual approach to the idea of the site has evolved. A literal interpretation of the site as a specific location or 'local position' has been extended to include an idea of the site as involving context, audience and memory – as something more fluid and interactive. The term 'site-specificity' is sometimes used to describe this second emphasis, which is more concerned with the *processes* that inform how we understand specific locations. We might read Salcedo's *Shibboleth* in these terms. If we see it not simply as a crack in floor of the Tate Turbine Hall, but also as a work that suggests some form of institutional critique by speaking to us about the context and constraints of the museum, and that is affected by the ways in which we experience and walk around it, then it can be understood in a broader sense as related to culture and cultural debates, to our expectations as spectators, and to social and economic conditions around us.

Installation and performance

Extending this approach, some theorists have argued for an understanding of site-specificity as closely involved with an idea of *performance* or theatre, thus emphasising the participatory potential of installation art. In his book *Site-Specific Art* Nick Kaye has explored a definition of location or 'local position' that acknowledges the viewer's involvement in a process of reading an art object or installation. He suggests that this reading positions the work in relation to political, aesthetic, geographical, institutional and cultural contexts, all of which inform what the work can be said to mean. He argues that the meanings of such art installations, whether they are in conventional galleries or rural locations, involve some kind of '*working over*' in 'the production, definition and

performance of place'.[17] One of the examples which Kaye provides to illustrate this argument is a work by the Italian artist Michelangelo Pistoletto (b. 1933), *Le Stanze* (*The Rooms*), which comprised twelve consecutive installations that occupied the spaces of the Christian Stein Gallery in Turin between October 1975 and September 1976 (Plate 7.13). Pistoletto, who was one of the key figures in the Italian Arte Povera movement of the 1960s, has often used mirrors and Plexiglas to explore the roles of memory within gallery space (see Plate 7.14).[18] In Kaye's terms, the artist literally 'worked over' the spaces in *The Rooms* by placing mirrors in real doorways, especially in positions in which a sequence of doorways could be reflected. The galleries opened directly onto each other along the same axis, providing a sense of infinite recession. The effect was both odd and compelling, creating a confusion of real and mirrored space. Pistoletto accompanied each of the twelve installations with written notes explaining the work, providing an autobiographical documentation that helped the viewer to make sense of the project and directed his/her understanding (see Plate 7.15).

But how might we see this *activity* as a form of performance?

The Rooms was displayed as a series of activities in the gallery over a period of a year, with monthly changes. It was thus an on-going series of interventions in the gallery space, which could be experienced like a long performance. Pistoletto was exploring the roles of memory and anticipation, as each installation offered a challenge to memories of the gallery space and expectations of future installations, and invited the viewer to experience visual and spatial confusion. That experience might also be seen as part of the shared performance of the work. This raises again the problem of reproducibility; it is very difficult effectively to represent this series of installations through visual illustrations, which cannot capture the spatial and experiential nature of the work. In his written notes which accompanied the second installation, *The Rooms, Second Part*, Pistoletto explained this clearly, emphasising the need to experience such works in the gallery space over a period of time:

> my mirror pictures cannot be reproduced: that is, they cannot be transformed into other media, for that would mean the elimination of the dynamic which is their essential aspect. I feel the same is true for this exhibition of 'The Rooms'; the only proper medium for its documentation is the living eye which records it. The spectator moves forward with the light which floods in and which gets dimmer from room to room.[19]

Plate 7.13 Michelangelo Pistoletto, *Le Stanze* (*The Rooms*), 1975, installation at Christian Stein Gallery, Turin. Photo: courtesy of Cittadellarte – Fondazione Pistoletto, Biella. © Michelangelo Pistoletto.

Plate 7.14 Michelangelo Pistoletto, *Twenty-two Less Two*, 2009, performance, Italian pavilion, Venice Biennale. Photographed by Massimo Di Nonno. Photo: © Getty Images. © Michelangelo Pistoletto.

Michelangelo Pistoletto

The Rooms

October 1975 – September 1976

The idea of holding this exhibition came to me after seeing the three new rooms of the Stein Gallery in Turin last Spring.

The Rooms open directly into one another, along the same central axis, creating a perspective effect. The dimensions of the "doorways" are those of my mirror pictures (125x230 cm) and thus I imagined a mirror surface placed on the wall of the end room, as a virtual continuation of the series of openings from one room into the next.

Until I saw this new gallery, I had never found a reason for exhibiting a mirror surface alone, without any form of intervention on my part. In my mirror paintings there is one aspect which is constant: the relationship between the static image, as fixed by me, and the dynamic images of the mirroring process: in the case in point, the static image is pushed right up to the outer edges of the picture, whose perimeter represents the outline of the doorways which precede it physically and which continue in the reflection.

There are many things I could say about this work; for example, that it can not be transported elsewhere without relegating it again to the status of a mere mirror; that it "magnetizes" all the space within the gallery by immobilizing it (by virtue of the fact that the gallery immobilizes the mirror for the duration of the exhibition). I could go on to speak of the viewer, and formulate a hypothesis about the immobility by which he would find himself surrounded (even if he were to move) should he realize that his relationship with the phenomenon is only one of "registration".

For his point of view in relation to the picture is immaterial, in that each and every point of the three rooms has been considered in perspective. The particular point on which I should like to focus attention is the fact that there are three "doorways" which become seven through reflection. Only recently scientists discovered the law that all phenomena can be verified in mirror form, except one. Whenever we arrive at a discovery via the instruments of art, it is never microscopic or macroscopic, but always in a *human* dimension.

Plate 7.15 Michelangelo Pistoletto, *Notes to The Rooms, 1st document.* Courtesy of Cittadellarte – Fondazione Pistoletto, Biella. © Michelangelo Pistoletto.

What is place?

For both Pistoletto and Kaye, an idea of 'place' as the subject of art involves some kind of performance and interactive viewing experience. Perhaps you noted above that Kaye used the term 'performance of place'. 'Place' is yet another term, sometimes interchangeable with 'location', that is much used by artists and critics who are interested in site-specificity. Both these terms, 'location' and 'place', are often seen to imply more than a physical site, to involve something 'local'.[20] In the twenty-first century, 'location' has also acquired a range of meanings across many disciplines, but the term usually connotes the power or act of being located. It can signify a geographical, ethnic or cultural location. Moreover, in an era of a globalised migration and displacement, concepts of the 'local' can be disrupted, and the term can take on many political and emotionally charged meanings – for example, when migrant workers inhabit or believe they belong to a location (such as an urban area) from which they are subsequently evicted or removed. And art history has also used the term 'location' to designate the place where the art is made or displayed (such as a gallery), or even the original location of the artist.[21]

Similarly, the question 'what is place?' has engaged thinkers and artists for centuries; there is now an enormous literature from many disciplines, including anthropology, architecture, cultural geography, art history, art criticism, sociology, feminist studies and psychology, which explores the issue and the relationship of 'place' to 'space'.[22] The term 'place' is often used more loosely than 'location', and I have suggested above that the site becomes a particular kind of 'place' through artistic intervention and the viewer's interaction with it.

Plate 7.16 Robert Smithson, *A Tour of the Monuments of Passaic, New Jersey (The Fountain Monument)*, 1967, six photographs and one Photostat, dimensions variable. Collection: The Museum of Contemporary Art, Oslo, Norway. Photo: Robert Smithson. © Estate of Robert Smithson/DACS, London/VAGA, New York 2012. Courtesy James Cohan Gallery, New York/Shanghai.

The places that have featured so far in this chapter, apart from those in Smithson's *Partially Buried Woodshed* and Serra's *Tilted Arc*, have been largely gallery sites. We have looked at some of the ways in which site-specific installations have encouraged the viewer to critique or explore the nature and constraints of the gallery site. In the next section I want to explore some works in which a specific geographical place or landscape has been at the centre of an artistic project.

The term 'place' is often used to suggest a strong sense of local identity – albeit mediated through the perceptions and experiences of those who inhabit or represent that place. The British artists Tacita Dean and Jeremy

Deller have provided a useful short definition: 'One might say that "place" is to landscape as "identity" is to portraiture.'[23] An idea of place, then, has informed artworks which are concerned with local, regional or national issues and identities. Of course, a sense of place can be represented or denied for political, economic, social and environmental reasons. For example, national and nationalist movements often define themselves in relation to their accumulated local regions, their histories, geographies and cultural identities. People often fight to protect their local environments or places against the construction of international airports, motorways, high-speed rail links, oil fields or mines, the destruction of rain forests, and so on. By drawing on the

accumulated particularities and characteristics of a place, people can assert its social and personal meanings, thus countering the idea that it is nothing but a geographical site which can be offered up to the 'benefits' of various developers and investors.

As we shall see, artists who work with specific sites often build on such associations and local identities, reflecting on and layering the idea of the 'place' which first inspired their work. In fact, they may even use artistic devices to confuse or alienate a sense of place. For example, in 1967 Robert Smithson produced a series of photographs, which were published in the American magazine *Artforum*, called *A Tour of the Monuments of Passaic, New Jersey*. They consisted of photographs of buildings and other structures along the banks of the Passaic River, where a new motorway was under construction, accompanied by his commentary recounting his return to his birthplace in New Jersey. His commentary is deliberately descriptive and without nostalgia and the photographs appear alien and dislocated, thus undermining any sense of the

artist returning 'home' on an emotional voyage (see Plate 7.16).[24] The photographs and commentary are deployed rather as instruments which impose a distance between the viewer and places depicted.

An Icelandic place

Ideas of 'place', its geographical characteristics and particularities, and its potential to both engage and alienate the viewer, have featured prominently in the work of the contemporary American artist Roni Horn (b. 1955). With an early background in American Conceptual Art, Horn first visited Iceland as an American art graduate in 1975. Since then she has spent long periods living and working on the island, gathering material for her many photographic works, drawings, installations and artist's books, including her series *To Place* (see Plates 7.17 and 7.18). She could be seen as a paradigmatic travelling modern artist, living between international sites; she has appropriated Iceland as a second 'home' (she owns a house there) and her work has been intimately involved with the country's

Plate 7.17 Roni Horn, Untitled photograph, from *To Place*, Book 5: *Verne's Journey*, Cologne, Verlag der Buchhandlung Walter König, 1995. Photo: © Roni Horn Studio.

Plate 7.18 Roni Horn, Untitled photograph, from *To Place*, Book 5: *Verne's Journey*, Cologne, Verlag der Buchhandlung Walter König, 1995. Photo: © Roni Horn Studio.

landscape and meteorology.[25] Many of the photographic and lithographic works which make up the series *To Place* represent Icelandic motifs such as folds, lava, pools, glaciers and windswept tundra. Book 5 of the series, *Verne's Journey* (1995),[26] includes a series of images of spectacular rock formations, stormy waters and aerial photographs of the glacier Snæfellsjökull where Jules Verne began his famous descent into a volcanic crater in his *Journey to the Centre of the Earth*. Verne's nineteenth-century science-fiction work uses the Icelandic glacier as a framing landscape and metaphor for his psychological and metaphysical quest. In this context, place takes on geographical and metaphorical meanings beyond the physical site.

Horn's later project *Vatnasafn/Library of Water* (2007), in the harbour town of Stykkishólmur on the western Icelandic coast, provides an example of installation art in which an idea of 'place' is explored as a source

of aesthetic, geographical, geological, cultural and even environmental concerns. Commissioned by the London-based arts organisation Artangel, *Library of Water* (Plates 7.19 and 7.20) was constructed in the former library of Stykkishólmur and conceived as a permanent sculpture installation, a community arts centre and an on-going weather archive including a published book titled *Weather Reports You*.[27] Echoing several works we have already explored, including Pistoletto's *The Rooms* and Smithson's *Tour of the Monuments of Passaic*, Horn has included an artist's commentary as part of the installation; she has also incorporated a weather archive collected through local memories. Placed on a rocky mound at one of the highest points of the town overlooking the western fjords, *Library of Water* is replete with nautical metaphors. The building appears to ride the weather and the waves; its rounded art deco windows suggest a glass cabin at the top of a lighthouse, echoing a recurring theme in her work. Lighthouses are dotted

Plate 7.19 Roni Horn, *Vatnasafn/Library of Water*, 2007. Stykkishólmur, Iceland. Commissioned and produced by Artangel. Photographed by Stefan Altenburger, courtesy of Artangel.

Plate 7.20 Roni Horn, *Vatnasafn/Library of Water,* 2007. Stykkishólmur, Iceland. Commissioned and produced by Artangel. Photo: © Gill Perry.

all around the rugged Icelandic coast; they are seen as symbols of both the tempestuous climate and a seafaring nation, of local character – or 'place'.

Dispersed around the main room of the library are twenty-four glass columns, each 30 cm in diameter, containing water collected from each of Iceland's major glaciers (Plates 7.21 and 7.22); the nearest, Snæfellsjökull,

is a twenty-minute drive south – weather permitting. These watery columns have replaced the stacks of books, reflecting light, landscapes and human figures – sometimes in blurred and clouded form. Horn's installation has been compared to a reflective lens which encourages metaphorical musings on identity, climate, ecology and place. Mineral deposits have made some columns opaque, while others reflect clearly

Plate 7.21 Roni Horn, *Vatnasafn/Library of Water*, 2007, view of installation with glass columns. Stykkishólmur, Iceland. Commissioned and produced by Artangel. Photographed by Stefan Altenburger, courtesy of Artangel.

Plate 7.22 Roni Horn, *Water, Selected – Archive of Water, 24 Sources of Glacial Water* (limited edition), 2007. Photo: courtesy of Artangel.

Plate 7.23 Roni Horn, *Vatnasafn/Library of Water*, 2007, view of floor. Stykkishólmur, Iceland. Commissioned and produced by Artangel. Photographed by Stefan Altenburger, courtesy of Artangel.

defined landscapes from outside the space, reversed like mirror images. As the deposits have settled, tiny piles of sediment have formed at the bases of the tubes, combining miniaturised landscapes with reflected ones. From some angles, even the lichen on the volcanic rock of the mound is imaged through the glass sculptures, seeming to embrace the local environment within the installation.

Lichen can be an indicator of a lack of environmental pollution, an issue which Horn references obliquely in this work. The Icelandic air is so pure that the Kyoto Protocol gave Iceland permission to increase its carbon emissions by 10 per cent from 1990 levels. Many controversial geothermal and hydroelectric power plants have been established, along with several new aluminium smelters owned by global corporations such as Alcoa, that have been allowed to emit an extra 1.6 million metric tons of carbon dioxide until 2012. Meanwhile, the smallest glacier is now all but gone,

and others are visibly shrinking. And, according to the many local testimonies compiled and edited in Horn's book, *Weather Reports You*, and on her on-going website, the weather is changing and winters are now milder.[28] The dramatic range of Icelandic weather conditions, its seasonal contrasts of light and dark, and its devastating effects are vividly reported here, including tragic accounts of family members lost at sea or nearly frozen to death in storms or avalanches. This close relationship between weather and Icelandic life is also suggested by the floor; embedded in the rubber floor is a field of English and Icelandic adjectives which are used to describe the weather, reminding the viewer of the slippery connections between words, images and meanings. English words which evoke both weather and human emotions, such as 'oppressive', 'gloomy', 'dull' and 'frosty', are scattered among their Icelandic equivalents (Plate 7.23). Horn invites the viewer to see both water and weather as signifiers of place and identity; the columns can be read on many levels – as

melted glaciers, reflective lenses, ecological weather vanes and aesthetic sculptures.

While many Icelandic artists have migrated south, Horn has headed north. She is aware that, as a travelling artist, her engagement with Iceland is partly that of a 'tourist'. Of course, the tourist is always in danger of exoticising an alien culture, of romanticising and aestheticising its 'otherness'. Thus, Jules Verne's fictional journey helped to establish a discourse of the awesome, exotic, other-worldliness of Iceland, and there is no doubt that Horn was impressed with the spectacular aesthetic possibilities of the Icelandic landscape. But her project also raises some recent concerns with the fluidity of 'location', with the idea that site-specific works can carry meanings and resonances which go beyond the specific place in which they are sited.[29] She describes herself as a 'permanent tourist', an oxymoron which allows her to comment on and embrace this landscape and its culture, while also maintaining a certain distance. The increasingly global, geopolitical transformations of the contemporary art world and its relentless pursuit of international art fairs and corporate capital need not necessarily be directly conflated with the migratory patterns and hybrid aesthetic concerns of some of its 'travelling' artists. Some artists have exploited their nomadic lives and aesthetic interests to give an international stage to local concerns. Horn's work could be interpreted as a form of critical interplay between artistic interests developed initially within American Conceptual Art, but reworked and refocused through her engagement with the culture and geography of Iceland. As an art object and archive, *Library of Water* has a profound local relevance, but also signals global concerns.

Library of Water could be seen as a project which invites both an aesthetic encounter and a reflective cultural and ecological engagement. It could be seen as a modern *Gesamtkunstwerk* (total artwork) relevant to a local *and* global audience. Moreover, this is also a work which involves two different sorts of involvement from the viewer. First, the spectator is invited to engage physically with the installation (you are even asked to take your shoes off or wear protective plastic covers over them!), to move within and around the columns, reflect on their content, and respond to building as a whole. Second, *Library of Water* is also a collaborative or 'participatory' project. The weather archive involves the participation of local people who have contributed their memories, and who are involved with on-going community projects staged at the *Library*.

There's no place like home

Central to any exploration of ideas of 'place' or 'location' is the theme of the house or home. You saw in chapter 4 that, while the word 'house' is often used to describe the architectural or spatial structure, 'home' is generally used to designate the inhabited house. As a dwelling and a place replete with literal and metaphorical associations with family life and its traces, with gendered and class identities, with social status, and with being located in a community, the theme of the home is ubiquitous in modern visual, literary and popular culture. It has often been deployed in installation art of the last few decades. We saw earlier that in his *Tropicália* Oiticica evoked the idea of the Brazilian *favela*, with all its associations of slum dwelling and social deprivation. In recent British art, a series of ambitious installations have explored the theme of the house as a residue of intimate family traces, including the famous *House* by Rachel Whiteread (b. 1963), a negative cast of 193 Grove Road in East London, and *Semi-Detached* by Michael Landy (b. 1963), a life-size reconstruction of the artist's home in Ilford, Essex, that was installed in the Duveen Galleries of Tate Britain (see Plates 7.24 and 7.25). Both were temporary works demolished after several months, and both generated controversies about their respective value as 'works of art'. Whiteread was the first woman to win the annual British art award the Turner Prize, in 1994, and her success was part of the increasing visibility of women artists working in this large-scale, sculptural genre. Until the last few decades, a high percentage of the major installation projects in Europe and the USA had been made by male artists. Improved educational and cultural opportunities for women artists over the last 30 years or so have enabled their increasing engagement with ambitious and expensive installation projects. Whiteread and Salcedo are just two of many successful women artists (who might also include Louise Bourgeois (1911–2010), Judy Chicago and Mona Hatoum (b. 1952)) who have explored the home and its domestic associations in spectacular, large-scale installations.

The motif of the house or home has also been used by some international installation artists to explore related issues of migration, identity and cultural difference. The Korean-born artist Do Ho Suh (b. 1962), often described as an 'itinerant' artist, is renowned for a series of installation works which evoke his own hybrid and nomadic experiences of 'home'. Born in Seoul, South Korea, in 1962, he studied in the USA and now lives in both Seoul and New York, and long-distance

Plate 7.24 Rachel Whiteread, *House*, 25 October 1993 – 11 January 1994, Lokrete with metal armature, Grove Road, London, E3. Commissioned and produced by Artangel. Photo: courtesy of Artangel.

Plate 7.25 Michael Landy, *Semi-Detached* (front view), 16 May – 12 December 2004, mixed media with video, Duveen Galleries, Tate Britain, London M00843. Photo: © Tate, London, 2012. Used with permission of the artist.

travel is a part of his life. His *Seoul Home/L.A. Home/ New York Home/Baltimore Home/London Home/Seattle Home* and *The Perfect Home* use diaphanous fabrics such as silk or nylon to produce full-scale replicas of various spaces or buildings which have featured in his itinerant life (Plates 7.26 and 7.27). Although both

Plate 7.26 Do Ho Suh, *Seoul Home/L.A. Home/New York Home/Baltimore Home/London Home/Seattle Home,* 1999, silk, aluminium frame, 379 × 610 × 610 cm, installation view at the Korean Cultural Center, Los Angeles. © Do Ho Suh, 1999.

Plate 7.27 Do Ho Suh, *The Perfect Home*, 2002, nylon, silk, stainless steel structure, 3 parts: 149 × 240 × 240 cm, installation view at the Kemper Museum of Contemporary Art, Kansas City. © Do Ho Suh, 2002.

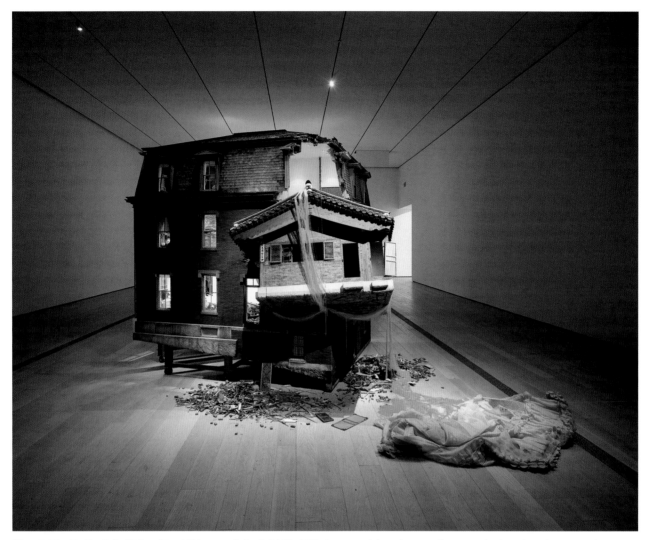

Plate 7.28 Do Ho Suh, *Fallen Star 1/5* (external view), 2008, ABS, basswood, beech, ceramic, enamel paint, glass, honeycomb board, lacquer paint, latex paint, LED lights, pinewood, plywood, resin, spruce, styrene, polycarbonate sheets and PVC sheets, 333 × 368 × 762 cm. © Do Ho Suh, 2008–2011.

are based on familiar architectural structures, they also involve miles of complex sewing, referencing a skilled occupation from his native Korea. While the former translates the recognisable shapes of an ornate Korean façade into a ghostly, fragile form, *The Perfect Home* (which was exhibited in the Serpentine Gallery, London in 2002) transforms the details of his New York apartment, including some of the furniture, into an ethereal, drooping space. Such delicate, diaphanous works can draw attention to the contrasting solidity and relative architectural permanence of the gallery spaces and institutions which frame and enclose them. Much like the installations discussed earlier, these works invite the spectator to move around the spaces and experience them physically. For me, these ethereal 'homes' also suggest both a confusion of cultural memories and references, and a sense of impermanence, showing us how an artist's practices can be directly informed by his/ her international career. The material structures are odd

and alienating; for example, in *The Perfect Home*, the familiar New York window frames appear to be hanging aimlessly, as if in a dream. Such works could be seen to complicate any clear sense of the national, geographical and ethnic identity of the artist.

In 2008, Suh produced another work on the theme of the home, which suggests a less comfortable, more violent conflict between cultures. His *Fallen Star 1/5* (Plates 7.28 and 7.29) is a 1/5 scale model of the artist's Korean childhood home crashing into the side of a four-storey apartment block in Providence, Rhode Island, where the artist lived when he studied at the Rhode Island School of Design. This was his first home in the USA, and the installation presents this experience as a crash scene, using colliding homes to suggest a disturbing cultural experience of uprooting and moving to the USA. This work depicts all the debris of a violent impact – broken brickwork, tiles, rafters, plaster, dust and general debris.

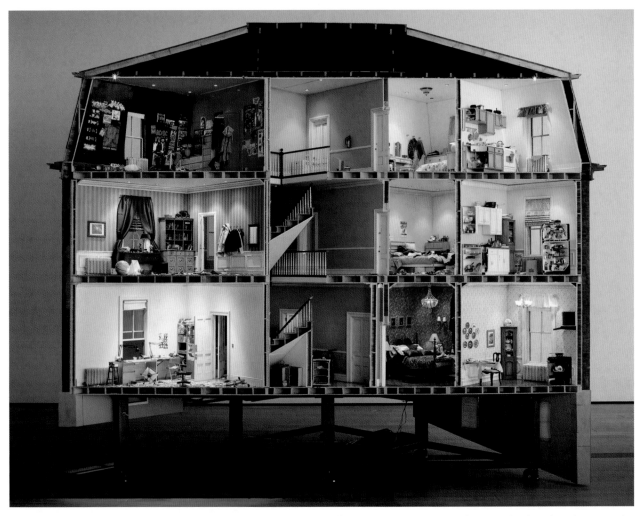

Plate 7.29 Do Ho Suh, *Fallen Star 1/5* (cross-sectional view), 2008, ABS, basswood, beech, ceramic, enamel paint, glass, honeycomb board, lacquer paint, latex paint, LED lights, pinewood, plywood, resin, spruce, styrene, polycarbonate sheets and PVC sheets, 333 × 368 × 762 cm. © Do Ho Suh, 2008–2011.

As such, it might be seen as a rather literal representation of cultural displacement. But, when viewed in the gallery space, the work looks like a slightly over-sized dolls' house, and has a playful element; the Rhode Island house has been dissected much like a dolls' house, encouraging a voyeuristic fascination with the frozen domestic activities and damage in each room. Miwon Kwon has suggested a filmic rather than an architectural inspiration for this scene: 'Not only does Suh's flying house recall the Hollywood rendition of Dorothy's airborne house in the *Wizard of Oz*, the work looks like a film set whose artificiality and unreal-reality is waiting to "come to life".'[30] This is an example of installation art which draws on other media and a variety of cultural references that embellish the key theme of cultural displacement. It suggests both the dislocations of Suh's itinerant life and also the playful and aesthetic potential of the theme of home as a metaphor for belonging.

4 Crossing borders

So far, we have discussed the ways in which artists have explored issues of site-specificity, location and place in installation art. Some of those artists have acquired reputations as 'global nomads' (Gonzalez-Torres, Salcedo, Horn and Suh) who have lived and worked in different international locations, although their installations may engage with issues which are relevant to specific places.[31] Since the 1980s, most successful artists are regularly invited to participate in international biennials and gallery exhibitions, increasing the need (as we have seen) to create site-specific works which can somehow be moved between gallery locations. Artists regularly find themselves moving around the world following major exhibitions that feature their work, a development that can be seen as one aspect of a *globalised* art culture, and that will be discussed in more detail in the next chapter. But

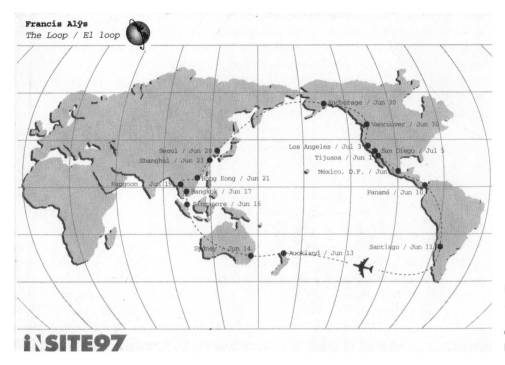

Plate 7.30 Francis Alÿs, *The Loop, Tijuana – San Diego*, 1997, ephemera of an action. Courtesy David Zwirner, New York.

In order to go from Tijuana to San Diego without crossing the Mexico/USA border, I will follow a perpendicular route away from the fence and circumnavigate the globe heading 67° SE, NE, and SE again until meeting my departure point.
The items generated by the journey will attest to the fulfillment of the task. The project will remain free and clear of all critical implications beyond the physical displacement of the artist.

Para viajar de Tijuana a San Diego sin cruzar la frontera entre México y los Estados Unidos, tomaré una ruta perpendicular a la barda divisoria. Desplazándome 67° SE, luego hacia el NE y de nuevo hacia el SE, circunnavegaré la Tierra hasta llegar al punto de partida.
Los objetos generados por el viaje darán fe de la realización del proyecto, mismo que quedará libre de cualquier contenido crítico más allá del desplazamiento físico del artista.

Plate 7.31 Francis Alÿs, *The Loop, Tijuana – San Diego*, 1997, ephemera of an action, postcard. Courtesy David Zwirner, New York.

this very process has encouraged some artists to reflect critically on the whole idea of 'free' international travel and open borders, often heralded as a characteristic of modern globalisation. In this final section, I look at some recent works that are directly engaged with the idea of geographical and cultural borders that might be less easy to cross.

The Belgian artist Francis Alÿs (b. 1959), who now works mainly in a studio in the centre of Mexico City, has made a series of works since the 1990s which invite the spectator to reflect on this theme of global tourism, and the possible role of artistic intervention. Although many of his works are performances enacted through time rather than installations, they are usually performed in specific sites from which they derive

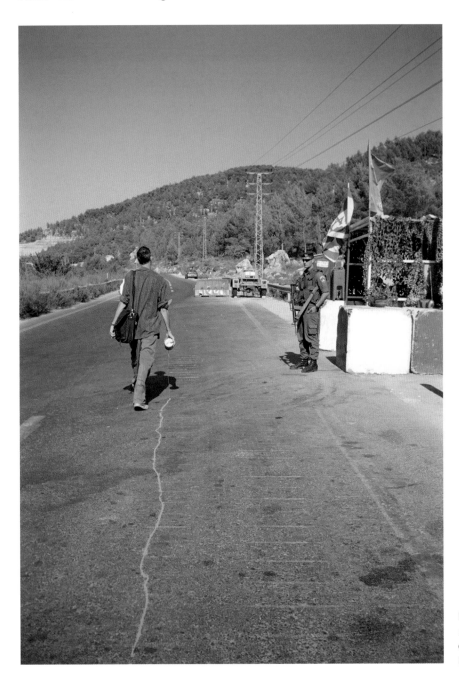

Plate 7.32 Francis Alÿs, *The Green Line, Jerusalem*, 2004, video documentation of an action. Courtesy David Zwirner, New York.

much of their meaning. In 1997, Alÿs was invited to contribute to the biennial 'InSite' held between Tijuana and San Diego on either side of the Mexico/US border. Recognising that Americans and art-world tourists could easily cross the border to visit the Mexican site, while Mexicans were subject to strict American immigration controls, he constructed a mischievous plan to go between the two exhibition sites without crossing the Mexico/US border, titled *The Loop* (Plates 7.30 and 7.31). He used his fee to travel from Mexico south through Central America, crossed the Pacific Rim, continued up through China and Russia, and then back through Canada into America. This was an absurd, playful response which drew attention to the

politics that surround the issue of border crossings, and by implication public access to site-specific art.

Perhaps some of the most contested modern borders are those which have separated the state of Israel from its neighbours and, more specifically, which have divided and diminished the Palestinian-inhabited territories. The armistice border, separating Israel and Jordan, was drawn in 1947 and called 'the green line'. But after the Six Day War in 1967, the Israelis occupied the Palestinian territories east of the line. In 2004, Alÿs made a work in Jerusalem, *The Green Line*, in which he walked along the original armistice line, trailing green paint. This walk was filmed (see Plates 7.32 and 7.33)

and accompanied by voices of commentators from Israel, Palestine and other countries who expressed differing political opinions on his walk. *The Green Line*, which also splashes over his shoes and clothes as he walks, avoids a dogmatic statement, but rather revives the memory of an earlier partition, framed by the different perceptions of individuals who reflect on the Middle East conflict.

Although this work is primarily a performance recorded on video, it left a physical trace in the form of a drippy, wiggly green line which runs the length of the original border. This hardly constitutes an installation, but it reminds us that the recent art of the expanded field is often hard to categorise clearly, and may sometimes hover between genres and media. Such artworks also remind us that national borders are not merely geographical lines drawn onto maps, but are politically and culturally contested boundaries, often rich in historical and military histories. Alÿs's apparently playful aesthetic strategies can encourage us to think critically about such borders.

A modern work on the theme of European borders which combines different media, but was installed in a gallery space, was produced by the Polish artist Krzysztof Wodiczko (b. 1943) for the Polish pavilion of the 2009 Venice Biennale. Titled *Guests*, this work involved a series of nine projections on three of the pavilion's windowless walls and ceiling. The projections each show semicircular windows behind which immigrants are caught walking, working, chatting on mobile phones, exchanging remarks on their problems seeking legal status, and even cleaning windows (see Plate 7.34). Wodiczko filmed meetings with and between actual immigrants from a wide range of countries, including Bangladesh, Chechnya, Vietnam, Romania, Sri Lanka, Pakistan, Morocco, Libya and the Ukraine, seeking legal status in Poland and Italy. Among the many conversations in different languages which can be heard in translation (through headphones), a Moroccan worker complains about the prejudices of the 'backward' Italians, a confused Libyan who has been imprisoned in Brussels and is seeking asylum in Poland expresses despair and incomprehension of the procedures, and a 'Yugoslav' immigrant expresses exasperation about the lack of rights and restricted access to education for Romani children in Italy. The scenes take place behind milk glass, thus blurring the identity of the individuals and the nature of the activities depicted, and giving them a strange, ghostly quality.

Plate 7.33 Francis Alÿs, *The Green Line, Jerusalem*, 2004, video documentation of an action. Courtesy David Zwirner, New York.

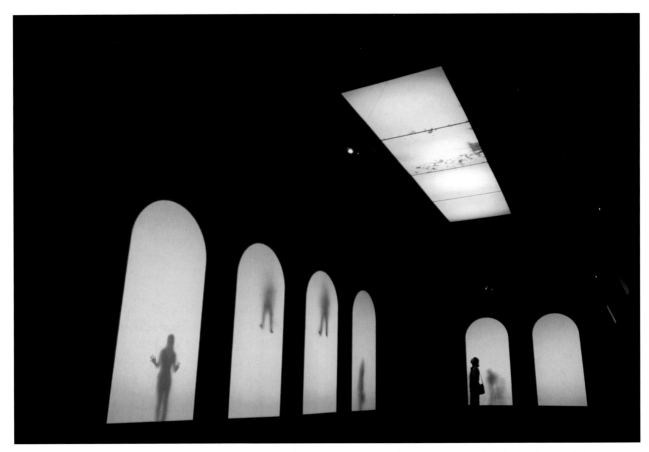

Plate 7.34 Krzysztof Wodiczko, *Guests*, 2009, five synchronised video projectors with sound system, Polish pavilion, 53rd Venice Biennale, Venice. © Krzysztof Wodiczko. Courtesy of Galerie Lelong, New York.

The artist was drawing on techniques developed in some previous installations which deployed similarly blurred projected images of immigrant figures that appear half hidden, or somehow on the other side. In 2005, he installed *If You See Something* at the Galerie Lelong, New York, consisting of four video projections of vertical windows behind which groups of immigrants discuss harassment and traumatic experiences in the wake of Bush's so-called war on terror. It addressed the media campaign begun by the Metropolitan Transit Authority (MTA) that placed posters and public announcements in New York's transport system encouraging citizens who 'see something' to 'say something'. Dora Apel has argued that this 'project addresses the effects of contemporary war culture and the incursion of the heightened power of the state into every kind of domestic or homeland space, creating a perpetual state of hyper-vigilance in which the "homeland" is always already mobilised for war'.[32] In the light of our earlier discussion of notions of 'place', Apel's use of the idea of 'homeland space' is pertinent; the 'homeland' which signifies belonging, security and national identity is perceived to be under threat. New York has become a 'place' which is apparently under siege and in danger of losing its cultural identity.

Both these works transformed the respective galleries into dark, cinematic spaces in which the viewer is invited to move between different projections, eavesdropping on the conversations taking place (through sound in the gallery and recordings available in translation), yet distanced from them by the blurred, ambiguous images within each frame.

Exercise

From the information about and image of the installation provided above, how do you think *Guests* explores the ideas of migration and borders discussed in this chapter?

Discussion

Although I have only mentioned a small selection of conversations, which does not give you the full range of voices that form part of the installation, they enable you to see the multimedia character of

Guests. I have also only been able to provide a frozen image of a filmed sequence that cannot, of course, adequately reproduce the experience of viewing this work through time.

The voices are speaking simultaneously, creating a confusion of sounds in different languages, as different activities are taking place, and producing what has been called the 'polyphonic' structure of the installation. The milky, semicircular windows form the barriers between ourselves and the phantom-like 'guests' depicted, and it is sometimes difficult to make out exactly what is going on behind those imaginary window arches, reinforcing the sense that these immigrants are often socially invisible; they are perpetual 'guests' or visitors. For me, the darkened space of the pavilion and arched rows of projections suggest the hidden spaces under urban railway bridges or flyovers, where marginalised groups often gather. We are also provided with some very personal narratives telling us about the varied experiences of individuals seeking legal status as European Union (EU) citizens. Although focused on different nationalities seeking legal status in Poland and Italy, they provide evidence of the range of social issues involved – from cultural prejudice and the plight of the Romani people to the restrictive bureaucracy which inhibits and delays the provision of visas. Produced at a time when the EU member states were increasingly seeking to seal their borders and control immigration from outside the union (as they still are), this work speaks directly to contemporary political issues.

Wodiczko has explained that he intended the work to engage with those international problems of migration which have been accentuated over recent years through the expansion of Europe and the global economic situation. The EU has expanded to include many former 'Eastern bloc' countries, opening up new opportunities for employment outside national borders, and creating different modes of 'border crossing'. This process has been characterised by many challenges and problems, including questionings of the function of the EU itself. As Ewa Lajer-Burcharth has written: 'One can say that the border has become a place where the major difficulties and challenges faced by the "new" Europe are concentrated, a place that has at once posed and represented these problems in an exacerbated form.

How should the borders of the European Community be (re)defined?'[33]

Borders have different meanings for different people; they help to structure identities and people's sense of who they are and where they belong. For those international travelling artists and art-world punters, the Venice Biennale is structured around supposedly 'open' borders – a global collection of national pavilions assembled in the Giardini, the gardens of Venice. *Guests* raises some of the contradictions inherent in the idea of a borderless, international Biennale. While visitors to the Polish pavilion have experienced the 'open' borders of this major Italian art event, the shadowy phantoms inside are restricted and rendered invisible by borders which are less easily crossed.[34]

Conclusion

Thinking back to our earlier discussion of the key characteristics of installation art, *Guests* is certainly a work which invites the involvement of the spectator to look, listen and move around the space, attending to each conversation or activity depicted. It also demonstrates the hybrid or multimedia nature of many installation works of the so-called expanded field of the last few decades. And by exploring ideas of border crossings, especially into Italy, it engages (directly and indirectly) with the site or location – in this case a national pavilion within the Venice Biennale – inviting the spectator to reflect on pressing social issues of migration within an art fair which claims to be international. Such works can encourage us to reflect on modern processes of transnational and transcultural exchange and the ways in which we engage with the world and with communities that are very different from our own.[35] Along with the earlier works of Oiticica, and more recent projects by Salcedo, Horn and Alÿs, *Guests* provides an example of installation art that is designed to encourage a critical awareness of social and political contexts. By placing the viewer *in* the work, installation art can encourage us to reflect on our changing relationships with both the material objects on display, and with our broader cultural environment.

Notes

[1] The precise nature of *Tropicália*'s relationship with these *favelas* has been the subject of some art-historical debate. For a useful account of *Tropicália* and some of these debates, see Brett and Figueiredo, 2007.

[2] The art historian and critic Rosalind Krauss explored the meaning of the term 'expanded field' in her 1979 essay 'Sculpture in the expanded field', reprinted in Krauss, 1988.

[3] Foster, 2006, p. 192.

[4] Bishop, 2005, p. 6. Julie Reiss has also emphasised this aspect; see Reiss, 1999. For a concise introduction to installation art and its origins, see also Stiles, 2004.

[5] Iversen, Crimp and Bhabha, 1997, p. 29; see also Kelly, 1996.

[6] For a useful account of this work and Oiticica's associated ideas, see Brett and Figueiredo, 2007, and Bishop, 2005, pp. 107–10.

[7] Marcuse, 1969 [1965]).

[8] Ibid., p. 107.

[9] Brett, 2007, n.p.

[10] Cited in ibid., n.p.

[11] Kwon, 2002, p. 11.

[12] Information about the artist's recommendations can be found on the Guggenheim Gallery website, and in an essay by Spector, 2001.

[13] Although initial visitor figures were projected at around 2–3,000,000 per year, Tate Modern now enjoys numbers closer to 5,000,000.

[14] Smithson wrote that 'the site has no seeming limits, but the Non-Site points to the site. In a sense the Non-Site, although it points to it, effaces this particular region', in Flam, 1996, p. 198.

[15] This comment has been much quoted by art historians and critics. See, for example, Deutsche, 1996, p. xi, and Kwon, 2002, p. 12.

[16] Serra, 1994 [1989], p. 193.

[17] Kaye, 2000, p. 3.

[18] Arte Povera was an Italian movement of the 1960s and 1970s. The term was used to describe an open-ended experimentation with materials and processes, and the artists involved (including Pistoletto, Alighiero Boetti, Jannis Kounellis, Mario Merz and Gilberto Zorio) explored the context of art making itself and the space of the gallery.

[19] Pistoletto, n.d., p. 1.

[20] These issues are explored in Lippard, 1997.

[21] A useful discussion of the term 'location' and its 'deep presence in the arts' can be found in Cherry and Cullen, 2006.

[22] One of the famous philosophers to address this issue is Michel de Certeau, who wrote: '*space is a practice place*. Thus the street geometrically defined by urban planning is transformed into a space by walkers' – de Certeau, 1984, p. 117.

[23] Dean and Deller, 2005, p. 12.

[24] Flam, 1996, pp. 68–74.

[25] Keynote speech, Reykjavik, 2006, in Horn, 2007a, p. 108.

[26] Horn, 1995.

[27] Horn, 2007b.

[28] Arni Helgason (born in 1914) claims that 'Winters always come here until two or three years ago. And now you can travel wherever you like, there's really no snowfall'; cited in Horn 2007b, p. 49.

[29] Some recent issues and debates around the concept of location are usefully explored in the *Art History* special issue *Location*; see *Art History*, 2006.

[30] Kwon, 2008, p. 148.

[31] I am using the term 'global nomads' in a broad sense to describe the peripatetic and global movements and locations of many contemporary artists. A more theoretical notion of modern 'nomadology' to describe the movements of minorities subject to modern global pressures has been developed by the philosophers Gilles Deleuze and Félix Guattari; see, for example, Deleuze and Guattari, 1986.

[32] Apel, 2008, p. 267.

[33] Lajer-Burcharth, 2009, p. 33. The book in which this appears (*Krzysztof Wodiczko: Guests*) contains several useful articles on Wodiczko's work and an interview with the artist about *Guests*.

[34] The issues of how migration and contested borders have been represented in visual culture, and some of the geographical and political problems involved, are explored in Rogoff, 2000.

[35] Some of these issues of transcultural exchange have been usefully explored in Meskimmon, 2010.

Bibliography

Apel, D. (2008) 'Technologies of war, media and dissent in the post 9/11 work of Krzysztof Wodiczko', *Oxford Art Journal*, vol. 31, no. 2, pp. 261–80.

Art History (2006) *Location*, special issue, *Art History*, vol. 29, no. 4.

Bishop, C. (2005) *Installation Art: A Critical History*, London, Tate Publishing.

Brett, G. (2007) 'Hélio Oiticica', *Tate Papers* [online], http://www.tate.org.uk/research/tateresearch/tatepapers/07autumn/brett.htm (Accessed 20 March 2012).

Brett, G. and Figueiredo, L. (2007) *Oiticica in London*, London, Tate Publishing.

Cherry, D. and Cullen, F. (2006) 'On location', *Art History*, vol. 29, no. 4, pp. 533–9.

de Certeau, M. (1984) *The Practice of Everyday Life*, Los Angeles, CA, University of California Press.

Dean, T. and Deller, J. (2005) *Place (Artworks)*, London, Thames & Hudson.

Deleuze, G. and Guattari, F. (1986) *Nomadology: The War Machine*, New York, Semiotext(e).

Deutsche, R. (1996) *Evictions: Art and Spatial Politics*, Cambridge, MA, MIT Press.

Flam, J. (ed.) (1996) *Robert Smithson: The Collected Writings*, Berkeley, CA, University of California Press.

Foster, H. (2006) 'Chat rooms, 2004' in Bishop, C. (ed.) *Participation*, London, Whitechapel/MIT Press, pp. 190–5.

Horn, R. (1995) *To Place*, Book 5: *Verne's Journey*, Cologne, Verlag der Buchhandlung Walther König.

Horn, R. (2007a) *My Oz*, Reykjavik, Listasafn Reykjavik Art Museum.

Horn, R. (2007b) *Weather Reports You*, London and Gottingen, Artangel/Steidl.

Iversen, M., Crimp, D. and Bhabha, H. (1997) *Mary Kelly*, London, Phaidon Press.

Kaye, N. (2000) *Site-Specific Art: Performance, Place and Documentation*, London and New York, Routledge.

Kelly, M. (1996) *Imaging Desire*, Cambridge, MA, MIT Press.

Krauss, R. (1988) 'Sculpture in the expanded field' in *The Originality of the Avant-Garde and Other Modernist Myths*, Cambridge, MA and London, MIT Press, pp. 276–90.

Kwon, M. (2002) *One Place After Another: Site Specific Art and Locational Identity*, Cambridge, MA, MIT Press.

Kwon, M. (2008) 'Do-Ho Suh' in Rugoff, R. (ed.) *Psycho Buildings: Artists' Take on Architecture*, London, Hayward Gallery, pp. 146–9.

Lajer-Burcharth, E. (2009) 'Borders' in *Krzysztof Wodiczko: Guests*, Venice, Charta, pp. 32–43.

Lippard, L. (1997) *The Lure of the Local: Senses of Place in a Multicentered Society*, New York, New Press.

Marcuse, H. (1969 [1965]) 'Repressive tolerance' in Wolff, R.P., Moore, B. Jr and Marcuse, H. (eds) *A Critique of Pure Tolerance*, Boston, MA, Beacon Press, pp. 95–137.

Meskimmon, M. (2010) *Contemporary Art and the Cosmopolitan Imagination*, London, Routledge.

Pistoletto, M. (n.d.) '*The Rooms*: October 1975 – September 1976' [online], http://www.pistoletto.it/eng/testi/the_rooms.pdf (Accessed 2 April 2012).

Reiss, J. (1999) *From Margin to Center: The Spaces of Installation Art*, Cambridge, MA, MIT Press.

Rogoff, I. (2000) *Terra Infirma*: *Geography's Visual Culture*, London, Routledge.

Serra, R. (1994 [1989]) '*Tilted Arc* destroyed' in *Writings/Interviews*, Chicago, IL, University of Chicago Press, pp. 193–213.

Spector, N. (2001) *Guggenheim Museum Collection: A to Z*, New York, Guggenheim Museum Publications.

Stiles, K. (2004) 'I/eye/oculus: performance, installation and video' in Perry, G. and Wood, P. (eds) *Themes in Contemporary Art*, London and Newhaven, CT, Yale University Press, in association with The Open University, pp. 186–213.

Chapter 8

Global dissensus: art and contemporary capitalism

Gail Day and Steve Edwards

Introduction

Art history has long associated modern art with a few western centres: Paris before the Second World War (with Berlin and Moscow coming to prominence in the 1920s and 1930s); New York for a period after 1945. Of course, there were always exceptions to this rule, and art historians have been paying increasing attention to them, but in the last twenty years this concentration on particular artistic hubs has changed markedly and the art scene has become increasingly global. This phenomenon is frequently linked to the spread of art biennials – large-scale exhibitions showing the work of dozens, and sometimes hundreds, of artists – often requiring of their visitors commitment over several days and international travel.[1] For example, the 2006 Singapore Biennial boasted '95 artists from over 38 countries'.[2] The art displayed in some recent biennials provides the framework for this chapter. First, we explore the changing conditions underpinning the international exhibition culture; in the remainder of the chapter, we consider two prominent modes of art practised today: relational practices and realism.

Plate 8.1 (Facing page) Ursula Biemann/Angela Sanders, still from *Europlex* (detail from Plate 8.26).

Plate 8.2 Freee, *The Aesthetic Function of Public Art*, Ponte dei Barcaroli, Venice, Venice Biennale, 2005. Photo: courtesy of Freee.

1 Biennials and politics

Biennials are not just show places for art; they are also economic and political events. They are used to regenerate declining centres of manufacture and to raise the profile of a city in order to compete for international tourism and investment. The exhibits can be mobilised to support this agenda; a process decried by the artist-collective Freee in their contribution to the 2005 Venice Biennale (see Plate 8.2). By drawing visitors for cutting-edge art, such events add lustre to local and state administrations, claiming, for a politically defined territory, intellectual openness and modernity. Take, for example, the Istanbul Biennial, where the agenda is palpable. Turkey's bid to join the European Union has been hampered by its record on human rights and its treatment of oppositional and minority groups; Istanbul's biennial, in contrast, presents a face of tolerance towards critical opinions.

The most longstanding and prestigious of these events have less overt agendas, but they too embody social and political claims. The Venice Biennale dates back to 1895, when it was instigated as a festival of Italian art with invited foreign representatives. From 1907, national pavilions began to appear, the first five reflecting the leading imperial powers of the time: Belgium (1907), Hungary (1909), Germany (1909), Great Britain (1909), France (1912) and Russia (1914) (see Plate 8.3). As host, Italy claimed its place in this company by building on its artistic heritage. In 1930, under fascist rule, the Biennale passed from municipal to state control. In 2003, it became an independent foundation open to private investment. It has continued to expand, with the 2011 Biennale involving representatives from 89 countries and attracting an estimated 440,000 visitors. National

PIANTA TOPOGRAFICA DELL'ESPOSIZIONE

Plate 8.3 Layout of Giardini, *La Biennale di Venezia: storia e statistiche, con l'indice generale degli artisti expositori dal 1895 al 1932*, Venice, Officio stampa dell'esposizione, 1932, frontispiece. Photo: courtesy ASAC, Venice Biennale.

competition is at the heart of the Biennale. While new national pavilions have been added, the hierarchy remains: the venues visitors pay to enter are based at the original core of the Giardini di Castello.

Over half a century old, Documenta, which is held every five years in the German city of Kassel, was conceived as part of the post-war reconstruction of Europe; specifically, 'to reconcile German public life with international modernity and also confront it with its own failed Enlightenment'.[3] That is to say, the focus

on international modern art was intended to counteract a national tradition which had fed Nazi race ideologies. Opening in 1955 with an exhibition of the works of modernism categorised as 'degenerate' under the Nazi regime, and receiving 155,000 visitors, Documenta also served as a beacon of western values sited close to the border with East Germany. Since 1968, Documenta has focused on contemporary art. Documenta 13 (2012) included works by 150 artists from 55 countries and received 860,000 visitors. Other longstanding exhibitions include the Whitney Biennial (New York),

Plate 8.4 Andreas Gursky, *New York Mercantile Exchange*, 1999, C-print, 180 × 240 × 6 cm. Copyright: Andreas Gursky/DACS London 2012. Courtesy Sprüth Magers Berlin/London.

which began as an annual event in 1932, and the São Paulo Biennial, founded in 1951. However, the escalating presence of large-scale art exhibitions is a phenomenon of recent origin and a significant feature of the late-capitalist landscape.

In this international exhibition culture, there appears to have been an increasing representation of artists from across the globe. It is sometimes claimed on this basis that the old distinction between 'core' and 'peripheral' countries is giving way to a decentred, transglobal culture. Based on a study of Documenta, the critic Chin-tao Wu observes that, before 2002, 90 per cent of artists in the exhibition had been born in Europe or North America. In 2002 and 2007, the proportion of western artists fell back to 60 per cent.[4] However, Wu notes these changes are not straightforward: almost all exhibiting artists from Asia, Africa or Latin America had already moved to Europe or the USA prior to participating, 'presumably in search of better support systems and infrastructures'.[5] To date, the centre/periphery structure of power remains intact, at least in prestigious western

venues like Documenta. Clearly, the emphasis placed on cultural diversity can offer a window dressing for much more unequal economic and political processes.

It has also been claimed that the central role of art today is to be 'a propagandist of neo-liberal values'.[6] Neo-liberalism is a political, economic and ideological trend that asserts the superiority of private investment and market mechanisms over state provision; it advocates the removal of trade restrictions and the pursuit of individual wealth as the path to global freedom and democracy. In practice, this has meant the sale of public assets (privatisation) and the corporate appropriation of collective resources. Manufacture was able to relocate in search of cheap labour, while states placed limits on the legal rights and mobility of workers. Huge new markets for investment and speculation were generated, especially following the fall of the Berlin Wall in 1989 and the subsequent collapse of the Eastern Bloc states. Meanwhile, China developed its own model of neo-liberal modernisation. Perhaps the most well-known manifestation of neo-liberalism has been the enormous

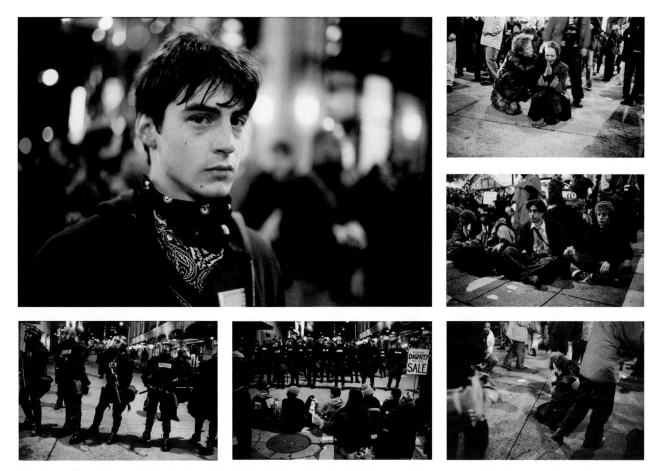

Plate 8.5 Allan Sekula, *Waiting for Tear Gas (White Globe to Black)*, 1999, from a slide sequence of 80. Courtesy of the artist.

speculation on the financial markets that resulted in the banking crash of 2008.[7]

Neo-liberalism is usually dated roughly from the period since the oil crisis of 1973–74 and General Pinochet's 1973 coup d'etat against the democratically elected government of Salvador Allende in Chile. Associated with the theories of the economist Friedrich von Hayek, it was adopted under the governments of Margaret Thatcher and Ronald Reagan. Under neo-liberalism, many of the gains of post-war welfare capitalism were rolled back. It has been said that we now live in an era 'beyond ideology'. We have arrived, some argue, at the 'end of history', where capitalism is the apogee of human development and our only future horizon.[8] Criticism of free-market consensus was often deemed, by the official media and political establishment, to be beyond the bounds of reasonable discourse – treated, at times, as a sign of 'fanaticism'.[9] In 1980, the British prime minister Margaret Thatcher said 'there is no alternative' to free-market policy – a sound bite that hung over the closing decades of the century. Of course, there were, and are always, alternatives, and some of them were proclaimed loudly; at the time,

however, they seemed inaudible outside small circles of dedicated oppositionists.

In the mid-1990s, something of a sea-change took place. Anti- or alter-globalisation campaigners began to contest the politics and priorities of the neo-liberal transformation of the globe, coalescing symbolically with the demonstrations against the World Trade Organization in Seattle in 1999. The slogan 'there is no alternative' was countered by the rallying cry 'another world is possible'.[10] In tandem, a new structure of feeling began to take shape in art – characterised by a critical engagement with the global politics of capitalism and imperialism.[11] The difference between two photographic works from 1999 seems to encapsulate this moment. The large-scale colour image *New York Mercantile Exchange* by Andreas Gursky (b. 1955) depicts an American financial institution of the type that played a core role in the neo-liberal project (Plate 8.4). This photograph is made with a large-format camera capable of capturing incredible detail and then reworked on a computer. Meanwhile, the deliberately low-tech slide sequence by Allan Sekula (b. 1951) – *Waiting for Tear Gas (White Globe to Black)* – documents five days of protests against the WTO in Seattle (Plate 8.5).

Exercise

Bearing in mind the radically different formats of the images shown in Plates 8.4 and 8.5, describe the point of view given by the camera in each work and consider how this suggests distinctive perspectives on the process of neo-liberal globalisation.

Discussion

Gursky offers us a very high vantage point from which to observe the vortex of financial activity; the camera's point of view is detached, but the vision he conjures up is awe-inspiring. His composition stretches and warps the space in a way that creates a parallel with satellite images that show the curvature of the earth set against the darkness of space. His vision of the galactic sublime sets off the human chaos and discarded paper against the serene information flowing above. This spectacular picture appears to be all surface, as if echoing the insubstantiality of electronic transactions. The scale of the picture and its extensive all-over detail almost overwhelm the viewer. In contrast, Sekula immersed himself – and his viewers – in an anti-capitalist multitude. In doing so, he tried to work against the usual techniques of photojournalists: 'The rule of thumb for this sort of anti-photojournalism,' he has said, is 'no flash, no telephoto zoom lens, no gas mask, no auto-focus, no press pass, and no pressure to grab at all costs the one defining image of dramatic violence.'[12] Accordingly, he was as likely to be subjected to the CS gas as the protestors. His sequence offers a view of the crowd from the inside. While Gursky gives us a single, mesmerising abstraction created from digitally manipulated images, Sekula offers a dispersed, low-plane vision. The one conveys vertiginous space and instantaneity, the other is a work of proximity and slow duration. While Sekula focuses on the conscious agency of individuals, Gursky conveys the agents of finance dwarfed beneath the displays of global transactions. In fact, Gursky's figures appear like the microcomponents inside a computer. Made in the same year, these works register different worlds. Whereas Gursky's picture embodies the web of high finance, Sekula stands with the anti-capitalist opposition; they seem to capture two aspects of neo-liberalism's polity.

Around the same time, high-profile international curatorial practice began to engage critically with the changing political situation. Perhaps the key moment

was Catherine David's curatorial directorship of the tenth Documenta in 1997.[13] This event was orchestrated around the conjuncture 'Politics–Poetics' and, at the time, was widely dismissed by art-world *cognoscenti* as a nostalgic leftism unable to face up to the 'end of history'. However, David's exhibition now appears as a perspicacious point of departure for the next decade or so. It is as though she and her team had detected early signs of the changing cultural mood and a need to recover a range of abandoned socially focused aesthetic traditions.[14] This trajectory was furthered at the 2002 Documenta assembled by Okwui Enwezor, with an increasing emphasis on the majority world.[15] (We will return to Enwezor's important exhibition later in this chapter.) Key sections of the 2003 Venice Biennale followed on from David's initiative, as did Seville 2006 (Enwezor), Istanbul 2007 (Hou Hanru) and Sydney 2008 (Carolyn Christov-Bakargiev).[16]

While the ideology of neo-liberalism is taken as unquestionable common sense by many politicians, mainstream economists and media pundits, a large number of artists currently working insist on their disagreement with this agenda; instead, they emphasise 'dissensus'. This term is employed by the French philosopher Jacques Rancière. For him, consensus is the very cancellation of politics. Seeming agreement, he suggests, is always built on patterns of exclusion. In contrast, genuine political moments occur when those who are marginalised – groups he calls 'the uncounted' – speak out to challenge their allotted place, thereby revealing the heterogeneous composition of society.[17] In this chapter, we extend this category of dissensus, developing it in a direction that Rancière would not. We will explore various ways in which dissensus erupts when those excluded from involvement in mainstream politics are made the subjects of artworks. By using the gallery as a platform for raising the visibility of excluded people, some artists and curators seek to articulate dissenting perspectives, but, as we will see, there is a great deal of disagreement about the effectiveness of such a strategy.

The 2009 Istanbul Biennial – put together by the Zagreb-based curatorial collective What, How and for Whom – assembled a wide array of recent critical projects.[18] Seventy-two per cent of the artists came from the majority world, and works shown addressed issues such as international patterns of migration, the secret state, the concept of democracy, memories of collective life under state socialism, and conflict in the Middle East. For example, *Soup Over Bethlehem* (2006), a video by Larissa Sansour (b. 1971), brings together, over a dish of mloukhieh, a family from the Palestinian diaspora. The food provides the only splash of colour in an otherwise black-and-white video (see Plate 8.6). Conversation turns

I think we have a big problem.
Since the tastiest mloukhieh is from Jericho

Plate 8.6 Larissa Sansour, still from *Soup Over Bethlehem (Mloukhieh)*, 2006, video, duration 9 minutes 30 seconds. Photo: courtesy of the artist.

Plate 8.7 Sanja Iveković, *Turkish Report 09*, 2009, crumpled paper balls, installation view at 2009 Istanbul Biennial. Photo: courtesy of the artist.

to border controls and passport ruses, to travel and being strangers in your own land. Sanja Iveković (b. 1949) posed an explicit challenge to Turkey's human-rights record with *Turkish Report 09* (Plate 8.7). She scattered across the floor screwed-up copies of an NGO report on women's rights – addressing gender equality, honour killings and virginity tests. On the one hand, the report appeared

to have been officially discarded by the authorities, while, on the other, the work suggested that a group of campaigners had recently passed through the buildings. With the prominence of themes like this in international exhibitions, many of the artworks we will be looking at in this chapter deal with controversial themes: some works are politically contentious, others are sexually explicit, and yet others are morally troubling.

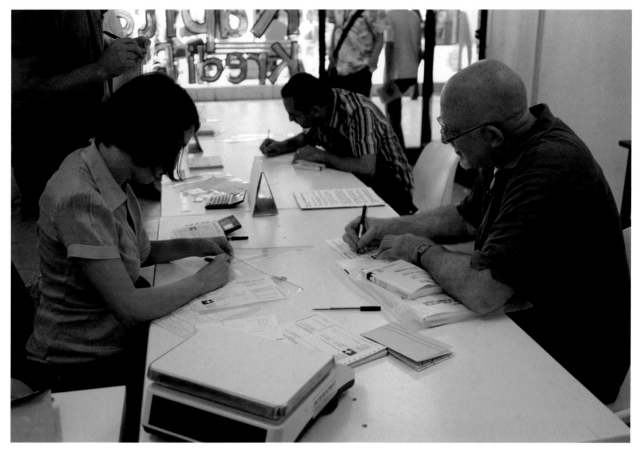

Plate 8.8 Sora Kim, *CapitalPlus Credit Union*, 2007, mixed media. Istanbul. Courtesy of the artist and Kukje Gallery.

2 Dissensual strategies

Let us now look in more detail at some of the practices that feature on the biennial circuit. The art that has come to prominence has been characterised with a number of labels: 'the political turn', the 'social turn' and, in some cases, the 'documentary turn'.[19] These 'turns' are rather journalistic formulations that emphasise changing fashions, but they do seem to register a shift in attitudes.[20] You saw in the previous chapter that art took on a post-medium character during the latter part of the twentieth century, and that installation art and an impulse to escape the gallery played a growing role; these characteristics remain significant. Not that anyone is fretting any more about being for or against medium specificity. The issue no longer seems to hinge on a choice between video and painting; often artists move between media. Rather, the current problem seems to turn on the *relation* between the viewer and the artwork, and the ability of art objects to convey complex social narratives. We will focus on two areas – relational practices and some different forms of realism. So far, we have emphasised the content or themes addressed by some artists. It is important to

grasp, however, that art is not just to be understood at this level; the form or artistic strategy adopted also carries social claims and investments. It is this aspect of the work that we will try to draw out.

Relational aesthetics

At the 2007 Istanbul Biennial, Sora Kim (b. 1965) occupied a space within a large complex devoted primarily to retail trade. Empty units were used to exhibit works from the biennial, inserting art venues into a working context. Kim used her site as an outlet for her financial institution, *CapitalPlus Credit Union* (Plates 8.8 and 8.9). Visitors were encouraged to 'invest' an item that they were carrying. The returns on investments were guaranteed at 3 per cent per month. '[T]hrough our services you will discover a way to prepare for the future', declared the promotional literature, aping the language of the financial industries. However, the guaranteed returns were to be calculated not according to a percentage of monetary value, but to a measure selected by the investor from

Plate 8.9 Sora Kim, *CapitalPlus Credit Union*, 2007, mixed media. Istanbul. Courtesy of the artist and Kukje Gallery.

a set of options: weight, quantity, length or amount. Having completed the paperwork, the submitted items were pegged to a washing-line in clear plastic bags, looking like forensic evidence (or toiletries at airport security). Objects invested were the sorts of thing people have in their bags or pockets, and which they can forsake without incurring too much personal inconvenience or expense (accordingly, there were few mobile phones). The authors submitted a broken pencil, selected a return in weight, and paid a small fee to cover the costs of international postage. We had no idea how Kim would fulfil her promise, or even if she would; the work depended on a relation of trust and our willingness to 'participate' in an artwork. A few weeks later, the pencil was returned in its plastic bag, along with a smaller plastic wallet containing a few wheat seeds and an official-looking letter confirming that the transaction was concluded. We need to account for activities such as this in recent biennial exhibitions.

Work of this type has become widely known as 'relational' practice. Towards the close of the twentieth century, a number of artists began working in ways that involved engaging with, or intervening in, social situations and processes. Art here is conceived not as something to be looked at, but as the activity in which we engage. The production of art objects was not the central motive for these practices. Objects were often involved, but they did not form the focus of the artistic act; rather, they served as the environments for, or the residues of, social encounters. What at first sight appeared to be 'installations' that looked like temporary canteens or alternative social centres were in fact the traces of social events. Library-like environments encouraged 'viewers' to become 'readers', or even 'researchers', inviting them to study newspapers, books and documents, to select a video to watch, or just to sit and converse with others. Situations were contrived where spectators would be provided with a service by the artist, or someone employed by the artist (as did Kim's credit union), for example: therapy (Dominique Gonzales-Foerster, b. 1961), museum tour (Andrea Fraser, b. 1965), city-excursion or fitness instruction (Christine Hill, b. 1968). In *Conflict Management* (2003) by Carey Young (b. 1970), people were invited to discuss their disagreements with a professional mediator or conflict-resolution specialist (Plate 8.10).

Plate 8.10 Carey Young, *Conflict Management*, as installed in Moscow Square, Budapest, 2003, as part of the exhibition *Moscow Square*, organised by Museum Ludwig, Budapest, 2003, professional arbitrator, table, chairs, two noticeboards, media advertising, members of the public. Commissioned by Museum Ludwig. © Carey Young. Courtesy Paula Cooper Gallery, New York.

Critics tried out a number of alternative designations for this trend: 'new-genre public art' (Suzanne Lacy, 1994); 'conversational art' (Homi Bhabha, 1998); 'dialogical aesthetic' (Grant Kester, 1999–2000); 'do it' art (Hans-Ulrich Obrist, 1994).[21] Although each term had a slightly different emphasis, they were indicative of the efforts made to grasp these developments. 'Relationality', 'relational aesthetics', 'relational practices' or 'post-relational art' – the terms that came to predominate – derive from the book *Relational Aesthetics*, published by curator Nicolas Bourriaud in 1998.[22] Bourriaud's exhibition *Traffic*, held at the CAPC Musée d'Art Contemporain in Bordeaux (1999), was pivotal in crystallising relational aesthetics. In preparation for *Traffic*, the artists did not just install their artworks, but were brought together for a week to pursue their daily lives collectively: to eat, discuss, debate and dance with one another. This principle of creating a social situation has been extended by artists to setting up more prolonged encounters between different individuals and groups. These encounters might take place inside or outside the gallery; sometimes they take the form of a singular art event, sometimes of a video recording of an interaction that occurred elsewhere. For *Traffic*, Lothar Hempel (b. 1966) worked with community organisations – a prostitutes' support group and a refuge for people coping with suicidal thoughts – and his installation displayed documentation of their work. Jens Haaning (b. 1965) located his work on the city's streets: through loudspeakers attached to lampposts, jokes were broadcast in Arabic, intelligible only to those who understood the language, primarily the city's North African population.

In the eyes of many, however, it was the work of Rirkrit Tiravanija (b. 1961) that most typified relational aesthetics. He provided cardboard tables and chairs, equipped with free minibars, as a means to encourage exhibition goers to gather and chat, turning the art space into a location for sociability. In probably his best known work, *Untitled 1990 (Pad Thai)* (1991–96), food was cooked and served to gallery goers (Plate 8.11).

Although there are important precedents, works like these do not conform to traditional conceptions of art. According to Bourriaud, western art since the Renaissance has generally involved some form of relationality between spectators and artworks. However, this quality became considerably heightened in the late twentieth century (and, notably, Bourriaud sees Gonzalez-Torres's work, addressed in the last chapter, as initiating this new tendency). At this point, he claims, 'the sphere of human relations' became a matter of aesthetic *form*. This is a difficult idea to grasp. His point is not simply that there are new social *themes* encapsulated in this art, nor is he suggesting that the places of social encounter provide new *contexts* for art. Rather, Bourriaud shifts the emphasis away from the traditional experience viewers have with particular aesthetic objects. Instead, he focuses on the interactions between people.[23] Seen like this, artists are not so much generators of aesthetic objects as facilitators of social connections and situations, encouraging participation, conviviality, hospitality, or an exchange of gifts or services.

Plate 8.11 Rirkrit Tiravanija, *Untitled 1990 (Pad Thai), 1990*, Project Room, Paula Allen Gallery, New York. Photo: courtesy of the artist and Gavin Brown's enterprise. Copyright the artist.

For Bourriaud, relational art is counterposed to the culture of the modern media, which he sees as a one-way, or 'monologic', mode of communication. In contrast, relational works are conceived as open dialogues that are said to be productive and even socially transformative.[24] In addition, sociability is counterposed to privatisation, isolation and social atomism – qualities that are considered to be generic to capitalism, but which have been exacerbated in its neo-liberal phase. To this extent, relational art is set against the prevailing consensual politics. Relational works, Bourriaud argues, suggest small or localised utopias ('microtopias'): that is, alternative spaces where artists and viewer-participants might temporarily evade the world of profit-led economics; where they can encounter different social priorities and build a sense of community.[25]

Bourriaud's book provided a rationale for works that often bemused viewers. At the turn of the twenty-first century, this renewed sense of purpose for art (and not only for art) – the reclamation of 'experimental, critical and participatory models'[26] – struck a chord, especially among those frustrated with the mood of political inertia or ironic complacency widely associated with the 1980s and early 1990s. However, despite his broadly socialistic claims, the gestures Bourriaud advocated were 'little', the enclaves were 'micro', the social agents in these alternative spaces 'fragmentary and isolated, like orphans'.[27] Relational aesthetics, in Bourriaud's hands, invoked some high social ambitions for art while simultaneously being

politically reticent. Critics were swift to spot further limitations with his approach. The organising of parties by Philippe Parreno (b. 1964) or Tiravanija's serving of noodles were dismissed as little more than an 'arty party' – more a diversion for a pre-existing group of art specialists than proposals for new ways of living.[28] Rather than suggesting alternatives to capitalism, the relational model of providing services was criticised for echoing the 'soft skills' and 'networking' advocated by late twentieth-century management-training gurus, which was prevalent under 'dot-com capitalism'.[29] In the museum context, relational practices were often used to meet government-initiated participation agendas. Accordingly, it was seen by many to function as a social salve, covering up society's problems, or just public relations for the museum.[30] Others thought it naive to assume that the mere co-presence of a number of people could heal the wounds of capitalism.[31] Yet others suggested that relational aesthetics failed to face up to the difficult questions of antipathy and contradiction that also shape social encounters, pointing instead to the work of artists who brought social antagonism or dissensus to the fore.[32] It is this last point to which we now turn.

Unsettling relations

A number of artists have tried to push relational practice much further. The climate camps, anti-capitalist and alter-globalisation movements often provided their arena, and their performances or actions have

Plate 8.12 Superflex, *Supergas,* Biogas Unit, Tanzania, 1997, application sample. Courtesy of the artists. Photo: Superflex.

Plate 8.13 Regina José Galindo, *Curso de supervivencia para hombres y mujeres que viajarán de manera ilegal a los Estados Unidos* ('Survival skills course for men and women travelling illegally to the United States'), 2007. Guatemala City, Guatemala. Instructor: Carlos Ixcot. Photo: Marlon García. Video: David Pérez. Courtesy of the artist and prometeogallery di Ida Pisani, Milano/Lucca.

contributed much to the carnival atmosphere of recent oppositional politics, sometimes blurring the boundaries between art and community campaigning. Many of those committed to relationality see their approach as opposed to art's usual role as representation. They contrast what they see as the 'passivity' of representation to the 'activity' of intervention. These artists do not wish to 'represent' anyone or anything, but to create situations for participation and involvement. There are currently many important practices that try to extend relational practice in a more overtly political direction, such as 'art activism' (in which artists use their skills and techniques to intervene directly in campaigns for social justice, or to stage disruptions of business conventions or arms fairs) and 'tactical media' (the production of alternative news and information systems).[33] There is also 'solution-orientated intervention art', which

proposes 'solutions for complicated social and political problems'.[34] This pragmatic use of art 'as a platform for constructive work outside the traditional space of the [art] institution' has included providing drug addicts with clean needles and facilities, and the opening of a shelter and centre for asylum-seekers.[35] The group Superflex developed a biogas plant, which had been installed in villages in Tanzania, Zanzibar, Cambodia and Thailand (see Plate 8.12). Regina José Galindo (b. 1974) collaborated with a dangerous-sports instructor and a people smuggler based in Guatemala City, to provide survival skills for men and women travelling illegally to the USA. They learnt map reading, orientation, abseiling, first aid and other techniques to help them get through the dangerous journey upon which they were about to embark (Plate 8.13).[36] If the 'arty party' label was a damning criticism of the social claims advanced by some relational artists, the designation does not so readily fit artists who press relationality to empower the 'uncounted'.

Social difference also appears in less immediately political or instrumental forms of art, which nonetheless cast relationality in an antagonistic mode. *Bataille Monument* by Thomas Hirschhorn (b. 1957), commissioned for Documenta 11, was constructed far from the main exhibition sites, on an outlying estate of Kassel that housed many Turkish *Gastarbeiter* (guest workers) (Plate 8.14). The 'monument' (strictly, an anti-monument) comprised a number of roughly built sheds, typical of Hirschhorn's aesthetic (cardboard, parcel tape, pages torn from magazines, graffiti-like signage and makeshift construction). Assembled with the help of the community, the sheds served different functions: an exhibition on the dissident Surrealist Georges Bataille (1897–1962); a library devoted to his writings, and to books or videos relevant to Bataillean themes (such as eroticism); a kiosk selling street food, with its deck of tables and benches; and a media station making programmes. Hirschhorn worked and organised events with the community, alongside the estate's youth worker (who had himself migrated to Germany via London from Africa). The artist hoped to generate dialogue more than confrontation. Nevertheless, the social differences involved (ethnicity, gender, class, generation) necessarily brought out a range of social tensions, none of which the artist sought to mask. Visitors to the *Bataille Monument* became hybrid viewers–viewed. They were viewers of the artwork, the estate and its residents (and, by implication, of social disenfranchisement). But they were also subject to observation by residents, or to a strong sense of being so just by entering the tight spaces of the courtyards. Images of the *Bataille Monument* often show visitors

Plate 8.14 Thomas Hirschhorn, *Bataille Monument (Bibliothek)*, 2002, Documenta 11, Kassel. Photo: Werner Maschmann. © ADAGP, Paris and DACS, London 2012.

huddled together in groups and looking distinctly uncomfortable; they seem more at ease in the interior of the sheds where they were better able to occupy the role of viewers of art. Yet even the 'art spaces' were not always colonised by the Documenta crowds: the snack bar became a social hub for the estate, a place to sit and chat with neighbours while the children played. When the authors visited (quite early in the day), the Bataille library's video monitor was monopolised by a group of teenage boys who were watching hardcore pornography. In this context, the idea of sitting down to study Bataille's writings did not appeal, although this relational conjunction certainly dramatised the themes at the heart of Bataillean eroticism.

Some works are even more uncomfortable and ethically challenging for their viewers. Artur Żmijewski (b. 1966) is a specialist in conflict and his work frequently engages with topics that are likely to trouble even the most liberal-minded enthusiasts of contemporary art. His video *The Game of Tag* (1999) depicts a group of naked men and women playing the children's game inside the gas chamber of a Nazi death camp. In *80064*, Żmijewski persuades Józef Tarnawa, an elderly Auschwitz survivor, to renew the camp identification number tattooed on his arm. In the video, we come to understand that Tarnawa has agreed to this procedure,

but once in the tattoo parlour, where the scene is set, he changes his mind because, he says, it would make his tattoo inauthentic (Plates 8.15 and 8.16). Ultimately, and under pressure from Żmijewski, he agrees again and the tattoo is refreshed. Viewers often find the artist's behaviour towards a vulnerable old man to be bullying or manipulative.

Żmijewski's work raises difficult questions: is this an acceptable thing to do? What are we to make of works that deliberately break the bounds of tolerable behaviour and can be excruciating to watch? How can any of it be justified? Does the title 'art' exonerate the treatment of a man like Tarnawa? In simply looking, does the viewer become complicit in some unseemly pact? After all, the works are made *for* us. They would not exist without an audience, funding systems and art institutions. As we will see, Żmijewski's case may be the most straightforward of these examples. Troubling as it is for many, his work is evidently ethical or political in intent, addressing the violent and oppressive history of the modern period, and of Polish history in particular. The work of Santiago Sierra (b. 1966) has been even more controversial, because he regularly employs impoverished people as participants in his works. He hired migrant street vendors in Venice to bleach their hair, paid prostitutes and unemployed men

Plate 8.15 Artur Żmijewski, still from *80064*, 2004, single-channel video, projection or monitor, colour, sound (Polish with English subtitles), duration 11 minutes. Courtesy of the artist and Gallery Peter Kilchmann, Zurich.

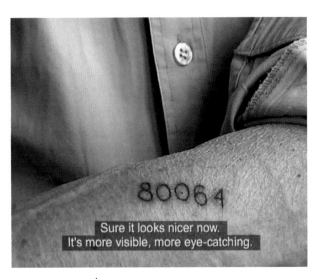

Plate 8.16 Artur Żmijewski, still from *80064*, 2004, single-channel video, projection or monitor, colour, sound (Polish with English subtitles), duration 11 minutes. Courtesy of the artist and Gallery Peter Kilchmann, Zurich.

to occupy boxes inside galleries, and covered workers and prostitutes in polyurethane foam. *100 Beggars* (2005) was made by hiring those who lived off street charity in Mexico to stand and face a wall for a specified period. In *Hiring and Arrangement of 30 Workers in Relation to their Skin Colour* (2002), men wearing nothing but underwear and footwear are positioned facing a gallery wall and arranged from light to dark according to their skin pigmentation (Plate 8.17). There is probably an allusion here to both the painter's colour palette and the racialisation of employment, but for some viewers Sierra's strategy is fundamentally unpalatable. Something similar is going on in *250 cm Line Tattooed*

on 6 Paid People (1999), which was produced in Cuba. Tattooing is more difficult to reverse than bleaching and it has connotations of concentration camps or the treatment of slaves as property. Staying just this side of legality, Sierra pushes boundaries of decorum beyond the limits of what many would feel to be acceptable. Upping the ante, he has sometimes paid those he employs with heroin rather than cash. To his detractors, this is rank exploitation of the dispossessed by a privileged international artist, turning people into commodities for the sake of his career. For others, these moral challenges are precisely the point: Sierra's shocking scenarios rub the face of the art-going public – secure in their liberal values – in exploitation. Ask yourself, these works seem to imply, what are the labour conditions like for those who grow the coffee you consume? Do you know the life expectancy of the majority-world workers on which your way of life depends? What is the wage rate of the museum guard you just walked past?

In the video trilogy *Beyond Guilt* (2003–05), Maayan Amir (b. 1978) and Ruti Sela (b. 1974) employ the dynamics of the erotic encounter. Part 1 is filmed in the toilet of a pick-up bar and Parts 2 and 3 in cheap hotel rooms; all three parts were made in Israel. The works are structured around a series of conversations with people solicited or hired by the artists – in Parts 1 and 2, with men; in Part 3, with a female prostitute. Unlike Sierra, and even more than does Żmijewski, Sela and Amir put themselves at the very heart of these relations, raising flirtation to the level of artistic form. The artists perform the role of seducers, and the implied promise of sex draws out their interviewees. The discussions with the men are frank and risqué; sometimes they are funny, sometimes the mood is threatening, turning from light to dark and back again. We see a gamut of emotions from embarrassment to plain excitation. The artists are non-judgemental towards their interviewees; their attitude is neutral – even blasé. In these works, the camera is used to explore the role of the media in structuring social encounters. The tenor is akin to the confessional mode of a daytime television chat show, where participants are simultaneously raised to stardom and debased, exploring what people are prepared to do or say for a moment in the limelight and the levels of embarrassment they will tolerate. In the first part, one of the artists offers oral sex in exchange for a necklace worn by a man. The man becomes extremely self-conscious and declines. There is a moment of intense awkwardness, which is defused by a raucous hilarity among his friends. The situation is edgy, but the power of the camera nevertheless seems to establish some basic protocols on behaviour. The artists use both their sexual power and their vulnerability to elicit some more difficult topics. In Part 2 of *Beyond Guilt*, the artists pick

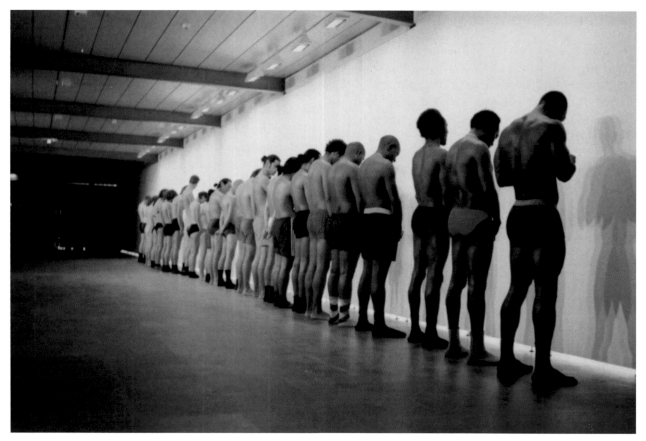

Plate 8.17 Santiago Sierra, *Hiring and Arrangement of 30 Workers in Relation to their Skin Colour*, 2002. Project Space, Kunsthalle, Vienna. © DACS 2012.

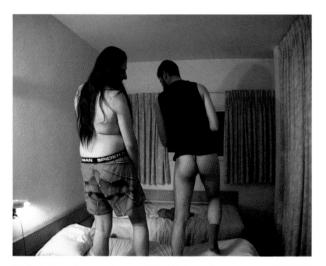

Plate 8.18 Maayan Amir and Ruti Sela, still from *Beyond Guilt #2*, 2004, video, duration 18 minutes, from *Beyond Guilt* trilogy, 2003–05.

up men via an internet site. After two hours of online chat, the men turn up at a hotel room anticipating a sexual encounter (one brings a bag of sex toys) only to find a video camera and an interview process that shifts from forthright come-on, to the intimation of hardcore voyeurism, to discussions of the state and military violence (Plate 8.18). In these circumstances, the men

prove surprisingly prepared to talk about their personal histories in the Middle East conflict and, in the process, the intertwining of sexual fantasy with military power is put on display. Even when the men are charming or humorous, an everyday sadism is made evident. 'Beyond guilt' refers most obviously to sexual attitudes, but it also alludes to the normalisation of social violence in a militarised society – achieved through both the content of the discussions recorded and the forms of behaviours shaped by the camera.

The artists that we have discussed in this section all create challenging works that confront viewers with the near invisibility of the daily exploitation and violence that sustains our ways of life. They create relational encounters of a type that many viewers experience as deeply uncomfortable. It might be said that extreme tactics such as these are required to break through consensus and the social silence that surrounds difficult questions. However, some will regard the strategies used as ethically dubious, even when they agree with the social criticisms implied by these works. Controversy is deliberately sought by these artists, but it is a matter of debate whether this is to some larger social purpose or if it simply dissolves into entertainment and artists' self-promotion.

Realisms beyond resemblance

If relational practice is one prominent component of recent art, what might be described as realist tendencies constitute another. Realism in art is often assumed to 'look like' or 'mirror' reality (thus, we commonly say that something 'looks realistic', or, more technically, that it is 'mimetic'). However, in the sense used here realism is best understood as a type of representation that has a strong cognitive dimension; that is, it is an aesthetic that seeks to produce knowledge about the world.[37] The key feature of realism is its attempt to go beyond appearances to reveal social truths that are not readily visible. In this sense, we are not so far from the work of Manet or the historical avant-garde. Some artists are now trying to find ways to represent the complex global networks of trade and power.[38] As we will see, the strategies employed to achieve this are highly varied, but they all engage with the problem of how to convey the links connecting large-scale economic processes with the intricacies of daily existence. How do today's artists confront the fact that the processes that seem most significant to grasp are invisible to the eye? It is not just that certain features of global capitalism are hidden behind high-security walls. How, for example, can non-specialists expect to fathom the operations of financial capital when, as we found out in the 2008 crash, even banking experts admitted to having little understanding of their own financial tools? Faced with such phenomena, how might artists find adequate strategies of representation? We are going to look at some different ways in which artists have addressed this cognitive problem – documentary, uses of video and mapping projects – all of which try to bring hidden connections into light.

Blind spots: documentary

During the 1980s and early 1990s, documentary was unfashionable with artists and critics alike. At this time, documentary's supposedly neutral representation of reality was called into question. This critique sought to unmask documentary 'truth claims' and reveal them as fictions. Accordingly, artists engaging with photography were most likely to produce staged or performed images that proclaimed the fictional nature of the photograph and explored the types of meaning and identity created. The younger generation are no longer so suspicious of terms like 'truth', 'evidence' and 'reality' – which is not to say that they are oblivious to the way that documentary images are constructed, quite the contrary – and there has been a notable re-engagement with documentary form in photography and video. Some artists have been drawn to documentary out of a need to record their relational events; others from a desire to bear witness to the catastrophes and violence of the age – indicating a new ethics of the gaze.[39]

In addition to the inclusion of a significant number of majority-world artists, Enwezor's Documenta 11 was also notable for the amount of documentary work on display. As Enwezor subsequently suggested: 'it was the structural and critical intent of the exhibition to elaborate on the reasons why artists and other image-makers have become obsessed with reality as such and the representation of everyday life, along with their effects on contemporary consciousness'.[40] Some critics saw this 'documentary turn' as an abandonment of the proper concerns of art for mere propaganda.[41] Whereas conservative responses were unable to recognise documentary as itself a form, the critic Linda Nochlin suggested that Documenta 11 involved an expanded, critical practice of documentary.[42] Exhibits ranged from film and photography of a highly aesthetic and meditative type to more classic documentary work, such as that depicting urban Lagos by 'Muyiwa Osifuye (b. 1966), though even here the images were presented on a large scale (Plate 8.19).

In the period of neo-liberalism, the conditions for documentary have undergone a three-fold transformation. First, the outsourcing of media production has seen traditional outlets for documentary contract sharply. The work of professional photojournalists has been largely replaced by locally made, and often amateur, images produced with camcorders or mobile phones. Second, political and military regulations restrict independent coverage of wars and other conflicts, and journalists are now increasingly required to be 'embedded' with military personnel. Third, the mainstream media has largely excluded oppositional points of view. These changes have led documentary photographers and filmmakers to look for alternative means of distribution. It has been argued that in a time of a conformist news media, the art gallery has come to operate as an alternative public sphere, providing access to reportage or investigations of the contemporary world no longer shown in mainstream arenas.[43] This is a contradictory process, however, since this higher visibility for dissenting perspectives is restricted to a smaller and more socially homogeneous gallery-going public.[44] If photographers such as Luc Delahaye (b. 1962) and Simon Norfolk (b. 1963) cannot obtain direct access to the 'action', they can, at least, make striking images of the destruction caused by sophisticated military technologies, and, behind this, the impact of political decisions (Plate 8.20).[45] In some ways, these pictures parallel the work of Gursky: they are sizable photographs taken with large-format cameras, and are highly formalised,

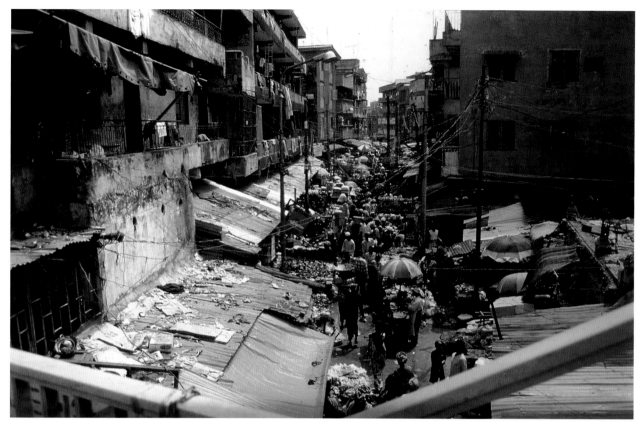

Plate 8.19 'Muyiwa Osifuye, *The Marina Scene*, 2002, from the series *Selected Feature Photographs of Lagos*, exhibited at Documenta 11, Kassel, Germany, 2002. Photo: courtesy of the artist.

Plate 8.20 Luc Delahaye, *Taliban*, 2001, C-print, 237 × 111 cm. Courtesy Galerie Nathalie Obadia.

often drawing on the genres and compositional forms of historical images. There is one notable difference: these photographers visualise scenes of carnage and devastation. Documentary in the gallery attempts to bring overlooked events into the open.

Not all recent documentary in the gallery has adopted this large-scale, formalised approach. One body of work typically records prosaic, everyday places – usually abandoned buildings – and without directly depicting human presence.

Exercise

Look at the pictures by Santu Mofokeng (b. 1956) and Shahidul Alam (b. 1955) (Plates 8.21–8.24). What kinds of places are being depicted? Consider what information can be gleaned about these sites and what mood is conveyed.

Plate 8.21 Santu Mofokeng, *Robben Island* triptych, 2002, silverprint. © Santu Mofokeng. Images courtesy Lunetta Bartz, MAKER, Johannesburg.

Plate 8.22 Santu Mofokeng, *Robben Island* triptych, 2002, silverprint. © Santu Mofokeng. Images courtesy Lunetta Bartz, MAKER, Johannesburg.

Plate 8.23 Santu Mofokeng, *Robben Island* triptych, 2002, silverprint. © Santu Mofokeng. Images courtesy Lunetta Bartz, MAKER, Johannesburg.

Plate 8.24 Shahidul Alam, *F M Hall Rickshaw*, 2009, from *Crossfire*. © Shahidul Alam/Drik.

Discussion

The photographs depict ordinary, banal places and there is little of note. The titles of these works give some information about the locations. You might recognise Robben Island as site of the now-abandoned South African prison, which once held Nelson Mandela and other leaders of the African National Congress. The jail was infamous for its brutal regime, but also served as a symbol of resistance to Apartheid. In Alam's case, the title of the photograph is unremarkable, but the name of the larger project from which it is taken – *Crossfire* – suggests that something significant has occurred. In Bangladesh, 'crossfire' is a euphemism that refers to extrajudicial executions committed by 'off-duty' policemen and military personnel. This is the site of one such unlawful killing. In both instances, you may have detected a sense of unease. These works do not directly show violent acts but they record the places where violence took place. The camera is typically excluded from depicting the dreadful events that occurred, but by concentrating on the aftermath the artists focus attention on these actions.

It is worth considering in what ways your perception of these images changed when the sites were identified. Photographs and videos depicting poignant spaces are remarkably ordinary, even when they have a certain beauty: viewers find themselves scanning the image searching for meaningful signs and traces. Sometimes, vision alights on a discarded item or bit of debris, but there is no way of telling if it bears significance. The lack of evident import in these images seems to be the point. According to Enwezor, in the context of art, documentary is 'a hole in vision, a blindspot, the blank stare'.[46] Such images operate in a gap between an absence of clear significance in the picture and the beholder's expectation, or knowledge, of events outside the frame. They occupy the fissures between what you can see, what you can read in the caption and what you may know. One consequence is to generate a highly active form of spectatorship – we bring meaning to the pictures and catch ourselves reading in connotations. We should note one further point. It is frequently said that art is politically ineffectual and this oblique strategy might be thought to have even less impact than, say, a photograph evidencing a

Plate 8.25 Canan Şenol, still from *Exemplary*, 2009, video, duration 27 minutes 30 seconds (from *Act V, Power Alone*). Courtesy of the artist.

murdered body; however, in Alam's case, this is not so. His exhibition *Crossfire* was surrounded on the opening night by armed police in an attempt to prevent these images being shown. Through a pictorial strategy that did not depict the assassinations he was able to force the issue of extrajudicial killings – hitherto officially denied – on to the public agenda. At times, even an oblique aesthetic approach to representation can shift awareness.

Recovering agency: varieties of video

It is a commonplace to say that video technology occupies a core role in recent art. Like any medium, video can be deployed to many different ends. It can be used, for example: to record simple actions; to serve as a vehicle for grandiose and portentous statements; to tell personal and intimate stories; to document developments with a 'scientific' gaze; or to bear belated witness to past events (in ways similar to Mofokeng and Alam). Video is often accused of being a displacement of older artistic skills, but in *Exemplary* Canan Şenol (b. 1970) employs the technology as a vehicle for traditional artistic proficiencies. Şenol uses video animation to chronicle one woman's 'exemplary' passage from rural south-eastern Turkey to life in the city, from pre-Kemalist to modern times. Şenol adopts the story-telling mode of the folk-tale, and her drawings are in the style of Ottoman miniatures (see Plate 8.25).

Time-based media may be particularly amenable to realist strategies. They enable artists to make compositions that layer multiple sounds and images using interviews, graphics, animation, found footage, music, dialogue, narration and restaged events. This capacity allows for especially nuanced ruminations on contemporary history. The juxtapositions that can be made through filmic montage can help to dramatise social contradictions, to collide voices from past and present, or to draw out the links between a particular experience and its global historical causes. Here we are going to focus on three types of realism in video: the video essay employed by Ursula Biemann (b. 1955); the comedic and theatrical vision of life in contemporary Serbia by the group Chto Delat; and the silent elegiac look at global labour politics made by Chen Chieh-jen (b. 1960).

A good example of the video essay is *Europlex*, made by the artist Ursula Biemann with visual anthropologist Angela Sanders (b. 1974).[47] Biemann construes her practice as a type of fieldwork or research project, drawing on models from anthropology, ethnography and social geography, which she creatively reworks. (Multidisciplinary research projects are a notable feature of art in recent times.) *Europlex* is a detailed meditation – combining sound and images with essayistic commentary – on the patterns of migration between the European Union and North Africa. More

Plate 8.26 Ursula Biemann/ Angela Sanders, still from *Europlex*, 2003, video, duration 20 minutes. Courtesy of Ursula Biemann and Angela Sanders.

Plate 8.27 Ursula Biemann/ Angela Sanders, still from *Europlex*, 2003, video, duration 20 minutes. Courtesy of Ursula Biemann and Angela Sanders.

specifically, this is a materialist-feminist practice that considers the ways global geopolitics become inscribed on, and inhabited by, human bodies (or 'geobodies', as Biemann calls them) (Plates 8.26 and 8.27).[48] The border is not taken in its usual sense, as a line dividing nations to be policed and controlled, but as a wider spatial, social and economic geography of flows and connections, which extend from the visible movements

of people to the invisible patterns of radar and radio waves. Biemann and Sanders look at: the Straits of Gibraltar, through which international shipping passes, and over which helicopters seek out boats of migrants at night; the farms of southern Spain employing Sub-Saharan labourers to supply the European Union with salad and vegetables; the Spanish economic enclaves of Ceuta and Melilla, located on the North African coast; and the border complexes with their associated warehouses and tax-free markets. Their concern is with the micro-geographies established by the everyday activities of ordinary people intersecting with global economies.[49] Some women smuggle clothing by wearing the contraband, passing back and forth before the guards with alternating svelte and bloated body-shapes, each additional shirt they wear manifesting the small profit they hope to make. Others cross the border to work as domestic maids in the enclave, moving daily between time zones with two hours difference and, as Biemann and Sanders emphasise, living their lives permanently out of sync. Women are bussed into Tangier's transnational zone to peel shrimps for Dutch consumption and to work in other industries that 'translate' commodities for the European market. Often recording undercover, Biemann and Sanders chart these day-to-day negotiations of formal borders, narrating their observations and analysis, montaging their documentary footage with the technological imagery of surveillance (satellite maps, night-vision equipment and the computerised charts used in navigation). Sometimes they overlay their visual material with additional textual data, occasionally using technology to manipulate their images.

It is the 'constant subversion', 'invisible counter-geographies and dissident practices' – more than the structures of border control – which interest Biemann and Sanders.[50] Biemann emphasises the way human agency, despite the odds, is exercised in such spaces. She believes that adopting this perspective acknowledges how people act on and transform their world. Thus, she attempts to avoid showing humans as simply at the mercy of the technologies of surveillance and state power. This type of work has been characterised as 'aesthetic journalism', but it is better to say that the video essay is a form of realism that refuses journalism's claim to 'transparency' and 'objectivity', while attempting to convey a more complex sense of the modern world than anything usually found in the news media.[51] Sharing a working principle with Sekula, Biemann notes that, despite featuring in news items under the official discourse of 'illegal migrants', there is 'no defining image that can narrate the endless story

of inclusion and exclusion … no single, violent icon to which the event of crossing can reasonably be reduced'.[52]

The next two examples also pay acute attention to the problems of human agency, which is an issue often at the heart of critical realist practices. The video *Partisan Songspiel: A Belgrade Story* (2009), by Chto Delat with Biro Belgrade, narrates – through speech, dance and song – patterns of social conflict in modern Serbia. Chto Delat is a collective of artists, theorists and activists based in Moscow and St Petersburg, who produce exhibitions, a free paper and maintain a website.[53] Biro Belgrade is an artist-activist group based in Belgrade.[54] In the video, a group of oppressed 'types' – a Lesbian Activist, a Worker (who is the one usually associated with the large severed finger), a Disabled Veteran and a Romani Woman – relay stories of marginalisation and struggle for a dignified existence (Plate 8.28). The costumes are flamboyant, the set is clearly artificial and the actors address the spectator directly. They each dance for the camera, while another character narrates the hardship experienced – the harsh racism faced by the Romani Woman, whose home was demolished to make way for real-estate development; the labourer whose factory has been closed; the violence and bigotry experienced by sexual minorities; and the lack of sympathy and respect encountered by the disabled ex-soldier. Intercut with these performances are speeches by the victors in the new Serbia (a neo-liberal Woman Politician, an Oligarch, a Mafioso, a Nationalist and their heavies) who make grand speeches from a raised podium. The winners proclaim their vision for a 'cleaned-up' Serbia and bemoan the obstreperous nuisance caused by the four defeated groups. There is also a chorus, whose members are dressed in white body suits, which appears from behind the cut-out image of a stone monument dedicated to Yugoslav partisans. In theatre, the chorus has often represented collective forces, and here it remarks on the action from the perspective of history. This 'monument' is a montage composed from two distinct partisan statue groups, one located in Serbia and the other in Croatia.[55] In this way, it recalls the unity across different national groups in the anti-fascist fight and the foundation of Yugoslavia. The chorus is made of partisans turned to stone, and therefore a constant or 'immortal reminder' of unanimity in struggle. In the process, it throws into contrast the subsequent fragmentation of the state and the descent into inter-ethnic war. The chorus becomes the spectral representative of a forgotten socialism, the memory of class-conscious solidarity, commenting on the divisions now so evident among the oppressed. The partisans mourn the lack of unity among the oppressed and proclaim: 'close your ranks, comrades'.

Plate 8.28 Chto Delat, production shot from *Partisan Songspiel: A Belgrade Story*, 2009, video, duration 29 minutes. Courtesy of Chto Delat.

Plate 8.29 Chen Chieh-jen, still from *The Route*, 2006, DVD projection, black and white, silent, duration 20 minutes, installation view at Tate Liverpool. Photo: © Tate, London, 2012. Used with permission of the artist.

It might be imagined that *Partisan Songspiel* is dour and overly earnest; but there is nothing austere about the work. The mood conveyed is upbeat and humorous. In German, a *Songspiel* is a musical play, and the form was often used by the Marxist playwright Bertolt Brecht in his satires on capitalism and fascism. The artists draw on this tradition and again mobilise the pleasures of comic opera – song, music and biting wit – to examine the reality of neo-liberal restructuring of the former Yugoslavia. In an overtly theatrical mode, the work employs entertainment and popular forms to explore historical amnesia and the social transformation of eastern Europe. Laughter is often one of the strongest critical weapons in the realist armoury. Rather than turning its back on aesthetic pleasure, *Partisan Songspiel* puts satirical comedy, enjoyment and visual delight to work in the service of realist critique.

Our third example of realist video is *The Route* – a silent film commissioned for the Liverpool Biennial of 2006 and made by Chen Chieh-jen in collaboration with the Dockworkers' Union of the port of Kaohsiung in southern Taiwan (Plate 8.29). The work reveals the interconnections of global production. Following the sacking of 500 Liverpool dockers in 1995 for refusing to cross a picket line, international portworkers' unions declared a boycott on unloading any ships that had been stocked on Merseyside. One such vessel – the *Neptune Jade* – was turned away from ports in California, Canada and Japan. However, workers in Kaohsiung

unloaded the cargo, unaware of the Liverpool men's call for solidarity. Chen narrates this story with archive footage and a restaged event in which Kaohsiung dockers scale a fence in their port and symbolically re-enact the picket line that they would have mounted had they known. The men carry placards proclaiming 'The world is our picket line'. Like Chto Delat, Chen employs performance, but where the Russian collective use the joys of song and dance to comment on social divisions, he employs silence and a meditative pace. In this re-enactment, the men make voluntary recompense for their failure to assist fellow workers. Standing in the heat and humidity, they proclaim their identification with westerners involved in a far-off struggle. The belatedness of this gesture renders their internationalism all the more compelling. The camera lingers on their act of endurance. Chen's film is a subtle consideration of international labour politics; it also explores the connections between east and west. Liverpool's relation with Kaohsiung makes one important link through maritime trade, but the vessel's name also evokes Neptune, the Roman god of the sea, and jade is one of the precious commodities traded by the east. Further, this work is a reflection on the history of filmic representation. Shot on 35 mm film stock, and subsequently transferred to video, Chen's film is an elegy for the crafted imagery of Chinese Socialist Realism. Drawing on this lost style, with its propagandistic affirmation of the labouring body, he

Plate 8.30 Ashley Hunt, *A World Map: In Which We See* ..., acrylic paint on wall, installation view at *Patriot* show, Contemporary Museum, Baltimore, 2005.

offers beautiful images of resolve and heroism, but also raises the difficulties facing socially progressive politics in a world dominated by neo-liberalism. Offering an alternative ending in which human solidarity is sustained, Chen refuses to accept defeat as the conclusion to the specific story of the Liverpool dockers and the *Neptune Jade* – but he also rejects the wider narrative of neo-liberal triumph over labour. *The Route* presents a symbolic rewriting of history and, by implication, the future.

It should be apparent that mimetic fidelity to appearances is not a defining feature of these video works. Rather, their realism is pursued through other means: the critical deployment of restaged events, performance and documentary footage; analysis; mourning and pleasure; comedy and elegy; sound and silence; geographical charts; and singing statues. Utilising a diversity of techniques and strategies, the artists construct scenarios and stories that cut against the consensual grain. They also reflect on the potential agency of those adversely affected by neo-liberal globalisation. These works share realism's emphasis on reshaping our cognition of the existing world; they also share its search for openings onto alternative futures.

Tracing hidden states: mapping

Finally, we see another attempt at realist cognitive work. The sheer quantity of artwork in recent years attempting to 'map' aspects of capitalism has been striking. In the early 1980s, the theorist Fredric Jameson called for a 'new aesthetic ... of cognitive mapping' – that is, an artistic response to the dilemma of how to represent processes that seem to be beyond the powers of representation.[56] Maps, charts, plans and diagrams feature as devices for exploring, not simply spatial geography, but the complex range of modern capitalism's social phenomena. The idea of the 'subjective' map is as important as the 'objective'.

Ashley Hunt's *A World Map: In Which We See ...* is a good example of this trend (Plate 8.30). *A World Map* offers a conceptual analysis of the social features of capitalism in the age of globalisation. It attempts to collate the major factors contributing to capitalist crisis. Hunt, an artist and activist, works in video, performance and mapping. His aim is to reveal 'structures that allow people to accumulate power and those which keep others from getting power, while learning from the ways people come to know, respond to and conceive of themselves within these structures'.[57] *A World Map*

Plate 8.31 Multiplicity, *The Road Map*, 2003. The fieldwork and video shooting have been realised by Sandi Hilal, Alessandro Petti and Salvatore Porcaro. Multiplicity: Stefano Boeri, Maddalena Bregani, Maki Gherzi, Matteo Ghidoni, Sandi Hilal, Anniina Koivu, Alessandro Petti, Salvatore Porcaro, Francesca Recchia, Eduardo Staszowsky. © Multiplicity.

is available in a published wallchart edition or can be downloaded as a PDF, but Hunt also installs painted or drawn versions in galleries and other venues as the focus for organising political discussions. This should indicate that there is no hard-and-fast distinction between relational and realist practices.

The Road Map, by the Italian-based collective Multiplicity, includes TV monitors placed on the floor that display a map. These are just one component of the installation (see Plate 8.31). Two larger video projections follow, in real time, two travellers – one Palestinian, the other Israeli – as they make journeys, approximately, from the Hebron area to that north of Nablus. It is entirely feasible to watch the Israeli's trip in the gallery space; the smooth journey by car along fast motorways is completed in just over 1 hour. The Palestinian's ordeal lasts 5 hours and 20 minutes; this is a constantly interrupted passage (by taxi, bus and foot) along roads, rough tracks, across country, negotiating checkpoints and road blocks in urban areas. In the course of a single screening of the Palestinian journey, the Israeli one loops almost five times over, mapping

the spatio-temporal conditions of specific social bodies upon a real political geography. *The Road Map*, with its sharp allusion to the international strategy for building peace in Israel/Palestine, makes its point simply and with economical means.

In our third example, Trevor Paglen (b. 1974) employs documentary models to reveal the places and occurrences that powerful interests would prefer not to be seen or discussed. He uses high-end photographic technologies to track and plot the secret state. In *The Black Sites*, Paglen sets about locating the CIA's concealed facilities for the detention and torture of suspects in the 'war on terror' (Plate 8.32). He describes how he found one such facility, known as the Salt Pit, located in an old brick factory close to Kabul:

> To find the Salt Pit, I used a collection of commercial satellite imagery, a compass, testimonies from former prisoners, and a map drawn by a former prisoner. Although they were blindfolded, hooded, and shackled, prisoners held who spent time at the Salt Pit consistently describe a ten-minute ride from the Kabul

Plate 8.32 Trevor Paglen, *The Salt Pit, Northeast of Kabul, Afghanistan*, from *The Black Sites*, 2006, C-print , 61 × 91 cm. © Trevor Paglen. Courtesy Galerie Thomas Zander, Köln and Altman Siegel Gallery, San Francisco.

International Airport to the prison. I also had a map drawn by a man named Khaled el-Masri of what he believed the interior of the prison looked like. If you draw a circle around the Kabul airport that represents the distance that one might travel in ten minutes, and compare that to el-Masri's map, the Salt Pit jumps out at you.[58]

Paglen's photographs can look banal, so it is important to understand that his pictures are not in themselves the artwork. Like Biemann, research is at the heart of his activity and the pictures he makes provide documentary evidence for his discoveries. In addition, these photographs are just one element in a process of tracking and location. They are traces, put into the public domain, of power structures that otherwise remain invisible. If Paglen does not provide us with an actual map or diagram, his work nonetheless offers cognitive maps that reveal hidden facilities of the secret state.

Conclusion

In this chapter, we have considered some of the global conditions for art today and surveyed a diverse range of artistic practices that respond to this new configuration. While artists respond to the modern world in different ways, it is notable that so many feel the urgent need to confront the conditions of the global economy itself. The mega-exhibitions in which much of this work appears are themselves components of the late-capitalist scene, but they have also offered venues for perspectives that refuse its neo-liberal consensus.

Relational and realist practices – the two broad approaches we have focused on – involve different procedures and forms. As we noted earlier, many relational and post-relational artists explicitly object to artistic work based on 'representation' (which underpins our examples of realism). However, it is debatable whether relational work itself is able to escape from representation; some form of symbolisation is always necessary in 'art'. Photography and video are required to illustrate or record; written descriptions appear in catalogues and are used to disseminate the

work. Even the relational interactions or encounters themselves (whether they take place inside or outside the gallery) invariably involve metaphors: reading in a library represents 'learning' and serving food suggests hospitableness and they are cast in opposition to other images of social behaviour, such as ignorance or selfishness. Moreover, they provide condensed images of an alternative society. Of course, some artists using relational tactics do so without this anti-representational anxiety; indeed, they actively use the technologies of representation, even thematising the role of the camera in a relational context. Furthermore, the acute ethical issues raised by some works – the shock and scandal – seem to be particularly exacerbated by the presence of the camera as a recording and representational tool.

We have also seen that the realist works addressed in this chapter are not concerned with passively picturing the world as it is. This has been a realism of active enquiry that seeks to understand those aspects of modern social life that elude capture by any simple 'representation'. Indeed, many of our examples also extend this emphasis on dynamism in another dimension: they have an explicitly activist component. We have used 'realism' not in the sense of passive mimesis, but to mean an aesthetic which, first, encourages a procedure of active cognition (a desire to know the realities of the world around us) and, second, understands its own activity as a practical action that seeks to impact upon and transform that world. Despite their differences, relationality and realism share a tendency: they both imagine art as praxis, or as an engaged stance in the historical present.[59] Relational practice and realism can both provide dissensual ways of grappling with the forces shaping modern transglobal conditions.

Notes

[1] To give just a few examples, there are biennials in Venice, Istanbul, Havana, Cape Town, Singapore, Athens, Lyon, Seville, Berlin, Busan, Sydney, Tel Aviv, T'aipei, Sharjah, Shanghai, Gyumri, Guangzhou, Kwangju, New York's Whitney, Liverpool, Brighton. There are also triennials (Yokohama, Turin, Fukuoka Asian Art Triennale, London's Tate Britain); quinennials (Documenta in Kassel) and decennials (Münster Sculpture Festival). For convenience, 'biennial' is used as the generic term. Some material that appears in this chapter was developed for Day, Edwards and Mabb, 2010.

[2] Wu, 2009, p. 109.

[3] Documenta Archive, 2007.

[4] Wu, 2009, p. 110.

[5] Ibid., p. 113.

[6] Stallabrass, 2004, p. 72. On the growing imbrications of art and museums with privatisation and corporate culture under neo-liberalism, see Wu, 2001; Rectanus, 2002.

[7] Harvey, 2005.

[8] Fukuyama, 1992.

[9] Toscano, 2010.

[10] Callinicos, 2003; McNally, 2006; Bircham and Charlton, 2001.

[11] Dimitrakaki, 2003; Thompson and Sholette, 2004; Esche and Bradley, 2007.

[12] Sekula, 2003, p. 310.

[13] Exceptionally, the roman rather than arabic numeral was employed in 1997: Documenta X.

[14] David, 1997.

[15] Enwezor, 2002.

[16] Enwezor, 2006; Ayvaz, 2007. Information on Sydney 2008 can be accessed via: http://www.bos2008.com/page/exhibition.html and http://www.bos2008.com/page/theme.html

[17] Rancière, 1999, 2010.

[18] What, How and for Whom, 2009a, b.

[19] See, for example: Bishop, 2006a; Nash, 2004.

[20] Kester, 2006.

[21] Lacy, 1994; Kester, 1999–2000 (cf. Kester, 2004); Bhabha, 1998; for Obrist, 1994, see 'do it archive', n.d.

[22] Bourriaud, 2002. (The volume – published in French in 1998 – collects together essays from the 1990s.)

[23] Ibid., 2002, p. 28.

[24] Ibid., pp. 24, pp. 25–6; Bourriaud, 2006, p. 78.

[25] Bourriaud, 2002, pp. 13, 14, 36. Also see Bourriaud, 2006, p. 78.

[26] Bourriaud, 2002, p. 12.

[27] Ibid, 2002, pp. 36, 31, 13.

[28] Foster, 2003, pp. 21–2.

[29] Charlesworth, 2002; Holmes, 2006, 2008; Rasmussen, 2011.

[30] Stallabrass, 2004, pp. 182–3.

[31] Martin, 2007.

[32] Bishop, 2004, 2006a, b.

[33] Thompson and Sholette, 2004; Sholette, 2010.

[34] Rasmussen, 2011, p. 205; Thompson and Sholette, 2004.

[35] Rasmussen, 2011, pp. 205–7.

[36] Carolin, 2011, pp. 211–23.

[37] Jameson, 1977, p. 198. See also Wood, 1993.

[38] Demos, 2008, 2009; Farquharson, 2010.

[39] Azoulay, 2008.

[40] Enwezor, 2008, p. 34.

[41] Gopnik, 2002; Kimmelman, 2002.

[42] Nochlin, 2002. Other reviews include: Hartney, 2002, Higgs, 2002; Holert, 2002; Levin, 2002; Meyer, 2002. On expanded documentary, see also Verwoert, 2005.

[43] Jonsson, 2008, pp.166–87. For devastating critiques of the media under neo-liberalism, see Herman and McChesney, 1997; Davies, 2008.

[44] Steyerl, 2009.

[45] Edwards, 2009; Roberts, 2009.

[46] Enwezor, 2008, p. 71.

[47] Biemann, 2003; Guerra, 2008.

[48] Biemann and Lundström, 2008; Dimitrakaki, 2007.

[49] Biemann, 2008, p. 48.

[50] Ibid, 2008, pp. 53, 48.

[51] Camerotti, 2009.

[52] Biemann, 2008, p. 48.

[53] The name Chto Delat (which translates as 'What is to be done?') is taken from a Russian realist novel of 1863 by Nikolai Chernyshevsky, which became especially popular with early socialists. The title was adopted by V.I. Lenin for one of his most famous pamphlets published in 1902. The Chto Delat members who worked on *Partisan Songspiel* were Olga Egorova (Tsaplya), Natalia Pershina (Gluklya) and Dmitry Vilensky, with music by Mikhail Krutik.

[54] The members of Biro Belgrade are Vladan Jeremić and Rana Rädle.

[55] Vladan Jeremić composed the *Partisan Monument* (2009–10) from photographs of *The Rise* (*Ustanak*) by Frano Kršinić (1954, located in Sisak, Croatia) and *Fallen Fighters' Memorial* (*Spomenik Palim Borcima*) by Sreten Stojanović (1951, located in Iriški Venac, Serbia).

[56] Jameson, 1988.

[57] Hunt, n.d., n.p.

[58] Paglen, n.d., n.p. (The word 'shackled' in the quotation appears incorrectly on the webpage as 'shacked'.)

[59] Jameson, 1977, p. 198.

Bibliography

Ayvaz, I.B. (ed.) (2007) *Not Only Possible, But Also Necessary: Optimism in an Age of Global War*, 10th International Istanbul Biennial, Istanbul, Istanbul Külütur Sanat Vakfi.

Azoulay, A. (2008) *The Civic Contract of Photography* (trans. R. Mazali and R. Danieli), New York, Zone Books.

Bhabha, H.K. (1998) 'Conversational art' in Jacobs, M.J. with Brenson, M. (eds) *Conversations at the Castle: Changing Audiences and Contemporary Art*, Cambridge, MA, MIT Press, pp. 38–47.

Biemann, U. (2003) *Stuff It: The Video Essay in the Digital Age*, Zurich, Edition Voldemeer and New York, Springer.

Biemann, U. (2008) 'Logging the border: Europlex' in Biemann and Lundström (2008), pp. 47–54.

Biemann, U. and Lundström, J.-E. (eds) (2008) *Mission Reports. Artistic Practice in the Field: The Video Works of Ursula Biemann*, Bildmuseet Umea and Arnolfini, Bristol, Cornerhouse Publishers.

Bircham, E. and Charlton, J. (eds) (2001) *Anti-Capitalism: A Guide to the Movement*, London, Bookmarks Publications.

Bishop, C. (2004) 'Antagonism and relational aesthetics', *October*, vol. 110, pp. 51–79.

Bishop, C. (2006a) 'The social turn: collaboration and its discontents', *Artforum*, February, pp. 179–85.

Bishop, C. (ed.) (2006b) *Participation*, Cambridge, MA, MIT Press.

Bourriaud, N. (2002) *Relational Aesthetics*, Dijon, Les presses du réel.

Bourriaud, N. (2006) 'Pierre Huyghe: the reversibility of the real', *Tate etc*, vol. 7, summer, pp. 76–83.

Callinicos, A. (2003) *An Anti-Capitalist Manifesto*, Cambridge, Polity Press.

Camerotti, A. (2009) *Aesthetic Journalism: How to Inform Without Informing*, Bristol and Chicago, Intellect.

Carolin, C. (2011), 'After the digital we rematerialise: distance and violence in the work of Regina José Galindo', *Third Text*, vol. 25, no. 2, pp. 211–23.

Charlesworth, J.J. (2002) 'Twin Towers: the spectacular disappearance of art and politics', *Third Text*, vol. 16, no. 4, pp. 357–66.

David, C. (ed.) (1997) *Politics-Poetics: Documenta X – The Book*, Ostfildern-Ruit, Hatje Cantz.

Davies, N. (2008) *Flat Earth News*, London, Chatto & Windus.

Day, G., Edwards, S. and Mabb, D. (2010) '"What keeps mankind alive?": the 11th International Istanbul Biennial. Once more on aesthetics and politics', *Historical Materialism: Research in Critical Marxist Theory*, vol. 18, no. 4, pp. 135–71.

Demos, T.J. (ed.) (2008) *Zones of Conflict*, New York, Pratt Manhattan Gallery.

Demos, T.J. (2009) 'Moving images of globalization,' *Grey Room*, vol. 37, fall, pp. 6–29.

Dimitrakaki, A. (2003) 'Art and politics continued: avant-garde, resistance and the multitude in *Documenta 11*', *Historical Materialism: Research in Critical Marxist Theory*, vol. 2, no. 3, pp. 50–61.

Dimitrakaki, A. (2007) 'Materialist feminism for the twenty-first century: the video essays of Ursula Biemann', *The Oxford Art Journal*, vol. 30, no. 2, pp. 205–32.

'do it archive' (n.d.) [online] http://www.e-flux.com/projects/do_it/itinerary/itinerary.html (Accessed 15 April 2012).

Documenta Archive (2007) 'Documenta Kassel 16/06–23/09 2007' [online], http://archiv.documenta12.de/geschichte010.html?&L=1 (Accessed 13 April 2012).

Edwards, S. (2009) 'Apocalyptic sublime: on the Brighton Photo-Biennial', *Historical Materialism: Research in Critical Marxist Theory*, vol. 17, no. 3, pp. 84–102.

Enwezor, O. (ed.) (2002) *Documenta 11 – Platform 5* (Kassel, Germany), Ostfildern-Ruit, Hatje Cantz (exhibition catalogue).

Enwezor, O. (ed.) (2006) *The Unhomely: Phantom Scenes in Global Society*, 2nd International Biennial of Contemporary Art of Seville, Seville, BIACS.

Enwezor, O. (2008) 'Documentary/Vérité: bio-politics, human rights, and the figure of "Truth" in contemporary art' in Lind and Steyerl (2008), pp. 62–102.

Esche, C. and Bradley, W. (eds) (2007) *Art and Social Change: A Critical Reader*, London, Tate Publishing.

Farquharson, A. (ed.) (2010) *Uneven Geographies: Art and Globalisation*, Nottingham, Nottingham Contemporary.

Foster, H. (2003) 'Arty party', *London Review of Books*, vol. 25, no. 4, pp. 21–2.

Fukuyama, F. (1992) *The End of History and the Last Man*, London, Hamish Hamilton.

Gopnik, B. (2002) 'Fully freighted art: at Documenta 11 a bumpy ride for art world's avant-garde', *Washington Post*, 16 June.

Guerra, C. (2008) 'Narratives of Europe: video essays and collective pedagogies' in Lind and Steyerl (2008), pp. 144–64.

Hartney, E. (2002) 'A 600 hour Documenta', *Art in America*, September, pp. 87–95.

Harvey, D. (2005) *A Brief History of Neoliberalism*, Oxford, Oxford University Press.

Herman, E.S. and McChesney, R.W. (1997) *The Global Media: The New Missionaries of Corporate Capitalism*, London, Cassell.

Higgs, M. (2002) 'Same old same old', *Artforum*, September, pp. 166–7.

Holert, T. (2002) 'Bataille that binds', *Artforum*, September, pp. 164–5.

Holmes, B. (2006) 'The flexible personality: for a new cultural critique' in Cox, G., Krysa, J. and Lewin, A. (eds) *Economising Culture: On the (Digital) Culture Industry*, New York, Autonomedia, pp. 23–52.

Holmes, B. (2008) *Unleashing the Collective Phantoms: Essays in Reverse Imagineering*, New York, Autonomedia.

Hunt, A. (n.d.) 'CV/Biography' [online], http://ashleyhuntwork.net/ (Accessed 8 October 2012).

Jameson, F. (1977) 'Reflections in conclusion' in Bloch et al. (eds) *Aesthetics and Politics: Debates Between Bloch, Lukacs, Brecht, Benjamin, Adorno*, London, New Left Books, pp. 196–213.

Jameson, F. (1988) 'Cognitive mapping', in Nelson, C. and Grosberg, L. (eds) *Marxism and the Interpretation of Culture*, Urbana and Chicago, IL, University of Illinois Press, pp. 347–57.

Jonsson, S. (2008) 'Facts of aesthetics and fictions of journalism: the logic of the media in the age of globalization' in Lind and Steyerl (2008), pp. 166–87.

Kester, G. (1999–2000) 'Dialogical aesthetics: a critical framework for littoral art', *Variant #9 Supplement: Socially Engaged Practice Forum*, winter, pp. 2–8.

Kester, G. (2004) *Conversation Pieces: Art + Community*, Berkeley, CA, University of California Press.

Kester, G. (2006) 'Another turn', *Artforum*, May, p. 22.

Kimmelman, M. (2002) 'Global art show with an agenda', *New York Times*, 18 June.

Lacy, S. (1994) *Mapping the Terrain: New Genre Public Art*, San Francisco, CA, Bay Press.

Levin, K. (2002) 'The CNN Documenta: art in an international state of emergency', *Village Voice*, 2 July, p. 27.

Lind, M. and Steyerl, H. (eds) (2008) *The Greenroom: Reconsidering the Documentary and Contemporary Art*, Berlin, Sternberg Press.

Martin, S. (2007) 'Critique of relational aesthetics', *Third Text*, vol. 21, no. 4, pp. 369–86.

McNally, D. (2006) *Another World is Possible: Globalisation and Anti-Capitalism*, Winnipeg, Arbeiter Ring.

Meyer, J. (2002) 'Tunnel visions', *Artforum*, September, pp. 168–9.

Nash, M. (2004) 'Experiments with truth: the documentary turn' in Nash, M. (ed.) (2004) *Experiments with Truth*, Philadelphia, PA, Fabric Workshop and Museum (exhibition catalogue).

Nochlin, L. (2002) 'Documented success', *Artforum*, September, pp. 161–3.

Paglen, T. (n.d.) *The Black Sites* [online], http://www.paglen.com/pages/projects/CIA/black_sites.html (Accessed 17 March 2012).

Rancière, J. (1999) *Disagreement: Politics and Philosophy*, Minneapolis, MN, University of Minnesota Press.

Rancière, J. (2010) *Dissensus: On Politics and Aesthetics*, London, Continuum.

Rasmussen, M.B. (2011) 'Scattered (Western Marxist-style) remarks about contemporary art, its contradictions and difficulties', *Third Text*, vol. 25, no. 2, pp. 199–210.

Rectanus, M.W. (2002) *Culture Incorporated: Museums, Artists and Corporate Sponsorships*, Minneapolis, MN, University of Minnesota Press.

Roberts, J. (2009) 'Photography after the photograph: event, archive, and the non symbolic', *Oxford Art Journal*, vol. 32, no. 2, pp. 281–98.

Sekula, A. (2003) *Performance Under Working Conditions*, Ostfildern-Ruit, Hatje Cantz.

Sholette, G. (2010) *Dark Matter: Art and Politics in the Age of Enterprise Culture*, London, Pluto.

Smith, T. (2009) *What is Contemporary Art?* Chicago, IL, University of Chicago Press.

Stallabrass, J. (2004) *Art Incorporated: The Story of Contemporary Art*, Oxford, Oxford University Press.

Steyerl, H. (2009) 'Is the museum a factory?', *e-flux* [online], http://www.e-flux.com/journal/view/71 (Accessed 17 March 2012).

Thompson, N. and Sholette, G. (2004) *The Interventionists: User's Manual for the Creative Disruption of Everyday Life*, Cambridge, MA, MIT Press.

Toscano, A. (2010) *Fanaticism: On the Uses of an Idea*, London, Verso.

Verwoert, J. (2005) 'The expanded working field of documentary production' in Havránek, V., Schaschl-Cooper, S. and Steinbrügge, B. (eds) *The Need to Document*, Zurich, JRP Ringier, pp. 77–83.

What, How and for Whom (2009a) *Metinler/The Texts, What Keeps Mankind Alive*, 11th International Istanbul Biennial, Istanbul, Istanbul Külütur Sanat Vakfi.

What, How and for Whom (2009b) *Rehber/The Guide: What Keeps Mankind Alive*, 11th International Istanbul Biennial, Istanbul, Istanbul Külütur Sanat Vakfi.

Wood, P. (1993), 'Realisms and realities' in Fer, B., Batchelor, D. and Wood, P. (eds) *Realism, Rationalism, Surrealism: Art between the Wars*, New Haven, CT and London, Yale University Press, pp. 251–333.

Wu, Chin-tao (2001) *Privatising Culture: Corporate Art Intervention Since the 1980s*, London, Verso.

Wu, Chin-tao (2009) 'Biennials without Borders', *New Left Review*, vol. 2, no. 57, pp. 107–15.

Afterword

Leon Wainwright

This book has covered a period from about 1850 to the present day: a period in which the development of art and visual culture seemed to speed up, and the scope of art-historical attention spread across a broader geography, reaching beyond Europe to the wider world. Looked at in this way, the narrative of modern art is a story that changes as the priorities and interests of history-writing themselves change. The demarcation of art from a more broadly conceived visual culture is also shifting and complex. It is no easy task to understand how different practices of art and visual culture have influenced each other when the range of practices under consideration has to include painting and print culture, photography, design, architecture, video, and the wider arena of popular imagery.

That such transformations have taken place over what may be viewed as a rather brief period of time sets particular challenges for the writing of histories. The episodes selected here began with the time when some artists reached for alternatives to what were still influential art academies, as they sought to loosen the restrictions of the classical canon, or set their sights on a distinctly 'modern' art relevant to the modern world that was then emerging. In moving from contestations around the visual culture of nineteenth-century France and Britain to the concerns of a fully developed avant-garde in the first part of the twentieth century, the narrative has to take account of the increasing demand for art's independence from the traditional requirements of representing the world. Thus, one of the key points of contestation becomes a demand for the 'autonomy' of art, set against other demands for art's continuing engagement – by whatever means – with wider processes of history and politics. These concerns lie behind discussions in this book of Cubism, Futurism and abstract art, modern architecture and design, and the entry of photography into the sphere of art making.

Subsequently, in the period following the Second World War, when a particular conception of modernism centred on abstract painting came to hold sway in the USA, attempts to reassert the need for art to be related to 'life', and to challenge an exclusive focus on the aesthetic, were often perceived as anti-modernist. From our present historical distance, it makes just as much sense to regard all these competing tendencies as different forms of a more broadly conceived modernism. Be that as it may, in the period since the late 1960s – sometimes itself dubbed 'postmodernist' – the pendulum has swung once again towards a sense of art's necessary engagement with the world at large.

During the last third of the twentieth century, definitions of art were thrown open in favour of a radical revision of the status of artworks, artists and their audiences. It remains a matter for debate whether early twentieth-century avant-garde interventions were part of the same current that saw the expansion of the contemporary range of both the subjects and the objects of art practice, or whether there has been some kind of historical break between our current situation and a now historical 'modern' condition. Whatever the verdict ultimately is, the rise of a more global approach to both the practice of art and the writing of its histories appears now to be undeniable.

Index

Page numbers in *italics* refer to illustrations.